The Naked Blogger of Cairo

The Naked Blogger of Cairo

CREATIVE INSURGENCY IN THE ARAB WORLD

MARWAN M. KRAIDY

Harvard University Press

Cambridge, Massachusetts
London, England
2016

Library of Congress Cataloging-in-Publication Data
Names: Kraidy, Marwan M., 1972– author.
Title: The naked blogger of Cairo : creative insurgency in the
Arab world / Marwan M. Kraidy.
Description: Cambridge, Massachusetts : Harvard University Press, 2016. |
Includes bibliographical references and index.
Identifiers: LCCN 2015042051 | ISBN 9780674737082
Subjects: LCSH: Arab Spring, 2010– | Human body—Political aspects—Arab countries—
History—21st century. | Arts—Political aspects—Arab countries—History—21st century. |
Insurgency—Arab countries—History—21st century. | Political participation—
Arab countries—History—21st century.
Classification: LCC JQ1850.A91 K72 2016 | DDC 909/.097492708312—dc23
LC record available at http://lccn.loc.gov/2015042051

CONTENTS

ILLUSTRATIONS

The Naked Blogger of Cairo

PART I

In the Name of the People

———

THE PEOPLE WANT

"*W*hat on earth is it that can set off in an individual the desire, the capacity, and the possibility of an absolute sacrifice without our being able to recognize or suspect the slightest ambition or desire for power or profit?" The question arose as a reaction to the sight of students and workers marching in the streets of Tunis. Just weeks after this moment, people in other cities were clamoring for justice and dignity against a system that denied them both. This may sound like current affairs, but in fact it occurred in 1968. The French philosopher Michel Foucault was the contemplative observer comparing Tunisian riots in March 1968 to the events of Mai '68 in France.[1] Nonplussed by the pontificating on revolution in Paris, Foucault marveled at the "moral force" of Tunisian demonstrators, who brought a "direct, existential, physical commitment" to their battle.[2]

Forty-one years and nine months later, on December 17, 2010, Tarek al-Tayeb Mohamed al-Bouazizi blazed his way into history with a bottle of gasoline, a match, and his body. Within two days the people of Bouazizi's hometown, Sidi Bouzid, Tunisia, had taken to the streets. Bouazizi survived the attack and was lying in agony in the burn unit of a Tunis hospital. A now iconic picture, taken December 28, 2010, shows the twenty-eight-year-old fruit vendor in a hospital bed, bandaged like an Egyptian mummy. The dictator Zinelabidine Ben Ali grandstands over him and feigns interest while doctors and nurses stand mute in the background. Bouazizi succumbed on January 4, 2011, and on January 14, Ben Ali retired without dignity to that dictators' retreat otherwise known as Saudi Arabia. As oblivion snatched

the dictator from infamy, posthumous accolades exalted the martyr into myth. Bouazizi's likeness adorned handheld signs, revolutionary graffiti, and postage stamps. Sidi Bouzid etched his name atop a public square, Paris named a street after him, and he won the 2011 Sakharov Prize for Freedom of Thought. Bouazizi lives on as the Burning Man who set the Arab world aflame.

A few years later, on April 2, 2014, the Qena Misdemeanor Court sentenced Omar Abulmaged to a year in jail. The lowly Egyptian farmer had been in jail for six months when the ruling came. His offense? He named his donkey Sisi and adorned its head with a military cap similar to the one worn by Abdulfattah al-Sisi, the Egyptian field marshal and minister of defense. After having deposed the elected president Mohammed Morsi in a military coup in June 2013, Sisi won Egypt's controversial presidential election in May 2014, just weeks after Abulmaged's sentence.[3] The donkey-owning farmer came from Qena, a provincial capital about forty miles north of Luxor, in Upper Egypt, a region that many urban Egyptians see as backward. How dare a modest farmer, a rural lout, compare his country's strongman to an ass? What social meanings did his antic bring to mind? And why was his infraction worth a year behind bars?

Asinine trappings were a threat to Sisi because a bovine moniker had for decades defined Hosni Mubarak. Since the 1970s, the nickname Laughing Cow had clung to Mubarak to the extent that the dictator's own advisers tagged him with it. Ordinary Egyptians, who have mocked their rulers since the days of the pharaohs, relished mocking Mubarak with Laughing Cow jokes. By comparing his beast of burden to the strongman poised to lead Egypt, Abulmaged wielded a time-honored weapon of the humble against the powerful: unflattering animal symbolism. Images of cows, donkeys, pigs, and dogs help rebellious folk capture the tawdriest features of their masters, stripped from the civilizational patina with which humans conceal profane body symptoms. The actual political cost of such banter is difficult to measure as long as a political system is stable. But once the edifice of power begins to shake, political humor combines with other kinds of rebellion to precipitate a despot's downfall.

Enter the Naked Blogger of Cairo.

On Sunday, October 23, 2011, *A Rebel's Diary* appeared online with a warning to Internet surfers that "the blog you are about to display may have content suitable only for adults." Were you to click to access the blog, you

would see a full-body black-and-white photograph of a young woman, standing naked, with the exception of thigh-high stockings, glossy red ballet slippers, and a red flower in her hair. Facing the camera, she raises her right leg slightly and rests her right foot on a stool, revealing her pubic area. Atop the upper left corner of the photograph you might notice the caption "Nude Art," which is further explained in a manifesto under the photograph: "Put on trial the artists' models who posed nude for art schools until the early 70s, hide the art books and destroy the nude statues of antiquity, then undress and stand before a mirror and burn your bodies that you despise to forever rid yourselves of your sexual hangups before you direct your humiliation and chauvinism and dare to try to deny me my freedom of expression."[4]

By creating *A Rebel's Diary,* Aliaa al-Mahdy, then a nineteen-year-old student in communication at the American University in Cairo, unleashed one of the most heated polemics of the Egyptian revolution. Claiming to be a "secular, liberal, feminist, vegetarian, individualist Egyptian," she lobbed her body in the public sphere like an incandescent arrow, inflaming an already heated public sphere.[5] One-upmanship in invective against the naked blogger epitomized the ensuing debate. Nonetheless, the episode raised fundamental questions about women's bodies, revolutionary politics, national identity, and digital communication. Al-Mahdy did not perish like Bouazizi, but death threats, physical intimidation, and videos of her purported lynching in Tahrir Square forced her to seek political refuge in Scandinavia. Though biologically alive in exile, her body suffered a social death at home.

––––––––

The Naked Blogger of Cairo develops the notion of creative insurgency to explore the mixture of activism and artistry characteristic of revolutionary expression and tracks the social transformation of activism into Art and ensuing controversies. At the heart of these processes is the human body as tool, medium, symbol, and metaphor. In Tunisia, Egypt, Syria, and elsewhere, activists have deployed a rich array of art and media in fierce propaganda wars against murderous dictators. Mining the past for resonant symbols, creative insurgents execute daring physical performances, catchy slogans, memorable graffiti, and witty videos. There are two types of creative insurgency: the radical mode of Burning Man, an explosive and spectacular

militancy in which the body itself engages in deadly political feats, and the gradual style of Laughing Cow, a latent and incremental activism that draws potent symbolism from the human body. Radical and gradual activism entwine as heroic, revolutionary bodies toil to turn classical, despotic bodies into degraded, grotesque bodies—the Naked Blogger is a potent radical-gradual hybrid. Revolutionaries engage in these physical and symbolic practices to wrench political power from the body of the dictator and birth popular sovereignty.

The Arab uprisings' key slogan, *asha'b yourid esqat al-nidham* (The people want to topple the system), reveals a burning desire for popular sovereignty. In the key revolutionary period December 2010–March 2011, as Tunisia dangled the possibility of change and Egypt underscored its inevitability, this slogan circulated like wildfire.[6] Tunisians first clamored it on Avenue Habib Bourguiba, and then Egyptians roared it on Tahrir Square. From there it moved to Bahrain, Yemen, and Libya and reverberated in countries—like Jordan and Lebanon—that experienced no actual rebellion. In Jordan, it started as "The people want to reform the system," then escalated to demand the system be overturned. In Lebanon, a movement arose against political sectarianism, with the slogan "The people want to topple the sectarian system." After Mubarak's fall, Egyptians protested military rule with *asha'b yourid esqat al-mushir* (The people want to topple the field marshal). Even radical Islamists opposed to popular sovereignty riffed *asha'b yourid e'lan al-jihad* (The people want to declare jihad). As the Arab world convulsed, "the people want" was bawled and bellowed, scribbled, and screened. With hands, fists, eyes, and mouths, revolutionaries uttered and witnessed hitherto stifled demands for sovereignty.

The slogan expressed a desire for popular emancipation from an oppressive system rather than simply the replacement of a political regime. The pervasive translation of *nidham* as "regime" has from the beginning struck me as limited. *Nidham* also means "system," so why should we select the narrower definition? Revolutionaries had in their crosshairs a bigger target than Ben Ali, Mubarak, and Assad, who, they realized, were but cruel faces of a system experienced locally but sustained by global geopolitics and economics. Social inequality was as much a root of rebellion as political repression, and ideology did drive aspects of the uprisings. Ignoring that *nidham* means both regime and system misses the breadth of revolutionary demands and misconstrues creative insurgency.[7] "The people want to topple

the system" was an expression of political demands as much as it was a crucible of revolutionary identity. Expressed in classical Arabic (*fusha*), the language of officialdom, it reflected a solemn demand with momentous consequences.[8] Speaking in the name of the people is much more than expressing a political point of view or clamoring for the departure of a despised dictator. Speaking in the name of "the people" can legitimate vast political undertakings and forge nations.[9] In the Arab uprisings "the people want" constructs the people as much as it expresses their demands. It is what scholars call a "constitutive rhetoric."[10]

As extraordinary upheavals that affected millions and reshuffled geopolitics, the Arab uprisings are an elusive totality. But by focusing on how creative insurgents attack dictators and forge new political identities, we can identify and understand concrete practices of rebellion. To this end, *The Naked Blogger of Cairo* asks, How does creative insurgency emerge and thrive? What kinds of artistic practices does it spur? What debates does it foment? Grappling with these questions requires staging a cross-disciplinary conversation that inquires, What do self-immolations in 1963 Saigon and 1969 Prague reveal about Bouazizi's in 2010 Sidi Bouzid? How does Mubarak's switching off the Internet in 2011 resonate with the British ban on theater in 1919 Cairo? What historical perspective can we gain by revisiting the French Revolution? Can the aesthetic sensibility of Delacroix's *La liberté guidant le peuple* help us grasp the Naked Blogger of Cairo? What can we learn about political street art in 2010 Arab capitals from civil war–era stencil graffiti in 1970s Beirut? How do loaf-brandishing revolutionaries and the superhero Captain Khobza in 2010 Tunis echo past bread riots? How does *Top Goon— Diaries of a Little Dictator* recast ancient puppetry traditions for the digital era? Is revolutionary graffiti mere political messaging or is it art? How has creative insurgency evolved in different periods and places?[11]

THE DICTATOR'S TWO BODIES

The Naked Blogger of Cairo taps the human body as an organizing principle to understand creative insurgency. The body was a common thread in the massive trove of images and jokes, essays and songs, videos and conversations I gathered while living in the Arab world between June 2011 and August 2012, during shorter research trips to Amsterdam, Beirut, Berlin, Cairo, Copenhagen, and Istanbul, and in protracted expeditions on the Internet. Bodies, burning with anger and defiance, throbbing with pain and hope, brazenly violating social taboos and political red lines, haunted my primary materials. A stencil graffito I photographed in November 2011 in Zamalek, an affluent Cairo neighborhood, features a television set with a headshot of a Pinocchio with a nose so overgrown it bursts through the screen (Fig. 1). Here was a brief, compelling message that television is a liar, based on the body's ability to betray falsity. It echoed fists, hands, and fingers in graffiti of the Syrian revolution I tracked in Beirut. Watching satirical videos, I wondered whom they skewered most: Was it Ben Ali, trapped on an airplane and unable to land in the jocular *Journal du Zaba?* Or Assad, downsized to a pathetic finger puppet in *Top Goon—Diaries of a Little Dictator?* Or maybe Mubarak, diminished by the splendid Laughing Cow trope to dumb, regurgitating cattle? Spectacular body acts that underlay pivotal events of the Arab uprisings take center stage in this book: Mohamed Bouazizi, the Burning Man of Tunisia; Aliaa al-Mahdy, the Naked Blogger of Cairo; Assala, the Rebellious Singer of Damascus. Regimes responded with body mutilation: hand breaking, eye sniping, virginity

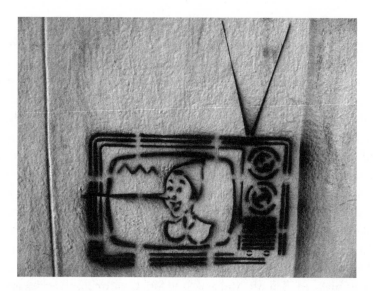

FIG. 1. *Pinocchio in TV Screen,* stencil, Cairo, 2011, photo © Marwan M. Kraidy.

testing, as street art commemorated heroic bodies of martyrs pitted against repressive bodies of despots.

Why is the body fundamental to the Arab uprisings?

History tells us that corporeal metaphor is central to political power: from before Louis XIV to after Bashar al-Assad, the sovereign's figure is the body of the realm. Writing in Baghdad and Damascus during the tenth century, the Islamic Golden Age philosopher and translator Abu Nasr al-Farabi cast the ideal polity as a healthy body, and he described in *The Perfect State* different parts of the state as limbs, ruled by a commanding organ, the heart, that unifies their efforts toward achieving the contentment of the community.[12] In *The King's Two Bodies: A Study in Mediaeval Political Theology,* the German-American historian Ernst Kantorowicz traced a concept of "body politic" that envisions a kingdom as a human body, the king as its head and his subjects as organs and limbs.[13] Developing fully in Elizabethan England, this notion recurred for centuries in European political thought and popular culture, from Rousseau's essays to Shakespeare's plays, and became influential in France in the sixteenth century. During the French Revolution, corporeal symbolism focused on separating the king's biological *body natural* from his symbolic *body politic.*[14]

In medieval Europe, God was considered the greatest good, and from him the body politic flowed as a unified organism.[15] In contrast, in the months beginning with Mohamed Bouazizi's self-immolation on December 17, 2010, the three Arab countries that we are most concerned with—Egypt, Syria, and Tunisia—were thoroughly secular autocracies. In all three, political leaders subjected clerics to their dominion and manipulated religion for political ends, but none of them derived his power from the divine, ruled in the name of God, or based foreign policy on religious grounds. Whereas in thirteenth-century Europe the body politic belonged to the sacred, in early twenty-first-century Egypt, Syria, and Tunisia the body politic was resolutely worldly. Body imagery is important to modern, secular absolutism, with its image of "the omniscient, omnipotent, benevolent" leader who "defies the laws of nature by his super-male energy."[16] As you read *The Naked Blogger of Cairo,* you will encounter the same language in encomia to Assad, Ben Ali, Mubarak, and Sisi. Creative insurgencies against these rulers subvert the imagery propagated by cults centered on the leader's figure. The body is as foundational to the fall of dictators as it is essential to their rise.

Over time, the notion of the body politic evolved to balance hierarchy with interdependence, leading to political pacts that preserved stability but, if broken, invited rebellion. By confirming "the irreplaceable and irreducible moral dignity and spiritual worth of individual man" and insisting that the king was an integral part of the body politic, not standing above it, the medieval notion succumbed to ideological manipulation by politicians leading the rise of new secular states.[17] Emerging lay conceptions of the body politic pilfered at will from Christian theology, Roman law, and canon law, diluting monarchical power. By the late 1300s, bodily metaphor was moving away from the absolute concentration of power in the body of the king, as a conception of a "composite" body of authority including courts, councils, or parliaments gained ground.[18] In the notion of distributive justice that arose to balance these different constituents, one can hear echoes, however faint, of bread-for-stability social contracts that since the 1950s have propped up Arab dictatorships. Because these bargains were fickle, bread riots occurred frequently. Since the 1980s, a combination of economic liberalization, political predation, and rising food staple prices has stretched the bargain to a breaking point. Though the uprisings are more than bread riots, bread symbolism is pervasive, from the Egyptian slogan *'aysh, hurriya, 'adala*

egtema'eyya (bread, freedom, social justice) to the Tunisian superhero Captain Khobza (Captain Bread).[19]

Medieval European despots were as likely as modern Arab autocrats to trample on individuals' bodies and violate their dignity. But in the contemporary, post-Enlightenment era, we have global talk of human rights and social justice.[20] This gives voice to aspirations for personal dignity and political liberty, fueled by endless demands for democracy and freedom of speech couched in the moral rhetoric of universal values. Creative insurgency circulates with this global cross-border language of rights, out of reach of Arab despots whose affinity for physical repression pushes body symbolism to the center of creative insurgency. In recent years systematic state violation of bodily integrity has made torture a widely experienced ordeal, and extensive circulation of photos and videos has made it a politically galvanizing issue. Since 2001 the war on terror, the invasions of Iraq and Afghanistan, the Abu Ghraib scandal, continuing U.S. drone attacks, and ongoing Israeli repression of Palestinians have deepened a sense of bodily defenselessness in the region. During the recent uprisings, state brutality in Cairo, Gaza, and Manama, political assassinations in Tunisia, violent anarchy in Libya, the bloody civil war in Syria, and the depredation of Daesh (which is what Arabs call Islamic State) have served up many a mangled Arab body. That is why bodies aching for dignity haunt the Arab uprisings and fuel the peculiar aesthetics of insurgent art and culture.

Creative insurgency circulates in a vibrant Arab media sphere that has developed for one hundred years. Cross-border networks of information arose in the late Ottoman era, and the 1919 Revolution in Egypt witnessed a mushrooming of popular media. Egyptian president Gamal Abdel Nasser established Voice of the Arabs radio in 1950s Egypt. At century's end the satellite revolution of the 1990s spawned polemical pan-Arab news and entertainment channels like al-Jazeera and the Lebanese Broadcasting Corporation. Finally, blogs and mobile telephones in the 2000s and YouTube, Facebook, and Twitter in the 2010s consolidated a linguistically Arab, geographically pan-Arab, culturally vibrant, and politically contentious public sphere.[21]

———————

Much—too much—has been said about the role of digital media in the Arab uprisings, but how technologies interact with the humans who operate

them remains unclear.[22] *The Naked Blogger of Cairo* asks, How does the rise of digital culture complicate our understanding of the body in revolutionary times? Technology publicizes corporeal dissent, but the human body is the indispensable political medium. As the sociologist Antonio Casilli put it, in digital culture, "*l'adieu au corps n'a jamais eu lieu*" (The farewell to the body never occurred).[23] Considering the human body as a vital nexus of physical struggle and virtual communication helps us realize that distinctions between expression and action, mind and matter, the Internet and the "real world" are actually flimsy. Philosophers from Baruch Spinoza in *Ethics* to Michel Foucault in *Discipline and Punish: The Birth of the Prison* have underscored the interplay of social, physical, and psychic forces in the body. Before the digital era, the French philosopher Henri Bergson considered the body a "center of action" that perceives, synthesizes, manages, and redistributes images and human action in relation to the objects that surround us.[24] His confrère Maurice Merleau-Ponty, whose *Phénoménologie de la perception* lay the ground for understanding embodied communication, wrote, "My body is the fabric into which all objects are woven, and it is, at least in relation to the perceived world, the general instrument of my 'comprehension.'"[25] New-media scholars have built on these theories to argue that corporeality plays an ever more vital role in the digital age because the human body filters a plethora of images spawned by media convergence.[26] This works in two directions. Digital culture "disperses" bodily experience across cyberspace.[27] In the Arab world particularly, as the Arab media scholar Yves Gonzalez-Quijano put it, digitization has had "a devastating effect on the control of bodies."[28] But the body anchors ideas and binds styles in mesmerizing, hybrid forms: operated by human hands and featuring handmade miniature bodies, *Top Goon* is at once revolutionary theater, finger puppetry, political satire, and digital video.

The belief in the centrality of the body to communication has led to the claim "the medium is the body."[29] The body is an important medium, but it is also more. The body integrates our physical world with our subjective feelings, our social experiences with the meanings they hold. As the historian Milad Doueihi has shown, digital culture transforms our body's relationship to space, and to culture at large.[30] The body constructs a language, in this case, a rhetoric of revolution.[31] But the body also extends in social space: the ubiquity of heads, faces, eyes, lips, arms, fists, palms, and fingers

in creative insurgency bear out the case that "far from our organs being instruments, our instruments are actually added-on organs."[32] By connecting ideas and action, perceiving, producing, processing, and disseminating images and feelings, the body is a linchpin of revolutionary change.

The Naked Blogger of Cairo brings to light omissions embedded in the doctrine of the king's two bodies. One minor issue concerns animal symbolism, which has since the Middle Ages spawned a vibrant repertoire of humor and invective where animals are base sidekicks to human corporeality.[33] But another elision concerns the place of women in the body politic. Women were restricted to a metaphorical role, by extending a religious image into a temporal one: like a bishop, who, once ordained, became the spouse of the church, so did the metaphor of "a ruler's marriage to his realm" consecrate women as an image of something to be ruled.[34] Thus corralled in medieval doctrine, women rose during the French Revolution as revolutionary icons and political agents.[35] This would later bind the figure of woman to nationalism and give rise to the oft-used image of women's bodies as battlefields. But as an "artificial man," the body politic absorbs and rules women's bodies.[36] The stories that follow showcase women as important catalysts in the Arab uprisings and in the creative insurgencies therein. But one disconcerting pattern emerged: most revolutionary martyrs-at-large were dead and clothed men, whereas the emergence of women as icons in the Arab uprisings tended to result from their disrobement.[37] Part V focuses on the extent to which women were merely an impetus for men's political battles, as opposed to enjoying a status akin to what the historian Joan Scott, writing about French politics, called "abstract individuals."[38]

CREATIVE INSURGENCY

*I*n the wake of the Arab uprisings, journalists, activists, and scholars coupled *creative* with *revolution* (or *dissent, protest, resistance*) to describe political graffiti, rap, art, and video. Distinguished institutions, from the Prince Claus Fund of the Netherlands to the Arab American National Museum in Dearborn, Michigan, lent the concept gravitas.[39] The notion of "creative revolution" has a nice resonance. It is hard to think of a negative meaning to "creative," and "revolution" acquires a positive sense when directed against loathed autocrats. "Creative revolution" appeals because it conjures up ordinary people standing up against oppression and doing so artfully. This language echoes rhetorical commonplaces about the uprisings being "nonviolent" and "nonideological."[40] But this nebulous notion is tricky. "Creative" seems to designate an artistic object, an item involving color, shape, melody, words, something that is supposed to stir feelings in us. Adding "creative" leaves a residual category of noncreative resistance. Can we really distinguish one from the other? Can we restrict creativity to aesthetics? Is using lemon juice to mitigate the pain of tear gas not creative? Are silent vigils not ingenious? Is using a cooking pot as a helmet to protect your head from police projectiles not imaginative? Are three persons riding a moped to a makeshift clinic, wedging the wounded and unconscious between the bodies of two unimpaired activists, not inventive?[41] For the pairing of creativity and rebellion to convey anything beyond a vague notion of hip, nonviolent struggle, it requires a definition that reaches beyond aesthetic concerns to incorporate actions that are physical and symbolic, violent and peaceful.

The notion of creative insurgency accomplishes just that. Insurgency means "rising in active revolt." The noun comes from the eighteenth century, through French and Latin, in which *insurgent* means "arising," from the verb *insurgere,* from *in,* which means "into" or "toward," and *surgere,* which signifies "to rise." *Insurgency* connotes more activity and intensity than *dissent, resistance, protest,* but less upheaval than *revolution.* The uprisings cannot be described as revolutions, perhaps with the exception of Tunisia, for even if leaders fell, their regimes have survived, and the overall system of political, economic, and cultural repression endures. *Insurgency* captures two tempos of action—radical and gradual—that this book identifies and explains. Insurgencies include regular successions of low-grade ambushes punctuated by occasional outbursts or major attacks, and insurgents are typically not recognized as worthy adversaries: Arab despots dismissed them as traitors and terrorists, as germs, rats, or snakes threatening the body politic. *Insurgency* also undermines claims that the Arab uprisings were nonviolent— rebels have torched buildings, hurled stones, clashed with police—and recognizes that violence can be symbolic, verbal, physical, and structural.[42] Creative insurgency combines two types of violence that overlap and sustain each other: the kind of violence inflicted with words, songs, and images and the one wreaked with fire, stones, and rifles, acting in tandem to dislodge dictators. Doing so summons a broader sense of creativity, germane to art and aesthetic concerns, but also to other kinds of revolutionary action: chanting slogans and burning your body, spraying graffiti and tending to the wounded, circulating jokes and building barricades. If creativity, in the sociologist James Jasper's definition, is an "extreme form of flexibility," then few instruments can be as creative as the human body.[43] People use their bodies for aesthetic expression, but also in actions that are creative in physical or political ways.

What are some attributes of creative insurgency?

Creative insurgency is willful, planned, and deliberate. Rarely is it spontaneous. Mural street art is a laborious endeavor. Even stencils, executed in quick squirts of paint through precut templates, take a great deal of honing. Graffitists first cut stencils from cardboard, then practice intently to test different kinds of paints and materials (cardboard? laminated paper?) and try out several colors. When I visited one graffiti artist in a decrepit suburb of Beirut, I noticed on the walls of his home studio half a dozen iterations

of a famous stencil that I had tracked around the city. Some were crisp, others murky. In one, spilling paint oozed several inches below the stencil itself; in another, too much paint was spattered, deforming the stencil's design. The artist used yellow on a dark wooden surface in the entrance, but daubed dark blue right on the off-white wall of the living room. Thorough preparation also applies to sloganeering, an intricate social process with formal and informal elements involving a division of labor between slogan composers who toil away from the limelight and charismatic slogan leaders who perform in public.[44]

Creative insurgency is not an external expression of internally preformed emotions, ideas, or beliefs. It expresses rebellion as much as it shapes it. Spinoza understood human nature as a fluid fusion of body and soul, and Herder believed that what we feel and what we express are intricately connected, that "the human being who expresses himself is often surprised by what he expresses, and gains access to his 'inner being' only by reflecting on his own expressive acts."[45] This is fundamental: Creative insurgency gives voice and shape to revolutionary claims as much as it prods insurgents to always reassess their aspirations and identities.[46] As a theory of power, creative insurgency rejects the distinction between mind and body, persuasion and compulsion, symbolic and physical violence.[47]

Creative insurgency is a social process. It is not the work of an individual artistic genius toiling alone in obscurity. Arab revolutionary figures became iconic precisely because they represent something bigger than themselves. The bodies of Mohamed Bouazizi, Khaled Said, and Aliaa al-Mahdy refract various kinds of repression and resistance. Figures you will encounter as Qahera, Captain Khobza, and Sprayman embody widely shared fears and desires. Revolutionary practice itself is collective: some well-known artifacts are the work of groups of people, dedicated, coordinated, often anonymous. Several activists toiled to create and maintain the "Kullina Khaled Said" Facebook page; a handful devised the *Top Goon* web series. Kharabeesh (doodles), creator of the *Journal du Zaba* satirical videos, is actually a Jordanian group. Others include Mona Lisa Brigades in Egypt and Asha'b Assoury 'Aref Tareqoh (The Syrian People Know Its Way) in Syria.[48] Like other kinds of human artfulness, creative insurgency arises out of social interaction.

Creative insurgents fuse familiar and foreign, old and new. These ingenious activists graft new meanings onto recognizable symbols. Bouazizi's self-immolation echoed Kurdish self-immolators and Palestinian suicide

bombers. A decades-old poem by Abul Qassem al-Chabbi, a gifted Tunisian poet who died in 1934, inspired revolutionaries in 2010. Revolutionary digital finger puppetry is a heady mix of ancient and avant-garde, wielding familiarity with puppetry, presidential speeches, torture sessions, and reality television. Firestorms of controversy surrounding naked activism are rooted in century-old quarrels over art and nation and contemporary polemics about feminist art and activism. It is in the volatile fusion of past and present that creative insurgency flourishes.

Hell-bent on projecting local struggles globally, creative insurgents use resonant symbolism. They draw on a historically deep repertoire in order to achieve a geographically wide resonance. Egyptian muralist Alaa Awad used neo-pharaonic motifs, and Franco-Tunisian artist eL-Seed found inspiration for "calligraffiti" in Islamic calligraphy. To reach a worldwide public without undermining local authenticity, these artists must reconcile local rootedness with global attention. Though swaddled in local politics, revolutionary art seeks to extend its reach, but it cannot allow global political or commercial forces to absorb it completely, for then it ceases to be art. This is a burning issue because the uprisings have spawned a global renewal of Arab art. When activist-artists exchange the grit and peril of the streets of Cairo and Damascus for the comforts and safety of European residential fellowships, American museums, and Gulf galleries, they enter transnational circuits of art, money, and politics. Many artist-activists of the Arab uprisings are now refugees in Amsterdam and Paris, Beirut and Berlin, Sharjah and Stockholm.[49] With the rise of the "creative-curatorial-corporate complex," risks of selling out are as big as the rewards of fame.

Finally, creative insurgency plays a documentary role that broadens the impact of revolutionary action. Consider how digital images expanded the reach of Bouazizi's self-burning from a desolate town in the Tunisian hinterland to global attention, and how activists used a panoply of media to spread their message to the world. Creative insurgency celebrates heroes, commemorates martyrs, and sustains revolutionaries. It depicts bodies murdered, maimed, or tortured and contributes to an evidentiary chronicle of political abuse. It triggers debate and contributes to a vast, crowd-sourced archive of revolutionary words, images, and sounds. Artistry is important, because the ability to attract a public depends on what the literary critic Michael Warner called the "differential deployment of style."[50] Creative insurgency, then, consists of imaginatively crafted, self-consciously pleading

messages intended to circulate broadly and attract attention: forms in search of visibility.

How does creative insurgency unfold?

The Naked Blogger of Cairo identifies two modes of creative insurgency, radical and gradual. The radical mode of Burning Man entails embodied, life-or-death revolutionary action, like self-immolation. This type of insurgency occurs in one-time outbursts. It is violent and spectacular. The survival of the human body itself is at stake. Radical deeds are life-threatening actions spawned by deadly conditions. The radical mode is crucial because it is a direct confrontation with the ruler, an open challenge to his sovereignty. In contrast, the gradual mode of Laughing Cow subverts the norms of sovereign power. It trespasses its boundaries by launching symbolic attacks at the ruler. Body imagery is central to this type of revolutionary action, and a peculiar aesthetic of peril and deprivation underscores corporeal vulnerability. The gradual mode is distinctive in the incremental and cumulative ways it chips away at power. It can be seen in revolutionary humor. Through symbolic inversion, such actions pull the powerful down to the level of the powerless.

The radical and gradual modes entwine. They fuel and shape, prod and pull each other. Gradual rebellion expands prerevolutionary dissent in Egypt, Syria, and Tunisia: double-entendre parodies, ambivalent art, and allegorical theater that autocrats encouraged, tolerated, or manipulated. In contrast, radical creativity is a no-holds-barred, high-risk, high-reward gambit. Sporadic radical actions fuel waves of gradual infractions that reverberate widely, setting grounds for the next radical gauntlet. The violent outburst of Bouazizi's self-immolation inspired graffiti, memorials, videos, and slogans that in turn galvanized other radical actions. Unfurling with different speeds, cadences, and visibilities, radical and gradual activisms mesh in time and space. Naked Blogger mixes Burning Man and Laughing Cow and muddies distinctions between them. By inviting both moral opprobrium and threats of physical oblivion, al-Mahdy's digital nude selfie had immediate rhetorical and physical consequences. Many acts of creative insurgency are hybrids of radical and gradual.[51]

Together, radical militancy and gradual activism set in motion a contest between three kinds of body—classical, heroic, and grotesque—that induces

status reversals. Classical bodies, like the statues of antiquity, are bounded, hard, erect, and dominant. They are high-perched bodies that dictators give to themselves via ceremony, pomp, and ubiquitous statues in heroic poses—arms raised basking in the adulation of their subjects, hands clasped and a bold forward gaze contemplating a bright future, captions extolling contrived heroic deeds. But classical bodies are also immobile, cold, and distant, disconnected from the people and impervious to their struggles. Had you visited Egypt, Syria, or Tunisia before the uprisings, you would have been unable to avoid the gaze of one or another statue, portrait, or monument glorifying the heroic body of the leader. Classical bodies pretend to be heroic bodies, but that cloak is flimsy.[52]

Heroic bodies put themselves in harm's way for noble, larger-than-self causes. They burn with the fire of righteous indignation and just rebellion. Consumed by the oppression meted upon them and others by the dictators' self-declared classical bodies, heroic bodies are leaders at the forefront of change. Because of their willingness to lead rebellion, heroic forerunners are vulnerable. They attract a lion's share of repression. But in their corporeal vulnerability, heroic bodies are a living witness to injustice and a breathing clamor for dignity.[53] In contrast to bounded classical bodies of despots, insurgent bodies are heroic when they overcome their own boundaries. Some are accidental heroes. Samira Ibrahim, a young Egyptian woman, stumbled into activism after Egyptian authorities subjected her to a "virginity test." This kind of state-sanctioned rape, like self-immolation and torture, violates bodily frontiers—thresholds of human dignity. Others achieve heroic status by a willful act, like Bouazizi, or by tragic happenstance, like Khaled Said, the Egyptian youth fatally beaten by the police. Heroic bodies tend to be young, but some are not, though compared to dictators gone to seed, they look youthful indeed.

Heroic bodies turn classical bodies into grotesque bodies. The Russian critic Mikhail Bakhtin developed the notion of the grotesque body to refer to the debasement of what is usually honored, respected, or feared. This is accomplished through contrarian imagery from human and animal anatomy.[54] My usage of the term in a lethal, revolutionary situation differs from Bakhtin's, who applied it to the sanctioned context of carnival, but the difference is a matter of degree.

Many believe that the revolutions stalled because revolutionaries agreed on the necessity to eject dictators but failed to articulate an alternative

political vision.[55] But as Annabelle Sreberny-Mohammadi and Ali Mohammadi wrote in their classic study of communication in the Iranian revolution, "All revolutionary movements are creative evolving processes that write their own scripts."[56] Claims that the Arab uprisings failed because insurgents focused on spelling out what they were against but were unable to articulate a set of positive demands—what they were for—miss the point of creative revolutionary expression altogether.[57] To the question, Did the uprisings really founder? the stories that follow offer glimpses of a momentous transformation of human bodies, from subjugated individuals to revolutionary persons. In fact, creative insurgency's most vital contribution is the way it stitches personal and political identities together and transforms both in the process. Creative insurgency is the harbinger of a new sense of self. The body is crucial to the rise of revolutionary selfhood, for it is the body that connects ideas to action, mobilizing and directing symbolic and material resources, in a cycle of radical and gradual acts that drive creative insurgency. Revolutions cause total upheaval that puts values, beliefs, and norms up for grabs. Creative insurgency is a response to a "revolutionary situation," a set of circumstances that compel individuals to congeal into collectives that challenge the status quo. In *The Creativity of Action,* the German sociologist Hans Joas describes a "situation" as "the ability of the body to move and communicate in an innovative way." For this to occur, "creativity must be enacted through both the body and the social system of meanings that recognizes the action as different from the norm." Indeed, "creative action unifies the mind and body in doing something perceived as different."[58] In the cycle of creative insurgency, a revolutionary situation spawns novel expressions that incubate new identities that fuel rebellion, which spurs a new understanding of the self, over and again.

Self-renewal and the birth of a new political identity depend on extracting sovereignty from the body of the ruler. Creative insurgency is the sum total of processes through which revolutionary subjects extricate themselves from the body of the sovereign in order to create a new body politic.[59] During the Arab uprisings, activists opened symbolic wedges between the dictator's two bodies, inserted levers in that space, and pushed with all their strength to widen the chasm to the breaking point between the nation and the dictator's body. Creative insurgency, then, is hell-bent on wrenching body politic from body natural to rescue sovereignty from the grip of the tyrant and give it to the people.

The Naked Blogger of Cairo follows a straightforward organization. Though scholars of politics, art, culture, media, and the Middle East have plenty to sink their teeth into, general readers should find the stories compelling and instructive. Part II explains the radical mode of creative insurgency, and Part III, the gradual. Though the first draws mostly on Tunisia and the second on Egypt, both analyze patterns that exceed single countries. With the two types of activism explained, Part IV features exemplary cases of creative insurgency that show how the human body extends itself through the revolutionary public sphere, mixing radical and gradual insurgency. Several stories in the third part come from Syria and some from Egypt, but the analysis has a broader purview. Grappling with issues of sexuality, citizenship, and nationhood through a comparative analysis drawing from Egypt, Tunisia, global activism, and the French Revolution, Part V, home to the book's title essay, probes a blind spot of the king's two bodies doctrine by exploring the politics, aesthetics, and ethics of naked activism. Essays in Part VI take up debates about contemporary art triggered by creative insurgency, evaluate counterrevolutionary currents, including the sinister rise of Daesh, and give a final assessment of the body in revolutionary politics.[60]

PART II

Burning Man

————

On June 11, 1963, the Buddhist monk Thich Quang Duc set himself aflame in Saigon to protest the U.S.-supported South Vietnamese regime's repression of Buddhists. Forewarned, the photographer Malcolm Browne captured the meticulously choreographed self-immolation, and his photo became an iconic image of the Vietnam War after the *Philadelphia Inquirer* published it.[1] Later Browne described what he had witnessed: "His eyes were closed, but his features were twisted in apparent pain. He remained upright, his hands folded in his lap, for nearly ten minutes as the flesh burned from his head and body. The reek of gasoline smoke and burning flesh hung over the intersection like a pall."[2] As the war tore the U.S. body politic asunder, several Americans burned themselves in protest, young and old, women and men, homemakers and students, even a thirty-one-year-old Quaker named Norman Morrison who set himself on fire while opposite Robert MacNamara's office at the United States Department of Defense.[3] Like Morrison in 1965 America, Mohamed Bouazizi in 2010 Tunisia came into physical proximity with a culpable and unresponsive authority figure before setting himself aflame in protest.

Why do people burn themselves? Religious groups like early Christians and Tibetan monks were among history's first self-immolators, but over

time the practice evolved in a political direction.[4] In Saigon, Prague, and Washington, the 1960s enshrined the practice as the ultimate political protest. People burn themselves only when under intense political, socio-economic, or social pressure, and self-immolations nearly always provoke social debates or political action. Consider sati, the rite of widow-burning in India. Mystical beliefs, colonial domination, patriarchal practices, and economic inequality shaped sati; nonetheless, it prompts impassioned polemics that expose rifts between a modern, cosmopolitan India, and a defensive, tradition-bound India.[5] Though rare, sati still occurs. The intellectual Ashis Nandy explained that to communities feeling vulnerable by Western encroachment, "sati became an important proof of their conformity to older norms" under threat.[6] Sati, in Nandy's words, gratified a search by the Indian elite for "grand spectacles of evil."[7] Self-immolators ignite debates about progress and backwardness, free will and social constraint, religion and economic deprivation, but they rarely spur discussion of the physical agony their act entails.

It is no strain to imagine how painful and destructive intentional self-burning is. Self-immolators typically douse their bodies with a combustible liquid, raising the temperature of the fire and making the burn deeper. Because they start the fire on purpose, they do not try to put it out, so the damage spreads all over the body. In the words of a medical specialist, "Any time this kind of severe burn happens . . . initially you're talking about the most excruciating pain that you could ever experience until you get to the deep burn where it's burned the nerves. And then after that the brain does this thing where it shuts itself down."[8] The burning skin then "sets off this chain reaction within the body . . . doubles the insult from the burn to a whole body infection."[9] It is remarkable that colonial narratives about sati ignored the immense pain of immolation, as if "the widow herself evaporates."[10] Without acknowledgment of their physical torment, Indian widows and Arab youths remain nothing more than symbols.

Accounting for pain alerts us that the body is object and agent. Physical suffering is intimately related to what scholars call "agency," the ability to lead one's life mindfully and deliberately, including the capacity to get rid of pain. To the anthropologist Talal Asad, this notion of agency is inadequate, assuming as it does that humans always have conscious intentions and are in full control of their bodies.[11] As an embodied practice, creative insurgency fuses embryonic ideas with mature artistry and forges unconscious impulses

into deliberate action. At once proactive and defensive, creative insurgency is intermittent and it sometimes fails. But unlike tradition, religion, politics, and culture, which are bound to place and time, bodily pain is universal. To be sure, there are different ways to describe, understand, and bemoan pain, but as an experience, pain is shared across time and space. In inhuman conditions, pain affirms the fundamental values of human life and dignity. Bouazizi's pain evaporated in posthumous myth-making, but the questions his death raised—Was it a desperate act or a heroic deed? Was his action "egoistic" or "altruistic" (to use Durkheimian language)? Was it inspired by religion? Was he, as the Algerian-French novelist Tahar Ben Jalloun put it, "the universal citizen who reached the end of his patience"?[12]—oversimplify the complexity of his act and its aftermath. A notion of agency attuned to Asad's critique means that body and mind, despair and heroism, free will and social coercion fuse in Bouazizi's radical insurgency. What can we learn by comparing it to other forms of radical body protest like suicide bombing and hunger striking?

PROTEST SUICIDE

*A*lthough the suicide bomber looms large in Western perceptions of Islam, those who have studied the phenomenon dispassionately have concluded that it cannot be attributed to religion alone. A comprehensive study concluded that "there is little connection between suicide terrorism and Islamic fundamentalism, or any of the world's religions."[13] Others have refuted arguments associating suicide bombers with Islam, arguing that interpretations of the phenomenon as an Islamic "sacrifice" stem from an inadequate Christian optic.[14] Everything in Bouazizi's case indicates he was a nonpious man who did a nonreligious thing, and Muslim clerics condemned his action.[15] So let us consider other factors that push people to protest suicide. Bourdieu famously noted deep inequality in distribution of "symbolic capital"—the sense that one's life is valued and deserves to be lived. People in politically precarious positions, like Palestinians under Israeli occupation, lack symbolic capital and suffer from a devastating absence of prospects for self-fulfillment. This bleak environment where males compete for social prestige creates what the Lebanese-Australian anthropologist Ghassan Hage calls "suicide capital" and fuels a culture of martyrdom.[16] There is no single reason that determines why, how, when, and where some people opt to blow themselves up, so we need to broaden our explanation. Religion, deprivation, mental health, ideology may lead people to protest suicide, but Asad warns against explanation of motives, because those of "suicide bombers . . . are inevitably fictions that justify our responses but that we cannot verify."[17] Focusing on motive may help reduce our anxiety,

but it is less likely to help us understand the phenomenon. Asad also calls for taking into account the draconian control by powerful armies of civilian populations in regions where suicide bombings occur.[18]

Can we conceive of self-immolation as a radical act that envisions the domestic sovereign as a foreign occupier, usurper of rights, and destroyer of lives—a violent harbinger of destitution, destruction, and death? If the desire to liberate occupied territory, rather than religion, motivates suicide bombers, then why not apply the same logic to self-immolation?[19] In India, sati became more public as British control shifted from mercantile to territorial.[20] As we consider the rap songs, satirical videos, Facebook contraptions, and slogans of the Tunisian revolution, it will become clear that revolutionary artists regarded their country as a cesspit of repression and deprivation meted out by a domestic dictator akin to a foreign occupier. Control of space, political subjugation, and social deprivation spur extreme body acts.

Though the hunger strike was not widespread in the Arab uprisings, aspects of the practice resemble self-immolation. Protest fast started in nineteenth-century Russia and rose to prime time in the mid-twentieth century with incarcerated Irish and Palestinian militants. In 1981, Irish hunger strikers, led by the now-legendary figure Bobby Sands, refused to wear clothes and smeared their cells with excrement to recover political rights the British had taken away.[21] Palestinians executed many hunger strikes, recently targeting Israel's "administrative detention" policy used to incarcerate Palestinians for indefinitely renewable periods of six months without charge. The hunger strike is a strategy of last resort used off and on to extract concessions from jailers.[22] But as Abdulhadi al-Khawaja in Bahrain and Alaa Abdelfattah in Egypt among others found out during the Arab uprisings, hunger strikes have mixed results. After a year in jail and a life sentence on charges of "using social networking sites to incite illegal rallies and defame Bahrain's security forces," veteran activist al-Khawaja declared a hunger strike on February 8, 2012, until "freedom or death."[23] He achieved neither, when 110 days later, he ended his strike as prison authorities force-fed him, and his comrade Nabeel Rajab was released.[24] A respected figure in the global human rights community with dual Bahraini and Danish citizenship, al-Khawaja declared another open-ended hunger strike on August 25, 2014, but called it off a month later because he was satisfied with the level of attention to his case in Europe, a reflection of his reputation, his Danish citizenship, and his media-savvy activist daughters.[25]

When Egyptian activist Alaa Abdelfattah learned from his jail that his father, the lawyer and activist Ahmed Seif al-Islam, was seriously ill, he joined other prisoners in their hunger strike on August 17, 2014, after he was allowed to visit his moribund father. His family posted to Facebook a statement, "Alaa on hunger strike: 'I will not play the role they assigned to me.'" The post explained that Abdelfattah "would not collaborate with the absurd, oppressive situation even if that cost him his life"[26] and declared his hunger strike would begin on August 18, continuing until he was released. Al-Khawaja and Abdelfattah's fasts were typical: they followed unsuccessful attempts to reach out to authorities, entailed a declaration, involved groups, and could be called off and on.

In the elastic time frame of the hunger strike, the body is a tool of bargaining as much as protest. Al-Khawaja, for example, had time to act, make demands, reassess, negotiate, curry media attention, and change course. In this form of theatrical blackmail, publicity is leverage and the human body collateral. As activists disseminated Bouazizi's self-immolation worldwide, so did various media disseminate al-Khawaja's and Abdelfattah's self-starving. A liberal writer penned a column, "The Hunger Strike," explaining the act as a "final means" to reclaim dignity, deflect defamation, and "exercise free choice in the one area over which they still have some control: their interaction with their own bodies and souls."[27] Twitter went on fire when Abdelfattah announced his slow suicide protest, giving regular updates and finally celebrating his release. Independent online outlets like *Mada Masr* kept a spotlight on the issue. *Mada Masr*'s website carried no less than fifty-four tags for "hunger strike," more than for any other topic. Articles humanized Egyptian strikers, explained their human and political aspirations, discussed legal and medical perspectives, and situated the practice within a global struggle for dignity including Irish and Palestinian activists.[28]

VIRAL PAIN

*S*elf-immolation and hunger striking are both "extreme communicative acts."[29] But the second makes up in margin of maneuver what it lacks in spectacle. Though hunger strikers are physically restrained and isolated, they can communicate directly and over time. Self-immolators are not incarcerated, though Bouazizi might have imagined Tunisia as a jail cell. Nonetheless, he and other self-burners are utterly dependent on witnesses to carry the message. How did a self-burning fruit vendor from the Tunisian hinterland become a global mythical figure? Though spectacular, the act of self-immolation alone cannot explain the level of global awareness of the incident. Numerous other self-immolators remained resolutely local stories, so how was Bouazizi different? Digital platforms played a role in disseminating the act, but by the time Bouazizi torched himself, the Arab Internet had for several years been chock-full of pictures, videos, and narratives of atrocities perpetrated against Arab bodies. So what was different this time?

Without an audience self-immolation would not occur, and as a communicative act it stokes primal feelings about fire. Life-consuming flames are on show; crackling can be heard; scalding flesh can be smelled. So in itself, before circulating on newspaper pages, television screens, and the digital ether, self-immolation is an arresting spectacle that leaves no sense untouched. Even if most of us only hear the story and see a stock photo, as humans living in bodies we cannot help but imagine the sights, smells, and sounds of sizzling human matter. Aiming to jolt others into action, self-

immolation compels the public to respond.[30] It enjoins us to pay attention by making tangible a violence that is often invisible: the everyday indignities, humiliations, and hurdles to a decent life inflicted on citizens by the system; the kind of grinding, elusive, everyday cruelty that social scientists call structural violence. As the French medical anthropologist Didier Fassin described it, the relation of structural violence to the state is "more pernicious but less obvious," its impact on the body "more profound but less tangible."[31]

Who exactly was Bouazizi's audience? Did he target the authorities, or did he seek a bigger public? The 1969 self-immolation of Jan Palach in Prague after Soviet tanks rolled into Czechoslovakia to crush the political opening under Alexander Dubček known as the Prague Spring is telling. Like Bouazizi, Palach initially survived the burning but then died in a hospital. Reminiscing about Palach on Radio Prague in 2003, the medical specialist who first tended to the young student's self-inflicted burns at the hospital revealed an important detail. As he was taken to the intensive care unit, Palach fervently repeated, "Please tell everyone why I did it. Please tell everyone."[32] What Palach was so eager to share with everyone was that his act was a protest not against the Soviet occupation, but against his fellow citizens' subdual: "It was not so much in opposition to the Soviet occupation, but the demoralization which was setting in, that people were not only giving up, but giving in. . . . I think the people in the street, the multitude of people in the street, silent, with sad eyes, serious faces . . . everyone understands, that all the decent people were on the verge of making compromises."[33] Palach did not defy Moscow as much as he exhorted his compatriots to reject Soviet dominion as a fait accompli. His addressees were not the oppressors, but rather those willing to tolerate the oppression.

If the objective of self-immolation is to spur others into action, Bouazizi's gambit, four decades after Palach's, was indubitably successful. Bouazizi's self-immolation was not visually recorded, but it created two iconic pictures: in addition to the photograph of the hospital-bound, bed-ridden, bandaged Bouazizi, a black-and-white passport portrait circulated posthumously. Iconic images are "widely recognized . . . remembered . . . understood to be representations of historically significant events, activate strong emotional identification or response, and are reproduced across a range of media, genres, or topics."[34] Heavy circulation of images in multiple media forms consolidated the Bouazizi myth.[35] Although there was plenty of evidence that

Tunisians were suffering under the combined weight of Ben Ali's repression and corruption, Bouazizi's act focused people's pent-up misery in a ball of fire and refracted it back to his countrymen. By witnessing his pain, Tunisians knew it was theirs as well and acted upon it. They understood that the violence he unleashed onto himself concretized the state violence that they all experienced. By countering the structural violence of the Tunisian state with political violence through and against his own body, Bouazizi forced the regime to acknowledge him, and a few days later Ben Ali rushed to his hospital bedside.[36] In burning himself, Bouazizi made concrete the fact that, under Ben Ali, a dignified life was no longer livable. He died "with a message, for a message, and of a message."[37]

Though the basic plot of Bouazizi's immediate afterlife is fairly known, important details are murky. Consider the case of a famous video. It started when the blogger Slim Amanou got a phone call with information about a video shot by Bouazizi's cousins the day after the self-immolation, showing people visiting the scorched ground where he burned. Knowing that Ben Ali's security kept tabs on YouTube, Amanou posted the video on Facebook, and from there it circulated widely. Al-Jazeera aired a clip from the video several times that evening. A few days after the video appeared on Facebook, street protests began, though Tunisian state television stayed quiet about it for some time.[38] Whether a policewoman slapped Bouazizi remains contested, and there is no visual evidence, photo or video, of his self-immolation. Rather, there was a concerted effort to capitalize on his death to foment revolution, and the picture of a body in flame that circulated online was actually of a Korean self-immolator downloaded from the Internet by the same cousin who falsely claimed that Bouazizi was an "unemployed college graduate."[39]

The news of Bouazizi's bodily act was widely diffused, reported in a variety of national and pan-Arab media that formed "hypermedia space," a space of communication that links streets, walls, cameras, mobile devices, blogs, and social media and contains graffiti, songs, pictures, videos, and words.[40] The 1991 Gulf War led to the rise of a television industry spanning all Arab countries, using satellite transmission as hardware and the Arabic language as software. Today, pan-Arab channels such as al-Jazeera, launched by Qatar in 1996, and al-Arabiya, started by Saudi Arabia in 2003, compete with national broadcasters for viewers. Tunisian authorities have censored pan-Arab channels, even banning al-Jazeera altogether from Tunisia. Ben

Ali, like Egypt's Mubarak and Syria's Assad, also encouraged commercial, regime-friendly satellite channels. Tunisia was an Arab Internet pioneer, the first Arab country to connect to the network, in 1991, and to make it publicly available, in 1996. Online dissidence flourished by the late 1990s, and by 2004 the collective blog aggregator *Nawaat* conveyed independent news continuing during the revolution. When platforms like Facebook, YouTube, and Twitter became available, they diversified an already rich Tunisian media sphere.

Whereas satellite television gave Tunisians more passive familiarity with other Arabs, the Internet reduced their isolation from one another and thickened active connections between home and diaspora. Online, Tunisian activists discussed sensitive issues, exchanged political music, and fustigated Ben Ali. This "parallel space of engagement" attracted police surveillance and pitted activists against the state in battles over Internet freedom.[41] These campaigns were crucial training grounds for the revolution, connecting the Tunisian diaspora with local activists in a tightly knit community whose members met one another at blogging conferences in Beirut and elsewhere before most social media were invented and who therefore knew one another long before they connected on Twitter and the revolution started.[42] This helped build a fledgling dissident movement online to counter sophisticated censorship by one of the most Internet-repressive regimes on earth. As censorship intensified, bloggers moved from the open Internet to Facebook, which the regime had not penetrated.[43]

Then came WikiLeaks.

The collective blog *Nawaat*'s TuniLeaks focused on Tunisia-specific cables. It went live on November 28, 2010, three weeks before Bouazizi's self-immolation, upholding what Tunisians knew of the depravity of the ruling clique. WikiLeaks provided juicy tidbits to TuniLeaks: "Whether it's cash, services, land, property, or yes, even your yacht, President Ben Ali's family is rumored to covet it and gets what it wants."[44] Another cable described a "lavish" dinner with Ben Ali's son-in-law Sakher el-Materi as "over the top." The menu? "Perhaps a dozen dishes, including fish, steak, turkey, octopus, fish couscous and much more. The quantity was sufficient for a very large number of guests. Before dinner, a wide array of small dishes were served, along with three different juices (including Kiwi juice, not normally available here). After dinner, he served ice cream and frozen yoghurt brought in by plane from Saint Tropez, along with blueberries and raspberries and

fresh fruit and chocolate cake."[45] As for the retinue of this dignitary? A lot of bodies were needed to prepare, carry, serve, entertain, and clean for such feasts. In addition to "a large tiger ["Pasha"] . . . [which] consumes four chickens a day," there are "at least a dozen people, including a butler from Bangladesh and a nanny from South Africa (N. B. This is extraordinarily rare in Tunisia, and very expensive)." The conclusion stridently understates the gorged bodies and opulent luxury of the ruling clan: "The excesses of the Ben Ali family are growing."[46] More shocking than the revelation of such depravity was the cable's substantiation of the Ben Alis' corruption.

The cables were perfect fodder for Tunisia's electronic activists, whipping them into action weeks before Bouazizi sparked the revolution. Mobilized as they were, no wonder they spread news of Burning Man through hyper-media space.[47] Bouazizi's cousin, video cameras, the blogger Slim Amanou and other Tunisian activists, Facebook, al-Jazeera, the hacker collective Anonymous, which attacked government Internet infrastructure, and many other Arab and Western media sources helped carry the news from Sidi Bouzid to the world. The question of whether Tunisia was "the first Twitter revolution" was misplaced, as one of the more nuanced studies of Twitter in the Arab uprisings concluded that the microblogging site played a negli-gible role in the Tunisian revolution.[48] Claims that overestimated the role of social media prioritized digital gadgets over several other key factors (unem-ployment, deprivation, injustice) and media (WikiLeaks, al-Jazeera, blogs) that constitute the Tunisian public sphere.[49] By focusing on the technologies rather than on the interplay between multiple forces, internal and external, symbolic and physical, that shaped Tunisia's rebellion, one traps oneself into providing unsatisfactory answers. Better begin by asking, What was life like for Tunisians under Ben Ali?

THE DEFENDER

*B*y the time Bouazizi was aflame, Tunisians had been enduring the dictatorship of Zinelabidine Ben Ali for a quarter century. This dour security officer, who became minister of the interior in 1986, deposed Habib Bourguiba in a "medical coup d'état" on November 7, 1987. A hero of Tunisia's struggle for independence from France and a resolutely modernist leader, Bourguiba enacted a state feminism, making Tunisia one of the most progressive Arab states in terms of women's issues. Admirers called it *l'exception tunisienne,* but in fact Tunisia had pioneered social and political rights long before Bourguiba. Tunisia banned slavery in 1846, one year before Sweden and two decades before the United States. The country also enacted women's suffrage in 1959, twelve years before Switzerland. Bourguiba, who was said to rule together with his partner Wassila, was a Francophile nationalist committed to a top-down modernization of Tunisia that became known as *bourguibisme.*[50] Because of the venerable leader's erratic behavior and failing body, Ben Ali was able to declare Bourguiba incompetent and graft himself as the head of Tunisia's body politic, young, vigorous, forward-looking. Mindful of lingering respect by Tunisians for Bourguiba, the "builder" of the nation, Ben Ali defined himself instead as the "defender" of Tunisia.[51] His idea of defending the nation, however, consisted of having uniformed men charged with protecting his rule while his family pillaged the country. After first proclaiming political change under the slogan *le changement,* even using the language of "democratic transition" to describe the future under his

leadership, Ben Ali established an authoritarian police state with more than 130,000 security personnel for a population of slightly more than ten million, in addition to 35,000 troops.[52] The new regime destroyed Bourguiba's statues and replaced them with gigantic clocks symbolizing "new times."[53]

Since the 1980s, the police state had been coupled with a restructuring of the economy along extreme free market principles. After signing a "structural adjustment plan" with the International Monetary Fund and the World Bank in 1986, and then an "association agreement" with the European Union in 1996 with an eye toward joining a Euro-Mediterranean free trade zone,[54] the Tunisian state privatized 140 of its entities in the late 1980s.[55] Ben Ali's program blended authentication, nationalization, sovereignty, and patriotism. Authentication emphasized how free market policies fit Tunisian culture, nationalization integrated economic liberalism in state institutions, sovereignty claimed full control of economic forces at play, and patriotism commandeered the entire population to sign on to the program.[56] The *benaliste* leitmotif *développement intégral* (comprehensive development) ostensibly projected a commitment to developing Tunisia economically as well as socially, culturally, and politically, but the trope splendidly suited a kleptocracy. Every year during the absurd November 7 commemoration of his 1987 ascent to power, Ben Ali shoved that same line down Tunisians' throats. "Stabilité politique, progrès social et prosperité économique," as the headline of *La Presse de Tunisie* announced on November 7, 1998.[57] This sounds appealing, but the ruling family's lecherous merger of despotism and rapacity belied the pretense of national success. Ben Ali inherited from Bourguiba a constitution that subordinated religion to politics, a ruling party-state, and an arbitrary and patriarchal style of governance in which the leader "suspend[ed] legal procedure to improvise himself righter of wrongs, distributing praise and blame, punishment and reward."[58] Ben Ali added the figure of the greedy thug to the image of secular despotism that Bourguiba wrought. But the starkest difference between the two autocrats was in economic policy: whereas to Bourguiba the private market was an ingredient of state building, to Ben Ali privatization was the pillar of rule, albeit enforced by the police state. *Bourguibisme* nested economic competition in politics; *benalisme* subordinated governance to nepotistic greed. Ben Ali blasted the line that Bourguiba had maintained between politics and economics.[59]

As if carrying the weight of the sovereign himself was not enough of a burden, Tunisians endured an intolerable first lady. A vulgar and venal *parvenue,* Ben Ali's second wife, Leila, was the center of a mafia-like structure that gave her Trabelsi clan commissions in every business, real estate, educational, touristic, or procurement transaction in the country. Thanks to this, Leila Trabelsi earned the sobriquet *La régente de Carthage,* the title of a best-selling exposé by two French journalists.[60] Tunisians referred to her and her kin as "The Family," evoking the Sicilian mob and Coppola's immortalization thereof in *The Godfather.* Nixing boundaries between business, politics, and private life, they plundered the country with abandon, inspiring the neologism "thugocracy."[61] Leila's elder brother, Belhassen, "the viceroy," was notably rapacious and particularly loathed by Tunisians. Her younger sibling Imed, the enfant terrible who frolicked on a stolen yacht, was a national embarrassment. Her tiger-pet-owning son-in-law, Sakher el-Materi, commanded whatever scorn his countrymen had not spent on Belhassen and Imed. Sexism and class bias against Leila Trabelsi's humble beginnings (the former hairdresser was often portrayed wielding a *séchoir,* French for hair dryer) might have contributed to accounts of her decadence, but the first lady's own actions "focused on herself all the fears and hatreds of society."[62]

As dictators are prone to do, Ben Ali mounted a cult of personality, filling Tunisia's thoroughfares, squares, monuments, and buildings with his photos and effigies. Drivers and pedestrians could not avoid seeing the statues and images of his face and body. Said one observer, "One multistory portrait loomed over the busy port of La Goulette, where the smiling strongman seemed to be reminding cruise-ship passengers and other travelers that he and his *mukhabarat* were always watching and listening."[63] Every day, everywhere, the body of the leader imposed on Tunisians. On most posters and billboards Ben Ali appeared in a dark suit and light shirt, with a red tie and pocket handkerchief—color of the RCD (Rassemblement Constitutionnel Démocratique, or Constitutional Democratic Rally) ruling party—his hands clasped in a cliché of resolve. On other posters he donned traditional garb, saluting the nation. Captions varied between "Ben Ali, Choice of the Future" and "All of Us with the Man of Change." Lest there be any confusion that the body of the nation fused with the body of the leader, Ben Ali nearly always shared poster space with the Tunisian flag; when the flag was absent, facile symbolism—think beach sunsets—took over.

Two-story posters and small flags disseminated Ben Ali as both monument and miniature. Digital manipulation made him look virile, his body erect, his jaw decisive, his hair perfect, a sempiternal head of the Tunisian body politic.

Not content with customary trappings of dictatorship, Ben Ali's cult had a bizarre twist. The superstitious ruler, who took power on November 7, was obsessed with the numeral seven. Mauve, his favorite color, was also omnipresent, but many political parties and nations are branded chromatically. Making a number emblematic of rule, however, is ludicrous. "Seven" showed up in "squares, markets, airport, and currency," and Tunisia had "November 7 Square, November 7 Street, November 7 University, and Tabarka-November 7 International Airport."[64] By dictatorial caprice, national television was called TV7, and November 7 was declared a national holiday.[65] During the revolution, videos of Tunisians destroying variously sized and located incarnations of the number seven appeared on YouTube, and one of the first acts of the revolutionaries after Ben Ali's exit was to rename the national broadcaster "Télévision Nationale Tunisienne." What a simple, yet radical act: changing the name and logo from one dictated by the sovereign's whimsy to one embodying the entire nation. Once a kind of royal seal, the numeral seven, along with the color mauve, had now been discarded onto the garbage heap of autocratic eccentricities.

The vicious police state perpetuated Ben Ali's power, but it was also Western support that bolstered the myth of Tunisia's "success story." Ostensibly modern, with a highly educated population, emancipated women, and gorgeous beaches a short flight away from the cold capitals of Europe, the country slid into a cozy relationship with the West, nurtured by Ben Ali's image as a foe of Islamists. Scholars of Tunisia will encounter references to Ben Ali's intellectual mediocrity, but his skills at upgrading authoritarianism belie such tales. He excelled at what Béatrice Hibou, a Tunisia expert at France's Centre National de la Recherche Scientifique, called "'the fine-tuning' (affinement) of modalities of human rights violations."[66] He limited the use of arrest, imprisonment, and torture, and instead expanded "slowness of justice, passport deprivation, cutting telephone lines, harassment, continuous physical and mental pressures," steering clear of measures susceptible to attracting foreign pressure.[67] The World Bank and the IMF signed on to the success myth, and between 1970 and 2000, Tunisia received more loans from these organizations than any other African or Arab country.[68] In

2005, the World Summit of the Information Society met in Tunisia, to the great frustration of free expression activists, who emphasized the irony of holding the meeting in such a zealously censorious dictatorship. Ben Ali bolstered his image with a charade of "elections" won by wide margins—for example, the October 2009 contest, which he won by 89.6 percent.[69] After the rise of al-Qaeda as global public enemy number one in September 2001, the West's love affair with Ben Ali grew warmer; he was the West's gladiator in the "Ben Ali against Ben Laden" show.[70] There is no escaping that the system propped up Ben Ali.

A BAD RAP

*B*ehind the façade of success, ordinary Tunisians were struggling. In mine shafts, at sporting arenas, and in rap music, discontent turned into dissent. In 2008, riots in the Gafsa mining region showed that a protest movement existed, but security forces contained it.[71] A year before Bouazizi torched his body, another young Tunisian, a street vendor of sweets harassed by the authorities, burned himself in the central square of the city of Monastir in front of the state's representative.[72] Spectators within soccer stadiums shunned the heavily censored public sphere, and during contests between the capital's archrivals, Espérance and Club Africain, fans chanted slogans and raised banners that were obliquely or even obviously political.[73] As hard as it might try, the regime failed to iron out these wrinkles in the fabric of its success story.

In the years leading up to the revolution, an underground rap scene survived repression and cooptation, and some songs focused on the travails of Tunisian bodies under Ben Ali.[74] From his exile in Spain, Férid El Extranjero (aka Delahoja) released "3bed Fi Terkina" (People in a Prison Corner), a graphic exposé of corporeal abuse: "We live in a prison corner, our flesh is cut with a knife. . . ."[75] On November 7, 2010, El Général (Hamada Ben Amor) posted "Rayyes Lebled" (Leader of the Country) on Facebook. A month later, Ben Ali's police arrested the rapper.[76] Violating its own rules designed to keep Western disapproval at bay, on January 6 the regime sent thirty security officers to Ben Amor's family apartment in the town of Sfax. Media worldwide covered the spectacular early morning arrest.

Several versions of the video exist online, with subtitles in many languages, and pieces of the song have been recycled in myriad clips.[77] El Général raps:

> Leader of the country
> Your people is dead
> Look what is going on in the country
> People have nowhere to sleep
> People eat from garbage dumps
> Crushed under worries

When I watched "Rayyes Lebled" for the first time, claustrophobia overtook me. Shot in black and white in what looks like an underground location, with the rapper in black hoodie, black cap, and black headphones, set against a dirty, scrawled-over white wall, the video captured the mood of the nation. As the cultural critic Nouri Gana put it, the timing of the release, on November 7, 2010, the anniversary of Ben Ali's "ascension" to power, made the song "a party-crasher" before Bouazizi's self-immolation turned it into a "whistle-blower."[78]

El Général rushed into the symbolism of sovereignty and the body politic, protesting against the continuous dominion of the sovereign, who himself moved the song into prophetic terrain when, in his January 13, 2010, speech, the autocrat confessed that his advisers intentionally kept him ill-informed about the state of the country "out of 'concern' for his declining health," reflecting Ben Ali's impending physical and political demise.[79] As if to hasten the decay of the body of the sovereign, a few weeks later, as Tunisia's streets began convulsing on December 22, 2010, El Général released "Tounes Bladna" (Tunisia Is Our Homeland)—ours, the people's, not the dictator's. The new song raised the stakes: where "Rayyes Lebled" was reproachful, "Tounes Bladna" was martial and intense, wrenching the country from the dictator and claiming it for the people.[80] Though Tunisia had a rich pool of singing talent, the stylistic harshness of rap resonated with daily life more than the lyrical style of protest, with vocals and acoustic guitar as one finds in, say, Elhem Methlouthi's "Kelmti Horra" (My Word Is Free).[81] El Général's intense indictment of corporeal abuse captured the country's pathos better than Methlouthi's passionate tribute to freedom of speech. Five weeks after the release of "Rayyes Lebled," Bouazizi confirmed the centrality of the human body in repression and rebellion.

DOWN AND OUT IN TUNIS

*B*ouazizi's gambit to Ben Ali was as follows: You are the sovereign dictator, and as such you claim the right to decide who lives and who dies, when, and where. I am wresting this power from you by burning myself in protest.[82] Escalating unrest forced the president to acknowledge the revolutionaries, then to offer some halfhearted solutions, later to compromise, and eventually to escape. The dictator's three televised speeches, given within a period of two weeks, punctuate his falling fortunes. Each marked an irreversible weakening of his position. In his first speech, on December 28, 2010, he accused the demonstrators of harming the economy and threatened them with suppression. In his second address to the nation, on January 10, 2011, he raised the specter of external enemies manipulating internal terrorists, but also promised the creation of 300,000 jobs, a signal of political bankruptcy if ever there was one. In his third speech, on January 13, one day before his disgraceful exit from power, Ben Ali struck a resigned note while casting the revolution as a misunderstanding: "I understood you," he said to Tunisians.[83] His contrived contrition did not fool the demonstrators, who by then had paid dearly for their defiance, and the following morning, after the army commander rejected orders to fire en masse at protesters, exposing the strongman's loss of control over the body politic, Ben Ali headed to forced exile in Saudi Arabia.

Were one to pay close attention to the slogans of the Tunisian revolution, one would notice that many evoked symbolic movement. *Dégage!* (Get Lost!) and *Ben Ali Dehors!* (Ben Ali, Get Out!) reflect a sideways shift, from

inside to outside, whereas *"asha'b yourid esqat al-nidham"* (The people want to topple the system) connotes a downward movement, from high to low. The former slogans express the people's desire to remove the dictator from Tunisia, and the latter announces their wish to bring Ben Ali down from his exalted position. By clamoring to eject Ben Ali from the country, inside-outside slogans challenge Ben Ali's sovereign power. Such slogans also echo radical insurgency. Dictatorship means a permanent suspension of the rule of law, so popular demands to sack the leader constitute a biopolitical rebellion. Biopolitics, as developed by the philosophers Michel Foucault and Giorgio Agamben, refers to the kind of power that manages people as "bare life" and decides which are worth continuing and which deserve death.[84] Bouazizi's self-immolation is an extreme manifestation of radical—biopolitical—insurgency, echoed in the motto of the revolution, "If the people one day decide they want *life*," by the Tunisian poet Abul Qassem al-Chabbi. By clamoring to crash the regime, up-down slogans convey the desire to bring Ben Ali down from the throne. Such slogans express gradual creative insurgency, which uses body symbolism to undermine the ruler in small increments. Up-down Tunisian slogans accomplish subversion through what Bakhtin called "leveling," pulling the powerful down to the level of the powerless, and this approach is manifest in parody across media, from the simple human voice telling jokes to digital videos on YouTube.

To understand how revolutionary parody challenges the official meanings attached to the body of the sovereign, consider the series of digital videos *Le Journal du Zaba,* released by the group Kharabeesh in January 2011. Kharabeesh started in 2007 in Amman, Jordan, as a "satirical, critical, spontaneous, youth media network," and during the uprisings it opened branches in Tunisia, Egypt, and the UAE. Their mission is to "convey the social and political situation in the Arab nation in a satirical way."[85] In "Ben Ali Searches for a Refuge," the first episode of *Le Journal du Zaba,* we see Ben Ali fretting on the outbound plane and trying to work the telephone to find a landing spot. First he calls Sarkozy, but the French president rebuffs him, saying the Trabelsi clan occupies all the beds in France (there is also the obligatory mention of Leila's *séchoir*). Then, his buddy Qaddafi turns Ben Ali down (as the rejected leader says, "I understood them but they did not understand me") because the Libyan leader does not want Tunisian revolutionaries to come to Libya. In quick sequence, Italian prime minister

Silvio Berlusconi's assistant tells Ben Ali her boss is busy with "pornographic negotiations," whoever picks up the phone at the White House hangs up in Ben Ali's face when he asks for Obama, and Egypt's Mubarak curses Ben Ali for "causing me problems with my people." However, at last, King Abdallah of Saudi Arabia offers Ben Ali hospitality as a "midfielder in the Jedda soccer team" after Ben Ali says, mendaciously, that he wishes to perform the *'umra* religious pilgrimage in Mecca and atone for his sins. The first episode of *Le Journal du Zaba* ends with Ben Ali donning traditional Saudi headgear, riding atop the airplane in celebration—a pathetic, big-headed buffoon.[86]

Being stuck in midair on an airplane, with no clear destination and no return path, is an abysmal low of powerlessness. Like thousands of Tunisians who attempt to cross the Mediterranean seeking a better future in Europe, Ben Ali, rejected, had to leave, but unlike them, not having been forced to imagine himself elsewhere, he had no terminus. One wonders whether the dictator, too, thriving in opulence, was also ever tempted by the balmier elsewheres that tantalized his countrymen. Politically finished, Ben Ali was legally and physically suspended, stuck in limbo. Did he relive the experience, in reverse, of those fateful hours twenty-three years earlier when he had been waiting for the medics at his command to declare Bourguiba incompetent? Now time is of the essence, fuel is burning, and the once omnipotent despot is an airborne beggar. Variously patronizing, humiliating, or outright hostile, the snubs of his consociates demonstrate Ben Ali's loss of mastery over his own life. Even when riding the fuselage in celebration after receiving Saudi permission to land, Ben Ali's balance is ludicrously precarious. The comic effect splinters the dictator's power to pieces, with the flight foremost a journey from sovereign to supplicant. This is gradual creative insurgency at its best.

The gradual mode builds on a rich tradition. Tunisian political cartoons mocked French colonialism in the 1930s and 1940s, and in 1956 more than thirty Arabic-language satirical newspapers appeared alongside others in French, Italian, and Hebrew.[87] In postindependence Tunisia comic strips helped promote Bourguiba's modernist project.[88] After Tunisians protested Ben Ali's alliance with the United States against Iraq in the 1991 Gulf War, the dictator sanctioned political humor to manipulate public opinion. In a January 26, 1991, speech, for example, Ben Ali sympathized with Tunisians' feelings on the war; in a second speech on February 26, he rejected the

"deliberate" destruction of Iraq by the U.S.-led coalition, while calling for national unity among Tunisians. Getting the message, newspapers published letters, poems, and essays about the Gulf War, and cartoonists lambasted U.S.-led UN sanctions on Iraq, celebrated Iraq's possession of Scud missiles, and ridiculed the Western media bias against Saddam Hussein.[89] Adroitly aligning official rhetoric with popular sentiment, remaining in control of public opinion while ostensibly permitting free communication, Ben Ali harnessed political humor for his own purposes.

A savvy dictatorship strives to co-opt transgressions, but Tunisian humor was tenacious and unwieldy. Political parodies of Ben Ali started long before the 2010 revolution, although they exploded in the couple of years preceding it. Since 2007, Tarak Mekki, a businessman and opponent of Ben Ali's, had been calling for a Second Tunisian Republic as an alternative to Ben Ali's police state, which he blamed for the ascendance of Islamism in Tunisia. In 2008, Mekki produced a series of satirical videos ridiculing Ben Ali, his wife, Leila, and the first lady's infamous Trabelsi clan. The most famous of these was *Elf Leila w Leila* (One Thousand and One Nights), a word play on the name of the first lady (*leila* or *layla* is Arabic for "night" and a woman's name) using the Arabic title of the *Arabian Nights*. But whereas in that legendary story Sheharazad deploys her narrative skills to keep Shahrayar happy and herself alive, in this revolutionary parody Ben Ali strives to impress his haughty wife with his lavish possessions. The video depicts them as a royal couple flying over their realm on a magic carpet, peppering commentary on how much the people love them.[90] Episode 2 of the series stars Leila Trabelsi Ben Ali, seated in her husband's throne, running the country, and episode 7, "Séchoir Magique" (Magical Hair Dryer), begins with a videotaped speech by Mekki defending the right of people to ridicule those in power, and then goes on to show the first couple having breakfast. When Ben Ali points a gun at his wife, the former hairstylist brandishes a hair dryer in his face, then proceeds to style his hair as she caresses his cheek with her other hand.[91] The message is as simple as it is devastating: Ben Ali, violent and vain, is manipulated by Leila, arrogant and arriviste, the image of a ruling couple low on class but high on vanity.

LOAVES OF CONTENTION

*D*uring the revolution itself, dissident humorists targeted Ben Ali's censorship of the Internet, but as dark humor filled blogs, Facebook, and YouTube, the most poignant motifs focused on the needs and travails of the human body. Morbid jokes featured bodies that were abused, vulnerable, and hungry. In January 2011, echoing the violence of Bouazizi's self-immolation, a picture of the crushed head of a Tunisian demonstrator circulated on Facebook with the caption "Brain Drain."[92] A French psychologist opined that this kind of humor is at once typical of Tunisian society while at the same time being a defense mechanism against an unbearable situation.[93] Another Facebook page purported to show a winter 2011 fashion show, with a picture mimicking online clothing catalogs but actually depicting a variety of flak jackets.[94] When Ben Ali announced in his January 13 speech that he had decided to lower prices for basic staples, photos of a dead man circulated on Facebook with the caption "Too bad, he won't be able to enjoy the new low prices." Other comments on Facebook included "*Sucre: en grande quantité, lait: en grande quantité, liberté: 404 not found*" (Sugar: available in large quantities, milk: available in large quantities, freedom: 404 not found).[95] A few days earlier, on January 10, 2011, Ben Ali had announced the creation of thousands of new jobs, and jabs such as "Great! Now thousands of French people will immigrate to Tunisia for jobs" abounded, inverting the painful reality of Tunisian migration to France. The violence of the dictator made Tunisians hyperaware of their bodily vulnerability, and humor was a make-do shield.

In the revolutionary cornucopia of body and food symbolism, bread enjoyed a special status. Why did Tunisian and other Arab revolutionaries display such a propensity to include food, particularly bread, in their symbolic repertoire? The availability and cost of food contributed to the perfect storm that triggered the Arab uprisings.[96] Placing bread at the center of the political contract has, since the 1950s, allowed rulers to maintain social peace. However, as the International Monetary Fund began pressuring Arab countries in the 1970s to stop subsidizing foodstuffs, social unrest ensued throughout the region.[97] This continued into the 2000s as food prices reached record highs.[98] Today, the Arab world depends on food imports, and non-oil-rich Arab countries, including Egypt, Syria, and Tunisia, are particularly vulnerable to price fluctuations.[99]

As a symbol, bread has long captured food-for-social-order Arab political contracts.[100] Following Edward Thompson's view of riots as "self-activating . . . highly complex form(s) of direct popular action, disciplined and with clear objectives,"[101] the Tunisian political scientist Larbi Sadiki argued that Arab bread protests were democracy by other means. They were renegotiations of the social contract between ruler and ruled in "bread democracies": many Arab citizens in the 1980s, Sadiki argued, extracted the right to vote by clamoring for bread. However, *khubz-ist* is now used as a dismissive moniker to refer to bread-seekers, deferent subjects who obey rulers as long as bread is provided. As such, contemporary bread uprisings are "kinds of indirect elections in countries where no pluralist politics exist."[102] This metaphor is helpful, but its view of protest as a deliberate and cyclical bargaining tactic is limiting. Bread democracy could instead be seen as a "euphemization" of dictatorship—the transformation of repression and submission into a social transaction.[103] By speaking truth to power, creative insurgency de-euphemizes tyranny, laying bare its brutality and injustice.

No wonder bread was a key symbol in revolutionary drollery. One image in particular reflects the revolution's original name, "Thawrat el-Khobz," Bread Revolution, before it became "Jasmine Revolution." An AFP photographer took the picture on January 18, 2011, in front of the Ministry of the Interior. The location was Avenue Habib Bourguiba, a street named after the first leader of independent Tunisia, whose regime had been shaken in 1984 by bread riots that Ben Ali was in charge of putting down. Known as *Baguette Man* (Fig. 2), the photo places the 2010 revolution in the context of a series of bread-related protest waves going back decades, even to a time

FIG. 2. *Baguette Man,* photo, Tunis, 2011 (Fred Dufour/AFP/Getty Images).

when Bourguiba used to call on Ben Ali to control demonstrations.[104] The photograph also evokes the symbolism of bread in politics, in the Arab world and elsewhere, reflecting once more indignation against an unjust global system enforced by a greedy local regime. In the picture's creative afterlife, bread symbolism shifted meaning and reflected what was at stake in the revolt above and beyond a hunger-centered revolution.

The picture depicts two protagonists: the police and a lone protester facing the policemen from some distance. The protester is at the bottom left corner of the picture, in the foreground. He has one knee on the ground and is pointing what looks like a weapon at the cops, who appear in the background, in the upper right corner. However, the weapon in fact is a long loaf of bread, a French baguette, and the symbolism is obvious: the Tunisian people were hungry (and poor, unemployed, repressed, angry) and were not going to put up with the situation any longer. By using bread as a weapon, the image not only conjures up a history of bread riots, but makes a fundamental statement about life and death—bread, which in Egypt is called 'aysh, meaning "life," is basic human nourishment. The photo conjures up the image of a bread revolution only to subvert the very same image. The man's pose, brandishing a weaponized loaf, suggests that Tunisians were no longer willing to trade their dignity for bread. If the best that was on offer for most Tunisians was the status of bare life, having a stomach full enough for basic physical functions but no more, well, now just being un-hungry no longer sufficed.[105] They were clamoring for a political life. This contest was not about securing human subsistence; it was about affirming human dignity. In the Tunisian uprising, bread completed a journey from cause of recrimination, to symbol of discontent, to instrument of contention.

The man in the photo, known as "Baguette Man," inspired five young creative types to create Captain Khobza (Captain Bread), a Tunisian superhero, as a "fictional character on Facebook, who talks like a Tunisian and has a sharp sense of humor," as one creator described the character.[106] Sustaining the metaphor, the five creators call themselves Baker 1, Baker 2, Baker 3, Baker 4, and Baker 5.[107] Captain Khobza wears the traditional chéchia hat, but, like Superman, he dons a red superhero cape and has the Arabic letter "kh" emblazoned on his hard-muscled chest. A Zorro mask covers his face, and he sports a goatee and a perennial cigarette hanging sideways from his lips.[108] After Facebook, Captain Khobza (or Captain 5obza), that is, Captain Bread or Captain Loaf-of-Bread (some have called him "the

Tunisian Superman"), showed up on YouTube.[109] A superhero captures the feeling of otherworldly empowerment that most Tunisians must have felt when they broke the fear barrier and deposed Ben Ali—the superhero is "an image of a Tunisian who is not afraid," said one of the Bakers.[110] By negating the hunger and poverty inflicted by corruption, pillage, and repression, Captain Khobza also blows a hole in the traditional notion of bread riots.

Whereas the prevalence of grub symbolism highlights the Tunisian uprising's roots in material deprivation, the richness of bread imagery underscores that this was not merely a rebellion of empty stomachs. Baguette Man and Captain Khobza, one real, the other fictional, reflect the fertile symbolism of bread, that most basic means of human sustenance. The image of a man holding a baguette in a comico-martial pose against the police makes it clear that Tunisian revolutionaries were aware of the vibrancy of the symbol. Similar incidents occurred in Yemen, where a demonstrator in the February 3, 2011, Day of Rage protest against the government wrapped three pieces of bread around his head, spawning the "Bread Helmet" viral Internet meme, as well as in Egypt, where pots and pans were used as helmets to fend off stones hurled by pro-Mubarak goons and bullets shot by Egyptian police snipers. Combining food symbolism with actual protection, these makeshift helmets reflected a merger of gradual and radical creative insurgency. If bread making is one of the most fundamental ways to turn nature into culture, bread activism is a way of turning culture into politics.

A BETTER FUTURE

*I*n hunger striking, self-immolation, and suicide bombing, the medium is the message, yet all three forms of protest suicide also, quite paradoxically, signal a will for life and an orientation toward the future.[111] This is what the Cameroonian intellectual Achille Mbembe, writing about suicide bombing, calls the "new semiosis of killing," whereby the extreme body act collapses present and future.[112] In this sense, self-burning is similar to self-explosion, although suicide bombing, in killing others along with the protester, is more morally fraught. The incandescent body of the self-immolator mediates between different time frames, rejecting an unacceptable present in order to conjure up a better future. This urge for a better future extends the reach of the act by mobilizing a public whose members propagate the original act. Addressees share the story in person, transmitting stories about the story and reactions to it from people they know and through the media. They circulate foundational myths and iconic photos. They post pictures, videos, comments, and laments on blogs and social media, and these in turn fuel more stories, trigger reactions, and further disperse the self-martyred body throughout historical time and public space. As pictures of Bouazizi appeared on handheld signs, Facebook pages, and street art, activists invested his radical act in their everyday, gradual activism. Bouazizi was no mere corpse: in death, he stubbornly egged his fellow citizens on, and as his sudden irruption into the consciousness of Tunisians ceded to the endless repetition of his name, face, and act, the radical mode of dissent fueled its gradual counterpart.

The human body is important to creative insurgency. In radical protest, humans forfeit their body to elevate their status above that of bare life, that condition in which they vegetate rather than live, toward a citizenly status endowed with civil and political rights. If the idea that Tunisians under Ben Ali were reduced to subsistence strikes you as hyperbolic, recall the darkness wafting from revolutionary songs and art like thick, suffocating black smoke. Systematic rights violations gave Tunisians a taste of the state of exception, a space where the ruler's whimsy determines life and death. And keep in mind that this is Tunisia, the only Arab country to emerge from its uprising with a functioning political system, a contentious but diverse public sphere, and reasonable hopes for these to endure.

Revolutionary self-immolators incinerate their bodies to challenge the concentration of power in the body of the dictator. The body serves as a combustible for physical action. Through spectacular violence, Bouazizi exposed pernicious structural violence.[113] Together, radical and gradual activisms achieve a lasting potency. The gravity and intensity of the former generate a burst of political energy that lights and fuels the latter. Consider how Bouazizi's self-immolation conjured up accusations, mockeries, and symbolic punches at the dictator, including a Facebook app that lets you hit, slap, strangle, and kick an avatar of Ben Ali.[114] Tormented people torment their tormentor. Many metaphors come to mind here, including the obvious one of spark, flame, and fire, or that of nuclear fission, which generates a tremendous amount of energy in a concentrated burst and which, when properly harnessed, spreads light and warmth to millions of people. In tandem, radical and evanescent acts and the progressive and enduring practices they spawn sap the foundations of sovereign power. Like heroic suicides in the French Revolution, Bouazizi's self-immolation signals "the end of the body and the beginning of history."[115] In doing so, it displaces the image of heroic dignity, which for a quarter century was Ben Ali's exclusive preserve, and turns this into a tool to attack the leader. Bouazizi's heroic body forced the dictator out of being a classical body on a pedestal, transforming it into a grotesque body in limbo.[116] Bouazizi made heroic dignity, acquired by fire, a necessary aspiration for other Tunisians. The fruit vendor from Sidi Bouzid demonstrated that revolutionary protest, at once acute and chronic, uses bodies in pain to animate bodies in rebellion to propagate bodies in pain in a cycle of violence, death, and emancipation familiar to revolutionaries everywhere.

PART III

Laughing Cow

The recurrence of animal allegory across time and space reflects long-standing dynamics of cultural diffusion. Whereas Westerners may know Aesop's and La Fontaine's fables or George Orwell's *Animal Farm,* Arabs have Ibn al-Muqaffaʻ, the Persian author and translator who lived in Basra, in contemporary Iraq, until his murder in 756 on orders of the caliph. Ibn al-Muqaffaʻ's translation from Middle Persian of *Kalila wa Dimna,* a classic volume of animal allegories, is considered a masterpiece of Arab literature, although most of its stories originated in the *Panchatantra,* an old Sanskrit text also known as the *Fables of Bidpal.* When we studied Ibn al-Muqaffaʻ in middle school in Lebanon, the teacher emphasized a literary aspect of the work that remains etched in my memory: *assahl al-mumtana,* or "the inimitable easy"—the Arabic version of *sprezzatura,* or "studied carelessness"—describes narratives so tightly rendered in prose so limpid and easy to read that an undiscerning reader would be excused for assuming it had been written with equal ease. Through this inimitable effortlessness, animal symbolism delivers compelling stories and imparts political and moral lessons to illiterate folk and children: in 1668, La Fontaine chose to dedicate his first tome of fables to the six-year-old Dauphin of France.

The donkey was first domesticated some five thousand years ago in the Middle East and has since spread all over the globe. It is no wonder, then, that the long-eared, short-legged animal shows up in tales from around the world. *Equus asinus* pops up in ancient mythology, popular idioms, children's tales, and literary masterpieces. Yet the donkey inspires ambivalent feelings. Some people associate it with divinities like Midas, who was famously gifted donkey ears for misjudging a musical contest, or Jesus, who entered Jerusalem riding one. In Aesop's *The Ass in the Lion's Skin,* Apuleius's *The Golden Ass,* and La Fontaine's the *Horse and the Ass,* donkeys radiate inflexible imbecility. But in Cervantes's *Don Quixote,* the donkey is a loyal, ultimately human companion; and in Orwell's *Animal Farm,* Benjamin the donkey is wry and intelligent.[1] In American politics, the donkey came to represent the Democratic Party through political jujitsu and creative humor: when opponents called him a "jackass" during his populist 1828 presidential campaign, Andrew Jackson deflected the attack by appropriating the joke, and the cartoonist Thomas Nast solidified the association between party and animal. Nonetheless, today donkeys inhabit the lower stratum of many a country's vernacular wisdom, and Buridan's Ass, with its suggestion that a donkey situated halfway between food and water would be unable to decide where to go first, and thus die of hunger and thirst, has a universal echo.

When farmer Omar Abulmaged dressed his donkey as Sisi, in Qena, Egypt, in April 2014, he summoned a wealth of unflattering images. In Arab countries, the word for donkey, *hemar,* is an insult, serving the same purpose as "ass" in the United States. Like condemnations of sati by Indian upper classes, donkey jokes reflect Egyptian urbanites' desire to distinguish themselves from the rural bumpkins who arrive into Cairo's slums, beast in tow. Yet such self-performed boundaries of distinction are blurry. Animal symbolism in medieval Europe was one way in which the elite sought to reject the lower classes, only to discover that "the cultural categories of high and low...are never entirely separable."[2] In the 1512 Peasants War in Germany, in the Kett's Rebellion of 1549 in Norfolk, England, and in Egypt's 1919 and 2011 Revolutions, people used animal imagery to ridicule potentates.

How does animal symbolism cross class lines and bring high and low closer to each other? The answer to this question depends on popular perceptions of animals. Like donkeys in contemporary Egypt, pigs in medieval Europe were ambivalent creatures. Stallybrass and White invoke both

Mikhail Bakhtin and Edmund Leach in seeing the pig as an "intermediate category" that violates divisions of high and low.[3] Egyptians associate pigs with Copts, who as Christians are unburdened by Islam's injunction against porcines and therefore use pigs in an informal but remarkably efficient process of garbage recycling in Cairo. Prohibited for the majority of Egyptians and associated with a minority, pigs entered the volatile mix of sectarian tension and socioeconomic resentment that surfaced during the 2009 swine flu scare, when authorities ordered a mass slaughter of pigs. Donkeys, in contrast, are usually subjected to grinding, daily torment, rather than periodic controversies. So by humanizing his donkey, Abulmaged did something unusual. The khaki uniform of the Egyptian army dressed the animal's neck, shoulders, and front legs, an oversized visor cap featuring military insignia covered his massive head, a badge was set on his shoulder, and a white-handled revolver hung from the belt. Abulmaged covered his donkey's trunk with fabric in a darker shade of khaki, emblazoned with a gold-rimmed black banner with the word "al-Sisi" in gold.[4] Seen from the front, it looked like a midget with a bulky asinine head.

Abulmaged's prank in the hinterland, it turns out, mirrored an art exhibit in the capital. The farmer got himself into trouble for portraying a strongman as an ass, but he was not the first Egyptian to humanize donkeys and dress them up. In May 2013, months before Abulmaged's transgressive stunt, Cairo's 2013 Caravan Festival of the Arts chose the donkey as its motif. Founded by an American Episcopal cleric who runs an interfaith church in Cairo, the festival commissioned forty-five artists, Egyptian and foreign, to use ninety fiberglass donkeys as their canvas. A selection would then appear in European galleries before being auctioned in London, with proceeds going to charitable projects in Egypt. Reda Abdulrahman, the Egyptian artist who was also responsible for designing the fiberglass donkey model, came up with "Renaissance Donkey," featuring a bearded head with a prayer mark on the forehead to mock the Muslim Brotherhood's "Renaissance"-themed 2012 presidential campaign. But by dressing his donkey in a suit jacket and camouflage pants, Abdulrahman was also attacking the unholy alliance between Egypt's military and business classes. Another artist's donkey wore a quote from the Qur'an's Sura 62.5, "Those who worship Allah but follow not his laws are like a donkey which carries books and understands them not," to ridicule religious dogmatism.[5] The exhibit and the rhetoric surrounding it, from Cairo to London's Saint Paul Cathedral,

articulated through the donkey a message of interfaith harmony, all the while mocking the donkey itself, the Muslim Brotherhood, the army, and the business elite. The farmer was punished because the return of military rule in June 2013 brought tighter censorship, but the artists were not, perhaps because of their higher social status.

What a rural boor like Abulmaged pulled off in Upper Egypt and artists exhibited in a Cairo gallery, elected representatives performed in the very heart of national political institutions. During the post-Mubarak, pre-Morsi interregnum (February 2011 to June 2012), Ziad Eleimy, a member of Parliament from the small Social Democratic Party, evoked a folk saying, "We let the donkey run but hold on to the saddle," a reference to Field Marshal Muhammad al-Tantawi, head of the Supreme Council of the Armed Forces (SCAF), which ruled Egypt at the time.[6] Negative sentiments toward military rule were steadily on the rise at that time, and when I visited Cairo in November 2011, anti-SCAF graffiti were all over the city, but Eleimy's jibe stood out because it built on a long Egyptian tradition of drollery laced with animal symbolism. In an 1883 edition of the Egyptian satirical periodical *Abu Naddara,* Egypt is depicted as a donkey, with Ismail Pasha, the khedive (governor) of Egypt and the Sudan from 1863 to 1879, riding the animal as his entourage aggressed it.[7] In the recent cases, both the legislator's jocularity and the farmer's high jinks feature allusions that leaders were asinine, and this stings because Egyptian politicians feared political humiliation by animal appellation. What animals did Egyptians associate with rulers? How did animal imagery explode in Egypt's creative insurgency?

PHARAOH'S HEALTH

*T*o answer these questions, we first need to understand how the boundaries that protect the rulers' body work in practice. In the late nineteenth century, Ottoman sultan Abdulhamid decreed press laws making it mandatory for news items to lead with a mention of "the good health of the Sultan," and ever since, the ill health of rulers has been off limits in critical public discussion in the Middle East.[8] The Ottoman press edict helped enforce a strict separation between the sovereign's human and political bodies.[9] Because the ruler's body was the body of the realm, reporting on its ill health was tantamount to imperiling the health of the nation. Many modern media laws in the Arab world continue to prohibit reporting on a leader's ailments, and in Egypt a bold red line encircled the health of President Hosni Mubarak, the present-day pharaoh, and the cost for crossing that line was steep.

Ibrahim 'Eissa learned about the king's bodily duality the hard way. Born in 1965, the feisty journalist launched a magazine when he was only eleven and worked at the state-owned but irreverent magazine *Rose al-Yusuf* before rising to prominence in Egyptian journalism. 'Eissa's political troubles started in 1991 when he opposed Egypt's decision to join George H. W. Bush's military coalition to oust Iraqi troops from Kuwait. In 1995 'Eissa cofounded the daily newspaper *Addustour,* a paper that fearlessly featured writing about sensitive topics like corruption and relations with Israel. *Addustour* focused on young Egyptians, disaffected by the country's dismal political life and their abysmal socioeconomic prospects. It published a

variety of voices, although it excluded Islamist writers. So appealing was *Addustour*'s direct style that it gave rise to a neologism, the notion of *dustourization,* meaning the way that other newspapers emulated 'Eissa's daily.[10] The government shut down the newspaper in 1998, and in response 'Eissa escalated his criticism by publishing *Maqtal al-Rajul al-Kabir* (Death of the Great Man), a novel about a feeble autocrat whose death leads to a military coup. The novel's value rested in its transparent reflection of political reality.

Over the next decade 'Eissa learned that broaching the health of the body politic meant breaching red lines. In three successive years, as editor-in-chief of *Addustour,* 'Eissa violated three taboos: corruption, the leader's health, and the national economy. In April 2006, the paper published a story about a lawsuit filed against Mubarak asking him and members of his family and regime to return five hundred billion Egyptian pounds of loot and requesting the repeal of presidential immunity from prosecution. The paper was prosecuted for publishing the story, and the judge's ruling that "freedom of the press flows not from the law but from the president himself" was an absolutist affirmation of Mubarak's body as the head of the body politic.[11] Undeterred, 'Eissa declared the verdict illegal and directed a reporter to ferret out other lawsuits against the president, going into another cycle of dissent and harassment. When *Addustour* ran stories about Mubarak's failing health, 'Eissa was swiftly sanctioned with a one-year jail sentence handed down in December 2007. In 2008, 'Eissa published a piece about capital flight from Egypt, for which he also received a jail sentence, which was eventually pardoned by Mubarak under fierce pressure from groups like the Arab Network for Human Rights Information and Amnesty International. In 2010, two businessmen bought *Addustour* and committed to preserve its editorial line, but weeks thereafter they fired 'Eissa and a senior associate. 'Eissa also lost his position as cohost of a talk show on ONTV, in what looked like a campaign orchestrated by the ruling National Democratic Party to silence its chief critics ahead of important parliamentary elections.[12] But the January 2011 revolution gave 'Eissa an ever expanding range of professional opportunities. He cofounded the channel Tahrir TV, which started on February 8, 2011, a few days before Mubarak's ouster, and then launched the daily newspaper *al-Tahrir*. These were two separate companies, but their shared name reflected the rise of revolutionary media.[13]

'Eissa is an unusually combative journalist, but his growing resolve reflected the wider systemic evolution in Egyptian media, which grew increasingly assertive in the 2000s in confronting the dictatorship even as it was repressed. The emergence of privately owned satellite television and nominally independent newspapers from the late 1990s to the early to middle 2000s and the advent of blogging made for a more diverse, if still repressed, Egyptian public sphere. Bellicose editors like 'Eissa and other courageous journalists and bloggers tested the boundaries of permissible speech. Undeterred by onerous legal battles and arduous jail sentences, they chipped away at the red lines encircling pharaoh's body, injecting a dose of dissent into the body politic.

A DIGITAL BODY POLITIC

*E*gypt's ruling clique compulsively put the body of the ruler front and center. The ensuing scandals exposed an unhealthy state media sector, obsessed with maintaining an image of a strong leader while Mubarak was physically ailing and increasingly marginal in Arab politics. Every effort to install his son Gamal as his successor backfired. Opposition voices denounced what they saw as monarchical overreach, spawning the neologism *gumlukiyya* by blending *gumhuriyya* (republic) and *melkiyya* (monarchy).[14] State propaganda had grown so brazen that it routinely insulted people's intelligence. But with a fed-up opposition press and an active blogosphere, it was only a matter of time before scandal would erupt.

On September 14, 2010, the venerable *al-Ahram* newspaper, a regime platform, published a doctored photograph taken from a Middle East summit in the United States on September 1, 2010. The photograph depicts President Barack Obama striding in the White House flanked by Palestinian leader Mahmoud Abbas, Hosni Mubarak, King Abdullah of Jordan, and Israel's Benjamin Netanyahu. In the original picture, Mubarak is walking behind the other leaders, slightly to the left. But in the photoshopped version published by *al-Ahram*, Mubarak struts in front and at the center of the group. Even Obama is walking behind the Egyptian leader. A large white caption set against the red background of the White House carpet reads, "The Road to Sharm al-Shaykh."

"Mubarak in the lead, with Photoshop," blogged Wael Khalil on the same day. The way in which the blogger exposed the fraud was bold and

devastating. He used a series of pictures with captions: First, "This is the front page on *al-Ahram*'s website on September 14, 2010"; second, "And this is the paper version"; third, "After enlargement (of the photograph)"; fourth, "And this is the original photograph from the Associated Press"; finally, "As you will see repeated in the following research," followed by a Google link with all the pictures. Khalil ridiculed *al-Ahram*'s deplorable bid to make Mubarak look less feeble than the lame duck dictator he had become; Khalil also posted a link to his blog post on Twitter.[15] By multiplying access points to the blog post, links to Google and Twitter help preempt electronic blockage.

The next day, Wednesday, September 15, the relatively independent Egyptian daily *al-Masry al-Youm* was the first "mainstream" outlet to break the news, mocking the desperation and duplicity of the regime's spinmeisters. By September 16, the story had gone global. As if this were not embarrassing enough, Usama Saraya, editor-in-chief of *al-Ahram* since 2005, defended the newspaper's editorial decision in a column published on Friday, September 17, arguing that the doctored photo was *taʻbiriyya* (expressive, but also expressionistic) of Mubarak's central role in the Palestinian-Israeli peace process and that the photo was "a succinct, lively, and true expression of the strict stance of President Mubarak and his position on the Palestinian issue, and his distinctive leadership of the issue before Washington." The editor concluded his preposterous defense by accusing those who exposed the fraud—this is particularly rich—of "misleading, lying, believing themselves, then accusing us."[16] During an interview with journalist Yosri Fouda on the quality television talk show *Akher Kalam* (Last Word) on September 26, Saraya once again defended the photo, praising the newspaper's "department of infographics," even after *al-Ahram* had that same morning published a column about the affair titled "*Al-Ahram*'s Mistake," written by the head of the Egyptian Journalist Syndicate, Makram Mohamed Ahmad.[17] Yet, by replaying the original and manipulated photographs side by side, Fouda undermined whatever Saraya said, the images exposing the editor's verbal deception.

The Egyptian opposition criticized the deception and the public mocked it widely as a pathetic attempt to give the ailing leader a contrived centrality in Middle Eastern affairs. A new wave of "Mubarak clings to power" and deathbed jokes arose. One blogger produced a series of photoshopped pictures of Mubarak under the heading "Update your history books,"

showcasing Mubarak usurping important historical figures, from Napoleon to the captain of Brazil's national soccer team when it won the 2002 World Cup.[18] In addition, a Facebook page, the "al-Ahram Graphic Expressionist School," mocked a newspaper that for years had "re-touched" photos of Mubarak to make him appear younger and more vigorous.

As it turns out, Mubarak had been a career fraudster, manipulating photographs since the very beginning of his ascent to power. *The Ethics of the Journalistic Photo* was one of the many exposés that typically follow the fall of an autocrat, and it reveals that during the 1973 war against Israel, Mubarak had all photographs of fellow commanders of the Egyptian air forces expunged from the records.[19] By tampering with photographs of the operations room, Mubarak sought to change his public image in the October 1973 war from undistinguished career officer to strategic military commander. With Mubarak gone, other revelations came to light about how he had choreographed his image. For example, Mubarak had images edited to remove the commander of the armed forces, Sa'deddin al-Shazhli, who stood next to President Sadat, from all official photographs of the operations room during the 1973 war.[20] Mubarak's visual deception was as old as his political career.

As official propaganda tried to cast Mubarak as a classical body, an erect, dignified, commanding leader, satire exposed the dictator as a grotesque body—grotesque not only in its being digitally manipulated into an array of comical avatars, but also in the shameless desperation of its clinging to power. By insisting, against all facts and decency, that Mubarak was a leader worthy of his pedestal—a respected classical body—sycophantic media goaded activists to deride the ruler as a grotesque body. With no popular legitimacy and no distinguished accomplishments, forgery fueled the dictator's pretense to greatness for forty years.

LIVING MARTYR

A few months before *al-Ahram*'s photoshopping scandal, the heroic body of Khaled Said irrupted into Egypt's collective consciousness, poignantly complicating the contrast between classical and grotesque bodies. Said was a twenty-eight-year-old man from Alexandria who spent most of his time indoors glued to the Internet, dreamed of living in the United States, and dabbled in drugs. On June 6, 2010, two plainclothes policemen beat him to death. In the late evening, the two goons confronted him in an Internet café, pulled him to the entrance of a nearby building where they beat him to a pulp, loaded him into their van, then came back and dropped off his corpse in the street. The reason for the incident remains murky. Although news media and activist websites claimed Said possessed a video implicating police in drug-related corruption, doubts have arisen about this claim.[21] However, the impact of the incident matters more than its aims. A sibling of Said's took photos of his wrecked body and disfigured face and enlisted Cairo legal activists. Although many witnesses recalled that Said's face did not look so abused when the police dumped his corpse on the street, and some speculated that the medical autopsy mangled the face in search of a drug bag that Said might or might not have swallowed during the incident, the perception that the state had brutalized the martyr's visage hardened into truth as it made the rounds on social and other media.[22]

The "Kullina Khaled Said" (We Are All Khaled Said) Facebook page appeared online four days later, on June 10, 2010. It featured excruciating

details of tortured bodies and at the same time prodded and pushed other bodies into street activism. Torture was central to the page's emotional and political impact, and photos, videos, news, and narratives of physical abuse by Egyptian police constituted a large part of the content. The page's core evidence, after all, was two pictures of its namesake: in the first, Khaled wears a light gray hoodie and an endearing grin, the very picture of middle-class youth culture interested in music and technology; in the second, his face is mangled, smeared with blood, ears torn, teeth broken, eyes frozen. Together, the cheerfulness in the first picture and the morbidity of the second spurred one of the most gut-wrenching digital artifacts of the Arab uprisings.

For the Facebook page, terminology was destiny. Much of the success of the site was due to the creation of the "alshaheed" avatar as a live martyr witness. The Arabic verb *shahada* is at the root of several terms that together form a semantically rich and emotionally powerful field of meaning inclusive of martyrdom, witnessing, faith, authenticity, watching. *Shahaada* is the Muslim profession of faith, but it also means certificate, credential, attestation, or diploma. A *mashhad* is a place of assembly, a vista, or a (theatrical or filmic) scene, but it can also refer to the holy ground where a martyr died. *Mushaahada* is the act of seeing, viewing, watching, witnessing, and *mushaahed* is spectator or observer. *Shaheed,* martyr, and *shaahed,* witness, are cognates. The official holder of the Facebook account, then, was "The Martyr," a virtual Said. That a digitally resuscitated Said was the virtual *auteur* of the page helped Egyptians coalesce around the figure of the living martyr. It also helped a group of activists to maintain the site collectively by protecting their anonymity and keeping the spotlight on "the martyr of the revolution."

By virtually resuscitating Said and focusing emotional energy on his abused body, the page's administrators also initiated several silent vigils calling bodies into street action. They called on citizens to dress in black, stand at a distance from one another, and converge at specified times and places. The first event was held in Sidi Gaber, the Alexandria neighborhood where Said lived and died. The call asked for people to "remain silent and calm, stand with their backs to the street and the passers-by, and hold a copy of their holy book in their hands, whether it is the Bible or the Koran."[23] The detailed instructions aimed to create a meticulously choreographed protest, as total control of the body was essential to its success. It was important for

the protesters to turn their backs on passersby to avert provocation, and it was essential to remain silent and calm to avoid antagonizing the police, who under the Emergency Law (supposed to be temporary, it lasted for three decades and was older than Khaled Said when he was murdered) had wide latitude to harass, arrest, and detain protesters. "If a policeman provokes you, don't reply, act as if he's not even there," alshaheed instructed his Facebook followers. These "inventive vigils" succeeded in eschewing state violence.[24] This silent protest lasted for one hour, after which participants quietly walked away, separately. Activists repeated this choreography several times, and page administrators jealously guarded the protest: when one member of the page mocked a protest photo, alshaheed threatened him with eviction from the page.[25]

It took more than six months for the world to discover one of the creators of "We Are All Khaled Said." Arrested on January 27, 2011, and released on February 7, Wael Ghonim revealed his identity and catapulted to global fame after tearing up two days later during an interview with talk show host Mona al-Shazhly on Cairo's Dream TV. Though Ghonim's Google affiliation, entrepreneurial spirit, English-language skills, and incarceration endeared him to global media, he was not the only person behind "We Are All Khaled Said." Other participants included 'Abdulrahman Mansour, a Muslim Brotherhood–affiliated activist; Ahmed Saleh, an Egyptian Ph.D. student at the University of Toronto; and Nadine Abdelwahhab, a Washington, DC, public relations professional, who all helped administer the page, create content, devise strategy, and reach out to Facebook to confront government-initiated shutdowns of the account.[26] A collective with deep commitment and an array of technical and rhetorical skills was behind the alshaheed avatar.

In her detailed analysis of postings on the site, sociologist Linda Herrera showed that considerable marketing expertise was behind the growth and success of the site. Page administrators deftly strategized timing, language, and networking to expand their "brand." Because Internet usage peaks in the evening and during weekends in many Arab countries, where the workweek ends on Wednesday or Thursday evening, Ghonim put up his maiden post at 9:01 p.m. on Thursday, June 10, 2010. Titled "Oh you inhuman: We will claim Khaled Said's right," the post deftly combined language that was emotionally laden ("blood," "torture") and morally charged (good versus evil), with recrimination against police brutality and aspirations for a better

future. Other postings reflected a shrewd strategy to enhance the page's impact.[27]

Like Bouazizi in Tunisia, Said achieved mythical status after death. Confusion about his identity abounded: Was he an "entrepreneur," as the *Daily Beast* and *al-Ahram* called him? A "businessman," per the language of an academic article? Or a "handsome, professional young man," in the words of an Egyptian blogger?[28] All of these terms oversimplified a complicated individual, and by raising him to rarefied heights, obscured how he operated in death as a call to arms for a deeply alienated generation.[29] An imperfect and multifaceted human being was exalted and reduced to a myth. Is it possible for someone to be a chronically unemployed, romantically frustrated, socially marginal, Internet-addicted, politically inactive young man dreaming of emigrating to the United States, as well as a pet lover and petty drug dealer, and also be the foundational myth and enduring icon of the Egyptian revolution? The evidence says "yes." Consider his multiple nicknames: labeled Khaled Sena (tooth) at school for a crooked tooth, Khaled Tayyara (kite) on Alexandria beaches because he attached razor blades to his kite to cut off competitors, Kaled Wave the music fan on MySpace, Marijuana Martyr from the government's perspective, and "martyr of the revolution" for thousands of Egyptians, he was what semioticians call a floating signifier—a figure whose visibility matches the figure's symbolic pliability, compelling actors in a social drama to appropriate it to further rival agendas.[30] In spite of these rival perceptions, Khaled Said's heroic body was incontrovertible evidence of the moral bankruptcy of the state, and of its rampant corruption and unbridled violence. The figure of Said also illustrated the power of committed, competent activists who used digital communication to spread images of brutalized bodies in the public sphere, feeding an impassioned "online martyrology."[31] Most potently, the story of Khaled Said impresses on us how revolution can turn a disposable body into an indispensable myth.

FUNNY MEN

*H*ow does this figure of Khaled Said, an average Egyptian made into a legend by torture and death, help us understand the less tragic travails of other revolutionary figures who survived repression but incurred personal, political, and financial losses for their courage? Can the martyr give us insight into the struggles of Ibrahim 'Eissa, the muckraking editor who continually butted heads with the dictatorship? Does Said's tragedy relate to the woes of Bassem Youssef, the comedian whose political satire earned him popular acclaim and a state ban? Said, 'Eissa, and Youssef can be considered heroic individuals whose risk taking helped expose the fraudulent classical body of the dictator for the corporeal grotesquerie that autocrats typically are. Against great odds, they cut through the chatter in a repressed public sphere. If Ibrahim 'Eissa typified the struggles of emboldened media within a repressive police state, the comedian Bassem Youssef embodied the tribulations of media figures in revolutionary Egypt. Suppression grew significantly after the June 30, 2013, coup, which deposed Morsi and returned military rule under Sisi, who became Egypt's sixth president in the controversial May 2014 election.

Youssef, dubbed "Egypt's Jon Stewart" by the US media, debuted on YouTube in March 2011 in the wake of the January 25 Revolution. Success online led *el-Bernameg* (The Program) to a slot on the politically liberal ONTV network in August 2011, where Youssef mercilessly skewered both President Morsi and the movement he came from, the Muslim Brotherhood. On April 5, 2013, in a memorable episode, Youssef parodied a famous

Egyptian song, "My Beloved Homeland," to mock the oil-rich Gulf emirate of Qatar for supporting the Muslim Brotherhood.[32] The president brought charges against the comedian, and Youssef's statements and court appearances made for great newspaper headlines. But it was only when Youssef directed his satirical firepower at Sisi, strongman and presidential favorite, that the real trouble began. *El-Bernameg* was shut down at the beginning of its third season in October 2013. Over the following months, newspaper headlines were full of rumors and speculations about the program's fate. In February 2014 Youssef moved his show to MBC Misr, a channel belonging to the Saudi conglomerate MBC Group. MBC is known for popular entertainment programs, but the company's insistence on avoiding controversy at all costs and MBC Misr's minuscule audience constrained Youssef, whose very move to MBC reflected the growth of Saudi clout in Egypt as the kingdom championed Sisi.

A Saudi platform could not save Youssef. As Egypt's rulers tightened their grip on public life, they stamped out criticism in the media, detained dozens of journalists without charge, put several bloggers in jail, and accused academics of treason. Ahead of the 2014 presidential election a personality cult grew around Sisi, and thitherto respected journalists, in state and independent outlets, began writing sycophantic columns about the man widely assumed to be Egypt's next leader. A cult of personality depends not only on the systematic manipulation of images to establish favorable perceptions of the leader as vital head of the body politic but also on the population's believing or pretending to believe that propaganda. Drawing on a kind of humor that inverts hierarchies of power and decorum and lowers the leader to the level of the people and below, parody is inherently inimical to personality cults. It did not matter whether Youssef was online or on the air, or that pro-Sisi Saudi interests had reined him in a little. A comedian as skilled and popular as Youssef would still pose a threat to the political credibility of Egypt's emerging leader.

Sisi won the presidential election in late May 2014 by 96 percent, a number reminiscent of pre-uprising "elections" under leaders who used trappings of democracy to upgrade their autocracies. In March 2014, "mysterious" transmissions jammed broadcasts of *el-Bernameg*. For a few days after the election, rumors swirled that King Abdallah of Saudi Arabia had personally weighed in to have Youssef taken off the air. One can imagine the reaction of the Saudi monarch, still reeling from the undignified exit of his friend

Hosni Mubarak, on being told about a comedian who, as we shall see shortly, compared leaders to animals, hit them with sexual innuendo, and used underwear as comic props. Perhaps the aging monarch even watched an episode or two. The Saudi monarchy, itself built on a royal cult bolstered by a ritualistic cleric-political system, was a rich potential target of satire. Over the years, Saudi authorities managed to neutralize the impact of popular Saudi comedies like *Tash ma Tash,* which never targeted the monarchy itself to begin with. That any Saudi channel, albeit one focused on Egypt, would carry *el-Bernameg* increased the odds that more Saudis would be exposed to Youssef's brand of humor. This popular Egyptian comedian was undermining a regime that Saudi Arabia considered a strategic asset for its foreign policy, focused as it was on containing Iran and neutralizing the Muslim Brotherhood. In this context, Youssef was more than an irritant. He was a threat. He had to go.[33]

So it was no surprise when on June 2, 2014, Bassem Youssef held a press conference in his studio carrying a banner that said "The End" in Arabic and English and declared that the show was being terminated because he was tired of being harassed and was growing concerned for the security of his family.[34] Youssef's treatment pales in comparison with the crackdown on the news media since the June 2013 military coup. As mentioned before, under Sisi, Egypt shut down television channels and withdrew broadcasting licenses, intimidated and imprisoned journalists, shot and killed protesters, and fostered deference and fear in the public sphere. They sought to undo a central achievement of the revolution—the people's loss of their fear of rulers—and so Egypt's leaders brooked no dissent. The state decreed the Muslim Brotherhood a terrorist organization on December 25, 2013, and shut down the official Freedom and Justice Party's newspaper *al-Hurriya wal-'Adala.*[35] The sentencing to death of 528 people in March 2014 exposed a grotesque tyranny. Youssef's epic rise to fame, his legal and political hassles, and his ultimate demise reflected the waxing and waning intensity of the power of the sovereign. Revealingly, this comedian's revolutionary journey shows that Islamist reign was more tolerant of political satire than military rule. Youssef was a high-profile casualty of the return of the uniforms, but he energized a venerable tradition of jocosity against the ruling class, underscoring the idea that satire was a mercurial art that switched targets with speed and ferocity to attack whoever sat on Pharaoh's throne.

Egyptians are reputed satirists who in past millennia already told dirty jokes and developed pictographs akin to political cartoons.[36] Five thousand years ago, Egyptians joked about pharaoh's sexual appetite: "the only way to convince the king to fish was to wrap naked girls in fishing nets."[37] The image of a people particularly adept at humor remains true in the modern era. "Egyptians are particularly prone to satire," wrote an observer in the 1930s, for they "lampoon their rulers in songs, and humor."[38] The first Arab satirical magazine was published in 1877 in Cairo.[39] Political humor proliferated over the next fifty years and exploded during the 1919 revolution in satirical publications, public readings, colloquial poetry known as *zajal* (plural: *azjal*), and street theater. Using an Egyptian vernacular that grated against the *fusha* (classical) Arabic of officialdom, these media resonated deeply and widely among Egyptians.[40] According to the historian Ziad Fahmy, in a comprehensive study of media during the 1919 Revolution, the targets of satire included the khedive Ismail's incompetent management of Egypt's finances, the corruption of the ruling clique, rising foreign meddling in Egyptian affairs, and public morality and sexual scandals, themes that returned in anti-Mubarak humor. Fahmy marshaled extensive evidence about the concrete impact of satire in 1919 because it "created a counterhegemonic atmosphere" fomenting defiance against the British and their collaborators. Orations of revolutionary *azjal* from satirical magazines in coffee shops and public squares were one widespread type of protest.[41] Whether combining the printed word with the human voice, or digital pixels with the human body, in 1919 or in 2011, satire circulated through multiple interconnected media.

Harnessing animal and body imagery for political ridicule is another commonality across time. In 1919 the satirical newspaper *al-Babghlu al-Misri* (The Egyptian Parrot) depicted monkeys dressed as Englishmen, alongside circus dogs and cows representing passive Egyptian collaborators. Body symbolism was also in evidence: during the diverse and raucous assemblies at the Islamic university al-Azhar, which earned that venerable religious institution the nickname of "Egyptian Congress," one Coptic Christian priest, Murqus Sergius, intoned humorous sermons that expressed a desire to subvert the prevailing body social and politic, saying, for example: "As a servant of God my duty is to celebrate marriage and funeral rites, and I long to *bury* the authority of England and to *marry* Egypt to liberty and independence."[42] After the magazine *Rose al-Yusuf*

began publication in 1925, it quickly became an incubator for satirists and cartoonists who would go on to create some of the enduring archetypes of Egyptian humor, such as the bourgeois *effendi* and the salt-of-the-earth *ibn al-balad*.[43]

The art of the political joke continued to develop during the years of the monarchy, and after the Free Officers Revolution deposed King Faruq in July 1952, jokes about the successive military dictators Nasser (1954–1970), Sadat (1970–1981), and Mubarak (1981–2011) spread like wildfire.[44] As Nasser's military regime consolidated power in the 1950s, political jokes proliferated in Egypt, so much so that Nasser was rumored to receive a daily briefing from his secret police about political jokes. A handful of themes persisted: regime repression, the failure of socialism, and, following Egypt's defeat in the 1967 war against Israel, the incompetence of the armed forces. Another set of jokes articulated political repression through the human body. Consider this example: "Once someone saw a man with his nose bandaged and asked him, 'Why is your nose bandaged?' The man said, 'I had a tooth removed.' The first man rejoined, 'Why didn't you have it removed from your mouth?' Whereupon the reply was, 'Can anyone in this country open his mouth?' "[45] In this joke, the issue of freedom of speech is tackled through a mundane visit to the dentist, with a twist. Although ostensibly resulting from dental surgery, the bandaged nose hints at a punch in the face, a contrived medical intervention underscoring political coercion. Whereas in this joke the body provides evidence of state violence, disguised as dental procedure and therefore preserving political deniability, in other jokes lower registers of the body defile the dictator's classical body and redefine it as a grotesque corporeality.

When Anwar Sadat took the helm from Gamal Abdel Nasser in 1970, he inspired political humor of a sexual nature focusing on his wife Jehan, an avowed feminist who was active in public life and gifted with great looks. However unfairly, a number of jokes in the 1970s alleged that Jehan was sexually promiscuous and featured Mubarak, then Sadat's vice president, profiting from this, for example, performing oral sex on the boss's wife. One, for example, tells how, before traveling abroad, Sadat leaves his wife with a chastity belt equipped with a razor, and upon his return he finds Mubarak lisping because he lost the tip of his tongue.[46] Exposing Mubarak's venality and undermining his virility, such jokes planted seeds that developed deep roots and blossomed during his tenure.

They harped on his subpar intellect and utter incompetence, aloofness and detachment from regular folk, corruption and vanity, all made worse by his relentless clasping to power. One humorous trope—the Laughing Cow—captured these misdeeds so aptly that Mubarak's own advisers adopted it.

LAUGHING COW

*T*he fascinating story of why and how the cow became Mubarak's unshakable alter ego explains his successors' eagerness to dodge any animal sobriquets. Bovines were positive symbols in ancient Egypt, when Hathor, goddess of dance, music, and fertility, and Hesat, whose milk nourished the gods, were both depicted as cow divinities and wild bulls were celebrated for their strength and sexual vigor. Over time, however, the cow acquired negative connotations, and in line with contemporary perceptions of the bovine the Laughing Cow captures a set of features associated with Mubarak. A French processed cheese, *La vache qui rit* trotted into Egypt after Sadat and Mubarak opened the country to global capitalism in the 1970s. As a foreign-processed cheese, the brand was a target for people's resentment toward economic *infitah* (opening) policies and Mubarak's economic mismanagement and dependence on foreign aid. To the alarm of the bourgeois classes, livestock can still be seen inside major cities and suburbs like Cairo and Giza, giving the Laughing Cow added social resonance. In addition, as side-by-side pictures online cruelly demonstrate, Mubarak's visage bears a disastrous (to him) and auspicious (to rebels) resemblance to the jolly bovine.

In one fell swoop, the Laughing Cow captured the despot's political, mental, and physiognomic features, which it packed into the red logo of the earring-wearing bovine, a dubious but memorable alias. In jokes from the 1980s and 1990s, stickers, comics, and blogs in the 2000s, and kinetic memes on Facebook, Twitter, and YouTube in the couple of years before it

exploded during the 2011 revolution, the Laughing Cow motif is the stuff of dictators' nightmares. The revolution released the Laughing Cow from its enclosed online pasturage to roam free on street banners. One photograph of a handheld sign in Tahrir Square, with the cow and the caption "Mooooo . . . barak" or "Muuuu . . . barak, dégage!" ("Get lost!") went viral. Assonance helps, but the moniker's stickiness to Mubarak's persona made it an immediate revolutionary jocular hit. One Twitter account in particular deserves mention because it was dedicated especially to the bovine leader. Launched on February 3, 2011, and in operation until April 9, 2011, @MubarakTheGreat had the original *La vache qui rit* as a profile name and photo and "I am the most loved ruler of all time. Egypt will be remembered for me. I Mubarak. I President. I Eternal" as a descriptor.[47] The tweets reflected familiar anti-Mubarak and antimilitary themes, chumminess with the United States and Israel, political repression, and corruption, connecting Mubarak to Tunisia's Ben Ali, who preceded his Egyptian counterpart in going into forced retirement: "Zein (Ben Ali)'s face is red, mine is blue; We're spending your money and you don't have a clue."[48]

The *La vache qui rit* Twitter handle could be the fruit of a bored person with an Internet connection, the labor of an Egyptian activist, or a foreign psy-ops operation. Authorship matters less than the account's style of parody, mirroring other jokes, posters, videos, and graffiti in a blast of revolutionary wisecracking. As the most widespread form of political humor, parody repurposes existing words and gestures.[49] Its power comes from transforming its object into a mere representation of itself, inviting defiance and ridicule.[50] By resorting to leveling and using "lowly things" and animals as comedic props, parody is effective with the common folk. To understand parody, the audience needs little formal education, conceptual sophistication, or language skills. One needs to be part of the culture to "get it." Compounded by repetition and circulation in hypermedia space, parody is successful on a very wide scale.[51] The Laughing Cow trope is a spectacular demonstration of parody's uncanny ability to thrive as gradual creative insurgency.

A dictator's fall liberates theretofore embargoed stories. Thus, after the January 25, 2011, revolution in Egypt, Mohamed Hassanayn Haykal, confidant to presidents and éminence grise of Egyptian journalism, published a book and a series of "witness to history" interviews and articles in *al-Shorouk*, an independent Egyptian newspaper, discussing Mubarak's legacy.

There, Haykal revealed that the Laughing Cow moniker had emerged when Mubarak was still vice president to Sadat.[52] Haykal confirmed that the epithet came from Mubarak's reputation for dim wit. However, Haykal asked the obvious question: "How was the Laughing Cow able to rule Egypt for thirty years?"[53] The systematic manipulation of the photographic record of the 1973 war, positioning Mubarak as a military strategist and visionary leader, bolstered his status.[54] But Haykal also suggested that Mubarak had a secretive, guarded demeanor that kept allies and opponents on their toes. Though "Mubarak did not understand things quickly," he was "more complex than the laughing cow."[55] When he was once invited to have breakfast with the new president and warned by mutual friends to broach only "a single issue in a single meeting" and avoid "conceptual issues," Haykal came out of the experience convinced that Mubarak "had a good understanding of how power worked."[56] Indeed, for more than thirty years Mubarak outmaneuvered rivals in spite of his reputed dull intellect.

The Laughing Cow continued its political life even after the man who inspired it had left the stage. In a column entitled "The Laughing Cow and the Sacred Cow," in the Egyptian daily *al-Yawm al-Sabe'*, 'Abdul-rahman Youssef wrote that Mubarak got the vice presidency because Sadat wanted "a clerk with no ambition" whose role was mainly to show up at official functions where his fatuous smile fanned the belittling bovine moniker.[57] However, the columnist continued, "The strange thing is that with time, this man nicknamed the laughing cow saw himself inflated . . . and saw only himself, and Egypt in all its glory became merely an entity created by God so that Mubarak can enjoy ruling it, and in his view the people became mere creatures created to serve him. . . . That is what Mubarak became, and that is what ended him, for *he tried to transform himself from the laughing cow to the sacred cow,* untouchable and unaccountable."[58] Written in May 2012, the column warned against a pending constitutional decree that was threatening to make "the armed forces a sacred cow, untouchable, and would transform the head of state into another laughing cow."[59] Cautioning that only Parliament would have the power to enact such a law, the columnist called on candidates in forthcoming elections to reject any such decree, warning that "if you acquiesce to the existence of a sacred cow in the state, then this means we would get a president who is a laughing cow. Long live Egypt for Egyptians and with Egyptians."[60] Once employed to ridicule a sitting leader,

animal symbolism now nourished a cautionary political idiom during revolution.

As it endured after Mubarak, the ox-based political vernacular deviated from portraying the leader as Laughing Cow to instead depict Egypt as a bovine republic. "The Dairy (Cash) Cow" mural, which appeared in Cairo during the revolution, embodies the metaphorical shift to Egypt as *al-baqara al-haloob* (*haloob* technically means "lactiferous," but the phrase denotes "cash cow"). This of course raises the notion that the ruling clique "milked"— plundered—the country, and the Internet will give you plenty of udders and shudders about the lavish lifestyle of the Mubaraks. Through the bovine trope, the body of the nation displaced the body of the dictator. Verbal Arabic inscriptions accompany the image of a prostrated cow. This motif makes a specific reference to a 1960s song by the Egyptian vernacular poet (and longtime thorn in the side of Egyptian leaders) Ahmad Fuad Nagm, in a duo with legendary singer Sheikh Imam. The song is about a fighting cow that was exploited and then fell in a well.[61] The first few lines set the mood: "The weepers wept at the fate of Haha's struggling cow (*al-baqara al-natiha;* the verb *nataha* means to struggle, to push, to butt, but also to struggle); and that is a dairy / cash cow, she produces bountiful milk; which is robbed, by people of the house; a house with owners and eleven doors; underground tunnels and a roaming wolf." A few verses later we learn that "foreigners came and drew the milk," followed by two lines that appear in the graffito: "The cow called 'O My Children,' but the children of shame, were asleep." Tormented by outsiders and neglected by insiders, the cow "fell in the well." Why did she fall? "Fear . . . lack of vision . . . hunger and . . . complacency."[62] The symbolism is evident: The cow is Egypt, whose ample resources are pilfered by insiders and outsiders alike; weakened by corruption, stagnation, poverty, and lack of vision, the country falls into the abyss. The song was written in the wake of the *nakba,* as Arabs refer to the disastrous loss of the 1967 war against Israel (the foreigners), which seized Sinai (the cow) while the "people of the house" (Egypt's military) were asleep at the wheel.[63]

But the trope of the exploited dairy cow goes deeper into Egyptian history. Back in the late 1870s, cartoons in satirical magazines like Ya'qub Sannu' 's *Abu Naddara* depicted Egypt as "a cow . . . being milked dry by ministers and by the European powers or sucked by foreigners."[64] The cow's resurrection 130-some-odd years later in revolutionary anthems and graffiti

reflects a continuity of both historical iniquities and the idioms to contest them. It reflects the fusion of past and present in creative insurgency, but also its ability to grow and expand: later photos show two stencils added to the original "Dairy (Cash) Cow" mural, one of the Daesh banner, another of the clenched fist-and-star logo of the Revolutionary Socialists: an uncanny amplification of the mural's depiction of Egypt as a battleground.[65]

THE POODLE AND THE BEAR

*A*fter initial exhilaration following Mubarak's exit from power, anger began building against SCAF and its head, Field Marshal Mohamed al-Tantawi. Arrows of ridicule targeted Tantawi less than the council as an entity, suggesting that once people are no longer able to personalize sources of resentment in the individual ruler's body, political humor loses its bite. Even though he was in power for a very brief period of time, Tantawi still could not escape the curse of animal imagery. Courtesy of WikiLeaks, we know that colleagues in the officer corps nicknamed Tantawi "Mubarak's Poodle" for his fealty to Mubarak. But it was Tantawi's successor, the elected Islamist Mohamed Morsi, who incurred hostility in mainstream media and relentless skewering by Egypt's comedians. To Bassem Youssef, official funnyman of the revolution, Morsi was the gift that kept on giving, and many episodes of *el-Bernameg* focused on the burly president.

By parodying Morsi, Youssef introduced bawdy humor into his repertoire. Episode 3 of the second season, "Ehna Thawrat Culottat" (We Are an Underwear Revolution), exudes ribaldry, winks at a graffito by Adham Bakry of Tantawi's boxer shorts decked with blue helicopters, and hints at the *sans-culottes* of the French Revolution.[66] Youssef begins by blaming Morsi's leadership for "mixing hatred with religion after mixing politics with religion," going on to conclude that "in the end, what happens to the people on the street, and whoever dies from either this or that camp is the responsibility of the person who calls himself the president of the whole

country."[67] Three and a half minutes into the episode, serious political editorializing gives way to Youssef's introduction of the protagonist, the *culotte* (French for briefs, men's underwear). Youssef proceeds, "We got many complaints that we sometimes use inappropriate words and expressions . . . there is in this episode, a word that will be repeated a lot, so I want to take your opinion, before we start." The studio audience laughs as Youssef asks, "Is anyone bothered by the word *culotte?* Laughter and applause erupt. "It's a normal word we take . . . it's better than many other words." Suggesting that there were more offensive terms he could have used, Youssef continues, "It [i.e., the underwear] now has advertisements too!" Laughter and applause rise again. Youssef concludes this segment by repeating the question, ascertaining that underwear talk is not offensive to his audience.

Veering back into politics, Youssef shows footage of women chanting in a demonstration and comments, "Their voice was rocking all of Egypt. . . ." Chants continue: "Down, down, with the rule of the *murshid*" (spiritual guide and de facto head of the Muslim Brotherhood). Returning to his facetious tone, Youssef asks in fake baby talk, "Sister, did you take down Morsi's rule, or did you want to pull something else down [implying the *culotte*]?" Here, Youssef seems to be referring to the widespread sexual harassment of female demonstrators in Cairo before, during, and after the revolution (one wonders if he was also referring to Aliaa al-Mahdy—see Part V). Comparing toppling Morsi to pulling underwear down one's legs is obviously unflattering to Egypt's first elected president, whether in the bawdy prop or the suggested ease of his removal from power. But Youssef's insertion of the issue of free will versus coercion when it comes to removing both underwear and political leaders shows parallelism between sexual and political violence.

Youssef then dashed back into drollery with the same speed as he first zigzagged into earnest political talk: "One hundred *culottes,* for the *maly-ouneyya* [a one-million-person demonstration]. Meaning every 10,000 get only one *culotte?* One hundred dressed and others in the flesh?" he wondered with feigned incredulity. Then the payoff: "This revolution is sponsored by JIL [an underwear brand]," Youssef intones as a minuscule pair of men's briefs appears stretched between two fingers on a hand making the victory sign. Laughter erupts in the studio, as Youssef proceeds: "This is why for the next demonstration, we would like to contribute some slogans: 'Life, Freedom and Underwear' [rhymes in Arabic]; *yasqot, yasqot hekm al-*

boxer [Down with Boxer Short Rule (rhymes with *yasqot, yasqot hekm al-'askar,* or Down with Military Rule)]; and others." "For future revolutionary demonstrations, we would like to offer you a new line of revolutionary underwear," Youssef announces. A male model comes on stage in a suit, then strips down to his underwear, eventually brandishing oversized white briefs with "freedom" scribbled on them as Youssef apes catwalk banter.[68] Although diminished when translated into English, for Youssef's viewers who are hearing these jokes in their vernacular, they are hilarious encapsulations of the period's tensions and incongruities.

Proceeding with a detour to mock pro–Muslim Brotherhood turnout in a demonstration, Youssef doubles down on bawdy humor and somatic symbolism, targeting Islamists and secularists. Video excerpts show various religious figures making astonishing claims in public speeches, including an excerpt from a television talk show featuring a bearded religious figure addressing secularist rivals: "The fig leaf [*waraqat al-tout,* Arabic for mulberry leaf] has fallen; we say . . . put your pants back on." Youssef, comically clutching white underwear, asks secularists: "Why don't you rely on the fig leaf? . . . Why do you worry about the Islamists?" The segment concludes with a motley crew of Islamists making outrageous statements or clamoring for the "purification" of the media, another frightening bodily metaphor. Then, a photograph of a chair wearing white briefs appears on the left of the screen, with the caption "A Chair in the Culotte." The chair—the throne, seat of the sovereign—keeps appearing and vanishing from the screen, underscoring Morsi's absent body and his shaky grip on power. Animal imagery slides back in: brandishing a pillow bearing Morsi's smiling face, Youssef tells his audience that his daughter had slept with the "presidential pillow," and therefore he wanted to "share pictures that show her love for the president, his affection, and his embrace." In quick succession, Youssef introduces several pictures—of his child looking at a televised Morsi speech: "This is Nadia when she first saw the president"; of her seemingly embracing the screen: "This is Nadia hugging the president"; a third: "This is Nadia happy with the president's speech." Comparing Morsi to a (teddy) bear casts him as a cuddly, furry, harmless prop. However, the "bear" metaphor also includes brutishness and clumsiness, and indeed others have commented on Morsi's ursine aura.[69]

Up to this point in the episode, the comedian's skill is evident in the way he sticks to clever bawdy innuendo, skirting explicitly excremental humor.

But when viewers hear a loud toilet-flushing noise (at minute 44:34) preceding Youssef's return to the stage after a commercial break, they get the signal that a more degrading attack is afoot. The blow comes with Youssef's fourth and final picture of his daughter: "And now this is Nadia after she understood the president's speech," showing Youssef's toddler laughing as she crouched, a posture primed by the sound of toilet flushing to suggest impending defecation.[70] Youssef concludes mischievously, "She is the only one who understood [(Morsi's speech] at home."[71] The president, viewers are made to understand, induces a desire to defecate. As we see his daughter standing up, Youssef hammers the nail all the way into Morsi's presidential body: "Is this a *nahda* or not?" The Arabic word *nahda* means "standing up," but also "renaissance," which was the Muslim Brotherhood's electoral motto. Youssef dragged it down the gutter of excremental humor.

Images of Tantawi as a poodle and Morsi as a bear were fleeting because both leaders had short terms (seventeen months and one year, respectively). Their pet names stuck to Tantawi and Morsi to only a limited extent, reflecting as they did frustration that had been growing for months rather than long-simmering anger. However, Egyptian politicians were nonetheless mindful that the Laughing Cow had latched onto Mubarak for more than three decades, so Sisi's propagandists wasted no time or effort in building a personality cult, trying to stave off beastly epithets. As demonstrated by the farmer who decorated his donkey as Sisi, the spin doctors enjoyed at best partial success. This may be why efforts to establish Sisi as a classical body at the helm of the body politic countered the asinine trope with images of other animals whose strength is the stuff of legend: the eagle, soaring emblem of fearsome empires, and the lion, roaring king of the animal world.

THE LION AND THE EAGLE

*M*orsi committed career suicide when he appointed Sisi minister of defense and commander of the armed forces. Soon after he had deposed his boss on June 30, 2013, Sisi set to work building a personality cult. Ahead of the May 2014 presidential election, Sisi's portraits pervaded billboards, windshields, and banners hanging from balconies, electrical poles, and shop fronts. People sold and ate Sisi chocolates, sold and (presumably) wore Sisi underwear—ironic given Youssef's use of underwear as a prop to demean Morsi. In the weeks preceding the election, bootlicking reached its apex. In Egypt's crippled economy, merchants capitalized on the cult, and an ever widening array of Sisi-themed merchandise—clothing, jewelry, framed photographs, sweets, even sandwiches (such as the "Sisy Mix sandwich," with chicken breast, sausage chunks, and "special sauce")—bearing the effigy of Egypt's aspiring leader saw a brisk business.[72] Sisi was portrayed as nothing less than a providential savior. Mock souvenir Sisi identity cards listing Sisi's profession as "Savior of Egypt" were also popular, alongside fake currency with the field marshal's portraits. Various stars and aspiring celebrities released songs lauding the budding president. The rising cult raised suspicions that the Egyptian military, through its Department of Morale Affairs, was campaigning to elevate Sisi to the presidency.[73]

In its ham-fisted imagery, the celebration of Sisi as a glorious and generative leader brings to mind medieval notions of the body politic. A columnist in the English-language *al-Ahram Weekly* put it thus, unburdened by irony: "He stands straight and tall, impeccably attired and starched from

head to toe. His freshly washed countenance and youthful zeal shield a Herculean strength and nerves of steel. He wears the feathers of a dove but has the piercing eyes of a hawk." Sisi is a providential savior: "During our thousand days of darkness, dozens of potential leaders pranced and boasted, to no avail. The leader of the people should combine a love of country, a deep faith in God and the desire to serve the nation's will." Then the tone waxes prophetic: "Abdel-Fattah Al-Sisi's name lit up the darkness. He was called upon at a supreme moment in history; a kind of mysterious rendez-vous with destiny." A hero basking in glory, the leader is nonetheless portrayed as modest.[74] Sisi's masculine traits are emphasized in ways that combine physical strength and mental clout: "In the full vigour of his prime, he exudes a magic charm, afforded to a select few. His physical appearance—and appearance counts—is flawless. He wears the emblems of his rank on his shoulders as he does the legends of his ancient land, with gushing pride. But it is the swelling reservoir of love for his Egypt and his God that sealed the deal. We responded to this love a million times over. Therefore, for those who raise an eyebrow at the portraits, flags, pins, pictures, chocolates, cups and other forms of Al-Sisi mania that fill the streets of Egypt, it is only a fraction of the love and appreciation we feel for this strong yet modest, soft-spoken, sincere and compassionate leader. It is Kismet."[75] *Kismet* is a Turkish word that comes from the Arabic *qisma,* or portion, whose first known use was in 1834. Here it means fate, "a power that is believed to control what happens in the future."[76] The column also tells us that Sisi is "shy and reserved . . . a man of few words and much action," "born to the right kind of father, in the right kind of district—Al-Gammaliya," and therefore has "a sharp perspective into the hearts of his people, their pains, their aims, their wishes, their dreams," and is thus able to heal both their souls and their bodies.[77] Dwelling no further on the leader's special connection to the people (which makes him un-Mubarak-like), the column concludes with positively imperial imagery, bolstering Sisi's body as savior, healer, and soother of the nation: "Yes, the Eagle has landed. His bronzed, gold skin, as gold as the sun's rays, hides a keen, analytical fire within. He challenges the world not with bellows and bravura but with a soft, sombre reproach, with an audible timbre of compassion. . . . There is almost poetry in his leadership, but the ardour of the sun is in his veins. He will lead us to victory and never renounce the struggle, and we will be right there at his side."[78]

Other columnists were more attentive to the leader's masculinity. In the putatively independent daily newspaper *al-Masry al-Youm,* Ghada Shareef wrote that Sisi "does not need to invite or order, it suffices that he winks. . . . We will all heed his call. . . . This is a man Egyptians worship! And if he needs four wives, we will heed his call. . . . This is a man repeating what happens with Abdel Nasser in year 1956, when he called Egyptians into battle against the third aggression."[79] As one commentator aptly summarized it, "The Strongman became transmogrified into a kind of 'Supermale'"[80] who needed only intimate his desire in order for eager Egyptian women to start lining up. What is more, the nation itself, seeing his valor in historical precedents, was at the leader's disposal.[81] Sisi's cult enlisted Egyptians into the emerging body politic via consumerism. From all the Sisi branding and memorabilia, one would think that Egypt's rising leader made food more healthful, underwear more intimate, and commodities more valuable. You could partake in Sisi's amorous vigor by purchasing leader-branded food items, such as cooking oil "guaranteed to make your food more nutritious and invigorating."[82] In a short time, "male consumer products . . . enticed purchasers to acquire for themselves some of the virility and allure of the new leader. . . . Many were of an almost startling intimacy, including women's pajamas, bras, and even knickers, explicitly bearing the super-male's imprint."[83]

Although some have noted the explicitly sexual messages, in sync with portrayals of Sisi as the white knight in shining armor rescuing Egypt, the damsel in distress,[84] commentators overlooked the deeper undertones of the sovereign body, omnipresent and omnipotent. On the Tumblr site "Where else have you seen Sisi today?"—a question that itself presupposes a desirable ubiquity of the leader, essential to a personality cult—one can find images of Sisi as "the lion of the Egyptian army."[85] Elsewhere, Sisi is in full military regalia in the background, with a huge head of a lion, mouth wide open, with the caption "Heart of the Lion."[86] There is at least one image of Sisi as Atlas, whose bulky musculature enables him to carry the whole terrestrial globe.[87] As a virile, dominant, leonine, nearly divine, seemingly nonvulnerable leader, Sisi oozed attributes of the sovereign dominating the body politic. After the sickly and impotent Mubarak, last seen on a hospital bed in a cage in the courtroom where he stood trial, and after the portly and graying Morsi, Sisi was the very picture of vigor. That Sisi's hypermasculine imagery made its way into Egyptian wedding celebrations established him as the

symbolic head of every Egyptian family and the unequivocal head of the mother of all families, the Egyptian nation.

By groveling over and over again, fawning Egyptian journalists, anchors, politicians, and citizens closed the loop on the Egyptian revolution. Forgotten was the fact that the man hailed as a new beginning was head of military intelligence under Mubarak and SCAF, then defense minister under Morsi. If the primary raison d'être of the revolution was to start a radically new political order, in which, through sweat, tears and blood, sovereignty is stripped away from the toppled dictator and redistributed to the people, then Sisi's cult and elevation to the presidency signaled the victory of a counterrevolution, aided by the Saudi king's warm embrace of Sisi, calling his election "a historic day."[88] In the meantime, Sisi occasionally showed off his chiseled calves during choreographed cycling trips on the streets of Cairo, emphasizing his fitness to lead. Fueled by spin doctors, bolstered by the media, and put in practice by patriotic consumerism, the cult of Sisi grew bigger. Social media pushback and ridicule did not really matter, and after television channels sacked several critical talk show hosts in 2014, in October of the same year newspaper editors pledged publicly to be "less critical of the government."[89] As far as media and speech were concerned, Egypt—like the poet Nagm's "struggling cow" in the well—fell into a narrower, deeper, darker space.

THE DICTATOR'S TEAR

*T*he trials of fallen dictators are big spectacles. They show key characters in a national drama participate in a catharsis as they reveal and contest once jealously guarded secrets. The early rounds of the trials of Mubarak in September 2011 included secret testimonies by security men involved in the bloody repression of Tahrir Square demonstrators.[90] In late May, during the final ten days of the campaign to elect a new president, Egypt's Administrative Court ordered "Mubarak's name to be removed from Egypt squares and public facilities."[91] This finalized a process that had begun with renaming a Cairo metro station; initially named after Mubarak, the new name was "The Martyrs," to honor those who fell in the early months of the January 25 Revolution. If stamping your body all over the country's landscape and public squares is a hallmark of dictatorship, then dismantling those emblems of power is a loud and visible proclamation of the fall of the sovereign. That this was done not only by angry revolutionary mobs destroying statues of their oppressor but also through the gravitas and decorum of a court of law certified Mubarak's demise.

From the beginning, in the pictures of the trials, Mubarak appeared as a tragic, ailing figure. Looking aged and in physical decline, the dishonored despot often donned large and dark sunglasses, as if to shield himself from the glare of public humiliation. Taken through the metal netting of the cage, photographs looked truncated, and Mubarak looked disheveled and diminished. On June 1, 2014, while facing the verdict for giving orders to shoot at demonstrators in February 2011, Mubarak wore the blue shirt of

the convicted, because a court had already found him and his sons guilty of embezzling funds for the "palaces of the Egyptian presidency."[92] Sitting in the "accusation cage" in the courtroom, Mubarak shed a tear that made the rounds of the media.[93] The dictator whose body had overshadowed the country for a lifetime was now witnessing the final stages of his undoing. That his two sons, Gamal and Alaa, were also accused, convicted, caged, and physically diminished after losing weight added to the poignancy of the death of Pharaoh, who was not only in decline himself but also unable to pass sovereign power on to his progeny. In the scales of justice, it looked as if the Egyptian body politic were being decapitated.

As I read *al-Ahram*'s coverage of what Egyptian media dubbed "the trial of the century," the magnitude of the shift in Mubarak's stature dawned on me. Once dedicated to singing the leader's glory, *al-Ahram,* that loudest of cheerleaders, which had stooped to abysmal depths to shine Mubarak's image, now described his demise with devastating detachment: "Amidst tight security measures, the accused, Mohamed Hosni Mubarak arrived on his medical wheelchair, and he was dropped off in the accusation cage, wearing the blue prison uniform, and quickly tears overcame him and on him appeared signs of crying as he was in a state of intense emotion (*ta'athur shadid*), then he gathered the fragments of himself and started waving his hands to those present in the courtroom and sending them kisses in the air."[94] The language is mortifying in its banal casting of the erstwhile sovereign as a simple outlaw. The need to spell out the autocrat's full name, the description of his pathetic entrance on a wheeled hospital bed into *a cage,* the insistent reiteration in the sentence "tears overcame him and on him appeared signs of crying," and the metaphor of the lachrymose dictator collecting "fragments of himself" declared stridently that this was a man unable to control his own body. Unable to walk, unable not to cry. Marking the momentous shift from the stolid fortitude of the Laughing Cow to the sordid decrepitude of common criminality, the scene sealed Mubarak's fate.

Attempting to salvage a modicum of dignity, the erstwhile autocrat, in a brief encounter with supporters, denied the news, saying, "Surely they photographed someone else."[95] But seeing another military officer replacing him must have felt to Mubarak like a long and heavy chapter in Egypt's history book was finally being slammed shut on him. As the Saudi, pan-Arab daily newspaper *al-Hayat* put it, "Cairo Awaits Sisi's Installation . . . and Mubarak Cries."[96] Mubarak's teardrops authenticated his demise; his body, incapable

of dissimulation, marked the autumn of the autocrat. The lack of speculation on the ex-leader's sincerity was telling. There were no suggestions that these were crocodile tears; no hints at emotional counterfeit. Whether the droplets streaking the old man's wrinkled cheeks signaled bitterness, regret, or pain was less important than the fact that the tears flagged a once classical body now supine and suppurating, boundaries broken and leaking liquids, the very definition of a grotesque body. An implacable if unspoken consensus held that the dictator's tears were simply an admission of defeat, his ultimate concession to history.

So by the time the verdict finally came down on November 29, 2014, clearing Mubarak, his minister of the interior, and six aides of all charges on a technicality, it rung Egypt's crossing of a threshold from revolution to counterrevolution.

PART IV

Puppets and Masters

Puppetry is a pungent metaphor of power. Arab leaders dependent on foreign states earned sobriquets of various types of marionette, and a time-honored Arab literary and cultural tradition features puppets that dramatize human meekness and greed. Recent examples include the Lebanese television satire *dumakratiyya* (*duma* is Arabic for puppets, *demokratiyya* is democracy), the Libyan writer Ibrahim al-Koni's 2008 novel *The Puppet,* and a 2007 music video by the Kuwaiti singer Shams, *ahlan ezzayak* (Hi, How Are You?), which ridiculed George W. Bush's Iraq war and Middle East democracy promotion and featured effigies of Arab Gulf leaders as puppets of the Bush-Cheney administration.[1]

So it is no wonder that puppets have appeared in Cairo graffiti, Syrian videos, and various television talk shows and Facebook pages during the Arab uprisings. In Egypt, Hosni Mubarak's fall and the military's rise spurred various puppetry-themed graffiti: of Mubarak as a horned, devilish puppeteer steering the Supreme Council of the Armed Forces (SCAF), of SCAF as "puppetmaster" of decapitated of men in suits, then of Mohamed Morsi and Mohamed Shafik as marionettes in SCAF's hands.[2] In a volatile environment where people believed in a "deep state," puppetry underscored

widespread convictions that the true holders of power lurk backstage and direct obedient stooges on stage. Puppetry also infused Syria's creative insurgency: from drawings and caricatures of Bashar al-Assad as a wooden mannequin executing a robotic Nazi salute, to the engrossing finger puppetry in the web series *Top Goon,* human figurines haunt the aesthetics of mastery and rebellion. In life, as in people's imaginations, there are masters and there are puppets.

But consider a situation in which puppets begin to disobey their masters and to act autonomously. Imagine further puppets turning against the puppeteer, not only refusing to move as commanded but vocally questioning their master's right to steer them and directly attacking the puppeteer's body. Puppetry turns out to be an equally apt metaphor of body politics. Once limbs rebel, the head and puppet master must double down on repression in order to stay in charge. As the people publicly turn their bodies against the power of the ruler, they enter creative insurgency. Considering puppets as erstwhile compliant extensions of the sovereign, the question arises, How do insurgents extend their bodies in the public sphere as they battle to relocate sovereignty from the despot's person to the people?

Here we see the radical and gradual modes of creative insurgency, mixing Burning Man's life-or-death struggles and Laughing Cow's cat-and-mouse skirmishes. Part IV, "Puppets and Masters," showcases how heroic human bodies extend physically, visually and orally in the public sphere to fend off the classical body of the dictator. The epic cast of combatants includes Eye Sniper and Sprayman, a rebellious pop star and the Syrian Electronic Army, and a fingerling dictator and a twice-blinded revolutionary who turns his eye patches into rallying cries. Everywhere, bodies and faces, eyes and hands, seats and thrones, health and disease, germs and detergent keep the human body at the center of the battlefield. The body haunts walls and screens, slogans and speeches, and its appearances fuse ancient symbols and contemporary images in a revolutionary iconography. From murals of Cairo's eyeless in "An Eye for an Eye?" to the digital death match revolving around the Syrian singer Assala's body in "In Sickness and in Health," these battles reflect the centrality of the body to creative insurgency.

AN EYE FOR AN EYE?

*I*n the series of iniquities punctuating the Egyptian revolution like a dour drum in a funeral march, the week of November 19 to 26, 2011, was particularly dark. Under SCAF rule, a contingent from the Central Security Forces clamped down on demonstrators on Mohamed Mahmoud Street. Ensuing clashes lasted around six days, and more than forty people died. But what added a bloodcurdling quality to the scuffles was police sniping protesters' eyes—around sixty demonstrators lost one eye—and the rise to notoriety of one sniper caught in the act. On November 20, Mahmoud el-Shennawy, a first lieutenant in the Central Security Forces, the Egyptian riot police, removed from his rifle the tear gas grenade launcher that he was supposed to use, filled his magazine with bird shot, and aimed at demonstrators.[3] To el-Shennawy's misfortune, Ahmad Sukkar was in the vicinity. Sukkar, an erstwhile applicant to the police force who was rejected for bad test results, was at work nearby. This is his description of the incident: "Around 1 p.m., I went down to the street, like other youths, to live through the events that resembled January 25, 2011, when I saw a clash between demonstrators and the police, and several youths filming the clashes with their mobile phones, so I, too, wanted to record these scenes from this second revolution, so I stood on the sidewalk by the library of the American University [in Cairo] behind the police force. . . . Suddenly an officer entered my frame, pointed his rifle at the demonstrators, and as I made a step forward he fired four shots. . . . Immediately I saw a young man standing on the other side take his hand to his eye and mumbled to myself 'he hit

him in the eye.' . . . Another policeman congratulated the sniper saying, 'You are an ace—you got him in the eye!'" That afternoon, Sukkar said, he posted the video to Facebook, and three days later he started getting calls from as far as Saudi Arabia telling him of an online campaign against him. Internet trolls accused him of acting out of revenge against the Egyptian police, who had rejected his application to join the force.[4]

By identifying the name and affiliation of the loathed *qannas al-ʿuyun* (the eye sniper) and by circulating widely, the video compelled el-Shennawy to "surrender" to his unit, as the government said in late November, denying rumors he had fled the country. Authorities incarcerated el-Shennawy, and his prosecution rested on Sukkar's video. Two photographs of the culprit circulated in Egyptian and world media: the first in uniform blue, cap backward, two stars on his shoulder; the second in white turtleneck, Ray-Ban shades, and a black baseball cap. Young and handsome, el-Shennawy was physically redolent of Khaled Said but symbolically antithetical to the memory of the revolutionary martyr. Although the incontrovertible video evidence suggested el-Shennawy would pay for his crime, activists knew that this was not a foregone conclusion. The eventual three-year sentence for attempted murder brought relief tinged with ambivalence: relief because legal sanction of police officers was exceedingly rare, ambivalence because the light sentence—bloggers had received longer jail terms on trumped-up charges—was jarring. Suspicions lingered that el-Shennawy was in fact one of several eye snipers, scapegoated because he was caught on video. In *al-Shorouk,* the veteran columnist Fahmy Howeidy enjoined Egyptians to compare the sentence to "the seventeen-year sentences that al-Azhar students got for demonstrating, and to ask yourself afterwards whether this was tyranny or justice."[5]

The incident had far-reaching symbolic repercussions. Dozens of people had lost an eye to the state's birdshot, and the media were full of pictures of faces grimacing in shock, pain, and anger, with eye patches covering blood splashes where eyes once saw. Among many poignant personal stories, the young dentist Ahmed Harara had the most moving. Having lost one eye in the first revolutionary wave on January 28, 2011, and walking around Tahrir Square wearing a white eye patch on which he had written the date he lost his first eye, Harara lost his second eye on Mohamed Mahmoud Street on November 19. A picture of him circulated with two white eye patches held with black rubber bands, a hero who gave his sight to the revolution.[6]

The activist group Mosireen Video Collective created grisly videos showing blinded eyes with microscopic details.[7] Large murals sprang up, of gray faces with white eye patches that sometimes functioned as text bubbles on which revolutionary slogans were inscribed. Some of Egypt's most famous street artists participated, and activists clamored to have the street renamed "Eyes of Freedom Street." From the murals, revolutionaries stared at the Mogamma, the mammoth government administrative building on Tahrir Square, as if daring the state to take the other eye.[8]

The Luxor artist Ammar Abo Bakr, who drew the *Aliaa vs. Samira* mural discussed in Part V, painted a disturbing portrait of Bassem Mohsen, a revolutionary who lost an eye in the Battle of Mohamed Mahmoud in November 2011, was shot again in December 2013, and died within two days (Fig. 3). The mural depicted the martyr's face with wings jutting out below the ears. The wings are those of a fly, which symbolized bravery and persistence during the era of the New Kingdom, which extended from 1550 to 1069 BC. The "Golden Fly" was then a military medal of valor.[9] The martyr's blown-up eye is framed by what looks like a green fish. By combining flies, eyes, fish, violence, and death, Abo Bakr was drawing on a heady mix of myths and symbols. In addition to the fly, the artist invoked the myth of Osiris, a histrionic family drama wrapped in a royal succession battle. As Osiris's sons Set and Horus fought to succeed their father, Set gouged Horus's eye out and dismembered his brother's body. Their sister, Isis, reconstituted all of Horus's body except his penis, which was eaten by Nile fish. Since then, the Eye of Horus has symbolized the light of the moon, which dims in times of tragedy, hence darkness.[10] Eye and fish have appeared in tandem since Paleolithic art, reflecting fertility and renewal, and in some cultures the fish was a talisman against the evil eye.[11] Abo Bakr painted the mural to wrench from the military the commemoration of martyrs it had itself killed—"committing murder, then marching in the funeral procession," as the Arab proverb goes. So he inscribed Bassem Mohsen's face on the wall "to disturb the people who murdered him."[12] According to the artist, "Bassem's portrait is painted symbolically with the eye of a fish, which remains open even after it dies, as a notice to all who cross Tahrir Square that Bassem and those killed like him are watching what's happening in the country, the eye of the revolution that never dies."[13] He also painted large portraits of eighteen one-eyed protesters. Horrific eye sniping and artful responses to it renewed the political symbolism of the human eye, which

FIG. 3. *Martyr-Fish-Fly,* mural by Ammar Abo Bakr, Luxor, 2013, photo by Abdelrhman Zin Eldin, used with permission from Ammar Abo Bakr.

engaged in a lopsided eye-for-an-eye battle that would soon expand beyond intentional blinding by police.

Murals of eyeless revolutionaries joined the wealth of graffiti sparked by the January 2011 revolution. Though insurgent art proliferated in other rebellious Arab capitals, none witnessed a graffiti explosion of the magnitude of Cairo's, signaling a popular reclamation of public space. The cacophony of voices one encountered on the walls of Cairo throughout 2011 testified to aspirations sequestered for four decades. From the very beginning, martyrs of the Egyptian revolution—and there were approximately eight hundred of them by then—had pride of place on Cairo walls.[14] At least one painting symbolically renamed the central roundabout "Martyrs' Square."[15] Every mural, to paraphrase Roland Barthes's musing on photography, signaled

"the return of the dead."[16] Eyes of the martyrs stared down at Tahrir Square, testifying to the inevitability of death during revolution, haunting the body politic. The murals created what the German art historian Hans Belting called "iconic presence," bridging dead and living, past and present, the body with art and politics.[17]

Commemorating the martyrs went hand in hand with excoriating their murderers, for the gaze of the dead shamed their murderers as the stare of the one-eyed cursed their tormentors. Graffiti fired against Mubarak's personalization of Egypt in propaganda binding his body to the pyramids of Cheops—the mother of all classical bodies—or to the Eagle of Saladin, which anchors the Egyptian flag. Consider how the artist Ganzeer decided to counter "that Mubarak was the symbol of Egypt" by designing visuals that showed the opposite: " 'Mubarak Equals Not Egypt' was just a stencil of Mubarak's face and an equal-sign crossed out and then the Egyptian eagle."[18] In other depictions Mubarak was "a grimacing King of Spades," an effigy dangling from a rope, the reviled King Farouk, a pharaoh, even Hitler.[19] These depictions were unequivocal: the dictator's body was monstrous and preposterous.

Other famous graffiti expressed desires for popular sovereignty and rejected the dictator as a usurper of the body politic. When SCAF turned out to be as repressive as Mubarak, one artist painted a large visage combining the faces of Mubarak and Tantawi, split in half. No matter the person, the graffito intimated, a leader who would not bow to popular sovereignty was illegitimate. The police whitened it, but the image was painted over again, a tenacity that underscores the importance of leaders' faces to the revolution's expressive repertoire.[20] No graffito extricated sovereignty from the dictator like the widespread stencil of a youth "with an aura around his head, along with the slogan 'I am the people.' " The aura, used in dictators' propaganda across the Middle East, signals eternity.[21] But crowning a young man with a halo and designating him a representative of the people underscored the claim that sovereignty belonged to the people, not to the dictator.

As the eye-sniping scandal unfolded, Egyptian authorities unwittingly provided revolutionary artists with a canvas and perpetuated the importance of human vision as a revolutionary battlefield when they started erecting concrete barricades blocking streets around the Ministry of the Interior in downtown Cairo. Stacked up to seventeen in length and three or four in height, the three-by-three-foot cubes constituted massive barricades

that blocked sidewalks and asphalt from building to building, cutting streets in half. The sites immediately attracted artists, whose work turned the barricades into favorite haunts for legions of graffiti hunters. This was a reminder, if any was needed, that political walls are a stubborn sight in history and that they inevitably invite multicolored subversion. What makes walls an instrument of power and symbols of resistance?

Walls are powerful tools and symbols. They block, separate, channel, and manage bodies. They demarcate spaces, fix boundaries, manage flows, and determine trajectories. Above all, they reflect symbolic, ideological demarcations. Walls have inspired creators, from the French novelist Marcel Aymé's eerie 1941 novella *Le passe-muraille,* which featured a gray Paris functionary with the gift of walking through walls who ends up trapped in one, to the British rock band Pink Floyd's 1979 album *The Wall,* which grapples with loneliness and isolation. Walls also express hardening political conflicts: recall the Berlin Wall throughout the Cold War, the makeshift street blockages that cut wartime Beirut into two halves, the eerie concrete barricades of Belfast and Derry in Northern Ireland, or the barrier that Israel calls the Separation Wall but Palestinians call the Apartheid Wall. In turn, walls spur artfulness: Belfast's, Berlin's, and later Beirut's turned into vast canvases and inspired poetry, and Palestine's attracted the global graffiti superstar Banksy and was immortalized in movies like *Omar.* One of the graffiti in 2011 Beirut featured Mubarak's face with the motto "My Wall Kills Palestinians," excoriating the Camp David regime for its role in sequestering Gaza.

The Egyptian government started erecting the massive concrete walls in November 2011 to block key arteries around the Ministry of the Interior, each episode of protest and violent crackdown followed by a new barrier, and by February 2012 there were seven barricades in the area. The effect was nothing short of a rezoning of the downtown area.[22] The walls triggered an episode of creative insurgency. On March 9, 2012, artists and activists initiated "No Walls," a campaign of defiance against the walls erected by the military.[23] Sheikh Rihan Street, where the state built one of seven barriers around the Ministry of the Interior, featured a gorgeous trompe l'oeil that transmuted concrete cubes into an embellished street where a revolutionary scene unfolded. This was an act of symbolic one-upmanship. One of the artists involved, Mohamed El-Moshir, said, "We can't pull the walls down" but "we can deliver a message that there are no walls, that the streets are

open."[24] Ammar Abo Bakr and Layla Maged, along with El-Moshir, led the Sheikh Rihan Street mural, but several other artists contributed to an artwork more complicated than an ordinary mural by several orders of magnitude. For a trompe l'oeil to have the intended effect, many details had to be spot-on. "This is the first time many of us done something this size, freehand and with perspective," said artist Hossam Shukrallah.[25] Yet the result was breathtaking, mixing the harshness of riot police molesting protesters with glimmering water puddles whose shards shimmer like shabby shades of Dutch light.

Concrete may be harder than human bodies, but against the human imagination emboldened by the promise of emancipation, concrete had no chance. In an epic game of rock-paper-scissors, human creative chutzpah fended off the state's compulsion to control. Unable to overcome the material obstacle, creative insurgency trumped its sensorial effects. After all, trompe l'oeil is French for "deceive the eye." The ability to manipulate the human sensorium with paint matters because it affects people's lived experience of the city. The French philosophers Gilles Deleuze and Félix Guattari distinguished between *espace lisse* and *espace strié*—smooth and striated space. The former is the space of subjective experience and intensity, the latter the space of straight lines and dimensions. The state, according to Deleuze and Guattari always strives to striate smooth spaces because striation enables control, and cities are exemplary striated spaces.[26] By drenching hard concrete blocks with colors that compelled the human eye to transcend the physical barrier and experience beauty where the military had intended stoppage of vision and movement, Cairo's revolutionaries smoothed spaces that the state had striated.[27] Insurgent bodies thus trumped the system.

To understand the distinction between smooth and striated space fully, consider the contrast between two other murals painted on concrete barricades surrounding the Ministry of the Interior. On Mansour Street, El-Zeft and collaborators daubed concrete blocks with a bucolic public park scene: antique street light, a woman with purse and with a baby in a vintage stroller, a person sitting on a park bench with a dog, a balloon seller handing a globe to a little girl, and two children playing on a seesaw, as a rainbow crowns the middle of the scene and birds flutter above it. The title of the mural, "Tomorrow," was its most poignant element, for it expressed a dream that chafed against the present.[28] The balloon seller was inspired by Banksy's "Balloon Girl," which the famous British graffitist painted on Israel's wall

in the Palestinian West Bank. This was clearly a smooth space, and the characters reminded me of the whimsical stencils of free, playful, happy human stick figures in Beirut.[29]

Another mural offered the sharpest of contrasts with "Tomorrow." On a barricade on Farid Street, facing the Ministry of the Interior, another trompe l'oeil depicted a deeply striated space—in high contrast and heavily geometrical, with black-and-white sidewalk borders, advancing in straight lines before making sharp angles rightward and leftward in front of a re-created entrance to the Ministry of the Interior. There stood a child character widely recognizable by many Arabs—Hanzala, barefoot and humbly dressed, brandishing a vertical sword as if to confront the Ministry of the Interior.[30] The presence of Hanzala on a Cairo wall is significant. Hanzala is the signature character of Naji al-Ali, a Palestinian artist and the Arab world's most famous cartoonist, who was assassinated by gunshot in London in 1987. In more than forty thousand cartoons he had skewered Palestinian, Israeli, and Arab leaders.[31] A hirsute boy always seen from behind, his hands clasped behind his back, Hanzala is a symbol of Palestinian fortitude, and stencils of him, from Beirut to Cairo, testify to the ongoing salience of the Palestinian cause among Arabs. In *A Child in Palestine,* al-Ali explained that Hanzala represented him when he had to leave Palestine at the age of ten, never to grow up until he returned to his homeland.[32] This is a metaphor of stunted growth, whence a member severed from the body politic ceases to develop until reunited with his natural corpus. Plugging a symbol of Palestine on a Cairo wall expressed transnational Arab solidarity and suggested collusion between Egyptian and Israeli authorities. By prodding Egyptians to realize that they shared the experience of political injustice with Palestinians and others, they underscored that the slogan "The people want to topple the system" imputed a system of power that went beyond the Mubarak regime per se.

But how do walls relate to seeing? Urban ramparts create physical and sensory obstacles that prevent movement and block sight. Both moving and seeing are embodied faculties, determined by the context of the body. Scholars tend to consider ocular centrism a Western construction that grounds visual knowledge in analytical distance, often opposed to the supposedly oral culture of the Arabs. Nonetheless, an approach that considers vision as an embodied faculty helps us understand relations between bodies, graffiti, and the cities in which they unfold. Rather than considering the visual to

PUPPETS AND MASTERS

be a tool of rationalistic knowledge, I approach it as an embodied and therefore subjective practice. Vision, then, is one way in which the body comprehends the world, moves in it, and extends itself through it.

Vision and movement are intricately connected. In his famous essay *L'Œil et l'Esprit* ("Eye and Mind"), Merleau-Ponty argues that the body intertwines seeing and moving because eye movement determines what we see.[33] This claim that we see through our body applies to our fleshly corporeality but also to the way we see and define ourselves within the social body. Not only is the body the medium through which we see, but seeing itself is an "act of embodiment, taking position in a body."[34] By painting murals of the martyrs, the eyeless, and the single-eyed and by transforming ugly concrete barriers into gorgeous tableaux of a desired life, revolutionaries took position in the body politic and sought to alter it. Here we can extend the idea that "images are about the bodies that are lost and the bodies that seek reconstitution" to the body politic that the revolutionaries aspired to build and have.[35] A healthy body has functioning eyes and unimpeded connections between its members. These images do not only connect past and present; they also conjure up the future. If anti-ocularists fear vision because the desire it awakens turns humans into restive malcontents, then by arousing and focusing dissatisfaction with the status quo, murals contribute to revolutionary fervor.[36]

We should not forget that walls anchored a central metaphor in the Arab uprisings: "breaking the wall of fear." Under murderous dictators who personalized power and controlled their people's bodies, fear bound the body politic. Fear regimented bodies to move, see themselves, and see each other in certain ways. Fear was palpable, it was thick, like a concrete wall, the demarcation of permissible and forbidden. The same wall elevated the leader's classical body above the populace beneath. The "breaking the wall of fear" metaphor represents the mother of all movements: the kinetic energy from fearful to fearless, from acquiescence punctuated by occasional bouts of dissent, to all-out insurgency. Without breaking the wall of fear, creative insurgency would not occur. By breaking it, it unleashes a refashioning of the body politic.

If vision and movement are related, then vision and touch are also connected, for touch is movement that culminates with contact with another body.[37] The Lebanese actor, director, and visual artist Rabih Mroué's video *Shooting Images,* which I saw at the SALT Galata art space in Istanbul in

May 2014, captured the deadly dance between eye and bullet, seeing and touching, vision and death through a video of a Syrian sniper shot by his victim on the victim's mobile phone, which falls to the ground as the marksman's bullet penetrated the body of his target. Here we begin to see that the Arab uprisings entrenched sniping in Arab cultural lore. Long before Egypt's eye sniper and the sharpshooters of the Syrian civil war, this frightening phenomenon was a widespread social fact during the Lebanese Civil War. As a teenager, I remember sniping incidents opening radio and television news bulletins and haunting daily conversations, fueled by invisible precision killers mowing down civilians crossing the no-man's-land between Beirut's eastern and western halves on a daily basis. One of the funniest and most humane depictions of sniping in wartime Beirut can be found in Maroun Baghdadi's 1988 film *Liban: Pays du Miel et de l'Encens,* which features a gruffly hilarious taxi driver, Abu Ali al-Benzin, who specializes in shuttling passengers through the danger zone, zigzagging through snipers' killing fields in adrenaline-soaked scenes that underscore the deadly connection between vision, movement, life, and death.

The relation of seeing to touching is an important consideration in understanding the trompe l'oeil mural of Sheikh Rihan Street. Just as seeing sometimes "dissolves a body into a pattern of information, and then reassembles . . . in the form of an image," so do trompe l'oeil murals accomplish a task vital for creative insurgency: they represent a particularly creative extension of the human body into public space, a foray that is as aesthetically pleasing as it is politically punchy.[38] Transforming gray concrete into colorful landscapes demonstrates that creative insurgency turns what the dictator unleashes on the people against the autocrat. If seeing, as the scholar of religion David Morgan has argued, "is an interface of the body and the world . . . a form of touching or tracing, a beholding, and a collaboration of the entire body with its environment,"[39] then the murals of downtown Cairo constitute, however metaphorically, an eye-for-an-eye battle with the authorities. Touching, which can mean a warm connection with another body or a heinous gouging of eyes with birdshot, is most closely associated with the hand, which would soon become another important political symbol in the Egyptian revolution.

THE UPPER HAND

*O*n August 14, 2013, thousands of supporters of the Muslim Brother-hood were gathered for a sit-in on Rabea al-Adaweya Square in Cairo, protesting the June 2013 military coup that unseated the elected president Mohamed Morsi. Although details of what happened next are unclear, there is no doubt that it was a pivotal moment of the Egyptian revolution, hardening a division between two Egyptian publics associated with two city squares, Tahrir and Rabea al-Adaweya. What is beyond dispute is that hundreds died and thousands suffered wounds among the twenty thousand demonstrators, in addition to a few dead policemen. It also appears that security forces stormed the demonstration in armored vehicles, shot with live ammunition, and flooded the area with tear gas, while rooftop snipers mowed down fleeing protesters. Whether the police ambushed the demon-strators or simply reacted to being shot at by them is disputed. Human Rights Watch reported that a dozen protesters indeed had guns, but that the state's response was premeditated and went "all according to plan."[40]

Out of the massacre a new symbol entered revolutionary prime time: an open-palmed hand with the thumb folded in and the other four fingers spread out. The symbol originated with Cairene minibus drivers who made the hand gesture to announce the square as their destination.[41] The symbol spread very quickly as a hand gesture performed in public and a visual meme circulating on social media. Turkish prime minister Recep Tayyep Erdogan, whose Justice and Development Party is a kindred spirit of the Muslim Brotherhood, made the hand sign during a speech after the bloody

Rabea clampdown.[42] Athletes from Egypt, Mali, and Turkey made the gesture during international sporting events, and Egyptian activists used the black-and-yellow visual rendition as their profile photograph on Facebook and Twitter.[43] As the symbol became a lightning rod, splitting Egypt into supporters and opponents, people began seeing it everywhere. When Elissa, a Lebanese pop star, greeted fans at an event with an open palm, social media activists buzzed with rumors and attacks that she supported the Muslim Brotherhood, even though the Christian singer had made several statements critical of political Islam.[44] Opinions were inflamed further when authorities declared the Muslim Brotherhood a terrorist organization on December 25, 2013, criminalizing "anyone who carries the Rabea sign, prints it or uses it on their social media accounts."[45] A few days later, things got downright surreal toward the end of a football (soccer) match in the Egyptian League, when the referee, wanting to signal there were four minutes of extra time left but wanting to avoid making a hand gesture that could be perceived to be the Rabea motto, lifted both hands with two upward fingers each, leading one team to understand him and the other team wrongly to believe that only two minutes remained.[46] A wave of humor ensued with jokers competing in ways to say "four" without actually uttering it, which included "the number before five," a square root of sixteen, or even winks like "you know what sign."[47] Within a few months, the Rabea open palm had become another iconic image of Egypt's revolution.

What does the symbol mean, and how did it take hold and spread so quickly? "Rabea" means "fourth," for a female, in Arabic, and Rabea al-Adaweya was an eighth-century Sufi saint and the fourth child in her family. In addition, according to some people, the sign emphasized that Morsi, the *fourth* president in Egyptian contemporary history (after Nasser, Sadat, and Mubarak), was the country's legitimate leader. But the motto also grew in an environment where hand signals emerged as a popular and effective way for people to express their political affiliation: The four-fingered, open palm thus stood in contrast to the victory sign, which supporters of the military used, and then later of the "C" made by curving the thumb and index fingers, which indicated support for Sisi ("CC"). Revolutionaries rejecting rule by the Muslim Brothers, the military, and the *fulul* (remnants from Mubarak's regime) raised their hand with three fingers up (by some account it signifies 'third way,' not the Islamists and not the military), and of course, Egypt's April 6 Youth Movement, like the Serbian group Otpor and

other activist formations worldwide, used the clenched fist as its logo to symbolize strength and unity.[48]

Why the hand? The hand is one of the most useful and most visible body parts, but there are sociocultural and political reasons for the rise of the hand in political iconography. In Egypt and elsewhere, the hand is a fertile symbol that permeates daily conversation and enables several expressive gestures. In Arabic, English, and other languages the hand symbolizes an astonishingly rich array of human actions. It is an idiom of power and control: "It is in my hand" means I decide or I control, having "the upper hand" means winning. Someone's "right hand" is their principal subordinate. "It is out of my hands" and "my hands are tied" connote impotence and constraint. "At the hands of" imputes agency and often culpability, and "in the wrong hands" conveys worries about malfeasance. "Get your hands off" of something means leave it alone, and "clean hands" connotes probity. Fists in shackles or tugging at metallic bars are time-honored images of oppression. But the hand can also bespeak unity, usefulness, and cooperation: "hand in hand" means together, "at hand" means available ("between the hands" is the Arabic version), "one hand alone cannot clap" underlines the necessity of cooperation, and "handy" means suitable or practical. "Giving someone the finger" is a well-worn gesture in the arsenal of zany teenagers and enraged drivers everywhere. Ethnologists have parsed specific symbolic correspondences between (on the one hand) the left and right hands and (on the other hand) cultural beliefs and ritual practices.[49]

The hand has symbolized human battles with powerful forces: from Italian Renaissance art like Michelangelo's *The Creation,* in which God's hands barely touch Adam's; to the Mexican muralists, such as Diego Rivera, whose Detroit industry frescoes use gigantic hands; to the Arab uprisings' graffiti with clenched fists, erect fists, and open palms.[50] Consider the evolution of the clenched fist. As a gesture of protest, the clasped fist debuted in the 1880s, disseminated through paintings with Socialist themes by the German-American painter Robert Kohler. Then, in 1917, in the wake of the Bolshevik Revolution, the Industrial Workers of the World took it up, and in 1924 the Roten Frontkampferbund (RFB), a paramilitary group affiliated with the German Communist Party, adopted it as its emblem, before it appeared in 1934 as a photo-montage by John Heartfield on the cover of the labor publication *Arbeiter-Illustrierte Zeitung.* The gesture gained visibility in the "new, aggressive, mass paramilitary style of Weimar

political symbolism and ritual."[51] But it is the time frame spanning the Spanish Civil War and the 1960s youth protest movements that consecrated the clenched fist as a global symbol of the left—from the Atelier Populaire Paris poster collective in France to the Black Panthers and the Students for a Democratic Society in the United States. From there, the emblem was used by the Socialist Party of Malaysia and the Organization in Solidarity with the Peoples of Asia, Africa and Latin America (OSPAAAL) in Cuba, before making its way, through the anti-Milosevic Serbian organization Otpor, to the April 6 Youth Movement in revolutionary Egypt and other battlegrounds.

In addition to spurring visual gestures, the hand inspired verbal metaphors in the Arab uprisings. Revolutionary slogans invoked it: "The people and the army are one hand" in the early effort to oust Mubarak became "the people and the people are one hand" after Supreme Council of the Armed Forces abuses. Political leaders doubled down on manual symbolism. A few days before he was dislodged in February 2011, Mubarak said in a televised speech that "foreign fingers are trying to shake the country's stability," referring to an external conspiracy, and a couple of years later his successor, Morsi, justifying the many crises that Egypt experienced during his reign, said "two or three fingers play inside Egypt," to describe sinister forces sabotaging the work of the government and dividing the country.[52] There were also abusive fingers of virginity tests, ink-stained fingers as voting certificate, and the sinister *al-aydy al-khafiyya*, the invisible hands, those unidentified goons who killed protesters in Tahrir Square.[53] Hand symbolism was widespread in Egypt, but not exclusive to it.

Consider its use in Syria, where for more than forty years the Assad regime, *père et fils*, developed a horrific tradition of destroying the hands of its opponents. In 1980, the Beirut publisher and journalist Salim al-Lawzi's right arm was dislocated and broken, his fingers were dissolved in acid, and his abdomen was perforated by pens while he was being tortured to death (he was kidnapped February 25 and his body was found on March 4) for criticizing the ruler of Damascus. On August 25, 2011, thugs crushed the hands of the Syrian cartoonist Ali Ferzat in Damascus after he published cartoons mocking Assad (one featured the leader giving a speech with soap bubbles coming out of his mouth to connote emptiness, another showed Bashar hitchhiking his way out of the country, flagging a car ridden by other toppled autocrats). As Ferzat himself told the story, two goons kid-

napped him and sat around him in the back seat of a car, broke his hands so that, as one said to the other, "he dares not draw Bashar, draw leaders, draw his masters," Ferzat said, leaving no doubt about body politic symbolism and about his desire to subvert it: "In my satire I aim to reduce the importance of the dictator to give hope to the people." Ferzat recurrently draws the "chair," the seat of illegitimate and hereditary power.[54] After the abuse, the cartoonist left for Kuwait.

It is no wonder that hand symbolism suffuses the Syrian uprising and Syrian art in its wake. Hands and fists, long deployed in political struggle, infused Arab revolutionary imagery. As we will see in "Stencil Standstill," hand imagery appeared frequently in Syrian revolutionary graffiti in the Lebanese capital. There were stencils of open palms and clenched fists all over the place, all supporting the Syrian revolution. Another stencil included a fist clenching a writing feather, and yet another featured two interlaced hands emphasizing Lebanese-Syrian solidarity, "Freedom We Make Together #Syria #Lebanon." A memorable stencil appeared when Assad's troops surrounded the city of Homs, with a clenched fist and the caption "Homs, Mother of Heroes."[55] A drawing by Nidal al-Khairy featured a large, stylized hand full of human faces, with two men hanging over the top of the palm and thumb, while a third man hanging from the monumental hand's ring finger is stabbing it with a knife, bloodying it, with the politically pregnant caption "The People's Hand over Their Hands."[56] The art of Sulafa Hijazi, the stencils of The Syrian People Knows Its Way, and others feature the human body and specifically the hand as a symbol of will, defiance, and resilience.

Whether considered in world politics or in the Arab uprisings, the open hand is not as widespread as the clenched fist. It entered Indian politics in 1951, when the All India Forward Bloc (Ruikar Group) used an open palm with parted fingers as an election symbol, reprised by the Akali Dal in 1962.[57] In 1978, Indira Gandhi chose an open hand but with the fingers together as the symbol of the newly formed Congress Party for the 1980 election in India because of its simplicity, which was believed to resonate with the common people.[58] "It turned out to be a real boon," said an Indian journalist in 2012. "If you look at the human body, there are very few organs that match the utility aspect of the hand. . . . A life without a hand is something which is very dreadful."[59] The open hand is also the emblem of the Movement for Democratic Change (MDC) in Zimbabwe, connoting

transparency: "We have nothing to hide, we carry no weapons and we promote the ideas of a peaceful democracy."[60] It has also been used by the French racism watchdog Mouvement Contre le Racisme et Pour l'Amitié Entre Les Peuples (MRAP), notably in a 1997 poster later reproduced on postcards. But nowhere did it grow with the same speed and level of controversy as it did in Egypt in the span of weeks in the summer of 2014. The sign clearly arose from a bloody episode against a group that a few months earlier occupied the Egyptian presidency and benefited from sympathy outside the country. But is there a deeper symbolism that explains the rapid rise of the Rabea sign and the controversy it triggered?[61]

One explanation of the open palm's political resonance resides in the hand's historical connection to the eye. Pharaonic mythology (the Eye of Horus), Roman philosophy (Virgil), and Romantic poetry (Goethe) saw connections between eye and hand.[62] In different parts of the world, but especially around the southern and eastern Mediterranean, the open palm signifies the Hand of Fatima (or the Hand of Miriam in Jewish culture), raised to fend off the evil eye. The hand is an *apotropaic,* Greek for prophylactic, meaning it prevents disease. Many North Africans, for example, believe that the hand is the only effective defense against the evil eye and express it in proverbs like "The eye is charged with desire, the hand cannot service it" and *khamsa be'aynik, al-rabb ya'mik* (Five in your eyes, may the Lord blind you).[63] In parts of the Middle East and especially in North Africa, for Muslims and Christians alike, the gesture and its representations are simply known as *khamsa* or *khomsa,* Arabic for "five." The open hand, typically in blue, sometimes with an eye in the middle of it, is a symbol of protection from evil: a poster by artist El Zeft features that hand with the caption "God Maintain the Revolution and Protect It from Demise."[64] Some hardline Sunni readings scorn the gesture as a symbol of polytheism and instead favor a single lifted index finger, connoting monotheism, the unity of God, which Daesh militants perform on social media.

The Rabea hand, then, can be interpreted as a symbolic defense mechanism against the all-seeing and tyrannical eye of the Egyptian military state (and the numeral 4 it calls up stands in stark contrast to the way Ben Ali used the numeral 7 in Tunisia). This understanding resonates with the oral and anti-ocular epistemology of the kind of religiosity that has arisen in Egypt since the 1970s, pushing the pious to immerse themselves in what the anthropologist Charles Hirschkind has called an "ethical soundscape,"

through disciplined, attentive, and self-reflexive practices of listening.[65] In line with both Jewish and Christian anti-ocularism, this community privileges hearing as a medium of communion with God, and much like the First Epistle of John, it castigates the "lust of the eyes."[66] The open palm, then, jibes with the anti-ocularism that has since the 1970s characterized some of Egypt's pious publics who fear that by objectifying the world, the visual fragments authority and distances believers from God.[67] Aniconic signs—ones that ask you to avert your gaze—can be seen everywhere in the region, where paper, plastic, and glass reproductions of the Hand of Fatima enjoin you to avert your eyes.[68]

Tahrir and Rabea, two city squares; eye and hand, two body organs. Pitted against each other, members of a body politic torn by revolution. Through the imagery of the eye—instrument of sight and symbol of vision, mirror to the soul and window to the world—creative insurgents overcame the state's efforts to contain, maim, and blind them. They cheated the all-seeing gaze of the state, which by building concrete walls forced them into small and separate enclaves, by executing trompe l'oeil murals and the many haunting images of killed, maimed, and blinded revolutionaries. Once these body organs become part of the expressive repertoire of the revolution, they demonstrate that art is in fact a war zone in which the body itself is at stake—its ability to see the world, hold objects, and counter threats. They underscore that revolution entails a difficult but necessary collaboration between what Belting called "representing bodies" and "represented bodies," the former, living, performing; the latter, departed, as images.[69]

The Rabea motto suggests the rise of a counterpublic within the Egyptian revolution, one less enamored with the visual profligacy of revolutionary graffiti and more interested in expressive forms that fall in line with a certain idea of politics guided by piety—it is noteworthy that no major Egyptian graffiti artist claims an explicit Islamist identity, and that the counterrevolutionary media apparatus tried to slander artists like Ganzeer precisely by claiming they belonged to the Brotherhood.[70] In this context, and keeping in mind the concrete barricades of downtown Cairo and the murals that subverted them, the rise of the hand of the protester to counter the eye of the state suggests that, as the anthropologist Walter Armbrust has argued, we should be attuned "to the emerging authority of vision, but also to its limits."[71]

The Egyptian state attacked people's eyes, sniped them, tear-gassed them, and enjoined them to avert their gaze from its abuses. Revolutionaries used their hands to paint those eyes on walls, to subvert barriers that blocked their vision, and to stare back at the state and shame it for its actions. Recall that the revolution broke the bounds of the dictator's own eyes, extracting tears from Mubarak during his trial, even though he eventually walked away in the wake of the killing of the poet and activist Shaimaa al-Sabbagh in January 2015. A tool and symbol of action and creation, of engagement with the world, the hand can also be a substitute to the eye. Blind people and artists "see" with their hands. Goethe famously said, "I see with an eye that touches, I touch with a hand that sees."[72] In *Lettres sur les aveugles,* Oeuvres, II, 183, Diderot stages a dialogue in which someone asks a blind man, "What are, in your opinion, eyes?" to which the blind man answers, "an organ on which air has the effect of a stick in my hand."[73] But the hand, in addition to countering the evil eye, is also the primary tool of *homo faber,* and it conjures up the labor of creative insurgency, not the least the movements of eye, hand, and body of graffiti painters who represent their departed comrades. Because the elaboration of revolutionary selves is a primary facet of creative insurgency, the hand is a vital revolutionary asset that connects action and artfulness. Touching and seeing are antagonistic but complementary ways in which people perceive, define, and express themselves and others. They are at the heart of creative insurgency.

SPRAYMAN

Stepping outside the entrance to the decrepit building where he lived, a young Syrian man discovered a pile of garbage flung there from the posh building next door. Resolving to identify the culprit, he walked up the marble stairwell dotted with dark and glossy wood doors, and rang a bell. A middle-aged woman opened the door and quickly got agitated and scolded the man for intimating she were the offender. When a gigantic, mustached man opened the second door, our hirsute and goateed protagonist was petrified. Not daring to bring up the detritus, he offered instead to pick up the giant's trash and meekly trotted down the stairs with two black plastic bags. But bristling with frustration by the pile of detritus that welcomed him every morning, he purchased a spray can for 100 liras, painted the wall above the pile of garbage white, and scribbled a black-ink injunction against littering. To his satisfaction, the rubbish disappeared. Applying his new-found tool of persuasion elsewhere, he began spraying civic and political messages throughout the city. Running out of ink, he returned to the shopkeeper, who charged him 250 liras for a second spray can. Angered by the extortion, our man furtively sprayed the shop's wall with the warning "this shopkeeper is a crook."

Thus began "*al-Rajul al-Bakhaakh*" ("Sprayman"), an episode of *Boq'at Daw'* (*Spotlight*), a satirical Syrian television drama first directed by al-Laith Hajju in 2001, a year after Bashar al-Assad ascended to power and initiated the short-lived political opening known as the "Damascus Spring." Surya al-Duwaliyya, a privately owned and politically connected media production

company, commissioned the series.[74] First aired during the high-ratings Holy Month of Ramadan in 2001, *Boq'at Daw'* gained a wide audience.[75] Edgier than other Syrian television comedies, it combined a burlesque sensibility with gritty realism and broached topics hitherto untouched. It was critical of the Syrian television drama industry itself, skewering its haughty stars and despotic directors.[76] Taking heed of Bashar al-Assad's censure of corruption in his inaugural speech, *Boq'at Daw'* grappled with government graft and incompetence, sectarianism, and other social foibles, even the secret police. The series' director told the anthropologist Christa Salamandra that "the producer didn't really know what we were up to. We kept telling the censors that, look, the president said X, so we're following that policy." At the same time, the director of state television lost his job for allowing some sketches on the air.[77] The series survived, changing directors and casts over the years. Lampooning social pathologies, state corruption, and the feared secret police but avoiding direct attacks on the regime, *Boq'at Daw'* expanded, by increments, Syrian satirists' range of touchable targets.[78]

Sprayman appeared in 2008, during the sixth installment of the eighth season.[79] In the episode, Sprayman quickly rose to notoriety, attracting public enthusiasm and the unwanted attention of the secret police. His graffiti were everywhere: low by sidewalks or high on buildings, on bridges and thoroughfares, wide avenues and narrow alleyways. They encroached upon prohibited places, from district-level administrative offices to the Ministry of the Interior itself. Moving stealthily, Sprayman wrapped a *kuffiyah,* the Arab checkered scarf, around his face. Through this elusive and anonymous protagonist, Hajju ridiculed Syrian authorities in an escalating series of sketches. When two policeman reported to their chief that Sprayman spattered their car while they were trying to stake him out and complained that he was too nimble—"he ran too fast"—to be caught, the security boss ordered the arrest of all runners in the city. When that did not work, the police chief himself led an elaborate stakeout, video camera in hand, to capture the offending scribbler. But Sprayman outsmarted his stalkers, taunting them by sprinkling "I saw you" on a wall, before vanishing into the night. After the police watched a slow-motion video of the action, they arrested a group of men donning similar head coverings. Every sketch exposed another layer of police incompetence and stupidity, as Sprayman became a folk hero, with newspapers propagating his exploits and television featuring ordinary people fawning over the mysterious graffiti artist.

But the police chief had one last trick up his sleeve. He commandeered a television crew and recorded a plea to Sprayman to identify himself to the police, because, the chief said, both Sprayman and the police wanted "what was best for the country." The officer promised a "civilized conversation" and dangled the opportunity to spray in the open with state support. As Sprayman returned home tired and hungry after an evening of daubing city walls, he switched on his television and watched the security officer's entreaty. Next, we see him showing up at the police station, where the chief again asks him if he would enjoy the freedom to spray as much as he wanted, with paint provided by the state, and two security officers dedicated to helping him spray.

With a twinkle of naiveté in his eyes, Sprayman acquiesces.

In the next scene, the police chief looks through a screen at Sprayman slouching on the floor at the center of a white cell, many spray cans scattered around, and the two thugs standing guard. Taunting Sprayman through a microphone, he tells him that he is free to spatter the white walls of his cell with paint, forever and ever, and that every time the walls are smudged, his two "assistants" will daub them in white again.

Sprayman in his cell: a Syrian Sisyphus.

Fast-forward a few years. A persistent story has it that on the night Hosni Mubarak fell in Egypt, someone sprayed *ejak al-dor, ya doctor* (Your turn is next, Doctor [it rhymes in Arabic]), under a bridge in Damascus.[80] If this story is true, that act was an early direct symbolic confrontation with Syria's ophthalmologist-dictator, prefiguring the youngsters of the southern city of Der'a whose antiregime doodles spurred a cycle of defiance and repression that escalated into a nationwide insurrection. As the uprising broke out, political graffiti started appearing in neighborhoods in and around Damascus.

People thought that the scribbles were the work of one man, and remembering the episode of *Boq'at Daw'* that aired three years earlier, they called him Sprayman. As graffiti appeared in Bab Touma and Ma'damiya, a website celebrating Sprayman and a Facebook page, "We are all the Sprayman," appeared. Then, a Syrian journalist identified Sprayman in a post to Facebook in which he told of meeting the man in custody of security officers. "His name is Ahmad Khanji. He is a thirty-year-old architect."[81] But he is not the only Sprayman. Nour Hatem Zahra, a twenty-three-year-old activist shot dead in April 2012, also earned the sobriquet. Pictures and videos of the young man's funeral in Kfarsoussah circulated in the Syrian social

media sphere, and his death inspired more graffiti, including a stencil of Zahra's bust.[82] Rumors that activists were able to spray-bomb government buildings and that authorities demolished a paint-defiled transportation office completed the life-imitating-art cycle and indicated that government action was more absurd than parodies of it like *Boq'at Daw*.[83]

In both incarnations, first as fictional television character and second as furtive street activist, Sprayman resonated with the Syrian revolution. He hinted at the potential of the human body to roam freely and express itself in public space, and he came to represent the heroic revolutionary body willing to risk limb and life for political emancipation. The *Boq'at Daw* sketch's dénouement condemned Sprayman to paint, repaint, and paint anew, to repeat the journey of Sisyphus pushing his rock uphill and seeing it roll down, over and again. Facing the daunting prospect of an ever whitening canvas that was at the same time his prison cell—his entire physical world—Sprayman was unable, presumably, to stop painting. But he was also unable to leave, for in spite of the legendary skills of evasion that made him famous, he was now incarcerated, and seemingly for a long time. In this way he was the ordinary Syrian, unable to flee, condemned to keep trying to find breathing space in a suffocating system.

Sprayman struck a chord because he evoked familiar imagery of darkness and light that has come to define Syrian cultural production. Consider how Sprayman and *Boq'at Daw* (recall that the title means "spotlight") resonate with "A Spot of Light," by the Raqqa writer Abdelsalam al-Ujayli, who describes imprisonment and torture in terms of self-discipline. In a solitary, dark cell, a prisoner is ordered to keep his hands up above his head. In the literary scholar miriam cooke's description, "All he has to do is keep an eye on the tiny spot of light that comes through the door when the guard is not blocking it; only then must he raise his arms. With time, however, staring at the spot becomes so intolerable that he prefers 'to bear whatever befalls me so long as I am free of this torture.' "[84]

The spot of light is as much a space of hope as it is a field of nightmares. It is at once where dreams alight and hopes die. It presents both the opportunity to resist and the temptation to surrender. It encapsulates the enigma of rebellion.

But it also signaled that a pillar of regime power—the ability to control public space—was crumbling. Public space is vital for revolutionary communication because it is at once a canvas for political expression and a field

where bodies infected by revolutionary fervor commune and rebel. Public space is a meta-medium of creative insurgency, and it is also central to images of the body politic. Public space, after all, is what constitutes a country's territory, the fount of national sovereignty, the sand, stone, and sky extensions of the dictator's body. In Syria, revolutionary graffiti appeared on walls as anti-Assad armed battalions took over swathes of Syria.[85] Public space carries creative insurgency as much it is shaped by it.

The Sprayman episode showed that dissenting artistry was alive and well years before the onset of the Syrian uprising in March 2011, giving lie to the argument that the uprisings were somehow an Arab awakening from slumber, while highlighting fundamental differences between mere artful dissent and all-out creative insurgency. In *Dissident Syria,* published four years before the uprising, miriam cooke coined the notion of "commissioned criticism." In contrast to what Lisa Wedeen called "permitted or licensed" criticism that aims at the system but not the leader, commissioned criticism is "the regime's Machiavellian manipulation of dissidence," encouraging it only to placate it, subvert it, let it fester in the maze of bureaucracy, or snuff it out.[86] Commissioned criticism, cooke concluded, keeps all stages of cultural expression, process, and outcome dependent on state support and therefore unpredictable. The practice makes possible "a policy of coercions that act upon the body," producing "subjected and practiced bodies, docile bodies" that internalize and satisfy the demands of power.[87]

Syria's revolutionaries broke with this kind of critique. Whereas Sprayman as the fictional character imprisoned by a fantasy henchman represented the trap of commissioned criticism, Sprayman as the real activist murdered by the actual regime embodied the ability of breaking free from the shackles and the menace of death therein. If commissioned criticism rests on a presumption of docility, and if docility is less about obedience and more about the malleability of bodies and their ability to be trained into acquiescence, then Sprayman is a reminder that this pliability goes both ways: people can be disciplined to obey, but they can also be schooled to rebel. Sprayman the television character performed the many rehearsals required to reverse the effects of the regime's disciplining of Syrian bodies. This set up the ground for Sprayman the real-life activist to militate against Assad.[88]

Sprayman did something more important than showing life imitating art. His story, of a citizen who could not take it anymore and picked up spray cans to let the world know how he felt, made visible the threshold,

always razor thin in revolutionary situations, between a life that is no longer sufferable and another that is not yet attainable. It is in this revolutionary situation that requires a mobilization of the human body's every resource that Sprayman lives and dreams. Sprayman is an accidental, downplayed, superhero. He is every Syrian graffiti artist dodging death, since in Syria "every city and village had their spray can man."[89] By illustrating how what the sociologist Hans Joas called a "situation" unfolds in revolutionary times, harnessing the body for routine-breaking creative action, Sprayman is a quintessential case of creative insurgency.

In the theater of the Syrian revolution, Sprayman showed up the first time as farce and the second time as tragedy. One "real" Sprayman's death—for there were several—was a somber reminder of the fate awaiting revolutionary street artists in Syria. Salim al-Lawzi's ritualistic 1980 assassination in Beirut was a reminder that members of the body politic that diverged from the body of the dictator would be not merely severed but annihilated (the Assad regime has always considered Lebanon to be part of Syria). Lest you think the son more squeamish than the father, Bashar's goons destroyed the cartoonist's Ali Ferzat's hands, pulled Der'a's teenage wall scribblers' fingernails, and cut the insurgent singer Ibrahim al-Qashoush's throat and tore out his vocal chords before murdering him. Such is the ferocity meted out against rebellious members of the autocratic body politic.

And so it was ironic that the Syrian revolution, and its street art skirmishes, would move west, to the city where al-Lawzi lived, wrote, and died at the hand of Assad's assassins. The sheer danger of the Syrian situation, the open border between Lebanon and Syria, and Beirut's always-already willingness to take on every possible cause and countercause in the Arab world, conspired to turn the Lebanese capital into a proxy space for the Syrian revolution, inaugurating an urban stampede of graffiti activists who would fill Beirut's walls with anti-Assad stencils, in turn fended off by pro-Assad activists scribbling slogans in favor of the Syrian leader.

STENCIL STANDSTILL

*B*eirut, in the novelist Rabih Alameddine's splendid quip, is "the Eliza-
beth Taylor of cities: Insane, beautiful, falling apart, ageing, and for-
ever drama laden. . . . She'll also marry any infatuated suitor who promises
to make her life more comfortable, no matter how inappropriate he is."[90]
For the three decades beginning in the mid-1970s, that suitor was the ruler
of Damascus, first Hafez al-Assad, then his heir, Bashar. Even after Syrian
troops were forced to evacuate Lebanese territory in the wake of the Inde-
pendence Intifada of 2005 (also known as the Cedar Revolution) under
combined Western and Arab pressure, Syria retained much of its influence
in Lebanon. Pro-Syrian political parties, language, geography, and family
connections maintained significant movement across a border that was
neither fully recognized (by the Syrians) nor fully controlled (by the Leba-
nese). Stuck in Lebanon by the Israeli onslaught in 2006, which ruined the
runways of the Beirut Airport, my family and I, like many Lebanese, found
overnight refuge and a functioning airport in Damascus, which we reached
by bus. So have many Syrians since 2011, caught in the increasingly violent
face-off between the regime and the armed opposition, sought refuge in
Lebanon. Among them have been hundreds of persecuted activists and
dozens of artists who clustered in the Lebanese capital. Rather than an ingénue
and her suitor, Beirut and Damascus were like an old couple who found life
together intolerable and life apart impossible.

By the time I landed in Beirut in June 2011 for a year of research and
teaching, the walls of the city were blanketed with graffiti about the Syrian

revolution, which had started a few months earlier. Though you could glimpse slogans and scribbles against Bashar al-Assad and his regime in most neighborhoods of the Lebanese capital, they clustered in two areas: Ras Beirut, especially in Hamra and around the American University of Beirut in the west of the city, and in Ashrafiyeh, especially in the neighborhood around the Université Saint Joseph, in the east. Ashrafiyeh, a mostly Christian hilly area, has a historical animosity toward the Baath regime, having been surrounded and shelled by its army in the 1980s. Ras Beirut was the most socially, religiously, and ideologically diverse spot in the capital, and in addition to hosting dozens of Syrian activists, it was also, until late 2011, the location of the Syrian embassy in Lebanon. Whereas it would be virtually impossible to see pro-Assad graffiti in Ashrafiyeh, in Hamra the odds were evenly divided between supporters and opponents of the ruler of Damascus.

Nothing announces a disputed territory more than the everywhereness of side-by-side rival graffiti, and nothing reflects the promiscuous hostility between camps than slogans sprayed, scribbled over, scrubbed clean, and subverted. In some cases multiple amendments often expanded the A4 size of a single stencil graffito to the size of a human being, from eyesight to ground level. What I saw did not square with the claim that graffiti are detached from "the obligations of debate, the abrasions of conversation" and that their "rhetoric is final and unimpeachable . . . secure."[91] On the walls around me, graffiti might have begun as edicts, but only as catalysts for debate, controversy, and invective. The stencils I saw were rarely definitive, never conclusive. Every inscription, it seemed, incited others to disagree with it and deface it. Graffiti, at least in Beirut, was a dispute, not a diatribe. A conversation, not a monologue.

A conversation can be an exchange of niceties and platitudes, but it can also be an intense argument, and the rhetorical jousting on the walls of Beirut has more often combined ideology and censure, sometimes in idiosyncratic style. For a city in permanent revolution against itself, waves of Syrian creative insurgency washing over the walls echoed battles of the past. A small and politically fractured country greatly affected by external political and social forces, Lebanon has always shaken to the tune of neighborly turmoil. From the 1950s to the 1970s, Beirut was an ideological crossroads, as exiled activists, dissident intellectuals, and a motley crew of Arab political migrants made it their home, their platform, their proxy battle-

ground. Recurrent spasms associate the city with conflict, the longest and most devastating being the 1975–1990 Lebanese Civil War, when graffiti served as territorial markers for militia-dominated enclaves. A glance at the scribbling on the wall and cloth banners hanging above the street showed who was in charge of the neighborhood at any given time. Graffiti were windows into the feelings and sense of place of humans embroiled in the war.[92]

As the Lebanese journalist Maria Chakhtoura documented in her *La Guerre des Graffiti, Liban 1975–1977,* Beirut in the early war years was awash in a rich array of stencil graffiti depicting logos of various Lebanese and Palestinian political parties and militias, in addition to free-form Arabic-language graffiti expressing various ideological opinions. Graffiti in languages other than Arabic were exceedingly rare—Chakhtoura's book features only one example.[93] Graffiti were sprayed in the name of the group, party, or militia, and not individuals. As militia-operated radio stations proliferated in the 1970s, before the explosion of wartime television channels, graffiti often acted as a rare medium, enacting a "public" but "silent" war between factions. As death and displacement became a daily reality for Beirutis, stencils were "proof of existence."[94] But what is most remarkable about graffiti of that era is their stripped-down style: stencils were loyal reproductions of party logos, and free-form messages consisted of mere phrases, rarely full sentences. That was the pre-aesthetic era of Beirut graffiti. It is important to note that party and militia logo graffiti regularly reappear in Beirut and other Lebanese cities and towns when groups feel the need to symbolically reassert their dominion over territory or population. Spillover from the Syrian revolution and the anxieties it reawakened in Lebanon spurred the return to walls of party insignia that had been out of circulation since the early 1990s.

After the war, graffiti changed in content and in style.[95] Postwar graffiti reflected fundamental changes in Lebanese political and social life as Syrian hegemony over Lebanon solidified, municipal elections returned, and businesses assiduously courted tourists and investors from the Gulf and the Lebanese diaspora. The center of Beirut was rebuilt for luxury consumption, and greedy developers bribed or bullied their way into demolishing old historic houses, building expensive, often gaudy high-rises for a wealthy clientele, and installing fences, gates, and security cameras. With a full decade having passed since the official end of the war and the novelty of electioneering wearing off, Beirut graffiti took an aesthetic turn, as urbanites

jaded by political messaging began paying attention to new, apolitical street art.[96]

By 2000, Beiruti space had shifted from militia-dominated enclaves to capital-dominated enclosures—with the exception of Hezbollah's security quadrant in the southern suburbs. Whereas wartime graffiti was consumed by ideological and political conflict between groups, postwar graffiti ventured into issues of sexuality, equality, civic participation, and what I would generally characterize as New Left campaigns militating for, for example, women's rights, lowering the voting age, gay rights, or the reopening of the Beirut Forest to citizens.[97] There were also statements against the formal political sectarianism that infused Lebanese politics. Regional political issues appeared regularly on the walls: Signs giving directions, "To Palestine," and stencils of Palestinian child-icon cartoon Hanzala abounded, and anti-Turkish scribbles often spilled over from Beirut's Armenian neighborhoods: "~~Eastern Turkey~~, Western Armenia" is one example. This would help graffiti-writing to carve a place for itself in the 2000s as a new media ecology was being established against the backdrop of Syrian hegemony over all aspects of public life in Lebanon and erstwhile prime minister Rafiq al-Hariri's market-driven reconstruction of the Lebanese economy and the Beirut central district as its façade to the world.[98]

The eventful mid-2000s were a fertile time for Beirut graffiti. The city's street artists reacted to things big and small. Grand, all-encompassing events like the Independence Intifada in the spring of 2005, when hundreds of thousands of Lebanese participated in competing demonstrations in Beirut's central district, and the Israeli onslaught on Lebanon following Hezbollah's capture of two Israeli soldiers in the summer of 2006, mobilized graffiti activists, who bemoaned, criticized, and prodded. But Beirut's wall artists also reacted to small incidents, with whimsy. When a Saudi preacher famous for his hardline opinions on popular culture issued a fatwa goading Muslims to kill Mickey Mouse, "a soldier of the devil," the walls in Ras Beirut erupted with stencils of the Disney mouse with the caption "We Stand with You." Sometimes it seemed no issue went unrecorded, from leading headlines to news of the weird. The walls of the city shivered with the interlaced traces of weighty events and trivial incidents.[99]

By the time the Arab uprisings got under way, Beirut had been steeped in a tradition of political graffiti going back forty years. The city is remarkably open to street art and graffiti, which is not counted as vandalism.

Unless street artists mounted direct, unambiguous attacks on heavyweight politicians, no one really bothered them. Some sprayed in broad daylight, in visible locations.[100] In addition, in late 2010 Lebanon was as fragmented as ever, its political forces pushed and pulled by powerful external actors, its population under pressure in a difficult economic situation and a rising tide of sectarianism, its borders uncontrolled. The capital, which included every single religious group and ideological orientation in the country and the wider Arab world, offered an array of canvases for the expression of these differences. On the fifteen-minute ride from the airport to the central district, stencils of Che Guevara, Karl Marx, and Hezbollah's logo whizzed by alongside those of hardline Salafi parties. The visual closeness of hammer, anvil, crescent, and AK47 testified to the city's hodgepodge ideological makeup.

As the Syrian uprising turned more violent and the number of Syrians crossing the border swelled, Beirut walls were primed to become battlegrounds between friends and foes of the Syrian revolution.[101] Words and images about Syria proliferated, and it was clear that Syrian revolutionary graffiti were of a different kind than Cairo's. Did you ever wonder why the Egyptian revolution spurred an outpouring of massive, elaborate, colorful mural vignettes and narratives, whereas the Syrian civil war spawned, aside from the literal writing on the wall, mostly stencils? What is it about Cairo that made it amenable to lush and elaborate murals and about Damascus and its proxy Beirut that led to the emergence of clipped and concise stencils?

The protracted violence of the Syrian uprising as it devolved into a civil war explains why stencil is the dominant type of graffiti coming out of Syria, as opposed to freestyle and muralist graffiti spawned by the Egyptian (and Tunisian, Yemeni, Bahraini) uprising. Freestyle graffiti consists of writing and painting over a surface, and Arab freestyle typically consists of words of brief sentences of stylized Arabic font with color under- or overtones. Murals, like the ones on Mohamed Mahmoud Street in Cairo, are much larger and are typically dominated by shapes and colors, though they sometimes include text. In Cairo and Tunis, many graffiti activists were actually bona fide artists. Some, like Egypt's Alaa Awad and Ammar Abo Bakr, taught art at universities. In contrast, stencil graffiti consists of amateurish spray paint over a precut frame—the stencil—typically made of cardboard.

Stencil graffiti have several crucial advantages over murals and freestyle inscriptions. Stencils are easily reproducible. Anyone who has a cardboard

copy and spray paint can reproduce the graffiti on a wall. The availability of personal printers and Internet access help. Blogs and Facebook pages have hosted repositories of Syrian revolutionary graffiti, which circulated between cities when activists in one country printed out and cut a stencil from a design uploaded online from another country. Some Egyptian stencils, like *kun ma' al-thawra,* "Be with the Revolution," spread all over the Arab world and in Beirut became associated with the Syrian revolution. By enabling multiple individuals to fan out in a city with cardboard frames of the same design, stencils facilitate the proliferation of political messages on a far broader scale than murals, which require painstaking work in a single location and are typically recognized as the work of one artist. Besides, by undervaluing individual authorship, stencil graffiti aids group solidarity of activists, maintains a popular "we the people" agency behind revolutionary graffiti, and protects the anonymity of the artist-activists.

Once they are cut and tested, stencils can be painted with astonishing speed. The bodies of artist-activists move swiftly from one location to another and execute their graffiti in well-practiced, clipped movements of arms and hands. Most stencils are relatively small, some as small as A4 paper, some as large as four times that size. Many stencils fit easily in a backpack or duffel bag, along with one or two spray cans, because stencil graffiti are customarily monochromatic and so can be completed by activists moving on foot or moped, unlike murals, which require an elaborate and therefore heavy gamut of paint brushes, spray cans, and ladders and a longer time to execute. In many cases, an activist can spray a stencil graffito in less than one minute, and the rush is manifest in the dripping, oozing traces of paint that can disfigure or surround stencils. Speed is essential for scribblers of insurgent messages in an environment where police harassment or arrest, sometimes ends in violence, torture, or even death. In contrast to freestyle murals, stencil graffiti allow stealth and anonymity.[102]

Stencils convey messages concisely. A stencil, after all, is a standardized frame. It is an inherently restrictive format that limits the space of communication. Unlike murals, which enable the artist to inscribe elaborate visuals, stencils dictate brevity. This is not detrimental. On the contrary, brevity has its advantages, as we know from *haiku,* advertising jingles, political slogans, and more recently Twitter. Stencils perform an eye-of-the-needle channeling of the energies of the human body, concentrating the effervescence of creative insurgency into narrow frames. Through compelling political messages

that are brief, concise, hard-hitting, and in most cases instantly recognizable, stencils are effective in a saturated information environment, wherein brevity helps a message achieve speedier circulation and more visibility. In a city overflowing with street art, curt stencils reflect a minimalist aesthetic of hurriedness. Crispness and concision also help online circulation. In the battle for visibility, stencils triumph because of style. Stencils turn representative figures, designs, and symbols into memes that circulate offline and online through practices of liking, sharing, forwarding, imitating, and contesting. Brief and repeated, stencils gain recognition, spreading and ingraining political messages in people's consciousness.

Let us consider a few cases.

In keeping with the notion of body politic, the body of the sovereign was a central feature of revolutionary graffiti. Assad's face and bust were all over Beirut walls, often with mentions of "the people" and animal symbolism. On a summer evening in 2011, as I was heading from the American University of Beirut to Clémenceau Street, which runs parallel and west to Hamra Street, a car's headlight landed on a whitened inscription on the wall that was usually indiscernible. But something in the chemistry of the paint made it translucent under the direct light beam, and underneath it I glimpsed the contours of a stencil about the city of Der'a, which sparked the Syrian uprising, and scribbles about a leader who killed his own people. Though I could not make out intricate details, I saw enough to know that an identical stencil sat, highly visible, on the side of a bridge in Ashrafiyeh, in the eastern side of the capital (it is unusually large for a stencil, approximately two feet by one). This was my very first witnessing of the graffiti war, and I realized that different neighborhoods presented vastly different scribbled slogans. In the year that followed, I often resorted to cross-neighborhood referencing and comparison to identify stencils and their afterlives.[103]

On a side street between Hamra and Verdun, another skirmish unfolded on a gray wall, this time about al-Jazeera. In a symbolic war in which media themselves were a battlefield, no other institution generated as much invective or ink. In Damascus a pro-Assad activist had mounted an anti–al-Jazeera graffiti campaign, spraying the network's famous pear-shaped logo with the caption "al-Jazeera Bureaus" on street garbage containers, which remained untouched since the regime controlled the city.[104] The Qatari channel was unabashedly supportive of the Syrian revolution, to the point that it affected

the performance of its Beirut bureau, which was in charge of covering Syria. More than once in 2011 and 2012, I went to that studio to record interviews about the media war in Syria and elsewhere for *The Listening Post,* a program about the media on al-Jazeera English, and sometimes the tensions were palpable in the studio. As Arab newspapers filled up with articles about the frictions Syria coverage was generating within the Qatari institution, the Beirut bureau hemorrhaged staff, and its chief, the distinguished Lebanese-Tunisian journalist Ghassan Ben Jeddu, eventually quit the channel over its coverage of Syria to found a new Beirut-based pan-Arab channel, al-Mayadeen. A scuffle around a stencil, designed by the secretive Syrian collective Asha'b Assoury 'Aref Tareqoh (AAAT; The Syrian People Knows Its Way), on that street reflected the battle of public opinion. Someone had sprayed a stencil of an old, two-dial-button television screen with "Liar" at the center of the screen and "Syrian Media" (meaning Assad regime media) underneath it. Another person sprayed black paint over "Syrian" and scribbled "Arab" instead, an indirect hint to al-Jazeera and other prorevolution channels funded by the Arab Gulf monarchies. Nearby, someone had modified a copy of the same stencil, erasing "Syrian" and spraying "al-Jazeera" instead. The last amender appears to have had a broader, though more cynical view. That person deleted "al-Jazeera," which was itself painted over "Syrian" and scribbled "All" next to "Media." The same stencil began as a swipe against Syrian regime media, shifted to being an attack against "Arab" media, was then appropriated to impute "al-Jazeera" directly, before concluding with scornful wit against "All Media." Like all good dialogue, the scribbling skirmishes of Beirut combined jest and drama.[105]

A graffiti campaign inspired by posters created by AAAT spurred similar quarrels. The name of the group, The Syrian People Knows Its Way, is important in two ways. One, by explicitly branding the author as a collective, it anonymizes and therefore protects individual activists from reprisals. Two, as an AAAT member told me, it reflected their radical commitment to "fighting the ego" and their rejection of "copyrights of all kinds. We create and throw online. Let them go. Even when people cut our name out and use our posters, we don't care." Third, the very name of the group, by speaking in the name of the people, betrays a desire for popular sovereignty and suggests that a leader was not needed. Everything AAAT did was in the name of the people. They coordinated with activist groups on the ground in Syria, creating on-demand black-and-white poster designs that were printed

and brandished in street demonstrations. AAAT is a collective of amateurs, and during the day we spent together, the member uttered, "We are *not* graphic designers," repeatedly and emphatically. The dozen members hail from all walks of life (there is a computer security expert, a restaurant waiter, a community art center coordinator), live all over the world (from Ramallah to Berlin), and have met in person only once. They use a password-protected Facebook page and Skype for extensive brainstorming sessions on theme, font, text, design, color, timing—"we don't just design posters," the AAAT member told me—underscoring the laborious and totally collective nature of their work, which reflects their commitment to the people. Underscoring that message were the clenched fists, symbolizing the unity and strength of the Syrian people, in addition to figures of children, suggesting that even Syrian youngsters knew their way. The Syrian people are therefore positioned as autonomous and mature, cognizant of their destination and thus masters of their destiny. Many posters feature vivid body imagery: bodies defying the illegitimate and murderous body of the sovereign, expressing solidarity with workers, mocking Assad and Daesh, advocating the burial of Assad's corpse, or running away with lines emanating from the people's fingerprints (Fig. 4).

One of the group's designs, featuring a young boy, his right hand stretched up painting the name/motto itself, underscores that even children know which way they want Syria to head and can mobilize their rebellious bodies in that direction, in addition to adding the unavoidable hint to innocence that comes with child imagery. This stencil was sprayed, alongside others, in Qantary, on the northern edge of Hamra. There, on a fence of glittering gray steel plates surrounding a construction site throughout the fall of 2011, proregime activists countered revolutionaries by transforming their stencils. One stencil in bright scarlet ink that originally featured a clenched fist with cycle-of-life curved arrows around it and the caption *"athawra assouriyya, mustamerra"* (Syrian Revolution, Continues) had "revolution" painted over, so it read "Syria Continues," and then later, "al-Assad" was inserted, turning it into "Assad's Syria Continues." As the months went by and the scarlet turned a shade of burgundy and cracks opened in the paint, the modified stencil remained, suggesting that Assad's backers, in that spot at least, had prevailed.

Assad's portrait frequently appeared in a widespread stencil portraying him with a Hitler-like mustache, a visual modification of the leader's actual

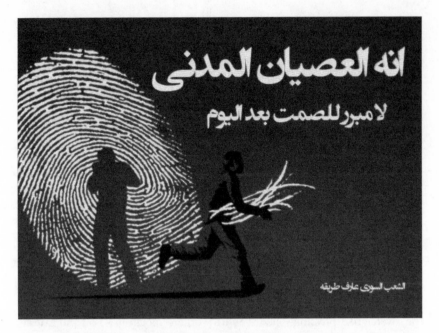

FIG. 4. *This Is Civil Disobedience,* Asha'b Assoury 'Aref Tareqoh, undated.

stubble. By comparing him to one of history's greatest butchers, activists reflected the horror of Assad's deeds against his people. In some instances, people had pinpointed red spray into Bashar's eyes and mouth, achieving a vampiresque appearance. The same stencil, of Bashar in suit and tie and Hitler's mustache, with the caption "The king of the jungle rides a tank," was at the center of a campaign designed by a duo of activists, one Lebanese and the other Egyptian, in solidarity with the Syrian revolution. First appearing in Beirut and Cairo, the stencil apparently showed up in Gaza, in the Red Sea Saudi city of Jeddah, and as far away as Berlin.[106] The symbolism of this stencil is striking, for it doubles down on metaphors of power and violence. Assad is Arabic for "lion," and this dominant animal who rules the jungle is one of the most widespread images of the Assads. Encomia to father and son exploited this association with the royal beast, which also appeared in pro-Sisi propaganda in Egypt. As I got ready to move to the United States for graduate school in 1992, I traveled by taxi to the U.S. embassy in Damascus because the U.S. embassy in Lebanon did not issue visas. Stopped at a major Syrian checkpoint in Lebanon, a

PUPPETS AND MASTERS

mukhabarat officer took me inside a narrow wooden kiosk where soldiers sheltered from the sun and asked me to enumerate seven synonyms of *assad* (lion). I guessed only three, learned a few Arabic words I would never need to use, and for my ignorance got a slight slap on the face meant to humiliate rather than inflict pain. But I got a firsthand experience in body politic ritual. It is noteworthy that the tank, as a symbol of massive, steely, state power, showed up frequently in graffiti of the uprisings. The artist Ganzeer's most famous Cairo piece and one of his very first features a face-off between a tank and a man on a bicycle carrying bread. Syrian stencils were chock-full of tanks, one of which survived in full gloss by the good fortune of a jasmine tree growing over it in Gemmayzeh, a nightlife district wedged between Ashrafiyeh and the Beirut Port, and showed a tank with its turret cannon, much like the hand of a clock, pointing in turn at different Syrian cities: Aleppo, Der'a, Homs—the head of the body politic systematically destroying its own members.

But can you imagine a lion actually riding a tank? The excess of raw power this image exudes has the effect of ridiculing the head of the body politic. Mixing two unabashed images of naked force (lion and tank) with two symbols of power (the Nazi icon of murderous totalitarianism and the man-in-suit-and-tie imagery of modern corporate power), the stencil skewered the dictator with the rhetorical question, Why do you need to amass this much might? The answer, underscored by the playful, curvaceous handwriting of the slogan "The king of the jungle rides a tank" (Fig. 5), is that Assad had no legitimacy whatsoever. Forced to resort to a great deal of violence to preserve his rule, the Lion of Damascus was in fact a mouse. This stencil used semiotic overkill to expose Assad's overboard power as an overdose for the body politic. If you needed a tank, the stencil said to its subject, you were not a real lion, and if you were not a lion, you had no business ruling the country. At best, Assad could lay a truncated sectarian claim to represent the interest of Syria's Alawis, reducing the president of Syria to the stature of a clannish boss.

Right before the explosion of acute sectarianism in the Syrian crisis, antisectarian activism increased in Beirut, especially in 2010, and since then so have antifactional graffiti. Many progressive Lebanese activists saw the country's institutionalized formula of political sectarianism to be a primal sin of the Lebanese polity and tended to make this issue a rallying cry for various social and political causes, from women's rights, to corruption, to

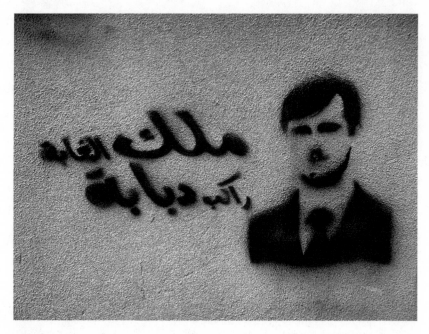

FIG. 5. *The King of the Jungle Rides a Tank,* stencil, Beirut, 2011, photo © Marwan M. Kraidy.

the independence of the judiciary. Lebanon is what political scientists call a consociational democracy, wherein political positions and resources are negotiated by a variety of sectarian-based groups (there are very few real political parties) that field syndical, municipal, and parliamentarian candidates clustered in cross-sectarian lists. Seats in the parliament, ministerial portfolios, and high-level state appointments are all subjected to the iron rule of sectarian consociationalism. Personal status matters are in the hands of religious courts, and since the 1990s episodic campaigns for civil marriage have been mounted, without clear success. Sectarianism is one of the most prevalent themes in Beirut graffiti because sectarian identification is institutionalized in the country's political system and permeates social life, and as a result, sectarianism is a central field of battle between entrenched political forces and progressive activists.

The peculiarity of the political system shapes our understanding of the politics of space. In contrast to Egypt and Tunisia, where a relatively homogeneous population held public demonstrations against the regime, in Leb-

anon marginal leftist and progressive political parties used public space to protest against entrenched political sectarianism. Consider that the multisectarian unity of the Independence Intifada of 2005 opposed to Syrian hegemony over Lebanon had within one year degenerated into sectarian political bargaining. In Cairo and Tunis "The people want" sounded plausible, but in Beirut arousing "the people" as a cohesive body is a vain act of mystification. This is why, though Lebanon was not a protagonist in the Arab uprising, Beirut activists long resentful against endemic political sectarianism saw in regional upheaval an opportunity. This was Lebanon's system from hell, and the Egyptian revolution goaded them into action. In March 2011, a campaign against *al-nidham al-ta'ifi*, "the sectarian system," gained momentum. Under the slogan "The people want to topple the sectarian system," which left no doubt about connections to uprisings in neighboring countries, activists organized a campaign in which graffiti were central. They met in Beirut, designed and cut a coordinated set of cardboard stencils, then fanned out across the country, spraying the stencils in black and red in the major cities (Fig. 6).[107]

FIG. 6. *The Sectarian System,* stencil, Beirut, 2011, photo © Marwan M. Kraidy.

I observed these graffiti in Beirut, but also in the central city of Byblos, the southern cities of Saida and Tyre, and heard that they could be found in the northern city of Tripoli as well. It is clear that activists behind the campaign ascribed major ills of Lebanese society and politics to sectarianism; remarkably, this was the only truly national graffiti campaign, eschewing the usual correspondence between graffiti tagging and territorial jurisdiction that explains much of graffiti's localism and spreading to several cities along the Lebanese coast. When the campaign failed to dent the system, some attributed this to the attempt to import a regional battle into Lebanon, others to its immature leadership. A more plausible reason is the sheer resilience of the deeply entrenched sectarian system. The campaign did succeed on another front: alongside other slogans expressing sympathy for both Bahrain, where a Sunni tyrant subjugates a Shi'i majority, and Syria, where an Alawi despot oppresses a Sunni majority, the campaign expressed an antisectarian view grounded in solidarity with the people of both countries.[108] (This underscores the need to translate *nidham* as "system" rather than "regime.")

Beirut walls were chock-full of stencils, not associated specifically with Syria, featuring the human body in a variety of postures, including a multitude of stick figures holding hands, dancing together, playing on a seesaw, jumping rope, riding bicycles—happy, playful, carefree human beings, jarring opposites of actual people's daily struggles and anxieties. There were cages and birds and human figures freeing the latter from the former. There was a campaign emphasizing the beauty of natural bodies and sexual rights, with stencils of youthful male and female bodies with separate captions like "I Don't Use Steroids," or "I Have Not Had Plastic Surgery," or "I Am Not a Faggot" and a common caption, "Only Lying Is Shameful." There were a couple of residual stencils from a condom-use campaign, with a sheathed erect penis and the caption "Protect Her," palimpsests from a preuprisings era when social campaigns predominated. A campaign against rape, with a stencil of a woman with a raised fist shouting, "Fight Rape!," rendered in black, blue, green, blue, red, yellow, or combinations thereof, was particularly visible in the Lebanese capital. Another stencil, "Lebanon, Between the Legs," featured a women's legs, spread widely, with the word Lebanon rendered in the stylized logo the Ministry of Tourism uses to brand the country and located in the genital area, not so subtly claiming Lebanon is penetrated.[109] The imagery there echoed the anti-SCAF, "Su-

preme Council of Aha" graffito in Cairo, which featured a woman spreading her legs, with *aha,* sometimes rendered *a7a,* slang for "fuck that" or "fuck it."[110] As mentioned in the section "The Upper Hand," the hand held pride of place in body imagery of the Syrian revolution, and fists, palms, and fingers were stenciled all over the place.[111]

There is one more series of Beirut stencils that use sexual metaphors to convey political messages. In one graffito, a hand grabs a horizontally inclined spray can with the caption "Freedom is Not a Secret Habit," using a metaphor for masturbation to excoriate those who remain unmoved by the revolution, or those whose activism begins and ends with private clicks on their phone or keyboard, and to exhort people to proclaim and practice their freedom publicly. By invoking habit, this stencil can also be understood as a stern reminder that freedom is enfleshed in humans and needs to be concretized in bodies through practice. Freedom, it seems to say, is not a mere word that one can utter in distance from its actual consequences. Freedom is embodied, and its practice must be public, even if that would court violence. Another, cruder stencil featured two human stick figures carrying a third one with the caption "Collaborator on the Shoulders, Suppositories Between the Buttocks," using a dual metaphor of penetration, one of the body politic by a foreign agent, the second of the rectum by a medical pill, to highlight the irony that foreign agents are celebrated—carried high on shoulders, like heroic bodies—while the people's suffering is merely numbed by anally introduced medicine. By impugning individual pleasure and private interests, images of genitals and orifices ascertained that political activism was a collective concern and freedom a public good.

Stencils imprint the body on the city. The images that they carry imbricate the human body with the urban fabric, fusing veins and avenues. Clenched fists, open palms, insolent eyes, or simple stick figures at play illustrate how this kind of creative insurgency extends human corporeality in public space. Whereas murals are elaborate and oblique, stencils are crisp and direct, but the skirmishes they inscribe show no clear winners. Rather, they underscore gridlock, reflecting the stalemate between Assad and his foes in Syrian fields and cities: a stencil standstill between a despot no longer entirely in charge and a people not yet fully sovereign, battling over a diseased body politic.

TOP GOON

*D*uring his long reign between 1971 and 2000, Hafez al-Assad tolerated a handful of jesters. Ghawwar al-Toshy, the signature character of the venerable comedian Durayd Lahham, rose in the early days of Syrian television and underwent a shift from slapstick buffoonery in the 1960s to political satire by the late 1970s. Lahham imputed the change to his desire to reflect the growing hardship of Syrian daily life in the 1970s, but a more credible cause was his collaboration with famed Syrian poet and writer Mohamed al-Maghout.[112] Lahham's early pan-Arab fame hinged on the transnational circulation of live performances, films, and radio broadcasts of his work, and later on national Arab television systems and videocassettes.[113] Assad tolerated comedians because the Baath considered culture, including painters, writers, and singers, as vital to the nation and therefore worthy of state support (Syria for a while had a Vice-President for Cultural Policy). But satirists kept on a leash were also useful in airing "commissioned criticism." Assad blended socialism, romanticism, and nationalism under the ruling Baath party into a fascist cult of personality that conflated the body natural of the leader with the body politic of the nation.[114] From the helm, Assad turned Syrians into extensions of his own body.

Growing up in a Lebanese community hostile to Syria due to Assad's interventions in Lebanon, which by the 1990s turned into total control, I recall Lahham as an exception: a Syrian actor, with a Syrian accent, he had a following among those allergic to many things Syrian. I remember, when I was around ten in the early 1980s, getting together with cousins on Friday

nights, watching Ghawwar's sketches on a bulky television set and a massive Grundig videocassette recorder. We did not understand all the innuendo, but we laughed wholeheartedly, for those jokes we did get were as percussive as the enormous mechanical "play" button on the VCR. Here was an object lesson in the power of comedy to overcome political animosities. For a time, the regime countenanced other national comedians, like the cartoonist Ali Ferzat, who published his first cartoon at the age of twelve in 1963.[115] As pan-Arab satellite television channels proliferated throughout the 1990s, I became familiar with the work of the director and actor Yasir al-'Azmi. Taking advantage of a changing Syrian situation, where private investment was allowed to flow to television production, and a growing pan-Arab media sector, which purchased most Syrian productions, al-'Azmi put out comedic works that were edgier than Lahham's, including *Maraya* (*Mirrors*) and *Boq'at Daw'* (see the earlier section "Sprayman").[116] But criticism remained tethered to the body politic.

The Assad cult held sway after Hafez died in 2000, and for a decade rule appeared to have seamlessly passed from father to son. The transfer itself was a classic drama of body politics. Right after Hafez passed away, a tightly scripted transition consecrated Bashar. The Baath-controlled legislature changed the constitutional requirement that the president be at least forty years old in order to install Bashar, thirty-four, on the throne. This, perversely, made sense, for the doctrine of the king's two bodies stipulates that the sovereign's *body politic* is everlasting, hence ageless, therefore never underage. In 2000 and 2001, Bashar initiated the "Damascus Spring," a short-lived thawing of tyranny that fueled hopes before swiftly dashing them. Consider the experience of Ali Ferzat, who by 2000 had become Syria's cartoonist of record: Bashar allowed him to publish a short-lived satirical weekly magazine, *al-Dumary* (*The Lamplighter*). The regime allowed it in 2001, slowed down publication in 2002, and snuffed it out in 2003. Commissioned criticism had a short life. Assad's confidence in his grip over Syria was such in early 2011 that he gloated that the unity of leader and people—notice the corporeal binding—made Syria resistant to the kind of upheaval that had just erupted in Tunisia and Egypt. As if mocking proponents of social media revolutions, he even allowed Facebook after having banned it from Syria. But in March 2011, when the Syrian state brutally tortured youngsters who had scribbled graffiti on school walls calling for the fall of the system, triggering a cycle of repression and rebellion, it was only a matter of time before unrest spread.

Having hedged its bets for decades, Syrian satire made a dramatic confrontational shift with the onset of the uprising. Comedians from the old order were divided between regime and opposition, and an exceedingly dangerous situation on the ground pushed new, amateur satire online.[117] Of the bountiful revolutionary wit to burst out of the Syrian uprising, the video web series *Top Goon—Diary of a Little Dictator,* is the most absorbing. Trenchant and tenebrous, it lampoons Assad, his police, and his media. The brainchild of Masasit Mati, a Syrian collective that emerged during the uprising, *Top Goon* debuted online in November 2011, when it launched a first season of thirteen episodes on a dedicated YouTube channel, to wide acclaim. Its creators describe it as "a weekly web-based finger puppet show."[118] Episodes open with a fearful Beeshu, "President of Syria," fussing in *falsetto:* "I am not crazy! I am not crazy! I am not crazy!" Then a captivating cast of characters rolls out: "Rose of Damascus" (a prostitute), "Peaceful Demonstrator," and "Shabih," a goon and Beeshu's enforcer, who beats up the peaceable protester while taunting him with regime leitmotivs: "Infiltrator! Salafi! Infiltrator! Salafi!" All the puppets are made of papier-mâché except Shabih, whose harsh features were carved from hard wood. Shabih bears a striking resemblance to the woody Asif Shawkat, Bashar's brother-in-law, regime hatchet man, and former director of military intelligence and then deputy minister of defense, who was killed in a Damascus bombing on July 18, 2012. Colors, graphics, and sounds convey a revolutionary pathos. The back screen is black, graphics red, subtitles white, echoing the dominance of these colors—pervasive, along with green, on Arab national flags—in the uprising's dissenting digital declarations. As the opening sequence winds down, the dactylic characters belt out a song about freedom and the impending fall of the Baath regime, then we read "Masasit Mati: Presenting *Top Goon—Diary of a Little Dictator.*"

Of the first season's thirteen episodes, about half show how rebellion and repression alter bodies, from classical to grotesque, like the finger puppet representing the absolute autocrat, and from grotesque to heroic, like the diffident protester transformed into a committed revolutionary. Episode 1, "Beeshu's Nightmares," features an insomniac Beeshu suffering from recurring nightmares about his demise, a classical body losing its majestic serenity as it contemplated the abyss of the grotesque. In episode 2, "Who Wants to Kill a Million?," Beeshu competes on the revolutionary version of the internationally popular reality quiz show, cruelly disposing of thou-

PUPPETS AND MASTERS

sands of bodies on his way to a macabre million-body prize. The third episode, "Prostitute Media," unsubtly compares regime television to a whore, that most grotesque of bodies. In the fourth episode, "Dracula," Beeshu is the famous Transylvanian vampire, sucking Syrians' blood, draining the national body politic of life. Episode 7, "Interrogation," is a dark and caustic take on the bloodcurdling experience of torture shared by many Syrian activists. Episode 10, "Devil," in which Assad plays Satan and his opponents resist the temptation to lose their soul, and episode 13, "Last Days in Hell," a satirical anticipation of Assad's exit and ultimate destination (and a homage to the French poet Arthur Rimbaud's *Saison en Enfer*), moved viewers to an underworld resonant with life in Syria.[119] Other episodes of *Top Goon* belittle Assad. In "Protests at Beeshu's Home" (episode 5), Beeshu is dismayed then infuriated when his own children begin clamoring for the fall of the regime. In "Opposite Direction" (episode 6), Beeshu performs dismally on the eponymous al-Jazeera talk show, withdrawing prematurely from the studio. "Reforms" (episode 9) shows a tragicomic clash between Assad's pomposity and the cosmetic political changes he dangled for a while as the protests against him grew. Two episodes struck a more hopeful tone: "Beeshu's Defection" (episode 11) plays an amusing fantasy of the dictator relinquishing his throne, and "Peaceful, Peaceful" (episode 12) wittily reasserts the value of nonviolent resistance.

In the meantime, early street protests gave way to a brutal civil war pitting the Syrian regime, aided by Iran, Russia, and Hezbollah, against a motley opposition whose multiple factions—from army defectors to radical jihadists—were incited or supported variously by Saudi Arabia, Qatar, Turkey, the United States, Israel, France, and the United Kingdom. As a cruel circus unfolded in international media, celebrating Syria's "creative revolution" while watching the country get scorched, *Top Goon* stood out. The world's media noticed the puny, punchy protagonists. Six months after first showing up online, *Top Goon* had "more than 175,000 YouTube views; over half a million 'likes' through Facebook broadcasts into Syria on opposition satellite channels, and write-ups in many of the world's leading media, including the *New York Times, Der Spiegel, El Mundo, Washington Post,* and *al-Jazeera English.*"[120] Many other outlets feted *Top Goon* as a special crop of revolutionary artistry.

Anyone following Syrian revolutionary media and culture might wonder: How did *Top Goon* succeed in cutting through the cornucopia of thousands

of videos bursting out of the Syrian revolution? A few other artifacts of the Syrian revolution did make it to global prime time. There were several write-ups of the hand-drawn, hand-held, witty signs of Kafranbel, "the Little Syrian Town That Could," but such banners, however poignant, remain salvoes in a raging battle.[121] In contrast, *Top Goon* wove many burning issues into a coherent and compelling narrative. How did it accomplish this feat?

In style and substance, *Top Goon* exhibits key characteristics of creative insurgency. These made it attractive to Arab viewers and courted public opinion in Western countries. Anti-Assad, prorevolution sentiment dominated both these publics. The comedians' Syrian vernacular resonated with Arabs accustomed to watching Syrian television series, a particularly popular fare on pan-Arab satellite television channels, and a separate YouTube channel on which all episodes had English subtitles helped Masasit Mati reach Western viewers. The web series, like other revolutionary cultural forms, was replete with global pop references. The title *Top Goon* riffed on the 1996 blockbuster *Top Gun*, starring Tom Cruise and widely popular in the Arab world. By connecting with Hollywood lore *Top Goon* resonated with other Syrian revolutionary imagery: Kafranbel signs featuring Assad as "Lord of the Thrones," or an Assad-and-Putin reenactment of DiCaprio and Winslet at the end of James Cameron's *Titanic,* when they brace themselves for the deep and dark, taking Syria with them to the bottom of the ocean.[122] In August 2014, after Robin Williams committed suicide, Kafranbel men raised a moving banner quoting the hero of *Mrs. Doubtfire* and *Good Morning, Vietnam* saying, " 'To be free. Such a thing would be greater than all the magic and all the treasures in all the world'—RIP Robin Williams," signed "The Syrian Revolution—Edleb Countryside 15-Aug-2014." Allusions to Hollywood and English-language subtitles helped this progeny of the revolutionary imagination resonate worldwide.

Top Goon integrated global media culture into the web series' very own structure. Consider episode 2 of season 1, "Who Wants to Kill a Million?," for a detailed vista of the show's deliberate appeal to a worldwide audience. Masasit Mati does so by grafting a political message on a global cultural trope. Viewers all over the world are familiar with the formula of the *Millionaire* game show. The British know it as *Who Wants to Be a Millionaire?* Indians call it *Kaun Banega Crorepati,* and Arabs appreciate it as *Man Sayarbah al-Malyoun?* As I showed in my book *Reality Television and*

Arab Politics, the Arabic version and other Arab reality television programs became controversial ratings busters by playing up the creative tension between the format's global popularity and the adaptation's local resonance.[123]

But *Top Goon* added a ghoulish twist. In contrast to the quest to accrue *dollars, riyals,* or *rupees,* which usually builds suspense, Beeshu accumulates casualties, turning his appearance into a compilation of cadavers. In the following excerpt, in Masasit Mati's own English subtitles, the humor is as aesthetically gruesome as it is politically devastating:

> *Host:* Welcome dear viewers to a new edition of our programme today. Who wants to kill a million? Remember in our last edition we had the contestant Hosni Mubarak on the show, who reached up to three thousand killed. And we've also had the other contestant, Muammar Ghadafi, who reached all of a twenty thousand killed. And today, we have a new contestant, and our expectations are that he will kill the million! The contestant Bashar al-Assad from Syria. How is it going?
>
> *Beeshu:* Eh . . . just great.
>
> *Host:* We start with the first question: If you could commit a massacre in the capital, Damascus. Who would you put in charge? Maher al-Assad, Rami Makhlouf, Asif Shawkat, or Ali Mamlouk?[124]
>
> *Beeshu:* It is a stupid question to be honest. I would charge my brother, Maher "the killer," of course. . . . Because my brother has so much experience. Just look at what he did in the beginning of the events in Deraa. And he is also responsible for the massacre of Sednaya. Hahhaha.
>
> *Host:* This is your final answer?
>
> *Beeshu:* Of course, of course—I'm sure of it.
>
> *Host:* How should I tell you your answer is . . . Correct! And you have gained a thousand killed!
>
> *Amidst applause, Beeshu and host sing:* "I love people who shoot without asking questions, but I avoid the people who protest on the street."

After another exchange, a fake commercial break dives directly into the politics of the body by alluding to Assad's infamous June 20, 2011, speech at Damascus University. Ninety-eight days after the outbreak of the conflict, the Syrian leader explained the "conspiracy against Syria" using a microbial metaphor: "Conspiracies are like germs, after all, multiplying every moment everywhere. They cannot be eliminated, but we can strengthen the

immunity of our bodies in order to protect ourselves against them." Arguing that the conspiracy was self-evident and exhorting Syria not to waste time discussing or fearing it, he called on his compatriots "to identify the internal weaknesses through which this conspiracy can infiltrate the country. Then we should work on correcting these weaknesses. The solution, at the end of the day, is for us to solve our own problems and to avoid ramifications that could weaken our national immunity." Then, fittingly for a speech delivered on a university campus, Assad struck a didactic tone, "Germs exist everywhere, on the skin and within the guts. Throughout the history of scientific development, scientists always thought of ways to strengthen the immunity of our bodies." After a long detour, Assad concluded his address with a return to body symbolism: "It is you who prevented all attempts of sectarian sedition scrambling at the gates of the homeland and cut off the head of the snake before it could bite the Syrian body and kill it. I say that as long as you enjoy this great spirit and this deep sense of identity, Syria is fine and safe."[125]

Creative insurgency feeds on its targets' words, actions, and appearance. Spoofing a leader's language being a trademark of political satire, *Top Goon* reprised Assad's microbial metaphor. As the host says "and now we will leave you before we go to the third question, for the commercials," Shabih appears, leading a choir to a dissonant "Those who want freedom and for Assad's gang to go; *Shabih asks*: They are called? *Choir answers*: Germs! They are called? Germs! Germs. Dettol [*A widely available brand of detergent*] kills germs efficiently. Brought to you by Syriatel." The faux advertorial ends with a direct swipe at Assad's maternal cousin Rami Makhlouf, Syria's richest man, who owns the cellular phone provider *Syriatel* and dominates the national economy. Then the episode's growing stakes ratcheted up the suspense:

Host: The third question. Will you manage to crush the protests and put an end to the Syrian revolution? Yes? No? Maybe? Or—Yes, but against everybody's will?
Beeshu: I think I'd like to call a friend.
Host: Why? You still have friends?
Beeshu (Obviously miffed by the host's rhetorical question): You're right, I don't have any friends left but I'll answer by myself because I don't need friends anyway. What I'm saying is that the answer is easy. I will manage to crush all the protests against everybody's will.
Host: Is this your final answer?

Beeshu: Final!

Host: (Quietly, a muffled whisper in his ear: "No, no, no."): Final answer?

Beeshu: Yes, final.

Host: Are you sure?

Beeshu: Yes, of course I'm sure.

Host: Your answer is . . . Wrong!

As Beeshu lowers his head, speechless with shock and seething with anger, the host wraps up with the usual question, to foment viewer participation and build anticipation for the next episode: "Dear viewers. The question for our next edition for whoever would like to join our program is . . . Where will the next protests break out after the Syrian regime has been toppled? Iran? Saudi Arabia? Algeria? Switzerland? [*The Swiss reference adds incongruity concerning the regime's lofty claims of reform.*] To vote, please go to www .MasasitMati.com."

The dénouement is punchy. In an Incredible Hulk–like moment, Beeshu blurts out, "To hell with you! To hell with this program!" suddenly becoming Bashar again. Still cursing, Bashar lunges at the host, beats him up, and pushes him to the floor and outside of the screen. As the fingerling autocrat turns around, looks straight at the camera, and proclaims, "My way or the highway!" a caption announces "Next Episode: . . . Prostitute Media."[126] The dramatic conclusion revealed a brute unwilling to play by any rules, lurking under the patina of a contestant in a suit. The last-minute transformation of Beeshu exposed Bashar's raw power, the display of which betrayed the flimsiness of the bond between the dictator's natural and political bodies. If the Syrian body politic depended on brute force for its survival, the ending of the episode suggests, then, it was not "natural."

Who are the revolutionary artists who created *Top Goon?* How were they able to avoid capture and sustain their creation for two seasons as the uprising turned into a violent, all-out war? Masasit Mati emerged during the uprising. The group's name refers to the utensil used to sip *yerba mate,* the tealike concoction that Syrian and Lebanese immigrants to Argentina brought back during visits to the homeland. From the name emanates a political hint—Syrians associate *mate* with minorities like Alawis and Druze. According to media accounts, Arwa, the writer, escaped southern Syria for Amman; Jamil al-Abyad, the pseudonymous director, lives in an undisclosed location; twins Mohammed and Omar Malas, the actors, lived in Beirut during the first season and in Cairo during the second. But regime

repression worsened and divergences emerged in the group: Arwa clung to his pacifism—evident in the series' emphasis on nonviolent resistance, but the Malas twins grew more supportive of the Free Syrian Army and violent opposition to the Assad regime.[127]

As the series burgeoned, various Syrian and non-Syrian activists helped with a variety of tasks, including English-language subtitling, underscoring that creative insurgency is indeed a collective effort. Whereas personal savings and pro bono work (camera, editing, translation, puppet-making) underwrote the first season, on March 26, 2012, Masasit Mati put out a call on Kickstarter, "the world's largest online funding platform for creative projects," to foot the second season's bill. The appeal introduced the group, explained the need for funding, and declared that "None of Masasit Mati will receive a salary from the funding." It also stated plans to broaden *Top Goon*'s audience via social media and satellite television, shared a production timeline, and flaunted audience feedback and positive media reviews. But after it attracted only "36 backers" and "$2,683 pledged of $20,000 goal" during the one-month posting, Kickstarter on April 25, 2012, declared it unsuccessful.[128]

Although the first season of *Top Goon* had flourished, the second season fizzled. Episodes in the second batch acknowledged new sources of support: Noss Tuffaha and the Prince Claus Fund.[129] Noss Tuffaha (Half an Apple) is a Syrian group that gained online visibility during the uprising, producing revolutionary music videos and posting them to YouTube. The Prince Claus Fund is an Amsterdam-based foundation supported by the Dutch Ministry of Foreign Affairs and the Dutch Postcode Lottery, which funds projects "with partners of excellence, in spaces where resources and opportunities for cultural expression, creative production and research are limited and cultural heritage threatened."[130] Nonetheless, season 2 was less successful, for it seemingly unsettled the fragile equilibrium between the comical and the macabre evident in the first season. As Jamil, the director, described the second installment, scenes were "more tragic. I think we lost a sense of humor that we had in the first series. The tragic element is greater. At least six scenes end with the death of the main character."[131] The growing duress of life in Syria surely showed through the second season, which was also the last. Some creative insurgent forms have shorter lives than others.

GIVING BASHAR THE FINGER

*T*op *Goon*'s successful incorporation of global popular culture publicized the show to an international audience, but what other attributes account for its wide circulation and critical acclaim? One way to answer the question is to consider *Top Goon* as a crossbreed of political theater, finger puppetry, and digital video and then probe how these components contribute to making *Top Goon* an exemplary form of creative insurgency. *Top Goon* is not the first instance of "resistance" theater. During World War II, for example, anti-Nazi theater in the Greek mountains instilled notions of resistance in common folk.[132] Theater and puppetry have a long history in the Middle East, and both Egyptian *khayal al-dhill* (shadow theater) and Turkish *karagöz* were already popular in the Middle Ages. Both were performed at the court, enjoyed by rulers, and occasionally controversial. A few centuries later, during the 1919 Egyptian revolution against the British, street theater and puppetry nourished an insurgent energy.[133] In 2012, Masasit Mati snuck back into Syria and held a live performance in Manbij, near Aleppo.[134]

The year 2011 resonates with 1919. In 1919 revolutionary Egyptian vernacular, theater was on a par with the satirical press and colloquial songs as brokers of a rising national identity.[135] The British, fearing the impact of street theater, ordered all theater activity to cease in Egypt for a month in March and April 1919, and a hundred years later, in February 2011, Mubarak cut the Internet in Egypt for a few days. Both actions had unintended consequences: by angering people, including, in 1919, famous actors and directors,

and in 2011, social media users cut off from their computers, they added to the number of demonstrators. Tools may change, but dynamics of control and contestation are rather consistent over time.

Masasit Mati's adroit inversion of the puppets-and-masters scheme no doubt contributed to *Top Goon*'s success, for the web series drew on a rich tradition of politically engaged drama and a familiar repertoire of puppetry metaphors. Like anti-Nazi Greek theater, *Top Goon* attracts people who are amenable to engage in symbolic resistance, though not sufficiently motivated to bear arms. Artful, nonmartial dissent is significant because the absence of nonviolent outlets might lead people opposed to violent action to sit out activism altogether. Jamil, *Top Goon*'s director, explicitly connected comedy and resistance when he said, "Comedy strips things bare and *gives you the strength to fight*."[136] He also told the Syrian writer and filmmaker Mohammed Ali Atassi that "the puppet theatre that we are presenting is like the demonstrations in which we took part. In both cases we have violated what was prohibited and bypassed the red lines. . . . When I play . . . Beeshu . . . I have the same feeling . . . that . . . provokes me to shout in the streets of Damascus: 'The people want the fall of power.'"[137] A thirst for popular sovereignty motivates *Top Goon*'s creators, as it does other creative insurgents.

Top Goon blends four generations of media: the human body; fabric, paper, and wood; a video camera; and the global web. The first moves the second, the third captures the movement of one and two, and the fourth circulates the trio through the Internet. *Top Goon* mobilizes a wide gamut of resources, from the kinetic energy of human fingers to the circulatory vitality of digital communication. Technological change has cast puppetry in a new light. In 1991, the U.S. chapter of the Union Internationale de la Marionnette created a new Citation of Excellence for "puppetry in video," later expanded to include "all recorded media," granted that "technology must not . . . create the puppetry, only . . . record it. . . . The performance must be at all times under the control of a live, human puppeteer, performing in . . . real time."[138] Experts identified several kinds of puppetry-digital hybrids, including "docu-puppetry," which employs "cropping and re-editing" and "depiction in puppet performance of factual and authoritative material, illustrating historical, social or cultural phenomena."[139]

This background is important because understanding *Top Goon* as "docu-puppetry in video" emphasizes creative insurgency's capacity to doc-

ument atrocities. It also highlights the medium of online video. A vital tool of creative insurgency nowadays, online video enjoys wide distribution and gives *Top Goon*'s original puppet performances an ample audience. This is reflected in elevated digital metrics of popularity such as "views" and "likes," but also in global and positive media coverage, helped by YouTube. Through online video, *Top Goon* spoke a lingua franca. As the video artist Tom Sherman argued in 2008, video "is the vernacular form of the era—it is the common and everyday way that people communicate." More important for creative insurgency, personal video reflects individual identity.[140] Though Sherman exaggerated the banality of video when he described it "as common as a pencil for the middle classes," he underscored video's potential as tool to fashion revolutionary selves and to spread revolutionary feelings because a production like *Top Goon* is accessible through television screens, laptop computers, tablets, smartphones, and even wristwatches.[141]

The ability to view a video as many times as you like helped *Top Goon* be visible. Marshall McLuhan, an early prophet of the information age, once surmised that instant replay was "the greatest invention of the twentieth century."[142] The ability to replay, resend, and retweet episodes fueled *Top Goon*'s borderless visibility. As filmmaker and postcolonial theorist Trinh Min Ha wrote long before the advent of Web 2.0, strategic repetition contains "seeds of transformation" through "circulation," "intensity," and "innovation."[143] By enabling practices of commentary, annotation, and circulation that ensconce the video in various narratives of creativity and rebellion, the architecture of the Internet amplified awareness of *Top Goon*.

Aside from political theater and digital video, are there any characteristics inherent to puppetry that might explain the emergence of *Top Goon* as a distinctive cultural production of the Arab uprisings, an exemplary form of creative insurgency? I am inclined to think so. Every time I click "play" for one of the episodes, I experience a strange, ambivalent enchantment. What is it about Beeshu, Peaceful Demonstrator, Rose of Damascus, and Shabih that makes them at once unbending yet moving, arthritic yet pathetic, pure yet evil?

Reduced models have a powerful effect on us. In Western aesthetics, from Aristotle to Lévi-Strauss, small is perceived to be beautiful. A miniature is "cute" or "exquisite."[144] *Top Goon* marionettes have both the size and the level of detail that explain much of the magical properties of miniatures.[145] But small, as John Mack notes in *The Art of Small Things,* is also powerful

and dangerous.[146] A venomous insect is "sneaky" or "stealthy," slight but lethal. But marionettes do something more, for the "combination of freedom and unfreedom" in puppets may clue us to our own innermost feelings.[147] The same phenomenon explains the magic of toy theater—its small scale compels us to imagine ourselves to be smaller, more vulnerable. Once the curtain opens on that minuscule world, we must adapt to fit its scale and logic.[148]

Here is where the peculiar alchemy of puppetry kicks in. Puppetry opens up new ways to comprehend our world. It establishes in our minds a vivid clash between the miniature and the monumental. The starker the contrast, the harder our imagination has to work in order to resolve the incongruity that arises—in the case of *Top Goon,* between finger puppets, whose entire stage is sufficiently small to be portable, and the blood-soaked, fire-molten, bomb-wrecked unraveling of a country. If we recall that puppets stir emotional responses because they capture tremendous drama in teeny form, then we realize that the more wretched life is in revolutionary Syria, the more poignant we perceive the puppets' performance of that existence to be. *Top Goon* shows that "the miniature has the capacity to make its context remarkable."[149]

By capturing Syria's collapse in a humanly portable arena, *Top Goon* allows us to see the Syrian cataclysm in its entirety: the abominable dictator, his sadistic enforcer, his slobbering sycophants, the brittle yet steadfast demonstrator, the perfidious media, the harrowing atrocities, the turpitude of clinging to power, the fecklessness of the West, the meddling of the Arab petro-monarchies all come together in a world so small you could carry it and walk away with it on your own—useful for peripatetic performers perpetually sidestepping Bashar's *mukhabarat.* Finger puppeteers lob arrows at the despot while giving us a sweeping vista of national calamity from our chair. We get an aerial view of their nation's undoing without taking off from the ground.

The minuscule and the gigantic are relative. The French anthropologist Claude Lévi-Strauss famously considered the large paintings of the Sistine Chapel to be a reduced model, "because the theme they illustrate is the end of time."[150] What he was trying to say is that no matter how big something appears to us, there is, somewhere in the world, another object so enormous that it dwarfs what we previously perceived to be huge. Though we may find reduced models challenging to perceive, Lévi-Strauss wrote, we suc-

cumb to their logic because diminutive things paradoxically help us under-stand bigger, more important issues.[151] The Latin American critic Nestor García Canclini reached a similar conclusion as he observed how Mexico's National Museum of Anthropology staged the national heritage. Disposing many miniatures together, he wrote, "can have a monumentalizing effect. It brings us closer to the abstract or invisible entity alluded to [the nation] and allows us to apprehend it in a single gaze."[152] In other words, puppetry re-adjusts the scale between human body and body politic. And like the min-iatures in the museum, which in García Canclini's words "seduce" rather than "overwhelm" visitors, so do the finger-sized characters of *Top Goon—Diary of a Little Dictator* beguile us into becoming willing, laughing, co-conspirators in the Syrian uprising's anti-Assad narrative.[153]

In this case, miniaturization, as a technique of gradual creative insur-gency, worked by merging puppetry and parody. This fusion is effective because finger puppetry's diminutive scale paradoxically amplifies parody's ability to turn the dictator into a mere representation of him.[154] The pa-rodic leap from Bashar to Beeshu produces an enfeebled, gnarled avatar of the tyrant, a downsized figure that invites scorn and ridicule. In effect, through the heroic efforts of the members of Masasit Mati, *Top Goon* turns the dictator's classical body into a grotesque corporeality. Repeated ad infinitum by thousands of eager fingers pressing "play" and "replay," it whittles down the body of the sovereign and begins to extricate members of the body politic from his deadly grasp. Nothing dispels the illusion of an eternal, mystical *corpus politicum* like a tiny, wacky, effigy sputtering, "I am not crazy."

A crossbreed of various media, *Top Goon* enjoys what we may call, bor-rowing from biology, hybrid vigor, the resiliency that characterizes plants of mixed genetic origins. By quickly cutting through the chatter of revolu-tionary media, reaching a large number of people and attracting attention to itself, *Top Goon* shares with hybrid offspring "rapidity of growth," "gen-eral robustness," and a "degree of dissimilarity" from its individual compo-nents.[155] This contributes to an aesthetic as spooky as it is alluring to a people who enjoyed the drubbing it gave their chief tormentor.[156] *Top Goon* was a collective way of giving Bashar the finger.

As a doomed dictatorship doubled down on death and destruction, *Top Goon*'s finger puppets compelled us to contemplate the revolutionaries' side of the story. In the battle between the regime's and opposition's narratives

of the Syrian rebellion, in the slovenly propaganda war online, on the airwaves, and on the street, the puppeteers of *Top Goon* held a considerable asset. As Heinrich von Kleist revealed in a famous 1810 essay, "On the Marionette Theater," the puppet "speaks to a higher order of innocence."[157] During rehearsals, the Masasit Mati actors sometimes stopped, overcome by strong emotional connections with their finger-sized creations. One of them told the Syrian journalist and filmmaker Mohamed Ali Atassi that "often we said to ourselves that Bichou [Beeshu] is just representing the President of the Republic and that he is not guilty of the acts of the latter."[158] That a finger-sized dummy was able to elicit such intense human emotions reflects how inhuman Bashar had become for the puppeteers. The affective bond also betrayed the great deal of emotional labor that goes into creating puppets.[159]

Indeed, the protagonists of *Top Goon* assert the original idealism of protesting against murderous dictators, even as the antiregime Syrian opposition, coming to encompass unsavory groups with extreme political ideologies masquerading as religious beliefs, commits its own atrocities. It is as if, with every replay, Beeshu, Shabih, and Peaceful Demonstrator reclaim the unimpeachable guiltlessness of the youngsters of Der'a who in March 2011 ignited the popular rebellion with antiregime graffiti and their peaceful acolytes who protested countrywide, only to be mowed down. They preemptively exorcised the rise of Daesh and its sinister savagery.

In a November 8, 2012, interview with the Kremlin-operated television channel Russia Today, one year after *Top Goon* came to life, Bashar al-Assad responded to British prime minister David Cameron's public muttering about offering Assad safe passage out of Syria. Assad said, "*I am not a puppet,* and I was not made by the West to go to the West or to any other country. . . . I am Syrian. I was made in Syria. I have to live and die in Syria."[160] Two months later, in his January 6, 2013, speech at the Opera House in Damascus, Assad repeated his disclaimer about not being a puppet, belittling his opponents as "enemies of God and *puppets of the West,*" refusing to negotiate with them because Syria wanted its interlocutors to be "masters . . . not servants."[161] Bashar's "I am not a puppet" echoes Beeshu's "I am not crazy," the lament the puppet predicates at the beginning of each episode of *Top Goon*. It is as if haunted by his avatar, the autocrat lapses into a visceral, however diffident, rebuttal. Does this blunder showcase a dictator taken aback as the gravity of the people's defiance sinks in or does it

belie a callous obstinacy? More tantalizing is the prospect that, somehow, the dictator watched the puppet, and that as a result Beeshu got under Bashar's skin, therefore penetrating the bounded classical body of the dictator and infecting it with the notion that he might be nothing more than a minuscule marionette after all.

Regardless of what Assad's repeated invocation of puppets and masters meant, it reflected the symbolic power of *Top Goon,* a sterling paragon of creative insurgency.[162] Bashar al-Assad, the omnipotent despot whose monumental posters have lorded over Syrians countrywide, whose portrait is everywhere on television and a fixture in government offices, becomes Beeshu the finger puppet, ostensibly insignificant but in effect commanding as a harbinger of a momentous turnaround. In his tininess lay the prospect of the dictator's body politic separating from his body natural, letting the latter decay and perish, freeing the people to reconstitute the Syria of their aspirations.

Ultimately, to the extent that exorcism is a kind of therapy, *Top Goon's* power to enchant may reside in the ways Beeshu acts as an accidental healer. Like the dactyls of Greek mythology, minuscule, phallic, healing magicians, Beeshu begins to soothe the harm Bashar inflicted on Syrians. Puppets are indeed therapeutic: international NGOs have been using puppetry to help Syrian children cope with wartime trauma, reflecting the belief expressed in the headline "Puppets Help Children to Deal with Disasters, War and Poverty."[163] Beginning with children, the most vulnerable members of the body politic, watching *Top Goon* is akin to participating in a healing ceremony aiming to repair Syrian bodies. As in spirit possession, the body, its boundaries violated, is both vulnerable and volatile. By hinting at a repair of the Syrian body politic, *Top Goon* shows a new way forward, enchanting us with a vision of a better future. It tantalizes us with the prospect that "puppets are the size of fallen and exiled gods, gods that have shrunk down and gone underground, or taken up residence on earth as minor demons."[164]

IN SICKNESS AND IN HEALTH

*O*n May 16, 2011, the Syrian singer Assala posted the message "Letter to Syrian Revolutionaries" to Facebook, in which she lauded the insurgency against Assad and followed with a flurry of media interviews. But the significance of Assala's stance did not fully sink in until news came out of a song she herself had composed and planned to release. The song, "Oh, If Only This Chair Could Speak!" was scathing toward Assad. "All the chairs have been smashed . . . the people no longer listen to you. All the killing won't help you," she said to the ruler of Damascus. When a television interviewer asked Assala about the lyrics, she chanted, "If this chair could talk, it would have screamed and complained. . . . The chair can no longer tolerate the Pasha who is getting heavier and heavier. When the chair told him to get off, he carried his weapons and said maybe. But the leader got his sword out to kill the people."[165]

The song struck symbolic blows at the body of the dictator. The tyrant's chair, like the monarch's throne, is the seat of power, an essential trapping of the sovereign. In medieval times the throne conjured the divine, and even in an ostensibly secular dictatorship like Assad's Syria, the ruler's chair symbolizes nonearthly power.[166] By personifying the chair, which tells Assad to leave for it could no longer bear the "heavier and heavier" weight of his body, Assala's song goes to the heart of the king's corporeal duality. The song depicted Assad's biological body as an intolerable burden on Syria's body politic. The despot's "maybe" was a bitter flashback to a time, early in the Syrian uprising, which started in March 2011, when Assad promised

political opening but delivered more repression. The reference to other dictators' "smashed" chairs evoked the inevitability of Assad's demise (like that of Ben Ali and Mubarak) and signaled that the battle to come was about the summit of Syria's body politic.[167]

A vicious cyberwar cut through the chatter of the Syrian revolution, amplifying and contesting Assala's gauntlet. By May 2011, the Syrian Internet was abuzz with videos documenting the revolution's achievements and setbacks, showcasing rebellious Syrian bodies. But the regime used social media to ensnare opponents via Facebook and disseminate propaganda via YouTube. As if this were not enough, shadowy henchmen known as the Syrian Electronic Army stalked Assad critics and hounded the media through which opponents spoke. They hacked websites belonging to Qatar and Saudi Arabia and Western media like Twitter and the *New York Times*. But video was the master medium in this cyberwar, with both sides flooding the Internet with a wide variety of audiovisual snippets, from satire of Assad's giraffelike appearance or donkeylike behavior, to grim documentation of chemical weapons use, to exactions and depredations committed by the many sides of the conflict. Stalkers and hackers, journalists and activists, politicians and ordinary folk liked and shared, mocked and scorned, defended and glorified one or the other contestant in this dictator-against-celebrity death match. Rival narratives swirled through the digital ether.

Body symbolism pervaded the Assala-contra-Assad cyber death match, linking the body of the star with that of the dictator, branching out into discussions of patriotism and betrayal. Opponents used Assala's childhood poliomyelitis and her treatment at the state's expense under Hafez al-Assad as a bludgeon against the rebellious singer. Official media, which until that moment had not focused on Assala, made much of other singers accusing Assala of ingratitude, for "throwing stones in the well you drink from."[168] Saudi- and Qatari-owned media were sympathetic to the singer, who in one television interview demanded that "this regime of tyranny should end. . . . We want a country that . . . we feel we own a part of, not one that we feel only belongs to a single person. Nations cannot belong to one man; they belong to a whole people."[169] This is a scathing attack on Assad's personification of Syria and on the identification of biology with sovereignty at the heart of the ruler's corporeal duality.

Retaliation by loyal members of the body politic headed by Assad started as a family affair.[170] Assala's brother, with whom she has had recurring

disagreements, appeared on television, badgering his sister for treason, feverishly clutching a portrait of Bashar al-Assad's father, Hafez, and, in a histrionic fit of body imagery, pledged to self-immolate along with his son if Assad were to be ousted.[171] Threatening a protest suicide was tantamount to cornering his sister to recognize that as limbs in the body politic, they would not survive its decapitation. In addition, brandishing the likeness of the dictator's father, who died in 2000, recalled royal funeral effigies in France and served as a vivid reminder to viewers that even after a decade of decaying underground, the body of the old despot remained symbolically powerful through his son's sovereignty. As time passed, the cyberwar shifted into a protracted simmering battle punctuated by vicious outbursts, but throughout 2013, body symbolism remained at the center. Most vehement were invectives between Assala and Raghda, a pro-Assad Syrian celebrity, who stridently focused on the Assads' medical backing that years earlier rescued Assala from living in a body deformed by polio.[172] The body of the leader, Assala's foes intimated, healed the body of the celebrity, who reciprocated with ingratitude and treason.[173]

Assala was no ordinary Syrian singer. Calling herself a "conservative Syrian woman" who eschewed the sultry antics of Egyptian and Lebanese pop stars and sang a repertoire that hewed to the classics, Assala was considered a genuine article. As if to accentuate this, her very name, Assala, is Arabic for *authenticity,* a deeply resonant notion in politics, culture, and *Baathist* ideology.[174] Thoroughly political under the iron lid of autocracy, authenticity was explosive in revolutionary times. What is more, Assala recorded patriotic songs and performed in official venues in her youth, intoning encomia to Hafez and Bashar that would come back to haunt her. To the father she sang, "We shall sacrifice our souls and bodies for you, under your shadow we shall unite, with your glory, the country shall flourish"; and to his son, "Syria, your people speak with one voice. . . . O Syria, Bashar is your promising hope and the protector of your dreams." These became regime propaganda hymns, tethering a singer called "authenticity" to a dictator whose name means "lion."

But by 2011, Assala's fame went far beyond Syria's borders to the realm of pan-Arab celebrity, so accusations of treason found fodder in Assala's multiple extranational moorings. The Syrian singer was a citizen of Bahrain, a resident of Cairo, and had her own talk show, *Soula,* on a television channel in the United Arab Emirates. In previous interviews, she had sometimes

discussed her love for Egypt and Saudi Arabia, telling a journalist in 2005 that she felt "a not ordinary belonging to Egypt" and considered Saudi Arabia her country, "for providing . . . financially and mentally for many years."[175] Such efforts to curry favor with the Arab world's most populous market and its richest country grated against Syrian pride and patriotism, so it was no wonder that Assala's opponents cast her words as alien threats to Syria's body politic. And again, members of the singer's family took the lead, with Assala's sister Rim rebuking her rebellious sibling and asserting Syrian sovereignty by speaking against the revolution and foreign intervention, saying, "We Syrians can judge what is happening from within . . . through dialogue not through a revolution."[176] Pro-Assad satellite channel al-Dunya went further when it accused Assala of endorsing "the crimes of the armed gangs against the nation" and of being "merely a cheap tool" in the "dirty war" against Syria.[177]

Cyberwarriors were even less restrained than scornful kin and hostile media, and they unleashed a barrage of attacks via YouTube mash-ups, Facebook hacks, and troll commentary on the star's own online appearances. One day after Assala posted the "Letter to Syrian Revolutionaries," hackers from the "Syrian Electronic Army-Syria's Falcon" (echoing standalone names for battalions of the short-lived Free Syrian Army) penetrated her Facebook page with the simple yet devastating "you are a traitor to the nation."[178] Nasty videos hammered the theme of Assala's diseased body having been healed by Assad's eternal body; for example, "She forgot that she would not even be standing on her legs were it not for the late Hafez al-Assad may he rest in peace. She is a bug that deserves to be squashed."[179] They pitted Assala's diseased child body's dependence on the sovereign with her healed adult body's betrayal: "If only this nation could talk. You had crooked legs but have learnt to walk at the nation's expense. . . . If this nation could only talk, [it would say] . . ."[180] The body of the star and its fraught bond with the body of the despot remained front and center in the cyberwar.

Other digital trolls spawned scornful spoofs of "Oh, If Only This Chair Could Speak!": "If only this nation could talk and respond to you. You have forgotten what Syria has given you. You have sought refuge in the Gulf and on the Nile and have sold the soil of Damascus . . . you do not deserve to be Syrian."[181] Another video mocked the singer's expression of admiration to U.S. president Barack Obama, with photoshopped hearts offering a stark

contrast with U.S. support to the revolution, then featured words of wisdom from the "eternal leader Hafez al-Assad" saying that "crises . . . test people's authenticity," then accusing Assala of treason: "Your essence [Arabic *'asl*] has been exposed. The Syrian people know that you are trash and inauthentic. Stay in Egypt, live and die in Egypt, and write in your will that you want to be buried in Egypt or anywhere else on the planet except beneath Syrian soil."[182]

Childhood polio created a bond between singer and sovereign, a relationship where care mingles with rebellion and where medical rhetoric ran amok. It was as if their two bodies were condemned to a game of attraction and repulsion that had now exploded online, dispersing their dueling bodies into digital smithereens, shifting and recombining *corpi* locked in a battle like mutant manga antagonists. From the perspective of her attackers, Assala was beholden to Assad, in sickness and in health, and should pledge loyalty and obedience. It was through the dictator's nurturing embrace that the budding artist had recovered from a deadly disease.[183] She owes him her survival and lives only through his omnipotence. Having betrayed her savior, she ought to be rejected, like a gangrenous limb excised from the body politic lest it infect the nation with her diseased body and ideas. What is more, as one of the videos made clear, Assala was an insect to be crushed. Bugs, like disease, can surreptitiously cause harm to the body, so they must be annihilated. But calling someone an insect, like Assad did when he referred to the rebels as germs, and like an Israeli general before him did when he referred to Palestinians as "drunk cockroaches in a bottle," was tantamount to denying their humanity. Repudiation is one thing, but dehumanization dramatically raises the stakes of the battle.[184]

Assala confronted her denigrators with every means at her disposal. In addition to her Facebook page and Twitter feed, the singer used the bully pulpit effectively, giving interviews to the two leading pan-Arab television channels, al-Arabiya and al-Jazeera. This enabled her to defend herself to a wide audience. But when Assala claimed in October 2011 that her political stance had been "misunderstood," she appeared to be caving in to threats.[185] She bounced back on al-Jazeera in April 2012. Admitting that threats had coerced her to renege on the song release, she invoked her childhood sick body in self-defense. The star argued that Assad treated her in return for services she had rendered to his regime, singing in official events since she was eleven, even having to leave school at fifteen: "This was all for free. So

the government paid me back for part of what I deserved."[186] Assala's performances, then, were quid pro quo transactions, not declarations of fealty, and even as she sang Assad's praises, Assala was never totally incorporated in the body politic he headed.

Though it is often difficult to identify a winner amidst the digital mud-slinging of cyber and media wars, the clash raises intriguing questions: Why did Assala, a singer who a few months before the Syrian uprisings was still an apolitical celebrity, emerge as a vocal and visible public figure in the Syrian revolution? Why did the Istanbul-based self-identified Syrian governments-in-exile fail to endure or gain traction as credible representatives of the revolution? Why didn't a central figure rise from among the field commanders heading contingents of Syrian rebel fighters? What prevented the advent of a leader who would unite the opposition and steer it toward ruling Syria?

External influences partly explain the impotence of the opposition. The sheer number of foreign players makes coordination impossible. The United States, the United Kingdom, and France have sought to influence the opposition, often in different directions, but the lack of a unifying vision shared by regional players like Turkey, Qatar, and Saudi Arabia has wreaked havoc. Turkey, which shares a long border with Syria and hosts the official Syrian National Council and the leadership of the moribund Free Syrian Army, has facilitated the entry of thousands of non-Syrian fighters into the conflict zone. Saudi Arabia and Qatar have championed different individuals to head the Syrian National Council and funded different groups on the ground. At some point, there were dozens of armed groups battling Assad and one another, but the emergence of al-Nusra Front, al-Qaeda's formal representative in Syria, and Daesh, has reshuffled forces. A half decade into the uprising, radical jihadists dominate an opposition congenitally unable to produce a credible leader.

The nature of Assad's regime is another reason for the opposition leadership vacuum. As in other authoritarian systems, the sovereign absorbed civil society. The state effectively controlled most means of political activity and public discourse. The creative professions were fully under its thumb, from the commissioning, funding, and showing of films to providing salaries, housing, and health care to artists and writers, from micromanaging appointments at the country's few universities and newspapers to the printing and distribution of books. The national economy was controlled by a ruling

kleptocracy close to Assad, and formal political life was under the control of the Baath, the single party-state, even if the regime has occasionally allowed docile cosmetic political groups to appear. Before the revolution, a crushed public sphere preempted the emergence of leaders of any kind. Since the onset of the uprising, political infighting, social fragmentation, external intervention, and the hardship of war have had the same effect.[187]

The absence of leaders paved the way for Assala to cut through the cacophony of the Syrian opposition, but she did not come out of the blue. The star had been building up symbolic capital for a long time. A celebrity of her caliber, who was at some point an important voice for the regime and who was also a commercially successful singer, conferred credibility on Assad's regime. For the regime had staked political and financial capital on the makeover it initiated, facilitating the emergence of a private sector, including media and advertising, and of a consumer society and the promise of a "good life."[188] But no one had any illusion about the regime's abiding grasp. As a Syrian bureaucrat told the political scientist Bassam Haddad, "It's true, this regime helped the private sector grow, but it will never tolerate a strong private sector. *I am under your control when I am a twig in your hand, but not when I become a palm tree.*" The arboreal metaphor of trees and twigs echoes the corpus and limbs of the body politic.[189] If in the West celebrities legitimate capitalism, the type of credibility that a glamorous and once loyal star like Assala provided was vital for the Syrian body politic, because in its combination of political energy and commercial ideology, it consecrated Assad as the head by making his power concrete to Syrians.[190] Turned into a vocal, visible vixen by the revolution, Assala posed a palpable threat to the ruler of Damascus.[191] In that she was unique.

By militating against the tyrant, Assala bucked a trend that has prevailed from Syria to Tunisia—most singers and actors have stood by dictators, who were happy to cash in on the symbolic capital of popular fame. Some Tunisian singers hedged their bets on the uprising before declaring in favor of the winners, leading to accusations of hypocrisy.[192] The Egyptian uprising divided movie and pop stars there, some siding with the rebellion, others with the Laughing Cow, and a third group staying mum. In both countries, folks in the creative industries abhor Islamists' moral puritanism and cultural suppression, so they backed military officers. In Syria's bloodier rebellion, some television and film stars criticized Assad, but they were drowned out by others' ardent support for him.[193] Assala's activism draws

　　　　　　　　　　　　　　　　　　　PUPPETS AND MASTERS

on an older model of politically engaged female stars—the legendary divas Asmahan of Syria and Umm Kulthum of Egypt. Umm Kulthum remained under the aegis of the state, so Assala's political journey hews more closely to Asmahan's, a famous Syrian princess, singer, lover, conspirator, and spy in the 1930s and 1940s, a striking transnational figure shuttling between Damascus and Jerusalem, Beirut and Cairo, hobnobbing with Syrian aristocracy, Ottoman officers, and possibly Nazi operatives.[194] The death of Asmahan, glamorous and incandescent, befitted her stardom. Like Grace Kelly and Princess Diana, she perished in a speeding car.

Assala's revolutionary foray is a peculiar contribution to creative insurgency. Whereas regular, often anonymous insurgents use their creativity to craft compelling revolutionary messages, Assala's fame meant that her body was the message. In a dictatorship in which politics is a spectacle centering on the ruler's body, but in which market-driven stardom is semiautonomous from the ruler's grasp, celebrity is one sphere where a counterspectacle could be mounted. As we have seen from exchanges in the cyberwar, Assala's spectacular body helped depersonify Syria from Assad, desubstantiate his power, and therefore decapitate an oppressive body politic.[195] Her recurrent claims "we want a country we belong to and not following one person" and "I reject my country's reduction to his person" fractured the regime's symbolic architecture that stitched the ruler to the nation.[196] Her celebrity body substantiated the power of the opposition to the dictator, signaling a fundamental shakeup of the Syrian body politic was at stake. She in effect drove a wedge between the dictator's body natural and his body politic, and it is the threat this poses to Assad that best explains the recurrence of her poliomyelitis in the cyberwar. Assala's attackers were basically saying that by severing herself from the dictator's body after that body had healed and nurtured her, Assala was both treasonous and suicidal.[197] So why did it have her opponents in such a tizzy? After all, only some lyrics were leaked online, and as a song, as lyrics performed to a melody, "Oh, If Only This Chair Could Speak!" never existed. What lurked behind the anger and anguish of regime supporters was the frightening prospect that Assala's body was a substitute to their sovereign's.

Assala's insurgency showed that the Syrian body politic was not healthy and united, but diseased and fragmenting, and that the source of its ordeal was its head. The more violent the Syrian rebellion became, the more Syrian bodies visibly broke away from the moribund body politic, and the more

Assad's power cracked. Wounded but not killed, controlling one third of his country's territory, Assad's body was residually sovereign, his power not fully sapped. A ruler who was no longer sovereign but who remained deadly battled several armed opponents to claim a population that was no longer acquiescent but not yet emancipated. Fractured regime, fragmented opposition. Such was the depth of Syria's disarray when the rebellious star entered the fray, and since then the chaos has worsened.[198] The specter of death that is darkest in Syria, constant in Bahrain, reemerging in Egypt, and lurking in Tunisia raises the question, Is it time to eulogize the Arab uprisings?

PART V

Virgins and Vixens

———

The Naked Blogger of Cairo mixed art, politics, and intimacy. Were you to scroll down *A Rebel's Diary* home screen after seeing Aliaa al-Mahdy's nude body selfie, you would see another photograph of her, standing with wet hair against a backdrop of shiny tiles, as if exiting the shower. Further down you would encounter the picture of a man, sitting naked on a wooden chair, left arm under the chin à la Rodin's *The Thinker,* right arm stretched to hold an acoustic guitar, right leg thrusting forward, left leg bent, a turquoise rug hanging in the background. Scroll back to the top right, and you would glimpse al-Mahdy in a brown sweater and matching plaid skirt, a book bag flung on her left shoulder, arms clasped, standing under a sign saying, "Waiting for Freedom Square." Cast your eyes downward again, and you would riffle through the female symbol with a naked woman's bust and raised fist, then an Egyptian flag with the usual upper red band and lower black band, but with a modified middle white band: instead of featuring the golden Eagle of Saladin, the center of the flag is bedecked with eighteen symbols for as many religious beliefs, with the caption "secularism is the solution," an antithesis to the Muslim Brotherhood's slogan, "Islam is the solution." The rest of *A Rebel's Diary* features political slogans, nude photographs, and

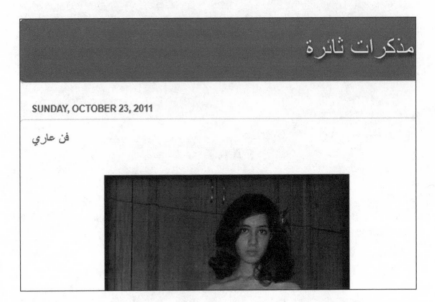

FIG. 7. *A Rebel's Diary*, blog, 2011 (AFP Photo/Stringer/Alia-Al-Mahdy Blog/Getty Images).

drawings by various artists; comments; explanations; and rebuttals between the blogger and readers (Fig. 7).[1] The blog was the first in a series of incidents that put women, their bodies, and representations of women's bodies at the very heart of revolutionary struggle. Part V tells their stories.

THE NAKED BLOGGER OF CAIRO

*A*l-Mahdy lit the controversy ablaze in mid-November 2011 when she tweeted a link to her blog. In the ensuing days, many stories appeared in the Egyptian, Arab, and global media, causing thousands, then hundreds of thousands, then millions to visit the blog (more than nine million page views in three years). In the previous decade, a vibrant Egyptian blogosphere had developed, so blogs had a ready audience in the country. The uproar itself was not surprising, but its one-sidedness was startling. In the scuffle that followed her stunt, virtually every single political grouping in Egypt condemned al-Mahdy. The magnitude of the young woman's isolation sunk in when even the secular April 6 Youth Movement promptly repudiated her.[2] Alumni of the School of Shari'a called for capital punishment. Condemnations piled on from actors across the political spectrum, liberal and conservative, secular and religious, Muslim and Coptic, congealing in a consensus that attacked al-Mahdy's credibility, questioned her intentions, defamed her character, and blasted her timing. Denunciations drowned perplexity about the young woman's motivations. Threats to her life fanned from speeches, sermons, and social media.[3]

Most reactions condemned al-Mahdy's nudity on moral grounds, but at least one commentator signaled that nakedness connoted an extreme form of transparency that resonated powerfully with other developments in the Arab uprisings: "Aliaa," he wrote, "by the simple fact of displaying her nudity, is trying in her bold way to raise questions that embarrass society in its most embarrassing locus, which is the example of youths that direct their

bare chests to bullets, and leaving their bodies exposed does not only receive bullets from the government alone but also from society. This is an act that to many may appear like madness, but in madness, sometimes, there is a lot, a lot of reason."[4] The author, whose lucidity benefited from the distance that comes with publishing in a pan-Arab newspaper based in London, rather than a Cairo publication caught in the fever of revolution, flagged links among nudity, truth, and violence. But his was a rare voice, drowned in a chorus of anger and disapproval, and in the desire to restore boundaries broken by al-Mahdy.

Indeed, an observer of the scandal may puzzle over the array of graphic devices that media outlets used to conceal al-Mahdy's groin and chest. Take your pick of color and shape: A red oval or a yellow band? White lines or black rectangles? A strategic blurring of the picture? Every one of these showcased a different way to parcel out and control the public appearance of a woman's body.[5] Then this question may come to mind: Why did this case garner frantic global media attention, dwarfing interest in other Egyptian women activists such as "anti-'virginity tests'" activist Samira Ibrahim? Were you to read the blog carefully, you might then consider the following queries: Why was the male nude, whose genitals were in full view in *A Rebel's Diary,* not mentioned in the brouhaha? Why did al-Mahdy's photograph eclipse her equally explicit political message? What do we make of the contradiction between the blog's massive "popularity" and its widespread condemnation? What does the general social disturbance that met this incendiary digital body tell us about the Egyptian revolution?

The revolutionary public sphere was hostile to a woman's sexually and politically provocative body. In *al-Ahram,* the Old Gray Lady of Egyptian journalism, one columnist wrote: "Woman derives her femininity from covering her body whether she wears the veil or does not wear it, but the young man's reaction after looking at a naked woman, even if it is just out of curiosity or desire, will be one of disgust and repulsion (*al-qaraf wal ishme'zaz*) when he looks at sensitive parts of her body."[6] By triggering disgust, a woman's naked body was abject, a concept developed by the French feminist theorist Julia Kristeva to refer to horrified reactions of disgust toward things that blur boundaries between ourselves and others. Though the abject typically stems from bodily demise, decay, and discharge—corpses, excrement, and fluids—abjection is caused not by lack of hygiene but by "what disturbs identity, system, order. What does not respect borders, positions, rules."[7]

Critics assailed al-Mahdy for violating boundaries, social and political. In an essay that circulated widely in Arab cyberspace, titled "Why, O Aliaa?" Khodr Salameh, a Beirut-based leftist blogger, argued that "Aliaa al-Mahdy committed a crime against the Egyptian revolution" because she pretended to be a revolutionary and appeared "on the damned screen, put her nude photograph, calling for a sexual revolution, in a country than has been unable to complete a single political revolution, let alone a total social revolution?" Expressing a sentiment widely shared by Egyptian and Arab liberals and leftists, he blasted al-Mahdy's timing: "She comes out at a critical juncture, when the left and liberals are wrestling with the Islamists who accuse them of weakness and apostasy and other epithets resonant with the majority of ordinary folks—the revolutionaries have been stabbed from the back, and one of the female 'progressives' has added to the misery of the situation!"[8] The problem with liberals, Salameh continued, is that they have not learned the lesson of the left's experience in the previous century, in that "they have not understood yet that replicating (foreign) societies is impossible, and that we are condemned to be in tune with our milieu, our environment, and to enter into a dialogue with the Arab mind, and not treat it with the Arab shock. . . . [We need to] accept the incremental nature of change."[9] According to this logic, al-Mahdy's act hurt the secularists' political appeal and electoral prospects. What is more, her action was inauthentic politically, because she was not a true revolutionary, and culturally, because it betrayed a mimicry of Western notions of sexuality in a society that rejected those ideas.

This was the argument: al-Mahdy's act was Western in spirit, hence inauthentic. It was too radical for Egypt, a stand-in for Arab societies seemingly equipped with a singular "Arab mind," per that blogger. To succeed, activists have to push for incremental change. But this argument can be rebutted on two fronts: First, as many critics have argued, the female body has a long history of being sexualized in the Arab world and particularly in Egypt. During the first half of the twentieth century, suggestively posed women graced Egyptian magazines, and in 1950s Egyptian films, actresses dressed daringly, spoke boldly, and moved provocatively. More recently, Cairo earned infamy as "the premiere public ass-pinching, breast-grabbing, and body-rubbing capital of the Arab world."[10] The pan-Arab public sphere has for years been awash with sexually provocative advertisements, music videos, and magazines, amplified by the digital echo chamber of blogs and

social media. Second, no one directed the same argument about political and cultural inauthenticity at Mohamed Bouazizi, the Tunisian fruit vendor who torched himself roughly eleven months before al-Mahdy hit prime time. The question that arises, then, is, by what criteria are radical, rebellious, bodies accepted or rejected in the revolutionary public sphere? What is the measure of revolutionary selfhood? Can women enjoy the citizenly emancipation of revolution fully?

But before we get there, it is helpful to consider one more dilemma, posed by the multiple messages one can discern in *A Rebel's Diary*. How do we respond to a jolt like *A Rebel's Diary?* Through moral judgment? An assessment of its political effectiveness? An aesthetic evaluation? To what extent should we let al-Mahdy's own words guide our interpretation of the photograph of her own disrobed body that she took, posted, and disseminated? Grappling with these questions, we will see how *A Rebel's Diary* confounds the gradual and radical modes of creative insurgency.

Dubious in the best of times, a woman's public nudity is inflammatory during revolutionary periods. In the symbolism of the disrobed body, al-Mahdy's jolt to the revolutionary public sphere recalled Marianne, the allegorical figure of the French Revolution.[11] From a contemporary viewpoint, Marianne, most famously captured in Eugène Delacroix's 1830 painting *La liberté guidant le peuple,* remains a symbol of liberty and emancipation but is also used for other purposes. In recent years she has graced anti-Russian banners in Kiev's *maidan* and French right-wing anti-Islam websites. But from the time she emerged in 1775, Marianne fended off challenges from other symbols, until she adorned the seal of the Republic in 1792. When counterrevolutionaries mocked the nascent republic as Marianne, revolutionaries appropriated the nickname: *"La République* was 'Marianne,'"* wrote the historian Lynn Hunt.[12] But even then, male symbols replaced or incorporated Marianne, and between 1793 and 1797, politicians variously replaced or overshadowed Marianne with the male figure of Hercules as the emblem of the Republic.[13] As a woman-symbol of the nascent republic, Marianne was repeatedly contested.

A Rebel's Diary emerged in an Egypt ravaged by political upheaval and economic deprivation, social injustice, and state repression, exacerbated by quotidian violence and amplified by an ungovernable public sphere exploding with a wide range of ideas and images. Revolutionary fervor was acutely threatening to women, for they were repositories of moral virtue

and political symbolism that made their activism more tenuous and perilous than men's. A century earlier, Egyptian nationalists had adopted Western representational conventions, including the use of women as political allegories. For example, Mahmoud Mukhtar's sculpture *Nahdat Misr* (*Egypt's Awakening*), which became famous in 1920, featured a woman with her right arm resting on the head of a sphinx. As the historian Beth Baron pointed out in *Egypt as Woman,* the sculpture combined a sphinx standing tall with a peasant woman baring her body to invoke Egypt's past grandeur and modern liberation.[14] Unlike previous sculptures using similar symbols, such as Leopold Savine's 1914 statue of the journalist and nationalist activist Mustafa Kamil, who dominated a sphinx and the body of a woman, *Nahdat Misr* featured no men. What is more, in later renditions of the statue, the woman's breasts got bigger.[15] In ensuing years, the French Marianne served as an inspiration to Egyptian artists and cartoonists, who used sexuality as a metaphor for politics. But unlike France, Egypt denuded only her face, and depictions of Egypt as clothed and light skinned contrasted with Egyptian depictions of the Sudan as a woman with darker skin and "nearly naked" underscored the former's superiority over the latter.[16] The rise of the notion of Egypt as woman with the artistic depiction of an actual Egyptian woman uncovering turned the veil into a controversial symbol of both political independence and religious purity.[17]

Since then, Egypt has experienced many upheavals. The Free Officers Revolution toppled King Faruq in 1952, and political Islam ascended after Egypt's defeat by Israel in the 1967 war. Then the 1970s transformed Egypt. After the October 1973 war, as the petrol-fueled rise of Saudi Arabia eclipsed Egypt's status as the Arab world's political leader, President Anwar Sadat (ruled 1970–1981) launched economic liberalization, known as *infitah,* moving Egypt from the Soviet to the American orbit, signing a controversial peace agreement with Israel, and exposing Egyptians to the whims of global capitalism and the local corruption that market forces foster. Once looking "inevitable" and hitched to nationalism, Egyptian modernity was now "beleaguered," as Walter Armbrust put it.[18] In the Mubarak era (1981–2011), Islamic morality pervaded swathes of the Egyptian population, for whom modernity meant belonging to a world of moral piety.[19] In the ensuing Islamic revival, people focused on training their bodies to be in harmony with their moral predispositions. Through daily self-improvement, women disciplined their dress, voice, gestures, and movements, in addition to

their rational and emotional faculties, until religious rectitude "acquired the status of embodied habits."[20]

In the 2000s, sexual repression became rampant in Egypt, fueled by an explosive mix of unbridled capitalism, political corruption, religious recrimination, sexual frustrations, and social injustice. Though sexual assault and harassment are pervasive problems worldwide, in Cairo they became a social epidemic that exploded in full view during the 2011 revolution. As the city waded into infamy, the state stood by, unable or unwilling to stem the epidemic. To make matters worse, authorities administered infamous "virginity tests," an infuriating euphemism for state-sanctioned rape, used as a tool of political repression during the January 25 Revolution. Though virginity tests existed in Egyptian society and were usually performed by older women on a bride-to-be, they were not discussed in public. But the state turned virginity testing into an instrument of political suppression, equivalent to anal probes of suspected homosexual men arrested in regular police raids. If we believe, with Michel Foucault, that sexual repression is political and that power enables resistance to itself, we should not be surprised that sexual defiance emerged alongside political rebellion on the streets of Cairo and other Egyptian cities. It is against this backdrop that the polemic surrounding *A Rebel's Diary* and what it means for creative insurgency should be understood.

THE AESTHETICS
OF DISROBEMENT

\mathcal{M}oral judgment rarely edifies, and the actual political impact of al-Mahdy's nude is impossible to gauge. Considering the nude blogger aesthetically, however, helps us understand how subversive images move public discourse. Al-Mahdy, we should recall, initially cast her photograph as "nude art" in October 2011. In November 2014, she reiterated that her action was "feminist nude art/protest." What can we learn if we seriously considered her claims to artistic performance, her argument that *A Rebel's Diary* featured a nude and not merely a naked body?

The nude has preoccupied art critics for as long as it has existed in Western art. In the classic *The Nude: A Study in Ideal Form,* Kenneth Clark argued that "naked" conveys an embarrassing situation, whereas "nude" reflects harmony and assurance.[21] The nude for Clark, as the book's title indicates, is more than a subject of art; it is an exalted form that holds a special place in Western art. In *Ways of Seeing,* John Berger disagreed with Clark, writing that "to be naked is to be oneself" but that "to be nude is to be seen naked by others and yet not be recognized for oneself." Whereas for Clark the human body is a form of art, for Berger it is an object of art. As Berger explained, "A naked body has to be seen as an object in order to become a nude." He went on to conclude: "Nakedness reveals itself. Nudity is to be placed on display. To be naked is to be without disguise. . . . The nude is condemned to never being naked. Nudity is a form of dress."[22] Nudity, then, is a contrived

version of nakedness. Once the contrivance is achieved, it denies the existence of its own subject. As display, nudity carries a strategic directive.[23]

What was the key message of *A Rebel's Diary*? Did the photograph upend the academic distinction between nakedness and nudity? Together, al-Mahdy's photograph and text generated tension between sexuality and politics, which, unresolved, fueled the impassioned polemic surrounding her blog. Writing about the nude in early twentieth-century Lebanese art, the anthropologist Kirsten Scheid argued that by combining "a foreign genre and local bodies," nudes urged onlookers to think about their society.[24] Though *A Rebel's Diary*'s text was obviously political, al-Mahdy's photograph was equivocal, playing on several aesthetic, moral, and social registers and consequently giving rise to competing interpretations. That may be why the photograph took in all the media oxygen, leaving the text to suffocate in obscurity. What claims was al-Mahdy making on the people who viewed her photograph?

Before we figure out the answer, we first have to understand a crucial distinction between al-Mahdy's body selfie and nude art in general: authorship. Whereas male painters usually sign artistic nudes, al-Mahdy created and disseminated her own photograph. Authoring the representation of one's own naked body is important because it proves an ability to convey one's own thoughts, the capacity to represent one's own self, the power to lead one's own life on one's own terms—agency. In *Naked Authority*, the art historian Marcia Pointon wrote that in nude art the female body embodies the creativity of the male artist, a creativity imbued with male power and tasked with containing female sexuality.[25] The argument that the depiction of disrobed female bodies encrypts "male cerebral processes" may help us explain the commotion surrounding *A Rebel's Diary*'s initial appearance.[26] In her own room, al-Mahdy took off her own clothes, put on her own accessories, took her own photograph, posted it to her own blog, and made her own political statement. She subverted the dynamic between male creator and female model simply by being both creator and model. This reversal of roles put the power to represent in the hands of a woman willing to violate the prevailing social script, publicly and unabashedly. As al-Mahdy repeatedly emphasized, her action stemmed from an individual's desire to reject social constraints. From the outset, the political manifesto and the nude photograph cast her action as personal and political. Writing about Delacroix's *La liberté guidant le peuple*, Pointon argued that Delacroix's signature deployed "linguistic authority" to disrupt the image's "fem-

inine power."[27] By signing her own representation, al-Mahdy acted like a woman unbridled by male authority. So even if we do consider *A Rebel's Diary* a form of nude art, as al-Mahdy claims to want us to do, we must recognize that in this fundamental aspect Aliaa al-Mahdy was an exception to a time-honored principle of Western art as much as she violated Egyptian social norms. Compared to even the small number of women artists who do female nudes, al-Mahdy's full-body selfie stood out because she was at once creator, model, raw material, creation, and, by virtue of digital self-dissemination, promoter and publicist.[28]

The nude body has a charged relationship with authority. If in the French revolutionary period Liberty preserved her womanhood in the eyes of French citizens, al-Mahdy appears to have lost both her womanhood and her intended symbolic thrust in the eyes of many Egyptians. But the space between woman and allegory is a fraught one, and the boundary between them is unstable.[29] Though al-Mahdy herself never claimed to represent any specific group of women and insisted on her individuality, critics, trapped in Egypt-as-woman symbolism that began in the 1880s, nonetheless repudiated her with the argument that her actions did not represent women—Egyptian, Arab, Muslim. The volatility characterizing the relationship between women, Islam, and identity increases when nudity is involved, for the naked body connotes both truth and sexuality.[30]

Further examination of the controversy surrounding *La liberté guidant le peuple* in 1830 and 1831 can give us insight into *A Rebel's Diary* in 2011 and 2014. Inspired by the 1830 Trois Glorieuses revolution, which ousted Charles X from the French throne, Delacroix's painting was first exhibited in 1831, and by 1874 it had made its way to the Louvre.[31] In the painting, Liberty, barefoot and breasts partially revealed by a rumpled and sagging dress, brandishes the French flag in her right hand and clutches a rifle in her left hand. On the blog al-Mahdy is fully naked except for red ballerina flats, black tights, and a red flower in her hair. Enacting forward movement, one leg in front of the other, Liberty appears as a fiery and martial leader. Executing a pose, one leg open and raised, al-Mahdy appears as a feisty provocation. In the first, the flag, the rifle, the posture, and the glimpse of Notre-Dame de Paris Cathedral in the background subsume the woman in the political allegory. In the second, the space is private, the accoutrements erotic, the pose provocative. Reminiscent of a *Playboy* centerfold, the photo's sexual aura absorbs its political symbolism. Even as we

consider that nakedness also connotes transparency and truth, al-Mahdy's self-installation raises questions, for a fully naked body in natural color would have conveyed truthfulness better than a black-and-white body with cabaret-style red accessories. *A Rebel's Diary* underscores the puzzle of the bare body in which "nakedness symbolizes Truth but Nudity suggests sexuality."[32]

Because al-Mahdy's action was at once personal, political, sexual, and artistic, comparing her photograph to Delacroix's painting puts the Naked Blogger of Cairo in historical perspective. If we consider the circumstances under which the debates about *La liberté guidant le peuple* and *A Rebel's Diary* unfolded, we would conclude that, by featuring an armed, patriotic, half-naked woman stepping on naked male bodies as she guides the people to their destiny, the French painting offers a blend of sexuality, politics, and violence that is more explosive than the imagery of the Egyptian blog. After all, in Delacroix's painting, Liberty tramples on the inert bodies of men lying on the ground beneath her. The violence visible in the French painting is indiscernible in the Egyptian blog, but both triggered vitriolic reactions. Many French critics repudiated Liberty as represented in the painting as a whore. Some obsessed over her dirtiness, and by one account she was "the most shameless prostitute of the dirtiest streets of Paris."[33] Many critics, trolls, and haters of al-Mahdy used similar language.

The controversy reflected the high stakes that come into play when women's bodies storm a revolutionary political field. Just as the controversy over Liberty could not be subsumed into a struggle between French republicans and monarchists, so the polemic over al-Mahdy cannot be understood merely as a scuffle between Egyptian secularists and Islamists. By deploying her nude body with a political manifesto in the endlessly reproducible and accessible realm of cyberspace, polarized by revolutionary spasms, al-Mahdy conjured an explosive mix of sexuality, politics, identity, and violence. In doing so, al-Mahdy came to represent Egypt, or to be more precise an anti-Egypt. A naked woman means a defenseless Egypt, vulnerable to foreign intervention and humiliation, resonating with deep historical memories that go as far as the 1919 Revolution against the British and their local consorts. Even as al-Mahdy signed her own visual representation, she could not avoid the societal countersignature motivated by womanly symbolism, revolutionary upheaval, entrenched patriarchy, and the politics of authenticity.

The inflamed battle to determine the meaning of al-Mahdy's disrobed body was as much about sexuality as it was about politics. Hers was a power struggle manifest through a dispute over sexuality.[34] By mixing sexuality and politics in an aesthetically equivocal, politically straightforward statement, about women, sexuality, and repression in Egypt and elsewhere, the initial and most inflammatory posting on *A Rebel's Diary*, al-Mahdy's full-body nude can be said to be feminist nude protest art, as its creator has insisted for several years. Al-Mahdy's black stockings, red flats, and red flower are contrived, erotically charged accessories that raise questions about the political sincerity and "purity" of her activism, but they nonetheless contribute to the aesthetic potency of the photograph.[35] Other figures would soon show that women's bodies can enter revolutionary struggle without premeditated undressing.

DUTIFUL DAUGHTER

"My name is Samira Ibrahim Mohamed, I worked as director of marketing. . . . I am twenty-five years old." Thus began a riveting video of the most famous victim of "virginity testing" in Egypt describing her ordeal. Shot in close-up, Ibrahim wears a salmon-hued head covering and matching lipstick, as a piano solo provides sonic poignancy.[36] Ibrahim had been arrested on March 9, 2011, while marching in Cairo in a demonstration for gender equality in the wake of International Women's Day (March 8). Tahrir Diaries, an organization dedicated to archiving video testimonies of the January 25 Revolution, posted the video to YouTube on November 15, 2011. Ibrahim's testimony was at once banal, because many Egyptian women had been subjected to the ordeal, and compelling, because Ibrahim stood out in her willingness to confront the injustice in court. How does Ibrahim's story differ from al-Mahdy's? Why were the two women explicitly compared in the public sphere, and what does the comparison reveal about the fusion of women's bodies and politics?

Virginity examination is not an Egyptian, Arab, or Muslim aberration. The practice is long in history and wide in geography. In this invasive, brutish procedure, the examiner typically inserts two fingers in the woman's vagina to inspect her hymen, which, if intact, is supposed to prove that the woman has had no sexual intercourse. The practice rests on flimsy medical bases: many women are born without hymens, and when it exists, that skin membrane has various shapes and levels of elasticity. It can be damaged during gynecological exams and restored through hymenoplasty. But

because, as the historian Sherene Seikaly wrote, a whole edifice of power and hierarchy is built on that small membrane, the practice remains widespread.[37] As the Arab uprisings raged, news came out of virginity testing in Indonesia, Canada, India, and Egypt.[38] British authorities used virginity tests as a border-control mechanism between 1968 and 1979. At consulates in India and airports in the United Kingdom, they tested Indian and Pakistani women intending to marry British citizens. The notorious practice was exposed in a February 1979 story published by the *Guardian* about a thirty-five-year-old Indian woman who was tested at Heathrow Airport. Ostensibly looking for "signs of marriage," UK inspectors followed procedures codified in immigration legislation to scrutinize women's bodies for "absence of hymen, enlarged breasts, and stretch marks."[39] After the controversy exploded, the government claimed there were only two other cases, and the official response was "Deny, Normalize, Obfuscate."[40] In 2011, the *Guardian* searched Home Office files and found that there were "at least 80 female migrants" victimized.[41]

Virginity examination has been an insidious tactic of intimidation in revolutionary Egypt. Part of a larger pattern of sexual violence facilitated by the presence of large, unruly crowds outdoors, and which ranges from verbal sexual harassment to rape, virginity examinations stand out because authorities, and not random thugs, have performed them. Sisi himself, according to the *Guardian,* admitted to the practice in June 2011 to representatives of Amnesty International.[42] Apparently Egyptian authorities "didn't want (the female detainees) to say we had sexually assaulted or raped them, so we wanted to prove that they weren't virgins in the first place. . . . None of them were (virgins)."[43] Rejecting this logic, Ibrahim filed charges.[44] In late December 2011, a Cairo court ruled against the military, finding virginity tests to be illegal and a human rights violation and dismissing the authorities' logic that the tests served to protect soldiers from rape charges. Women, including Ibrahim and other public figures, marched in Tahrir Square in celebration.[45] But future events sapped their victory. On March 11, 2012, roughly one year after Ibrahim's ordeal, a military court acquitted the military medic who tested Ibrahim, of rape, and found him instead guilty of "disobeying military orders" and "public indecency" and ruled, bizarrely, that no virginity testing had occurred at all.[46]

The verdict's legal acrobatics obfuscate the state's investment in virginity testing. As in the case of Turkey, where the practice reflects an incorporation

of social concerns about women's purity into the machine of the modern state, so in Egypt, the tests are better understood as a technology of population control rather than a remnant of tradition. The practice tends to target women with low social capital or political backing, but it focuses especially on dissenting bodies, with political prisoners bearing ruthless state violence under the guise of protecting the nation.[47] In this case, because medical expertise is part of state authority, it is no surprise that the medical officer who examined Ibrahim was cleared of charges of sexual assault. Nonetheless, as a vocal and visible woman clamoring for her dignity, Ibrahim publicized the issue of virginity testing, her righteous body a living reminder of a violent abuse masquerading as medical procedure.[48]

Ibrahim's activism underlined the young woman's sexual piousness. By repeatedly intimating she had not had sexual intercourse, she at once legitimated the narrative that upholds the importance of virginity and highlighted that virginity testing was a kind of state-sanctioned rape. What is noteworthy about Ibrahim's case, then, is that she abided by what appeared to be a social-moral consensus in Egypt about unmarried women and virginity, while challenging the narrative of the state about the infamous procedure. Her activism nodded toward separation between the social and the political. Several members of Ibrahim's Islamist, politically active family were incarcerated under Mubarak, and her parents supported their daughter's vocal dissent and legal action. Ibrahim was socially obedient but politically rebellious, demonstrating that women could be effective activists without espousing a sexually "liberated" model of femininity.

The enduring symbolism of the body of the ruler haunts Ibrahim's testimony, for it showed that the sovereign lingers even after he has been dislodged. In the room where she was humiliated, she said, "a picture of the deposed Mubarak was hanging," the watchful eye of a sovereign whose power lingers in his portrait. Ibrahim continued that the photograph "provoked me and overpowered me to such an extent that I asked [the interrogator], . . . 'What is his picture doing here?' After cursing us, he said, 'We love him [Mubarak], and if you don't want him, well, he is our president.' Then it was time for the search. . . . I walked into the room . . . a large window, the door was open, and soldiers standing looking. . . . He said, 'Take your clothes off,' so I took off my jacket, and he said, 'Take off all your clothes.' So I said, 'Can you please close the window and the door?' . . . Someone hit me, and I was forced to take my clothes off, against my will.

They were standing by the window, chatting, winking to each other, at the door, smiling, soldiers and officers. 'I can see you,' they were watching like that." In the video, she gets emotional, her eyes narrowing. It was as if, from Mubarak's portrait to the soldiers' gaze, state power not only inflicted humiliation but also reveled in watching itself demeaning the young activist.

Her body violated, Ibrahim thought of death: "By God, I started saying to myself, I wish I would have a heart attack and die like people die [*tearing up*]. Whatever I tell you, what happened on that day [*choking up*] . . . they ruined us . . . they humiliated us [*tears streaming down her cheeks; she raises a tissue to her face*] . . . one was wishing for death [*still crying*] . . . all these people who died, why did I not die?" Death would terminate her body, the site of state violence, and therefore end that violence. On the one hand, wishing for death is a capitulation to the tyrant. On the other hand, wishing for death challenges the head of the body politic by taking away from him the power to decide who lives and who dies. The state's clampdown on women who dared demonstrate reflected a classification of populations into differentiated bodies, key to biopolitical power, the kind that takes biological human life as its object, and Ibrahim felt its brunt: "Then the officer said, 'Women on one side, girls on the other.' I stood with the girls . . . [*still crying, wiping her nose*]. 'Let us see if you are into debauchery. . . .' They trump up the accusation before all things . . . first *baltagiyya* [thuggery] . . . then *da'ara* [debauchery]. . . . The girls started stepping out, the first, the second, the third, then my turn. I did not speak, I could not object, I was unable to speak to begin with. 'She said lie down so someone can inspect you . . . take your pants off and raise your legs' . . . me, a man was going to inspect me . . . officers and soldiers watching me. . . . I was electrocuted in the belly . . . insults, cuss words . . . I surrendered . . . a medical doctor, what was he inspecting for five minutes? [*Looking at the interviewer*] Can you answer me? He humiliates you, he breaks you . . . so that . . . you don't think of saying I want my right in this country, so you don't think about walking in demonstrations, or do anything against oppression. . . . After the inspection he asked me to 'sign a confession that you are a girl.' I had the good luck that I had not gotten married. . . . People go in, and when they come out, they stay silent because of what they saw. . . . After I saw, I, personally, expect anything from [them], anything."[49]

Ibrahim's utter disillusionment with the Egyptian state reflects a rather simple truth.[50] Whereas Aliaa al-Mahdy violated social norms of dress and

womanly behavior, triggering repression, state violence targeted Ibrahim even after she submitted to prevailing social norms. This makes clear that virginity testing reflects not the state's medical concern for women's sexuality, but the state's need to inscribe its power onto the bodies it governs. Mubarak's portrait, hanging on a prison wall, was itself a violent reminder of an obstinate body politic, officially dead but in fact sufficiently alive to wreak havoc on women's bodies. In effect, Mubarak's lingering gaze reflected the enduring symbolic power of what he stood for, and it motivated Ibrahim to persevere. Her activism was altruistic: "Had I conceded and remained silent," she said, "what happened to me could have happened to all girls in Egypt."[51]

Though al-Mahdy became an immediate and global media sensation, Ibrahim's case was covered piecemeal—she herself complained of scarce media attention to her case. The pious, hijab-wearing, dutiful daughter became known for pressing charges in an Egyptian court against the military for subjecting her to what can only be described as licensed rape. The atheist, nude blogger catapulted to fame by virtue of publicizing her full frontal nudity, without being directly provoked to do that by the state. Ibrahim's act was defensive and dignified; al-Mahdy's act was offensive in being both aggressive and objectionable. Ibrahim's ordeal and lawsuit held up the hope that the system afforded redemption, and al-Mahdy's deed gave Egyptians an uncomfortable stare at the abyss of abjection. The Egyptian and Arab press echoed online activists who wondered why the media paid so much attention to al-Mahdy while neglecting Ibrahim.[52] Why did a vicious stunt accepted by the few receive more attention than a virtuous action admired by the many? Because Egypt has long been construed as woman, comparing Aliaa al-Mahdy and Samira Ibrahim aimed to define the nation.

One of the iconic murals of the Egyptian revolution reenacted a classical dichotomy of virgin and whore that societies have historically used to judge public women. Painted by Ammar Abo Bakr, an artist, art teacher, and leading revolutionary muralist, the mural (actually composed of two stencils and text) enacts a simple, side-by-side comparison (Fig. 8). Ibrahim is in the center right; al-Mahdy occupies the entire left side. Under a large stencil of Ibrahim's head, rendered in blue, the cool color of reason, the caption says, "A salute of esteem, veneration and support to Samira Ibrahim, Daughter of Upper Egypt." To the left, al-Mahdy assumes her notorious

FIG. 8. *Aliaa vs. Samira,* mural/stencils by Ammar Abo Bakr, Luxor, Upper Egypt, 2011, photo by Ammar Abo Bakr, used with permission.

pose, her right leg open and lifted, her hands on her thighs, her lower torso level with Ibrahim's head. She is drawn in black and red, the latter used for her flats and the flower in her hair. Covering the area from below her shoulders to below her waist is a longer caption comparing the two women. Because this is a text-centered mural, and Arabic is read from right to left, Ibrahim takes primacy: "Samira Ibrahim, twenty-five years old, nakedness and a virginity test in front of officers and soldiers were forced upon her, and she rejected that her story not be told, so she lodged a judicial complaint with the Egyptian judiciary. No interest . . . no notoriety . . . no media . . . no one answers. Aliaa al-Mahdy, twenty years old: she went naked and unveiled her body entirely of her own will, the public and the media rushed toward her, nearly three million people saw her picture, and there were no less than fifty articles and numerous television programs."

The mural enhances the opposition between a virtuous and modest Egypt represented by Ibrahim and a vicious and wanton Egypt reflected in al-Mahdy with another powerful dichotomy, that of body versus mind: al-Mahdy's body and Ibrahim's head. Ibrahim is represented as a veiled head. A head speaks and thinks, reflecting rationality and deliberation. The veil

adds piety. Ibrahim looks sideways, modest and contemplative. Al-Mahdy, in contrast, is depicted as a body, unruly, irrational. She stares straight ahead, brazen and provocative. By reprising the old binary of mind and body, the mural opposes *logos,* logical argument, to *pathos* and *eros,* emotional appeals and erotic tension. Abo Bakr created a master opposition between head and body that sits atop multiple dichotomies, Ibrahim's side respectable, al-Mahdy's reprehensible. One posted naked pictures of herself with radical political pronouncement online. The other was violated by the state for simply showing up in a political march on the street. One was authentic, thus recuperated into the revolutionary body politic; the other, foreign and therefore expelled.[53]

As revolutionary icons, Aliaa al-Mahdy and Samira Ibrahim had drastically different meanings in the Egyptian public sphere. The first was preposterous, the second heroic. Whereas al-Mahdy wronged her country of her own volition by depicting a weak Egypt that had succumbed to Western ideas and practices, Ibrahim underscored a stronger nation whose wronged, coerced, daughters could seek redress from within the system. In contrast, an Egyptian woman posing naked made visible the cost of globalization, with its corrosive materialistic values, to a proud country that sees itself as a cradle of civilization and the cultural and political center of the Arab world. Her compatriot seeking legal vindication against official abuse redeemed Egypt by showing the country's own institutions could take care of the nation's children. The fallen woman and the dutiful daughter represented two faces of Egypt. Both became public figures and household names, and both had their portraits in newspapers, on television, and in graffiti. The contrast between al-Mahdy and Ibrahim cut through the chatter of the turbulent revolutionary public sphere, but they were not the only politicized bodies of Egypt's revolution. Another revolutionary icon would emerge, mysterious to the extent that, for a time, doubts lingered about her identity.

BLUE BRA GIRL

*O*n November 24, 2011, the Supreme Council of the Armed Forces appointed Kamal al-Ganzoury, who had previously been prime minister between 1996 and 1999, as Egypt's caretaker prime minister. Incensed by the return to power of a holdover from the Mubarak era, and seeing him as a fig leaf for the military's continuing grip on power, Egyptians started a sit-in the next day in front of the "Cabinet Headquarters" to prevent the new prime minister from entering the building. Security forces harassed protesters continually, and in the early hours of Friday, December 16, they started a brutal crackdown. Men in uniform and civilian clothes started throwing rocks and furniture from the roof of the adjacent buildings that housed the parliament. During clashes involving rocks, birdshot, bullets, and Molotov cocktails, the police beat and arrested many demonstrators. Detained and abused for a few hours, one released protester "looked like Khaled Said's infamous picture."[54] Violence escalated, and by the morning of December 18, ten protesters had been killed and five hundred injured. But a day earlier, on December 17, 2011, one year to the day after Bouazizi set himself aflame in Tunisia, a brutal scene unfolded on Qasr al-Ainy Street, where the police attacked "Cabinet sit-in" protesters. Video footage captured that day was replayed all over the world, and one frame from that video became an iconic image of the Egyptian revolution.

Shot from a high angle, the scene unfolds on a street strewn with garbage. We see around fifteen officers, in military boots, helmets with long visors, and long sticks. Eight men stand within a couple of feet from a body

lying on the ground; other cops are rushing toward the body or past it. The camera zooms in and we see a dozen officers beating a couple of demonstrators as they lay down on the asphalt. The footage radiates tremendous kinetic energy, as if the policemen were swinging their truncheons with their entire bodies, and not just their arms. When the camera zooms in again, around twenty seconds into the video, half a dozen officers pull a body by its arms. We see dark sneakers, blue jeans, and an unclothed midriff. At twenty-two seconds, a couple of cops move and a blue brassiere covering a woman's breasts can be discerned. One officer, who unlike his colleagues is wearing sneakers and not military boots, stomps the woman in the middle of her chest.

Then, most officers pull away as if obeying an irresistible command—is it the sight of the undergarment that frightened them? Did they notice that a camera was recording their brutality? One of them kneels over the woman, grabs her black robe, which had been pinned to the ground by the body of its wearer, to reveal a blue bra, and by the twenty-seventh second the blue bra can no longer be seen. The camera zooms out again and we see more paramilitary riot police beating a couple of prostrate bodies, which we assume, are demonstrators. All this took thirty seconds, the blue undergarment appearing for only five. In the rest of the video, the camera zooms in and out, showing people on their backs jerking their legs into the air to counter truncheon blows, officers stomping people with both feet and all their weight, and one policeman pushing his truncheon into the naked abdomen of a man, pinning him to the ground. It is only at the forty-seventh second that the camera zooms out for viewers to realize the large scale of the event, with crowds of people running from the police, who are then seen stomping demonstrators' tents, destroying them, amidst panic.[55] On Qasr al-Ainy Street that day, a protester became Blue Bra Girl, an unknown marcher catapulted to global but anonymous fame (Fig. 9).[56]

The case of Blue Bra Girl raises questions: Why not Blue Jeans Girl? After all, the woman in question, who remains anonymous to this day, wore blue jeans and a blue bra? Why did the incident make the first page of the *New York Times* on December 18, but only the third page of *al-Shorouk?* Why did U.S. Secretary of State Hillary Rodham Clinton opine that "this systematic degradation of Egyptian women dishonors the revolution, disgraces the state and its uniform and is not worthy of a great people"? Why did Clinton use the language of "degradation" and "honor" when talking about

FIG. 9. *Blue Bra Girl against the System,* stencil, Beirut, 2011, photo © Marwan M. Kraidy.

women? Did the systematic abuse of Egyptian men not undermine the revolution? Though the incident fit in customary narratives of Western self-righteous indignation and excessive media attention to brown women abused by brown men, Blue Bra Girl was not only a Western construction. The incident struck a deep chord among some Egyptians as well. It was as if the blue bra was a symbolic token, revealing the depths to which the Egyptian state would go in abusing the bodies of citizens if they dared to rebel. On December 19, 2011, Wael Qandil, managing editor of *al-Shorouk* and author of some of the Egyptian revolution's most memorable opinion pieces, penned a column, "For Your Sake": "It is your right to stay at home and watch the honorable young women of Egypt being dragged and their bodies denuded on the pavement at the hands of the soldiers of Egypt, but I beseech you to summon your conscience and your sound instinct before you let your mind be filled with lies." He reminded his readers that those abused by the police were none other than the proud revolutionaries: "And it is your right to ask who are those present on Tahrir Square and Qasr al-Ainy Street confronting bullets and truncheons with their chests, fallen

martyrs to God and taken to hospitals riddled with wounds and injuries."
He continued with an enumeration highlighting that demonstrators represented all of Egypt: "These, sir, are Egypt's minds and its beating hearts, university professors, intellectuals, media personalities, medical doctors and engineers, who carried their souls in their palms and descended for your sake on January 25, demanding for you, life and freedom and human dignity; so when they discovered that the dream for which they sacrificed more than one thousand martyrs and thousands of wounded, and hundreds who lost their eyes so that you are able to see a clean, free Egypt that you were deprived of for decades, they decided to pursue the journey, searching for the rights of the martyrs and the wounded, and to make a new Egypt, vigorous and washed from the dung of corruption and oppression." Then he got more specific: "Among those, sir, the respected, pure journalist Arwa whom you saw them dragging her on the ground, stumping her dignity with their heavy boots, denuding her body, in a scene that belongs to the basest and lowest periods of barbaric occupation, all this because she recorded with her lens the abominations and loathsome crimes perpetrated against Egypt's youth." After exhorting readers for sympathy, he posed a rhetorical question: "Is this the epitome of a revolution that arose for the sake of human dignity?"[57]

Highlighting the stakes of the incident, the column responded to rumors in the murkier quarters of Egyptian public discourse about the assault on Blue Bra Girl. Some commentators intimated that the young woman did it on purpose. Otherwise, why would she wear a blue bra? Others were aghast that she wore her *abaya* fastened by adhesive bands rather than buttons, as if buttons were sturdy enough to withstand the militarized violence of several men. But why did she become known as "girl," rather than "woman"? The designation carries intonations of purity and virginity, which we already saw in Samira Ibrahim's case, so it affirmed the notion of an unsullied daughter of Egypt abused by security officers. Finally, the bra is a charged symbol of women's liberation, and an intimate article that reflects personal vulnerability. As a symbol of femininity with erotic and political significance whose blue color made it more amenable to circulation and visibility (than, say, white), the garment stood in for the woman's face while at the same time becoming a revolutionary symbol.[58]

Though the woman's identity remained elusive for a time, the assault was widely considered an attack on Egyptian women, on the persons of activ-

ists, and on the revolutionary movement as a whole.[59] Taken by a professional Egyptian photographer, Ahmad Gaber, who said that every time he walks near where it happens, it brings the feelings of "astonishment, daze, and desire to document" he first experienced as he was looking through his telephoto lens, taking photos of the scene from the balcony of a hotel room overlooking Tahrir Square.[60] A young pharmacist who had appeared on a television talk show, *Sabahek ya Misr* (*Good Morning to You, O Egypt*), on December 17, 2011, to testify to her being beaten by the police was later identified as Blue Bra Girl.[61] A video testimony by the same woman, posted on YouTube December 19, 2011, identified her as *sitt al-banat* (a laudatory expression that translates uneasily as "a lady among girls"), which is the Egyptian moniker for Blue Bra Girl, but English-language media accounts continued to insist the woman was unidentified.[62] On July 26, 2013, at least one Egyptian newspaper published statements drawn from *sitt al-banat*'s Facebook page and identified Blue Bra Girl as "political activist Ghada Kamal" and featured her photograph, saying that she supported Sisi, gave the army a mandate to fight "terrorists," and would participate in pro-Sisi demonstrations the following day.[63] Unlike the nude blogger and the girl who legally fought virginity tests, the girl with the blue bra reentered the social and political fold without challenging the system. Though the woman's revolutionary appearance was short-lived, the blue bra entered the arsenal of creative insurgency.

VIGILANCE AND VIRULENCE

*W*hat do the experiences of revolutionary women reveal about embodiment and citizenship? Aliaa al-Mahdy is best understood as the allegorical culmination of Egypt after *infitah.* She represents an Egypt that is revealed, unprotected, denuded, an Egypt that has totally surrendered to Western values, an Egypt that has moved too far from its putative authenticity. This is an Egypt so abused by the combination of market fundamentalism and political autocracy that its sons and daughters are unable to recognize it, and when they glimpse a hint of the familiar in it, all hell breaks loose. A fallen woman, al-Mahdy raises the specter of a fallen Egypt. Having succumbed to foreign ideas, she fell into alien action, which in turn, through the infinitely networked digital environment, disseminated both alien ideas and incompatible actions. If estranged ideas and actions raise suspicion in times of social stability and national unity, foreign ideas are downright dangerous in times of flux, when the nation, busy adjusting its historical course, is vulnerable. And for an Egypt that had dislodged a dictator and was struggling to find a representative leadership beyond a military junta whose rule was heavy-handed and whose ambitions were mysterious, for an Egypt having rejected the past but unable to find a path to the future, this was the most unstable of times. The national body politic, sick after decades of systematic abuse and absent care, could not handle the shock of the foreign represented by her digital stunt. She was an alien body that raised the specter of an Egypt denuded, disfigured, and dissolute.

Aliaa al-Mahdy menaced national sovereignty in the digital era because she subverted important boundaries and left a permanent and networked record of her transgression. She not only violated social taboos against visible and vocal female sexuality but also fused the political with the aesthetic, biological, and digital. Recall her claim that her nude body selfie was art, and consider that one of the main tasks of the female nude in art is "containment and regulation of the female sexual body—to seal orifices and to prevent marginal matter from transgressing the boundary dividing the inside of the body and the outside, the self from the space of the other."[64] This compulsion to control the body is echoed in the rhetoric of virulence of digital culture, where digital files, like bodily fluids, violate corporeal boundaries.[65] Had al-Mahdy's action been recorded on photographic paper or celluloid reels, it would have circulated narrowly among activists, fetishists, and collectors. Many sexually transgressive pictures followed her maiden blogpost, for example, close-ups of a menstruating vagina and of pubic hair dyed blue that she posted in December 2014. Blogs are among the least ephemeral productions of cyberspace, and *A Rebel's Diary* lent permanence to al-Mahdy's creative insurgency. By violating social norms and using the female nude to release, deregulate, and disseminate her body into the Egyptian body politic, al-Mahdy enacted the ultimate transgression between body and machine, unleashing her corporeal gambit into digital particles that continue to circulate in a widely connected, attentive, and polarized media sphere and to recombine on the screens of gawkers, readers, and sympathizers worldwide.

To her critics, al-Mahdy was like a virus that risked infecting the entire body politic. Reactions to *A Rebel's Diary* reflect anxiety about politics and sexuality inflamed by apprehension about unbridled digital communication. A rhetoric of virulence, based on biological metaphors, has long infused computer culture, comparing the circulation of information to biological contagion.[66] But ever since Donna Haraway's seminal essay "A Cyborg Manifesto," this analogy has given way to notions of the body as a space where information and biology fuse.[67] By illustrating how the fragile bounds of the body fuse in the "open circuits of interconnectedness," of digital networks, al-Mahdy posed a threat at once biological and digital.[68] If the biological metaphor of virulence reflects a social crumbling of boundaries, *A Rebel's Diary* poses a threat because it turns a body into information and disseminates it through the networks, threatening to infect the Egyptian body politic.[69]

Details of what happened to the Naked Blogger of Cairo in the weeks after the scandal erupted are murky. Her every move was covered by the media, and a purported video of her killing by an angry mob on Tahrir Square circulated on YouTube. There were stories about her bad relationship with her family. A few months later, al-Mahdy reemerged as an activist with the group Femen in Scandinavia. Awarded political asylum in Sweden, she started periodic protests, garmentless, in front of Egyptian embassies in Europe. Al-Mahdy's exile was foisted upon her. Vitriolic online threats, calls for her execution, and histrionic denunciations left little doubt that her life was endangered in Cairo. Nonetheless, by joining Femen, al-Mahdy vindicated accusations that she was estranged.

Al-Mahdy evoked the ugly consequences of crony capitalism for Egypt, the climax of *infitah* policies decades after their beginning. Capitalism, after all, continually seeks new markets to penetrate and conquer, and does so by weakening national policies designed to limit its impact, which it dismisses as "protectionist." The spread of global capitalism, then, goes hand in hand with the rise of national vulnerabilities, and few countries have felt the impact of such insecurity like Egypt. As pundits often remind us, Egypt's economy in the early 1970s was comparable to South Korea's.[70] Haraway wrote that capitalism has a built-in exclusionary logic because it relies on a metaphor of the immune system that defines one corporeal norm as healthy and rejects all others.[71] *A Rebel's Diary* subverts neoliberalism's demand for conformity because al-Mahdy's act is too radical to be coopted by Egyptian market forces—one can scarcely imagine *A Rebel's Diary*–branded merchandise, reality show, or perfume.

In its violation of styles, mores, rules and boundaries, *A Rebel's Diary* is emblematic of a recent trend in Arab and Egyptian cultural production that muddies frontiers between social categories, narrative genres, and stylistic modes. As the literary scholar Tarik el-Ariss showed in his analysis of Egyptian novelist Ahmed Alaidy's 2003 *An Takun 'Abbas al-'Abd* (*Being Abbas el Abd*, 2006), the latter's disruptive style hacked into "the publishing establishment" and rattled "the codes of Arabic literary production."[72] The novel's protagonist made a declaration that eerily echoes the manifesto that inaugurated *A Rebel's Diary:* "You want us to progress? So burn the history books and forget your precious dead civilization. Stop trying to squeeze the juice from the past. Destroy your pharaonic history. . . . We will only succeed when we turn our museums into public lavatories."[73] It is noteworthy

that the conversation in which this was said was about Egypt's relation with the West. This attack on Egypt's culture reveals a generation not bound by its forefathers' notions of identity, whose creations are aesthetically and politically subversive. *A Rebel's Diary* and *Being Abbas el Abd* threaten prevailing cultural and political arrangements. They both feature cultural hackers sabotaging the status quo, like graffiti artists throughout the Arab uprisings.[74]

Aliaa al-Mahdy's body can also be understood as an interface—of human and machine, of the biological and the digital, but also of the foreign and the authentic, of the political and the sexual. Her action raises questions about connections between the body and authenticity. In light of the scandal surrounding *A Rebel's Diary,* can we still affirm that the body persists as "the bastion of communicative authenticity"?[75] Whether al-Mahdy's action enables a new understanding of the body and authenticity is more complex that it first appears. The argument that considers technology in terms of affordances that augment the material body makes way for a more relational view in which the digital and the biological are mutually activated, integrated, and expanded.[76] By violating borders of sex, politics, morality, body, and nation, al-Mahdy proved to be a formidable boundary buster. The global reach of the media sphere where her digitized body proliferates continues to enable people worldwide to ogle, deride, and denounce an Egyptian woman's body and behavior.

SEXTREMISM AND ISLAMOPHOBIA

On March 11, 2013, Amina Sboui, a nineteen-year-old Tunisian woman, posted a photograph of herself naked to Facebook, her torso bearing the inscription "My body belongs to me, and is not related to anyone's honor." Within days she had spurred a national controversy. As if following the Egyptian script that welcomed *A Rebel's Diary*, a wide range of Tunisian voices denounced Sboui.[77] Newspapers mentioned a difficult upbringing, absent parents, and mental health issues leading to a suicide attempt earlier in the year. Some argued that her psychotherapist recruited her to pose naked to fulfill a radical secular agenda seeking to subvert Tunisian identity after secularists lost elections to the Islamist party Ennahda. Hackers replaced topless images on Femen Tunisia's Facebook page "with quotes from the Quran."[78] As if on cue, an extremist cleric opined that Sboui "deserved to be stoned to death and she must be quarantined because what she did is an epidemic," that she was a "contagious disease" that had to be "secluded."[79] The rhetoric of infection echoed the *Rebel's Diary* fracas. Sboui appeared on Ettounsiyya TV and explained that her action was a protest timed to coincide with International Women's Day and the opening of a Femen franchise in Tunisia. Declaring "solidarity with Amina and all Arab women," another Tunisian woman posed a photograph of herself bare-skinned on Facebook, declaring, "No one has the right to decide when we live and when we die."[80] Tunisian women have historically demanded and obtained a wide range of rights, but post-Ben Ali, Islamists introduced a constitutional article about "complementarity between the sexes" as op-

posed to "equality between man and woman," which they withdrew under fierce resistance from secularists. Sboui's act looped into the secular-religious polarization that infuses revolutionary Tunisia.[81]

The controversy swiftly expanded beyond Tunisia. On March 22, 2013, a statement by Femen designated April 4, 2013, "International Day to Defend Amina" and enjoined women worldwide to post naked pictures and supporting statements and to tweet #Amina. This became known as "Topless Jihad Day." "Aliaa Magda Elmahdy, Egyptian Nude Photo Revolutionary" was first among forty signatories, including controversial French journalist Caroline Fourest, the English atheism advocate Richard Dawkins, and a variety of activists and women's organizations.[82] Founded in April 2008 in Kiev, Ukraine, Femen opened a Paris office in 2012. With a confrontational style, eclectic range, and a transnational scope, the group claims to target "the dictatorship, the church, the sex industry."[83] Their original slogan was "Ukraine is not a brothel."[84] Topless activism became their trademark in 2010, when five activists stripped to protest the reelection of pro-Russian president Viktor Yanukovych, realizing that their disrobed bodies attracted enormous attention. The group now presents its doctrine as "hot boobs, a cool head and clean hands," and its members as "the new Amazons, capable to undermine the foundations of the patriarchal world by their intellect, sex, agility, make disorder, bring neurosis and panic to the men's world."[85] A Femen leader described the group's style as "sextremism . . . aggressive but still not violent."[86] Sextremism depends on strict physical training focused on fitness and on optimizing the visibility of the naked body.[87] Applying these skills, Femen militants waged "Topless Jihad" in Berlin, Brussels, Kiev, and Milan. They also burned a Salafi banner, which features the Muslim proclamation of faith, in front of the Grand Mosque of Paris.[88]

The internationalization of the polemic expanded Femen's involvement in Tunisia. On May 19, 2013, Sboui was arrested for daubing "Femen" on a cemetery wall in Kairouan, central Tunisia, during a congress by the extremist Islamist group Ansar al-Sharia. Ten days later, one German and two French Femen militants staged a sextremist protest in front of a Tunis courthouse to advocate for Sboui's release. Tunisian lawyers and journalists declared solidarity with the activists, but authorities arrested the three women and charged them with public indecency.[89] A court sentenced the three women to four months in jail, but the government released them within weeks.[90] Sboui herself languished in jail for two and a half months, where she was

charged with assaulting a guard and faced the court again on July 22, 2013. The young woman was defiant, saying through her lawyer, "I am free and not crazy. . . . Being incarcerated is less bad than seeing Tunisia becoming the cradle of a religious dictatorship."[91] She was released from prison in early August.

Many around the world believe that Femen's tactics descend into immorality, undermine women's emancipation, or capitulate to the sex industry. Claiming to upend patriarchy and capitalism by fielding women whose bodies fit the ideal proportions of the global, predominantly Western entertainment-fashion-sexuality complex raises questions about motive and consistency. In addition, were Amina Sboui and Aliaa al-Mahdy not aware of the fraught relationship between white feminism and brown women? Perhaps they were unfamiliar with Arab and Indian feminist arguments against self-righteous white exploitation of brown women. Had they not encountered the writings of Franz Fanon on colonialism and the veil, Leila Ahmed on colonial feminism, Gayatri Chakravorty Spivak on the subaltern, Lila Abu-Lughod on whether Muslim women needed saving?[92] Could the two young body activists truly not realize how inflammatory it would be to claim membership in a group that boasted of sextremism? Judging from her rocky relationship with Femen, Sboui was cognizant, however sporadically, that something was amiss. Between April and August 2013, she joined Femen, then spoke against Islamic flag burning and cries of "Amina Akbar, Femen Akbar" in front of a mosque, recanted, and claimed her family pressured her to criticize Femen, then changed tack again, declared she was an anarchist, and broke with the group after questioning its funding and calling it "Islamophobic."[93] Even after quitting Femen, Sboui engaged in topless activism, showing up in front of the Egyptian embassy in Paris to protest mass death sentences handed down to hundreds of Islamist activists by an Egyptian court. A caption on her torso read, "No to the Death Sentence, Even for the Muslim Brothers."[94]

Is Sboui's characterization of Femen as an Islamophobic organization fair? What does Femen's rhetoric provide in way of an answer? A Femen statement about Sboui raised the specter of "a global war between a woman and an Islamist theocracy, the riot of freedom from slavery! . . . Religious dictatorship begins by enslaving women, but a woman's act of self-liberation is the first step toward destroying the sharia regime."[95] Whether due to ignorance or bigotry, the assertion was wrong. Though Tunisia had been polarized

between secularist and Islamist forces, it was far from being a theocracy. It was rather a nascent democracy, one in which Moncef Marzouki, the president with a leftist activist past shared power with Rachid Ghannouchi, the prime minister from the Islamist party Ennahda. After the election of 2014, Ghannouchi himself said that the battle in Tunisia was not between Islamists and secularists, but between those who believe in democracy and those who do not. Slogans such as "Better naked than in a burqa"[96] imply that most Muslim women wear the burqa, a full body-and-face cover, which is incorrect, and that nakedness or full cover are the only two options for women, a statement undermined daily by the myriad fabrics, styles, and colors worn by Muslim and non-Muslim women worldwide. Femen stunts that featured "topless women wearing towels as turbans and penciling unibrows and beards on their faces" conjured up racist clichés and colonial fantasies.[97] Topless Jihad slogans on sextremist bodies read, "No Sharia," "*Niqab ta mère*" (a riff on the French invective *nique ta mère*, "fuck your mother"), and one activist's nipples had stars painted over, with a crescent underlining each breast, and "Fuck Islamisi" was scribbled on her abdomen. Repeated ad infinitum in online slideshows exploiting a mix of titillation and Islam-baiting, such antics echo rightwing Islamophobic campaigns in North America and Europe. In July 2013, Femen's Paris chief, Inna Shevchenko, called the Muslim Holy Month of Ramadan "stupid" and Islam "bad" in a tweet, before promptly deleting it.[98] In truth, the controversy Sboui triggered outed Femen, whose words and actions crossed the line between the unprejudiced questioning of social practices by Muslims and the unwarranted denigration of an entire religion.

But Muslim women themselves invalidated Femen's warped views. British Muslim women started a campaign on social media, "Muslim Women against Femen: Muslim Women Pride Day," aiming to show that Muslim women can speak with their own voice, one activist accusing Femen of "racism and the propagation of stereotypical images of Arab and Muslim women" and vowing a long struggle ahead.[99] Thoughtful rebuttals of the caricatures peddled by Femen, along with defensive rants, echoed in the social media chamber, in Arabic, French, English, and other languages. The controversy even spawned an Arab Muslim female action hero, Qahera. "It all started as a joke with a group of friends," Deena Mohamed, the nineteen-year-old creator of the comic series *Qahera,* told the BBC. But when she posted a comic strip online, popular enthusiasm and publishers' interest

followed. Critics who rejected the notion of superhero as "Western" were few.[100] "Qahera" means "conqueror," "subjugator," or "vanquisher," and the Arabic verb *qahara* also means "overpower," "overcome," or "defeat." It is a name befitting a superhero, all the more since *al-qahera* is also Cairo's Arabic name. Imaginative, socially resonant, and aesthetically punchy, *Qahera* is gradual creative insurgency at its best.

In English and Arabic versions, the *Qahera* digital comic strips criticize a wide range of targets: sexual harassers, corrupt cops, kooky clerics, and Western feminists. The inaugural strip is illustrative. When a cleric hectors a group of men that "a good wife is an obedient wife! It is your Islamic duty to keep your women at home and in check," Qahera chucks it as "misogynistic trash" ' and hangs the cleric between a pair of pants and a sock, taunting him with "I especially like doing laundry." In a parallel scene, a blond feminist condescends to budding, wide-eyed disciples, "You see. That's why we need to rescue Muslim women" (Fig. 10). In the web comic's second installment, after Qahera is aggravated watching activists clamoring "Femen Akbar," she dons her headcover and sword and confronts the sextremists. When one of them says, "Look there! It's a Muslim woman! This is why we're here! We have to save her," and another beseeches the superhero to "take off your oppression! Join us!" Qahera replies, "You seem unable to understand that we do not need your help" before capturing the Femen posse in a lasso and hanging them from a tree stump on a cliff, chuckling, "Hey so, feel free to rescue me anytime."[101]

In contrast to Aliaa al-Mahdy and Amina Sboui, *Qahera* creator Deena Mohamed seems hyperaware of the dynamics of the controversy around Femen and deliberately preempts any confusion about her stand with a list of "frequently asked questions" on her website. To "why don't you like Femen?" she answers, "My issue with Femen is that they dehumanize, stereotype and exclude Muslim women from their version of feminism and liberation. It has little to do with nudity, before you ask. I don't care about it and neither does *Qahera*."[102] Through a web comic featuring an unmistakably Arab female superhero, an Egyptian woman thus shattered the false choice between all-exposed boob and all-concealing burqa. Is there more potent indication that Muslim women can represent themselves thoughtfully, passionately, and creatively?

Arab and Muslim women called Femen's conceit. Most religions have patriarchal doctrines, and most have been used to put down women and

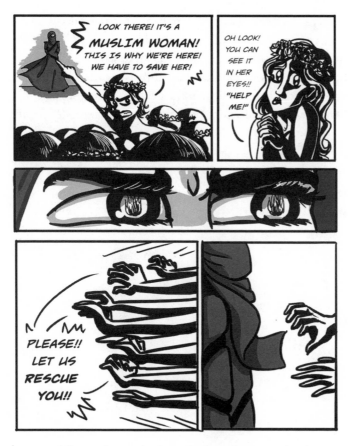

FIG. 10. *Qahera,* webcomic by Deena Mohamed, 2013, used with permission.

demonize people from other religions. Yet Femen focuses its ire on "Islam," the occasional attack on the Russian Orthodox Church notwithstanding. Whereas topless activism occasionally targets specific Christian icons and institutions, Islam is attacked at large, in claims belied by reactions to events worldwide. When U.S. drones annihilate Muslim women in Afghanistan or Yemen, however unintentionally, when Buddhist militants attack Rohingya Muslim women in Myanmar, or when Israeli soldiers and settlers attack Palestinian women, no Femen activist unleashes any sextremism against Christianity, Buddhism, or Judaism. All systems of thought, including all religious faiths, should be open to criticism. As the ballyhoo of global

culture wars, however, Islam is fair game for polemicists like Richard Dawkins, comedians like Bill Maher, politicians like Geert Wilders, entertainers like Donald Trump, novelists like Michel Houellebecq, and bare-breasted activists like Shevchenko in ways that other religions are not. By claiming a universal mantra while targeting a specific religious group, these figures undermine both free speech and gender equality.

THE DILEMMA OF THE LIBERALS

*T*he tension between sextremism and religion is predictable. But how do we understand the speed and vehemence with which "liberal" political actors disavowed al-Mahdy? A nebulous term in Egyptian public discourse, "liberal" may encompass secularist, leftist, Nasserist, pro-Mubarak, but it nearly always means non-Islamist. Historically, the Wafd (Delegation), founded in the wake of the First World War to end the British occupation of Egypt, was Egypt's enduring nationalist liberal party, but in the 2011 revolution's wake, the Egyptian Social Democratic Party and the Egypt Freedom Party also claimed the mantle of liberalism. The category is analytically fraught because liberal and illiberal, secular and religious political ideologies have had a history of cross-breeding and reciprocal accommodation in the Arab world.[103]

It is a truism that Egyptian liberalism today is in crisis. Though the cultural elitism, Western orientation, and social class of liberals like Mohamed el-Baradei explain why liberalism has limited resonance with the Egyptian public, the co-optation of liberals by the military as Sisi assumed power is a key aspect of the crisis. The outpouring of promilitary sentiment and media-fueled patriotism that gripped Egypt with the rise of Sisi swept most "liberal" groups. The armed forces co-opted the Tamarrud coalition (which had started a petition to recall Muslim Brotherhood–affiliated elected president Mohamed Morsi), then denied it a political license. The Egyptian Social Democratic Party and the country's main labor union are defanged, and the Wafd has supported the military. Many politicians from

these parties vocally incited the military to intervene in political life, leading to claims from within the liberal camp that Egyptian liberals betrayed the tenets of their political creed by advocating the criminalization of the Muslim Brotherhood and condoning human rights abuses.[104] The comedian Bassem Youssef wrote that the so-called liberals represented "a current that claims to defend liberalism and freedom but which, in the end, is less tolerant than the religious one. We [can] replace the beard with heavy makeup, the *miswak* (the traditional teeth-cleaning twig) with a glass of martini . . . but religious extremism and the political right are one and the same."[105]

There is another, social, rather than strictly political, dimension to the crisis of Egyptian liberals that the Aliaa al-Mahdy polemic brings to our attention. Though often described as "liberal," the April 6 Youth Movement, which immediately disassociated itself from Aliaa al-Mahdy, does not define itself with that word. Its self-definition is "a group of Egyptian youth of different ages, classes, geographical areas, and intellectual and political affiliations, gathered under a single idea which is the love of this country and the attempt to change it for the better."[106] The group, which endorses media freedom, political pluralism, and inclusive society, a state that respects all religions, administrative decentralization, and popular sovereignty, resonates with liberalism.[107] But April 6 also describes one of its goals as "the preservation of the authentic identity of the people and the nation, and to strike a balance between values and heritage and the necessary means of progress and rebirth."[108] Clearly, supporting a naked blogger would tip that balance. Others criticized al-Mahdy on liberal grounds by deploying rationalist arguments that took issue with her style even as they claimed support for women's emancipation.[109]

But some of the most scathing critics of topless activism were Arab women activists and intellectuals. This is one example by an Arab woman writing in a pan-Arab newspaper, who asked, "Would it be possible for Aliaa and Nadia [al-Bosta, a Tunisian actress who also posed naked] to explain to us how their nudity and fame that came from their nakedness, will pressure Arab parliaments to change and modify existing laws that oppress women? . . . Could they tell us how will pictures of their naked breasts affect the passing of laws that criminalize domestic violence and sexual harassment in the workplace, educational spaces, and the street? . . . And then how will pictures of their naked sexual organs impact securing Arab women

holding more parliamentary, ministerial and presidential seats in the era of revolutions, popular and youth movements, as some regimes are falling while others are changing their constitutions?"[110] Claiming to speak on behalf of Arab women who have devoted years to "real" activism, the author beseeched al-Mahdy and her consorts to "not restrict our demands in the liberation of the body . . . not restrict the styles of our struggle to the tools of the body because we utterly reject that."[111] This reflects an old debate between those focused on bread-and-butter issues and those concerned with identity and representation, understood in the West as a clash of an Old Left focus on economic redistribution and a New Left preoccupation with cultural recognition.[112]

But the columnist's claim that nude activism called for "public sexual intercourse"—something that al-Mahdy and others did not call for—and her use of the word "bestial" exposed a rift deeper than activists united by strategic objectives but disagreeing about tactics. Behind the insistence that all sexual matters must remain private lurked a fear of the abject, which, as Kristeva famously defined it, characterizes our horror when we confront the threat of a collapse of the boundary between self and other.[113] One critic argued that al-Mahdy created "a much worse nightmare for liberals than . . . for conservatives. This was the day that every Arab defender of free speech wished had never come, because it presented an act with which it is impossible to express solidarity without making a complete exit from the realm of social consensus."[114] As a result, "Aliaa put activists and intellectuals in the worst dilemma: give her up, or give up Mu'awiya's hair [the tiniest, most fragile link] between 'them' and 'society.' "[115] Al-Mahdy, the author continued, "lobbed questions like arrows in all directions reaching both conservatives and liberals. Conservatives were shocked by the massive visitation to her blog, which is preceded by giving free will to onlookers in the form of the two buttons (one that gives access to the nude photographs, another used to decline visiting the blog), removing the possibility of seeing the picture by chance or offending sensibilities by unintentional exposure." Liberals had a bigger challenge: "Liberals faced a moment of truth: is it possible in our society, at this juncture, to mount an absolute defense of freedom of speech: is rebellion complete when nudity is complete? Do we risk what we have in terms of a margin of freedom for an 'undeserving' battle? Or do we give in to restraints in the Islamists' turf?"[116] But denunciation can stem from desire.[117] The writer himself acknowledged that "maybe this is the secret behind the

anxiety of secular activists, that they know that Aliaa is (in fact) one of them."[118] The factor that made a difference, the columnist then argued, was that whereas other secular bloggers dissented with words, al-Mahdy did so with pictures. Through her deployment of provocative visuals, he argued, al-Mahdy was hypervisible in the blogosphere. Whereas dissenting writing can be supported, liberal forces cannot afford not to respond to the provocation of a woman's naked body underscored by a political manifesto, for it was inflammatory. To liberals, denouncing al-Mahdy was obligatory.

ABSTRACT BODIES?

\mathcal{W}eighing men-with-words against women-with-images in evaluating the effectiveness of revolutionary activism replays a version of the mind-body dichotomy we saw in the mural comparing Samira Ibrahim to Aliaa al-Mahdy and betrays a quaint iconoclasm.[119] The comparison also signals a deeper problem facing the Egyptian revolution and the Arab uprisings at large. This is the crucial question of whether women, and not only men, can be the neutral, prototypical citizen. By challenging the legality of her abuse in the courts, Ibrahim showed that one could work from within the system, even a system as corrupt and unruly as Egypt's. Does this mean that her action was gradual, in contrast to al-Mahdy's radical act? Whereas Bouazizi perished in his violent clash with the state, and al-Mahdy's ordeal can be said to be a social death, Ibrahim emerged as a folk hero, the female version of *ibn al-balad,* the salt of the earth figure that represents Egyptian folk authenticity in popular culture.[120] Ibrahim was *bint al-balad.* Hers was a heroic body that sought redress within the system, and in that she represents an exception in revolutionary activism, one that is neither radical nor transgressive, even if it was both daring and incremental. The Blue Bra Girl was also an unwitting activist, a part of her anatomy achieving iconic status while the woman's identity was still mysterious, though when she became known as Ghada Kamal, she supported the military. Taken together, the three cases show a wide gamut of women's bodies charged with revolutionary intensity. As we seek to understand them, we must recall that these are human bodies in pain and spurn what the media scholar Meenakshi

Gigi Durham called the "dalliance with virtual play" endemic to contemporary studies of media and activism.[121]

The stories of Aliaa al-Mahdy, Samira Ibrahim, Ghada Kamal, and other revolutionary Arab women raise the question of who can be the "abstract individual" of the Arab uprisings. The historian Joan Scott argued that a tension between equality and difference has remained unresolved in France since the French Revolution. For French universalism, "the foundation of successful politics" resided in considering both nation and individuals as "abstractions, not reflections of social groups or persons."[122] But because in France "equality" is based on "sameness," and since the single hurdle to sameness was "sexual difference: women were 'the sex' and so could not be abstracted from their sex; men could be so abstracted. Hence, abstract individuals were synonymous with men."[123] That embodiment and abstraction are opposites, as Scott maintained, was manifest in journalistic and academic writing about public figures of the Arab uprisings.[124] Whereas male figures were identified with their family or full name ("Mohamed Bouazizi," "Khaled Said"), some revolutionary women were called "Amina" (or "Amina Femen") or "Aliaa," and others were most often called by their full name, like "Samira Ibrahim," sometimes "Ibrahim." I recall no instances of "Mohamed," "Khaled," very few of "Samira." This suggests that only women who remained fully clothed were called by their full, public name, whereas those whose corporeal rebellion was considered radical were referred to by their intimate, private names. (In January 2015, the killing of Shaimaa al-Sabbagh as she marched in Cairo confirmed this trend. She was fully clothed, hence identified by her complete name.)[125] Postcolonial memories exacerbate this trend, for an association between women's emancipation and Western interference hobbles the Arab struggle for gender equality. Veiling and unveiling, as we have known since at least the writings of Franz Fanon about Algeria's battle against the French, are imbued with power, colonialism, and the politics of authenticity.

This is a principal reason why unbounded women's bodies are inflammatory in Arab public discourse. Women cannot be abstract individuals, for even as revolutionary icons, they serve as props, incentives, and sites for men's battles. But as we have also seen, not all men's bodies are abstract individuals, ideal citizens, or patriotic subjects. Egyptian and Arab liberals cannot countenance naked female bodies, because embracing the likes of Aliaa al-Mahdy and Amina Sboui marks liberals as willing to trespass red

VIRGINS AND VIXENS

lines, which in their political calculus means being shut out of power alto-gether. Even the woman columnist who berated al-Mahdy and Sboui, and advocated equality as fair access to socioeconomic resources, as opposed to equality as recognition of gender identities, helped preempt women from claiming the status of abstract individuals. This shows us a way to consider the significance of Aliaa al-Mahdy's bold move from a different perspective. If throughout the history of art, the female nude has been a discourse on the subject at large, not only the feminine subject, then we see that *A Rebel's Diary* aimed in its own way, however jarring, to claim a space for women as political citizens.[126] Not being willing to consider al-Mahdy through any lens other than that of self-righteous moral indignation is tantamount to rejecting the possibility that women can be abstract individuals, which is another way of saying full-fledged citizens. The ultimate message of this approach is, Unlike men, women are defined by their sex, and so will al-ways be concrete, context bound. Women, revolutionary or otherwise, are always merely embodied. Men, not suffering from mere embodiment, tran-scend biology as standard-bearers of citizenship and humanity.[127]

November 22, 2014, was a cold, crisp day in the western Netherlands. After a full day working on a draft of this chapter, I noticed it was getting dark, and a glance at my computer clock told me it was 5:45 p.m. I was about to leave my office at the Netherlands Institute for Advanced Study when Aliaa al-Mahdy tweeted a link to her blog titled "Talk about Feminist Nude Art/Protest in Växjö Konsthall." The post included a picture of her sitting on a chair, perched on a stage, clutching paper, and the text of a talk she had delivered in Sweden. The title suggested that she insisted that what she did was feminist, art, and politics at the same time. The text be-gins: "Why nudity? I was asked this question a trillion times by media, but my answers were never published as they are. Today, is the first time I will answer it without passing through somebody else's filter. . . . Without having somebody skew my words to pass them with his/her sexist, conformist or culture relativist agenda."[128] She went on to describe a strict upbringing, par-ents obsessed with controlling her body, and experience with sexual harass-ment and social ostracization. She also described how one day when she was nineteen, she "closed my room's door, wore forbidden items in a forbidden color: red gypsy flower, red shoes and floral stockings and my naked body. They are forbidden because they attract attention. . . . They express indi-viduality, when an individual, especially a woman, is supposed to hide any

sign of an own identity. . . . They show that I'm not ashamed of my body, and I refuse to carry the guilt of an alleged original sin. I took a photo and posted it on my blog later on 23 October 2011." Al-Mahdy then explained that "there is nothing wrong with nudity. Nudity is used in art to express different things. In my photo, I express defiance for the view that a female body is a commodity to be owned and controlled." After asking herself the putative question, "Do you regret it?" she concludes unequivocally: "I don't regret it, and I would do it again, and again, and again."[129] Hounded at home, forced into exile, extricated from the body of the nation, the Naked Blogger of Cairo represents a heady blend of radical and gradual insurgency, and were we to believe her, that mix is self-perpetuating.

PART VI

Requiem for a Revolution?

———

Five years after Mohamed Bouazizi's incandescent body blazed through the Arab body politic, the fire it started has torched many martyrs, witnesses, and victims. Now it has turned into an inferno, and the Arab uprisings are a smoldering heap of dreams. Syria continues to be torn asunder by a civil war with mounting atrocity. Libya, split in half, sinks deeper into anarchy. Yemen keels under Saudi bombs. Bahrain quivers in royal repression and worldwide apathy. Egypt endures the rise of a new pharaoh, and an armed insurgency there repeats the dreaded Algeria scenario of 1991, when the military canceled elections that Islamists were poised to win, plunging the country into a murderous civil war. Tunisia, the only country to emerge from its uprising with a reasonably working political process, contends with terrorist attacks. Daesh unleashes its savagery on millions and threatens regional order. Chaos and gloom have displaced the euphoria of the early months when a radical remaking of Arab politics was in sight.

Does this mean that a revanchist old order has rolled back the great revolutionary wave of 2010 and 2011? Historical comparisons are fraught, but they give us perspective. In *Anatomy of Revolution,* the historian Crane Brinston observed a pattern in the English, French, and Russian Revolutions.

They all started "in hope and moderation," arrived at a stage of "crisis in a reign of terror," and concluded "in something like dictatorship—Cromwell, Bonaparte, Stalin."[1] Revolutions have unpredictable time spans. Some are protracted and tortuous. The French Revolution unfolded over ten years, and between 1789 and 1799 it experienced many setbacks before Napoleon's dictatorship set in. But the Egyptian Revolution of 1919 had by 1923 secured independence from the British and instituted a new constitution, and the Islamic Revolution in Iran, which started with protests in 1977, had by 1979 installed a new constitution and a new leader. It is too early, then, to conclude that the Arab uprisings have failed, and even as they stall, creative insurgency has ushered in debates poised to outlast revolution.

Consider the debate, about the nature of art and its relation to society, which intensified in reaction to revolutionary street art. Can art be reduced to political messaging? Does fading political urgency turn it into "mere" art? Quibbling whether art is best understood as an autonomous aesthetic quest or a practice embedded in markets or politics is in itself prosaic. But the polemic and the uprisings that spawned it have nonetheless signaled an important shift in perceptions of Arab art. By showing that Arab art could no longer be reduced to exotic, quietist illustration, or authentic cultural expression emanating from an "Arab" or "Islamic" wellspring, creative insurgency demystified Arab art. It unshackled it from political repression at home but also from the strictures of Western expectations. Arab art had been growing in vibrancy and visibility for many years—the 2011 Venice Biennale featured the largest exhibit of Arab art to have ever been mounted on European soil[2]—but the uprisings put it in the global limelight.

The efflorescence of Arab art and the creative insurgency of the uprisings shone a global spotlight on Arab cultural production. A "creative-curatorial-corporate complex" stepped in, exploiting creative insurgency but also extending its life span and reach, at the risk of muting its radical thrust in order to make it palatable to market and museum alike. This spurs a series of questions: What happens when graffiti move from crummy walls to spotless exhibition spaces? What do we make of revolutionary street artists taking up residences in New York and Paris, exhibiting all over the world, or designing luxury fashion? What does creative insurgency lose and what does it gain in the shift from shabby to chic, from uncultured to high-brow? The threat that corporeal, radical rebellion morphs into a disembodied repository that catalyzes debate, attracts museumgoers, benefits art dealers,

and fascinates scholars looms large. But debate, exhibition, commerce, and research sustain an archive of creative insurgency.

Safeguarding creative insurgency is urgent at a time when street demonstrations give way to renewed repression. Looking back at 2014, for example, I cannot shake the impression that creative insurgency has been subverted by a dark, demonic force, an evil twin that matched every embodied revolutionary action with a sinister, reactionary rebuttal. Forces from a bygone era abused revolutionary bodies: erstwhile eradicated diseases like polio decimated communities while jihadists in ninja black, like revenants in a medieval horror show, decapitated orange-clad victims. After swinging from military reign to Islamist rule and back again, Egypt remains in the clutches of repression. Four years after the euphoria of Tahrir, activists fell to police birdshot, and Mubarak and his sons walked out of jail. As tyranny resumed, the human body was once more at the forefront of defiance. Familiar figures struck back. Aliaa al-Mahdy, the naked blogger who rocked Egypt in November 2011, reacted to the rise of Daesh with a more radical body act in August 2014 when she posted photographs of herself dripping menstrual blood on a Daesh banner.

But Daesh reshuffled the power map, pushing states to borrow from the tool kit of creative insurgency in their battle with jihadists. In *Dawlat al-Khurafa* (*Apocryphal State*), a television show whose very name is a spoof of Dawlat al-Khilafa (Caliphate State), Iraqi state television deployed images of eggs hatching devils and other bestial monstrosities to cast Daesh soldiers as usurpers of Islam and savage takers of liberty and life. Elsewhere, in a reprise of the execution by fire of a captured Jordanian pilot, Syrian activists placed children in a cage and pretended to set them on fire, scorning global inaction on Syria and rebuking the media for their obsessive focus on Daesh. Even the U.S. Department of State's social media campaign against Daesh has resorted to animal symbolism, featuring wannabe caliph al-Baghdadi and his henchmen as bloodthirsty dogs and wolves feasting on a dying Arab body politic. Components of the system, from Iraqi state television to the U.S. Department of State, have borrowed tricks from creative insurgency.

A more dangerous threat looms over the Arab uprisings: death, at every turn, awaits the body. "The Specter of Death" hovers menacingly above the rebels, quite literally in the case of Assad's air force raining barrel bombs onto flesh and stone below. If creative insurgency is an artful expansion of

the human body in public space that foments a new revolutionary identity, then the dark shadow of fatality—through guns, bombs, fire, chemicals, starvation, disease, exposure, torture, beheading—is a threat to creative insurgency. Handheld drollery that once enjoined Mubarak, "Leave, My Arms Hurt" (from brandishing revolutionary banners), looks positively rosy when set against pictures of emaciated corpses, bloody limbs torn asunder, or the numbers, those stupefying, ballooning numbers, of bodies slaughtered, diseased, displaced.

CONCEPT POP?

*C*reative insurgency spurred a debate about revolutionary art in Egypt, with complaints that street art had shifted from mischievous exploration to unrefined agitprop that "fails to see itself as art to reflect on and experiment with its aesthetic vision as aesthetics."[3] The polemic heated up in 2014 when artist Ganzeer bemoaned artists' adoption of dated and foreign styles and criticized media coverage for reducing graffiti to antiregime messaging.[4] He coined Concept Pop to describe art that is socially relevant, politically resonant, and resistant to appeals for authenticity. Replaying a familiar tune about art was sure to generate a riposte, and it came from architect and critic Adham Selim, who chided Ganzeer for "imagining the world as a spectacle, something that you can choose either to gaze at or participate in," and argued instead that the world was "an event" that forced us all to participate. Then Selim chastised Ganzeer's reduction of "art to a frontage" and excoriated attempts to replace experiencing art with grasping its meaning. Selim called this dreaded tendency the "aboutness" of art.[5]

This "aboutness" is a long-standing feature of art everywhere, but it is particularly acute in Egypt, where "discourse" is the most widespread activity in the art world.[6] Art talk was one way to deal with the multiple pressures from state, market, and taste that shaped art making, including pressures to "represent Egypt" and to heed influential but Eurocentric conceptual frameworks, a process that the anthropologist Jessica Winegar defines as "reckoning."[7] Contentious in normal times, the "aboutness" of art became more banal and testier in the wake of revolution: more mundane because it

permeated public space, the media, and daily conversation, because "when something happens, people go out in the street and draw. Then we talk about it," and more disputed because revolution raised the stakes of art.[8] In the total flux of revolution, art was a visible expression of "aesthetic uprisings" and thus a bone of contention.[9] So dueling critics summoned Adorno on commitment, Sontag on erotics and hermeneutics, Kundera on kitsch, and Badiou on imperial art. Tensions ran high between guardians of aesthetic autonomy and proponents of political art, and within each camp, reverberating among artists, activists, and critics. But if conflating art with art talk is one of the art world's knottier challenges, why is this debate relevant for creative insurgency?[10]

The answer lies in the circulation and aggregation of artistic work and art talk in a massive, crowd-sourced repository of creative insurgency. By creating a digital memory, this web-based accidental archive enables the survival of ephemeral street art. As it enters hypermedia space, a graffito bounces from concrete walls to digital life, where it is sent, shared, tweeted, liked, pinned, opposed, written up, and researched. In turn, accessibility fosters talk and media coverage of revolutionary art, provoking new rounds of polemic in the press and a number of English-language outlets like *Mada Masr* and *Cairo Review of Global Affairs*.[11] The zines *Jadaliyya, Muftah,* and *al-Monitor,* launched before the uprisings, disseminate images and controversies.[12] Lavishly illustrated books and dedicated, high-quality websites, personal blogs, and social media haphazardly yet successfully preserve revolutionary street art. The archive accomplishes several feats. It bears witness to the martyrs, commemorates their deeds, and preserves evidence of regime crimes. It also inspires new activists, who in turn replenish the stock.

By preserving and renewing itself, and by inspiring new activism, creative insurgency contributed to the revolutionary public sphere. Bouts of "aboutness" unfurled in cyberspace like brightly colored banners flapping in a tempest. They attracted attention. If publics gather around concentrations of attention-grabbing texts, then revolutionary art is exemplary of the kinds of lures that attract publics. At once whimsical, grim, and heroic, insurgent art is chock-full of stylistic features that attract attention, helping form rival camps that differ on creative insurgency's merits.[13] Inventiveness is vital to rebellion, but revolutionary publics place politics above aesthetics. Creative insurgency uses art to shape revolutionary political identities and promote cross-border solidarities, but it is not limited to art making. It is in the

seesaw of bodies-in-pain and bodies-in-paint, in the cycle of artful protest and protest art, and in the debate about art that creative insurgency unfolds.

Let us ponder the association and festival El-Fan Midan, which started in 2011, running one day of every month in Cairo's 'Abdeen Square. The word *midan* became widely familiar because of Midan al-Tahrir (Liberation Square). Since it was held in a city square, El-Fan Midan was commonly translated as "Art is a square," which is akin to rendering "*asha'b yurid esqat al-nidham*" as "The people want to topple the regime," not "system." It is the same kind of narrow translation that leads to an impoverished understanding of creative insurgency. *Midan* is Arabic for "arena" or "battleground," so El-Fan Midan also means "Art is a battleground."[14] The existence of street art is an important contributor to public culture. Recalling the Latin American writer Nestor García Canclini's understanding of graffiti as an important irruption in public space dominated by official monuments and commercial advertising, and considering that Cairo monuments have defined Egypt, we can envision how street artists contribute to redefining the nation.[15] It was simply impossible to separate art and debates about art from revolutionary politics.

Art and talk about art: examined, questioned, debated, and contested. These bouts of aboutness are best understood as revolutionary soul-searching. Creative insurgency underscores the limitations of either-or thinking about aesthetics and politics and reflects how vital the "aboutness" of our bodies is to the elaboration of revolutionary selfhood. By seeing revolutionary art, being stirred by it, and teasing out its meanings, people stay focused on the revolution. Chatting up cultural expression may elide the human pain that spurred it, but debating creative insurgency passionately keeps us watchful that it is through our bodies that we experience revolution, and that the Arab uprisings have been a herculean corporeal effort. Since embodiment is a junction of physical experience and attempts to understand that experience, of power and perception, the body is where the distinction between politics and aesthetics is undone. To the question "If revolutionary art . . . mocked and criticized Mubarak, how does this art remain revolutionary after Mubarak is gone and a new, seemingly more violent phase has started?" our answer should be: Creative insurgency does not die with incumbent dictators, for it is a broader struggle against the system. And the system is not going away any time soon.[16]

THE CREATIVE-CURATORIAL-CORPORATE COMPLEX

The old quip about Arab literature, "Cairo writes, Beirut publishes, and Baghdad reads," can now be adapted to art: "Cairo and Damascus paint, Beirut and Dubai exhibit, and Abu Dhabi and Doha buy," though worldwide dispersal of revolutionary artists, global curatorial consecration of their work, and deep-pocketed collectors and museums mean that Arab art today resists identification with single locales. The surge of an international network of media, foundations, galleries, museums, auction houses, collectors, and investors interested in Arab art, particularly the revolutionary kind, raises questions about the curatorial and commercial absorption of creative insurgency.

For a decade, Qatar and the United Arab Emirates have loomed large in the Arab art market. With massive infusions of petrodollars into art and heritage, these countries established museums and foundations and acquired cultural cachet at breakneck speed: In 2007, Abu Dhabi disbursed $525 million to use the name Louvre, and Qatar invested $434 million to build a national museum.[17] Their astronomical acquisition budgets and insatiable buying sprees have spurred fears about bending Arab aesthetic standards and political narratives to fit the Gulf's culturally and politically conservative norms. When a noted commentator and art patron wrote that Abu Dhabi, Dubai, and Doha were now "the nerve center of the contemporary Arab world's culture, commerce . . . art and academia," out-

stripping other Arab cities in everything except "political dynamism," he highlighted a divide between old cities like Beirut and Cairo, where local art and culture have a deep history, and the brave new world of Dubai and Doha, where money conjured up collections overnight.[18]

This speed has raised questions about sustainability. Were wealthy Gulf cities elevating brittle edifices on shaky foundations? Were they "cities of salt," as the exiled Saudi writer Abdulrahman Munif titled his 1984 quintet, which warned of the consequences of squandering oil wealth? The paucity of indigenous cultural production, which mirrored the vastly foreign workforce in Gulf States, raised a red flag.[19] To this debate, the Arab uprisings added a dose of outrage, manifest when Syrian blogger Maysaloon reminded debaters that "the Arab Spring was sparked by an impoverished street seller who set himself on fire in sheer desperation" and demanded "less talk about grand Arabian cultural and political revivals and more talk about simple acts of suicidal rebellion by small people," before upbraiding them: "You can keep your 'culture' and your cardboard cut-out cities . . . your glorious past. . . . I don't want any of that when human beings can't even live in our countries with the most basic elements of human dignity."[20] Art and culture rivalries should not overshadow the grim reality of oppression.

Gulf institutions grew as a major art force in tandem with a global network of distinguished institutions and individuals whose interest in Arab art was boosted by the uprisings: the Prince Claus Fund (Amsterdam), the Danish Center for Culture and Development, the Arab American National Museum (Dearborn, Michigan), Bryn Mawr College, the Brooklyn Artists Alliance, the Leila Heller Gallery (New York), the Institut du Monde Arabe (Paris), Sotheby's (London), the Barjeel Foundation (Sharjah), the Beirut Art Center, the American University in Cairo Press, Saqi Books (London), From Here to Fame Publishing (Berlin), corporate sponsors, festivals, dealers, collectors, and magazines. All promoted, funded, exhibited, screened, sold, or published creative insurgency. Together they constitute the creative-curatorial-corporate complex.

The complex is not entirely new or controversial. Egyptian artists have long taken advantage of both government curatorial venues and private Western institutions, turning into "bricoleurs of the neoliberal era."[21] Even revolutionary collectives like Mona Lisa Brigades openly discussed monetizing their graffiti.[22] The complex has been a boon to some artists. So even

though a critic, inspired by the philosopher Alain Badiou, may gasp when "commercial values about smiling, happiness . . . creep into artistic expression, leading to horribly shallow works of art," creators have been happy to smile all the way to the gallery, the museum, the residency, and the bank.[23] Rather than pawns of the complex, artists are active self-promoters who direct social media traffic to their opulent websites. Promotional savvy is as important as artistic sensibility, and many artists have seized the limelight of the uprisings. For an exemplary case, consider the Franco-Tunisian artist eL-Seed.

Born and raised by Tunisian parents in Paris, eL-Seed moved to Montréal then quickly established an international reputation in revolutionary Tunisia.[24] Prodded by Tunisia's polarization between Islamists and secularists, he executed the centerpiece of his emerging celebrity: a forty-seven-meter mural on the minaret of the Jara Mosque in Gabès, underwritten by the Barjeel Art Foundation in Sharjah, United Arab Emirates.[25] He inscribed a famous Qoranic verse, "Oh humankind, we have created you from a male and a female and made people and tribes so you may know each other," to fight religious extremism.[26] In 2013, eL-Seed showed some works at Leila Heller Gallery in New York, got a sponsorship from Qatar's Public Art Programme, designed a *foulard* for the luxury house Louis Vuitton, and embarked on a road trip painting murals throughout Tunisia, then published a book documenting that journey that he unveiled at Art Dubai in March 2014.[27] eL-Seed's Twitter feed reflects a high flyer in art, business, and fashion. In January 2015 alone, eL-Seed featured calligraffiti adorning an art center in Sharjah and buildings in Doha, a photograph of the silk scarf he designed for Louis Vuitton, book publicity, an art show in Doha, a mural in Melbourne, a multistory orange mural in Algiers, a lithograph at a Paris gallery, and a rooftop piece in a Brazilian favela, all cross-promoted on Facebook and Instagram in Arabic, French, and English.

Does this strike you as the portrait of a local revolutionary artist? eL-Seed is at once artist, activist, self-promoter, jetsetter, and navigator of multiple worlds. Calligraffiti cunningly blends the gravitas of Islamic calligraphy with the hipness of street art and adroitly sidesteps that "you can never call yourself a calligrapher unless you get certification from a master." Adept at cross-cultural lingo, eL-Seed rebuffs platitudes of East versus West but says that to use the Arabic script in his art is to "fight cultural imperialism."[28] Contemplative about fame and autonomy and equipped with a business

degree, he switched his nom de plume, inspired by Pierre Corneille's *Le Cid* ("the lord" in Arabic), from "El-Scid" to the English-friendly and visually distinctive "eL-Seed."[29] In contrast to creative insurgents like the furtive and understated Sprayman, some eL-Seed works require large machinery and logistics.

Driven by distinction, capital, fame, and politics, the creative-curatorial-corporate complex is not homogeneous. Exemplary dwellers of the complex like eL-Seed and Ganzeer are adept steersmen of the fraught space between art, commerce, and activism. Their talent, grit, self-promotion, and language ability helped lift them above other revolutionary artists. As bellwethers of the system, they have retained a political edge, however dulled: Ganzeer created anti-NYPD art in Brooklyn, and eL-Seed's art "took back the purple" from Ben Ali.[30] Their success foments art at home (art spaces have proliferated in Cairo) and demystifies Arab art abroad, undercutting Western criteria that worthy Arab art must clash with conservatism, exoticize Arab women, or be "authentic" (artists themselves invoke authenticity: eL-Seed recalls Islamic art in calligraffiti, Alaa Awad used pharaonic motifs, and Ammar Abo Bakr drew on folk Islamic murals). Sometimes it is a matter of presence: in 2013, eL-Seed was the first Tunisian artist in sixty years to exhibit in New York.[31] Finally, the complex allows variations in status. Celebrities live cheek-by-jowl with striving mavericks and contrarians hell-bent on staying out of the limelight.

Though the creative-curatorial-corporate complex is part of the system that triggered the Arab uprisings in the first place, the separation of art and world is increasingly untenable. The success of Ganzeer, eL-Seed, and others raises questions about revolutionary art as much as it does about the art world at large. Autonomy as defined by some theorists is too high a threshold for artists anywhere. Badiou's injunction that true, "non-imperial" art "must be as rigorous as a mathematical demonstration, as surprising as an ambush in the night, and as elevated as a star" may be too much to ask from artists in the midst or in the aftermath of revolution, even if Badiou is spot on that intellectual property rights, the star system, and evaluation based on commercial prestige prop the system. Arab critics echoing this perspective postrevolution advance an unrealistic idea of autonomy.[32] Stark opposition between aesthetics, politics, and business simply fails to capture the richness of creative insurgency, its ability to adapt, survive, and attack new foes like Daesh.

THE DAESH STAIN

*A*s the Arab uprisings got mired in counterrevolutionary quicksand, violent spasms shook the Middle East. Most terrifying is Daesh, whose murderous history began in the wake of the Anglo-American invasion of Iraq in 2003, ebbed and flowed with the Iraqi insurgency, and then reemerged in war-torn Syria, fueled by the chaotic proxy war in Syria. By resurrecting the notion of the caliphate, Daesh sought to rekindle memories of Muslim unity under a sovereign who combined earthly rule as sultan and divine power as caliph—a polity that ended with World War I. Daesh is *a nostalgic body politic* that manipulates memory toward strategic objectives. Lawless areas in Iraq and Syria created the physical conditions for the expansion of Daesh to the size of a large nation-state, but whether Daesh is a state or not matters less than its ability to inflict mass-scale bodily harm and disseminate it globally. In every utterance, video, tweet, and article in its magazine *Dabiq,* Daesh weaves a self-portrait that combines strategic clippings from Islamic doctrine with the trappings of a state and the rhetoric of war. It reflects a vision of the world with a cult of death at its center. After grasping the Arab uprisings as a corporal insurgency against a tyrannical system, we can now comprehend Daesh as a new regimen of bodily control justified by religion, enforced by brutality, and propagated as spectacle.

Striking is the extent to which Daesh has hijacked creative insurgency and subverted it in an orgy of death. The way its black-covered foot soldiers, looking like ninjas, have herded orange-clad victims and forced them to

kneel, before cutting their throats, conjures a demonic hybrid of snuff films and reality television. Daesh members include German rappers, British thugs, French malcontents, Saudi and Chechen militants, Syrian and Iraqi insurgents, and rebels and adherents from the furthest reaches of the globe. They have posted selfies, visual travelogues, zany braggadocio, and political slogans all over social media and disseminated videos in which members overrun enemy positions, capture tanks and planes, behead captives, or ritually burn their passports to affirm mutual solidarity and pledge allegiance to Daesh and its putative caliph. They have sprayed graffiti, released chants, and flung the index finger to underscore the notion of *tawhid,* or unity of God. They have stolen Bouazizi's inspiring self-immolation by setting a captured Jordanian pilot on fire inside a cage, turning a heroic action into macabre reality show. Their comrades, as if spiteful against the vibrant artistry of the uprisings, have vented an iconoclastic rage by destroying historic patrimony and razing entire cities in Iraq, though that also concealed their systematic looting of archeological treasures. Daesh has used some of the tools of creative insurgency in its morbid reenactment of the power exercised on Arab bodies by local dictators and foreign occupiers.

By hijacking creative insurgency, Daesh unleashed upon itself a new wave of it, eliciting the same kinds of satire that targeted Arab dictators, smearing the wannabe caliph al-Baghdadi's exalted, classical body in animal symbolism and casting it downward as a grotesque, murderous corporeality. In addition to programs on Iraqi, Palestinian, and Kurdish television channels, which featured al-Baghdadi as a midget demon hatched in an egg, familiar activists responded.[33] To Daesh's monstrous abuse of the bodies of its victims, the Naked Blogger of Cairo countered with her signature weapon, her body, which she projected in a particularly unbounded state. On Saturday, August 27, from her Scandinavian exile, the Egyptian activist lobbed her most inflammatory photograph yet: On Daesh's black-and-white banner, al-Mahdy squats, naked with the exception of ballerina flats, arms behind her for support, fiercely gazing forward. Her legs are wide open and her vulva, daubed in red, drips on the white circle in Daesh's banner, which includes "And Mohammed is His Messenger," the second half of the *shahaada,* the Muslim proclamation of faith. Next to her sits another woman, back turned to us, head, shoulders, and middle back covered in black cloth, excreta seeping from her rectum onto the *shahaada.* Two black machine guns protrude behind the two bodies. The initials IS (for

Islamic State) are painted in black above al-Mahdy's breasts and on the buttocks of her unnamed partner right below the Femen logo of two circles separated by a straight line. Whereas al-Mahdy stares intensely at the lens, face framed by black curls reaching down to her breasts, her comrade lifts her right middle finger in the universal "fuck you" gesture. Bodies, blood, and guns: Daesh's repertoire turned against it.

The photo was incendiary. Featuring two naked women menstruating and defecating on a visual rendition of Islam's core statement, weapons nearby, the image mixed unbound bodies, unbridled violence, unchecked sexuality, and undefined religion. The photograph appeared, disappeared, and reappeared on Facebook, before showing up again all over the world. A few Western publications featured censored versions of the photo, but Arab outlets were more circumspect, not only because of the nude body but rather, as one newspaper explained to its readers, it did not publish the photo because of the presence of the *shahaada* on the flag.[34] The stunt redeployed techniques honed during the Arab uprisings in a tit-for-tat battle of images against Daesh. Whereas Daesh cleansed public space from the bodies of women through sequestration and of "enemy" men through assassination, al-Mahdy and her comrade broke their own corporeal boundaries, oozing fluids on Daesh's banner and subverting the hand gesture from a sign of piety to a sign of defiance. Here we see a darker, bolder creative insurgency that blurs radical and gradual activism: bodies, fluids, hands, fingers, blood, and al-Mahdy's eyes fixed in an unrelenting stare, flung to the seven cyberwinds.[35]

Al-Mahdy performed the most fraught role in this body stunt. Defecation on Daesh's symbol conveys unequivocal scorn, but menstruation has ambivalent meanings. Historically, menstruation has meant either pollution, which often resulted in the isolation or sequestration of menstruating women from the community, or life-giving strength, which has evoked fears and prodded men to establish taboos to control that strength. In modern society, menstrual blood provokes anxiety and sometimes ridicule, and in North Africa, for example, blood has been long understood through myths that fear the absence or leakage of blood as harbingers of death.[36] Regardless, blood was a recurrent symbol in creative insurgency, from Syrian activists dying public fountains in red, to depictions of bleeding bodies in street art. Al-Mahdy was unapologetic: On November 23, 2014, she posted a text titled "Embracing Menstruating Vaginas," which ended with an excerpt from a talk al-Mahdy gave at an art gallery in Stockholm

REQUIEM FOR A REVOLUTION?

and shared that her mother told her she "should hide [her] periods as [she] should hide [her] naked body."[37] The tenor of the text and the close-up photograph of a vulva dripping blood confirm that in her stunt al-Mahdy celebrated her own body and excoriated the jihadists.

With the photograph al-Mahdy condemned Daesh's extreme strictures on women's bodies and affirmed the creative power of the body. But staging menstruation was tantamount to a radical performance of female embodiment, and this can be understood as a subversion of prevailing social norms for political purposes. Between life and death, menstruation conjures up what the American literary critic Peggy McCracken has called "the logic of monstrous birth, the idea that a woman's corrupting menstrual blood might produce monstrous offspring."[38] By staging her body to seep menstrual blood on Daesh's emblem, al-Mahdy implemented the mother of all creative insurgencies, subverting notions of femininity and dirtiness to depict Daesh itself as a monster. By doing this through her own bleeding, unbounded body, al-Mahdy warned that if women were prohibited from being abstract individuals, then at the very least they can turn symbols of women as abject bodies into a political weapon.[39] Here was a radical act, for in examples of creative insurgency we have seen, a patriarchal norm was ever present: The Laughing Cow feminized Mubarak, Bishu queered Bashar, and le Zaba (the title character of *Le Journal du Zaba*) infantilized Ben Ali. These tropes expressed the effeminacy inherent in the transformation from hard, bounded, classical bodies to soft, illimitable, grotesque bodies. Besides, until Shaimaa al-Sabbagh's demise, key martyrs like Bouazizi and Said were clothed men, whereas iconic women earned their status by disrobing. In the space between abstract bodies and abject embodiment, al-Mahdy blew up these norms.

The symbolic assault on Daesh with women's blood and feces and tepid media reactions indicated that the unbridled thrown-apartness of female body was intolerable. Just as al-Mahdy established a parallel between menstruation and terror to expose Daesh as a monstrous death cult, so did Daesh bare a global geopolitical system that often operates by the law of the jungle, against the principles of popular and national sovereignty, where the drones of the powerful fly unfettered killing sprees anywhere while their banks inflict painful regimes of financial austerity, a system concentrating brute force and the quest for material profit before unleashing this combination on the bodies of individuals and nations. The misery this system engendered was in full display in Cairo with the rise of a new leader.

ANOTHER PHARAOH?

*O*n the evening of Sunday, June 8, 2014, as crowds of jubilant Sisi sup-
porters gathered in Tahrir Square to celebrate the inauguration of their
hero as the fifth president of Egypt, groups of young men assaulted several
women. One case shocked because a video of it showed a group of young
men brutalizing a young woman's naked, bruised, and bloodied body.
The victim's friend said, "I saw . . . she was dragged, and surrounded by a
large circle . . . her clothes taken off, then another circle formed, and they
were blowing horns and singing so that no one could hear her screams,"
before a police officer rescued the victim and took her to an ambulance.[40]
Attackers' bodies concealed their victim's body and voice as they violated
her. The aftermath created a memorable visual: Sisi, defense minister and
chief of staff in tow, handing red roses to the victim in her hospital bed,
and Egyptian television showing Sisi apologizing to "you and all the women
of Egypt," offering her a trip to Mecca for spiritual convalescence.[41]

Reactions ranged from asinine (a television host nonchalantly cast per-
petrators as "people expressing their joy," and an actress envious of Sisi's
visit said of the victim, "Poor thing . . . is there no one who would harass
me?") to implausible (a proposal to legalize prostitution to aid in the "evac-
uation of bursts of frenzy and charges of anger and tension in the bodies
and minds of our inflamed youth").[42] One columnist impugned "stars of
seduction" and the "vocabulary of sex" in Egyptian film and television.[43]
Another worried about working-class youths and pushed for treating root
causes over criminal punishment.[44] A third lamented the assaults as "me-

thodical."[45] But yet another writer interpreted sexual assault as a geopolitical metaphor when he compared the "rape" in Tahrir to the "rape of Palestine by Israel . . . in 1948 and then in 1967," noting that Sisi's inauguration on June 8, 2014, occurred a single day before the forty-seventh anniversary of "the fall of Jerusalem." Then he rebuked Sisi for complaining that the assault video "scandalized honor and nation," writing, "What is scandalous, O Your Sovereignty Field Marshal President, is the nation that deals with the victim as if she were the cause . . . is he who asks 'what was she doing there in the first place' and 'look at how she was dressed,'" and concluded, "If no one had captured the incident on video, you would not have visited the victim."[46] This stood out in a debate focused on sexual assault as a social pathology to be remedied by school and church, rather than a political issue shaped by state power.

Sisi's office condemned sexual harassment and promised to eradicate the epidemic.[47] But no matter what Sisi's personal views and intentions were when he apologized to the victim, he was the head of a body politic unwilling or unable to address the endemic problem of sexual assault. That some of the worse sexual assaults occurred during the inauguration period of the new sovereign is not coincidental but reflects that sexual violence in the square resonated with the violent takeover of power in the country. Comparing the Tahrir rape to the Israeli takeover of Jerusalem was not only a scathing political indictment but a reminder of a recurring theme: people experience local dictators as foreign occupiers. When I first saw the photograph of Sisi visiting the victim at the hospital, it reminded me of the picture of Ben Ali lording over Mohamed Bouazizi in his hospital bed. Perhaps it was the mise-en-scène, the visual composition, or the cast of victim, leader, officials, and medical staff, but the visual echo between the two pictures was innerving. Differences between the two accentuated this feeling rather than dispelling it: Bouazizi's face was wrapped in gauze, and the assault victim's was digitally anonymized, but they both represented entire nations of abused bodies. Sisi's bouquet was an awkward prop, and many a social media joker wondered if he were asking her on a date. And why did Sisi bring the two top military officers into the hospital room of a sex-crime victim? He might have intended a show of determination to protect Egypt, but uniformed and beribboned classical bodies evoke raw power. Sisi's action might have intended to showcase a caring ruler, but the image portended the ominous return of Pharaoh.

Nothing in the next one and a half years—not the endemic police violence, not the mass death penalties, not the muzzling of the media, not the plight of incarcerated hunger strikers—captured the return of an overbearing sovereign like the murder of Shaimaa al-Sabbagh, who was shot on the eve of the fourth anniversary of the revolution while carrying a commemorative wreath. A published poet, social activist, folklore researcher, and, since 2011, member of the Socialist Popular Alliance Party, al-Sabbagh lived in Alexandria with her husband, a painter, and a five-year-old son. On January 24, 2015, after attending a meeting to discuss electoral strategy, she and a group of comrades headed to Tahrir Square with commemorative flowers. But the police had blocked access, so the activists headed to the nearby Tal'at Harb Square, where offices of Air France, the al-Shorouk bookstore, and the famous Groppi, the Swiss café and patisserie that has served as a political gathering place since the 1919 Revolution against the British, are located. Barely a few minutes into the march, security forces confronted al-Sabbagh and her companions.

The minutes that followed became some of the most discussed of the four years since January 2011, and cameras played a pivotal role, capturing a wrenching record of a moribund al-Sabbagh. A video captured an officer ordering masked policemen to "Fire!" toward the commemorative march.[48] A photographer for the newspaper *al-Yawm al-Sabe'*, in downtown Cairo by happenstance, snapped six photos in rapid succession. One of them showed al-Sabbagh, just shot, standing shocked, mouth open, hair sticking to her temples, blood trickling down her cheek and jacket, held upright by a kneeling male comrade. Women defied a ban on protests to protest her death, banners with al-Sabbagh's face brandished high, and people whispered her name in awe and shouted it in defiance. Drawings and digital mash-ups of her face circulated on social media, and a haunting stencil of al-Sabbagh's body held straight by her friend showed up on the walls of Alexandria and Cairo. Ammar Abo Bakr painted a mural of al-Sabbagh with angel wings in Berlin. Shaimaa al-Sabbagh entered the pantheon of iconic revolutionary martyrs.

The daylight murder of a photogenic thirty-one-year-old activist was a nightmare for the regime. As a leader of political marches, researcher of rural life, and militant critical of Muslim Brotherhood rule, al-Sabbagh was immune to attempts to tarnish her as unpatriotic or an Islamist sympathizer. Few figures threaten less than a mother and poet, and the roses com-

pleted a portrait of above-the-fray wholesomeness. Photos and videos quickly helped turn al-Sabbagh into a revolutionary icon. So after initial official reactions all but denied the possibility of police culpability, the next day the government backpedaled, deploring the young woman's death as "a devastating loss to all of us Egyptians," stating an investigation was opened while at the same time alluding to Muslim Brotherhood culpability.[49] State prosecutors imposed a gag order, concerned that "inaccurate and contradictory" media coverage would "negatively impact" the investigation, and Sisi publicly called al-Sabbagh "my daughter," casting himself as a benign paterfamilias.[50]

Al-Sabbagh's fate revealed how vulnerable Egyptian activists had become and suggested women were particularly unsafe—naked or clothed, liberal or leftist, secular or pious, uncovered or veiled. The murder exposed the return of the prerevolutionary body politic, a state of exception where life-and-death actions were unencumbered by the rule of law or the constraints of morality. The usually circumspect Islamist-leaning columnist Fahmy Howeidy feared the government was "consecrating killing" and compared the demonization of the Muslim Brothers and the forced unification of public discourse—an "invitation to a political purity . . . by power holders . . . and intellectual and media aides, to cleanse society from groups they decided had to be exterminated to resolve society's problems"—to the Nazi final solution.[51] The liberal Amr Hamzawy argued that the murder was a "natural result" of the complicity of the economic and political elite with the state in undermining "the sovereignty of the law," of the promotion of "corrupt, authoritarian trade-offs between freedom and security," and of imputing violence to "battalions of conspirators" or justifying them with "fascist sayings that insult people's right to life, dignity, and freedom."[52] With characteristic bluntness, muckraking journalist Ibrahim 'Eissa said, "President Sisi bears political responsibility for every drop of blood" and blamed the ministry of the interior for al-Sabbagh's death.[53]

But it was the blogger Wael Eskandar who cut to the crux of the matter. Probing why al-Sabbagh's death moved him so deeply," Eskandar answered, "because her passing resembles the murder of Khaled Said, all over again. If we can capture the revolution as a single demand, it was so that we never have another Khaled Said. It doesn't mean that people are never killed again, but that the regime does not get away with murder and does not use its institutions to cover up their crimes." He continued, "the revolution

failed, utterly and categorically" as the ongoing cover-up of the daylight murder attested: "We are asked to shut up about the whole matter . . . but when has the public prosecutor ever arrived at real conclusion or true condemnation for regime crimes? . . . The judiciary in Egypt has systematically attempted to disprove what we've seen with our own eyes."[54] Eskandar led us back to body imagery, showing how sovereign power required people to distrust their embodied experience, to mute their voice ("asked to shut up"), to veil their eyes ("what we've seen with our own eyes"), to disown their own bodies. Commanding bodies to retreat from public space, to give up demands for popular sovereignty, was tantamount to slaying the revolutionary spirit. Authorities first blamed protesters, then charged an unidentified policeman, then blamed al-Sabbagh's thin, "skin over bone" body.[55] Al-Sabbagh's murder and its aftermath announced the return of Leviathan, a body politic whose head sacrificed members with no rights and raised a menacing specter of death above the revolution and its creative insurgency.

THE SPECTER OF DEATH

*F*our years after the people chanted "If the people one day decide they want life," revolutionaries across the Arab world were harvesting death. Peaceable uprisings against oppressive sovereigns turned into death fields littered with bodies of martyrs and dreams of survivors. Jubilation in Tunis, euphoria on Tahrir, and the faith that dared scribble its name in Der'a were now the fuming ashes of the great Arab uprisings. Headlines conveyed how bleak things were: "Syria: Waiting to Die in Aleppo" and "Egypt: Graveyard Silence."[56] Reports from Bahrain and Tunisia reflected the omnipresence of death in countries where four years earlier determined protesters took over streets and squares and infused public space with symbols of a will to life.[57] Bridging the abyss between revolutionary aspiration and daily cruelty was the ever-growing number of corpses. But even against this grim backdrop, the situation in Syria was particularly ghastly: as the civil war there grew more violent, civilians paid the highest price, in kin lost, homes destroyed, livelihoods crushed.

In once-bustling Aleppo, a scene of sniping far more lethal than Egypt's Battle of Mohamed Mahmoud unfolded in September 2014. This is how one journalist described it:

> A woman is walking on the Sachur Bridge, a deserted highway onramp. Walking up it is potentially deadly. "My God, what is she doing there?" someone says over the radio. "She must be crazy!" . . . But the woman in black sidesteps the barricades and begins walking across the bridge. It takes

a few seconds for the first bullet to zip through the air. The voices on the radio become increasingly agitated as the shots continue. "What should we do? Shoot back? No, that would only goad them on. My God. . . ." The woman bends over and then keeps walking. There is a seventh shot and then an eighth shot. The woman falls to the ground. No one knows what she was doing up there. Gathering used plastic bags to sell? Or perhaps she was trying to get killed? Or had she simply lost her mind? People shrug their shoulders. No one knows her name. They recover her body in the darkness, and then her trail is lost. "We are still alive, but for how long? A day, a week? We are the living dead, like those creatures in the movies, zombies!" says a civil defense volunteer on guard duty. "Yes, zombies! Would you like your coffee with or without sugar?" Eastern Aleppo is a city of polite zombies, an eerie place that seems too exhausted for despair.[58]

As gory as the eye sniping was in Cairo, deliberately and repeatedly shooting a lone woman on an empty bridge was doubly sinister and highlighted the acute precarity of the human body targeted by murderous whimsy. But one imagines that there was also doggedness to the woman's desire to cross that bridge, a stubbornness borne out of a will to live that preferred death to mere survival. Seen, the impact of the war on human bodies could also be heard, in a city haunted as much by snipers as by death falling from the sky in the form of barrel bombs: "When there is no shooting, the city is eerily quiet, as residents silently go about their daily lives. Normal sounds are missing entirely: traffic, voices, music, birds."[59] The soundscape of death, strident in its silence, a soundtrack for a stalled revolution.

As grisly as the situation became, the revolutionary spirit remained steadfast. In March 2015, I met a group of Syrian activists, writers, videographers, graffiti designers, each a brilliant creative insurgent. One, a short story writer exiled in Europe, was working on a volume of short stories inspired by the revolution. Another, a member of the collective Asha'b Assoury 'Aref Tareqoh (The Syrian People Knows Its Way), shared anti-Daesh and anti-Assad posters that the collective was disseminating throughout Syria. On the fourth anniversary of Syria's revolution, he said, "I felt nostalgic for the early days of the revolution, but I immediately stopped myself. I am still in the event. The event is changing, but it is still here. I cannot allow myself to be nostalgic." A third activist, a writer and filmmaker, was busy preparing clandestine screenings of activists' mobile-phone videos in the city of Raqqa, the capital of Daesh. Others debated whether coverage of

Syria crossed ethical lines by showing graphic suffering and death. All were heartened to share that in March 2015, there were public demonstrations commemorating four years of revolution, in both regime- and Daesh-held areas. Even if the protests were small and brief, and not covered by the media, they ascertained that the revolution survived Syria's horrific devolution. At a time of widespread cynicism about the Arab uprisings, the activists themselves were energetic and hopeful, insistent that the revolution continued. They reflected the famed Syrian playwright Sa'dallah Wannous's famous 1996 dictum, one year before he succumbed to cancer: "We are doomed by hope." Wannous should know: in his 1977 play, *The King Is the King,* written under the totalitarian Hafez al-Assad, a humble beggar displaces the monarch, puncturing the myth of an eternal ruler.

A will to live, against long odds, birthed creative insurgency as an extension of people's bodies in the public sphere. In bursts of fire and bouts of satire, in physical contests and symbolic skirmishes, the human body was and remains central to the way that people represented themselves and their enemies and demanded dignity and justice. As time passed, creative insurgency mutated, moved across national boundaries, and migrated to cyberspace. It was featured in news stories and documentaries, it preoccupied art critics and academic researchers, and it graced galleries and museums. More important, creative insurgency heralded the rise of the heroic body of the revolutionary self. Creative insurgency continues to do all that as it grapples with finitude, focused on its essential task. As Dorinda Outram wrote, revolution "cannot be understood except in terms of a change-over from a public world constituted as coterminous with sacral bodies, and one conceived as a scene of conflicts over the achievement of heroic bodies which had to be recreated anew in each individual."[60] Even if the specter of death is the ultimate adversary of the rise of the revolutionary person, creative insurgency endures, for the struggle to reclaim popular sovereignty from the body of the tyrant is ongoing, however tortuous and arduous a path it follows. Burning Man, Laughing Cow, and Naked Blogger of Cairo are bound to stay with us for a long time, and in these styles of rebellion, human resilience and creativity flourish, and the will to live, despite the specter of death, implores us to be awed, over and again.

NOTES

PART I. IN THE NAME OF THE PEOPLE

1. Michel Foucault, *Remarks on Marx,* trans. R. James Goldstein and James Cascaito (New York: Semiotext[e], 1996), 136.

2. Ibid., 138.

3. Evan Bleier, "Farmer Jailed for Dressing Donkey like Egyptian Presidential Candidate Abdel-Fattah al-Sisi," *Egypt Independent/UPI,* April 2, 2014, http://www.upi.com/Odd_News/2014/04/02/Farmer-jailed-for-dressing-donkey-like-Egyptian-presidential-candidate-Abdel-Fattah-al-Sisi/3211396445914/.

4. Aliaa Magda Elmahdy, "Nude Art," *A Rebel's Diary* (blog), October 23, 2011, http://arebelsdiary.blogspot.com/2011/10/nude-art_2515.html. This text existed only in Arabic until November 19, when an English version appeared.

5. Ibid.

6. Marc Lynch, *The Arab Uprising: The Unfinished Revolution of the New Middle East* (New York: Public Affairs, 2013) uses "possibility" and "inevitability" (242).

7. Some scholars with Arabic fluency translated *nidhaam* as "system": Hanan Sabea, "'I Dreamed of Being a People': Egypt's Revolution, the People and Critical Imagination," in *The Political Aesthetics of Global Protest: The Arab Spring and Beyond,* ed. Pnina Werbner, Martin Webb, and Kathryn Spellman-Poots (Edinburgh: Edinburgh University Press, 2014), 67–92. Others clearly thought in systemic terms, like Alain Badiou in *The Rebirth of History: Times of Riots and Uprisings* (London: Verso, 2012).

8. Nabiha Jerad, "The Tunisian Revolution: From Universal Slogans for Democracy to the Power of Language," *Middle East Journal of Culture and Communication* 6, no. 2 (2013): 232–255.

9. Michael C. McGee, "In Search of 'the People': A Rhetorical Alternative," *Quarterly Journal of Speech* 61, no. 3 (1975): 239.

10. Maurice Charland, "Constitutive Rhetoric: The Case of the Peuple Québécois," *Quarterly Journal of Speech* 73, no. 2 (1987): 136. See also Elliott Colla, "The People Want," *Middle East Report* 263, no. 42 (Summer 2012): 6.

11. See John D. H. Downing, *Radical Media: The Political Experience of Alternative Communication* (Boston: South End Press, 1984) and Clemencia Rodriguez, *Citizens' Media against Armed Conflict: Disrupting Violence in Colombia* (Minneapolis: University of Minnesota Press, 2011). For a recent survey see John Downing, "Social Movement Theories and Alternative Media: An Evaluation and Critique," *Communication, Culture & Critique*, 1 (2008), 40–50.

12. Abu Nasr al-Farabi, *Mabadi' ara' ahl al-madina al-fadila,* translated and edited by Richard Walzer as *Al-Farabi on the Perfect State* (Oxford: Oxford University Press, 1985); see also Louise Marlow, *Hierarchy and Egalitarianism in Islamic Thought* (Cambridge: Cambridge University Press, 1997).

13. Ernst Kantorowicz, *The King's Two Bodies: A Study in Mediaeval Political Theology* (Princeton, NJ: Princeton University Press, 1957/1977), 449. See chapter 5 in particular. Al-Farabi, who helped preserve Greek philosophy through the Middle Ages, gets a single mention, in passing, footnote 240, page 387. Also Arnold D. Harvey, *Body Politic: Political Metaphor and Political Violence* (Newcastle, UK: Cambridge Scholars Publishing, 2007), 23 and Jean-William Lapierre, "Corps biologique, corps politique dans la philosophie de Hobbes," *Revue Européenne des Sciences Sociales* 18, no. 49 (1980): 85–99.

14. Antoine De Baecque, *Le Corps de l'histoire: Métaphores et politique (1770–1800)* (Paris: Calmann-Lévy, 1993); Dorinda Outram, *The Body and the French Revolution: Sex, Class and Political Culture* (New Haven, CT: Yale University Press, 1989).

15. Anton-Hermann Chroust, "The Corporate Idea and the Body Politic in the Middle Ages," *Review of Politics* 9, no. 4 (1947): 424.

16. Claude Lefort, *The Political Forms of Modern Society: Bureaucracy, Democracy, Totalitarianism,* trans. John B. Thompson (Cambridge, MA: MIT Press, 1986), 297, 300. On Syria under Hafez al-Assad, see Lisa Wedeen, *Ambiguities of Domination: Politics, Rhetoric and Symbols in Contemporary Syria* (Chicago: University of Chicago Press, 1999).

17. Chroust, "Corporate Idea and the Body Politic," 423; Kantorowicz, *King's Two Bodies.* For elaboration on the concept's migration from the spiritual to the secular, see pp. 207–231 of Kantorowicz.

18. Kantorowicz, *King's Two Bodies,* 225.

19. Recall that Hobbes, in *Leviathan,* was one of the first philosophers to develop the notion of a "social contract."

20. Medieval corporatism had introduced a language of rights and duties that applied to both rulers and ruled. See Chroust, "Corporate Idea and the Body Politic," 452.

21. See Ziad Fahmy, *Ordinary Egyptians: Creating the Modern Nation through Popular Culture* (Stanford, CA: Stanford University Press, 2011); Marc Lynch, *Voices of the New Arab Public* (New York: Columbia University Press, 2005); Naomi Sakr, *Satellite Realms* (London: I. B. Tauris, 2002); Marwan M. Kraidy and Joe F. Khalil, *Arab Television Industries* (London: British Film Institute/Palgrave Macmillan, 2009); and Marwan M. Kraidy, *Reality Television and Arab Politics: Contention in Public Life* (Cambridge: Cambridge University Press, 2010).

22. Mohamed Al-Bassyouni, *The Facebook State* (Cairo: al-Shurooq, 2011) [Arabic]; Muhammad Rayan, *How Did the Revolution Explode on January 25?! Facebook and Revolutionary Information Technology* (Cairo: Oktob, 2011) [Arabic]; Ilhem Allagui and Joanna Kuebler, eds., "The Arab Spring and the Role of ICTs," *International Journal of Communication* 5, no. 1 (2011), http://ijoc.org/ojs/index.php/ijoc/article/view/1392/616; Ines Braune, ed., "The Net Worth of the Arab Spring," *Cyber-Orient* 6, no. 1 (2012), http://www.cyberorient.net/article.do?articleId=7760; Philip Howard and Muzammil Hussein, *Democracy's First Wave? Digital Media and the Arab Spring* (New York: Oxford University Press, 2013). Some tackled the body to some degree: Lina Khatib, *Image Politics in the Middle East: The Role of the Visual in Political Struggle* (London: I. B. Tauris, 2013), and Linda Herrera, *Revolution in the Age of Social Media: The Egyptian Popular Insurrection and the Internet* (London: Verso, 2014). See also Yves Gonzalez-Quijano, *Arabités numériques: Le printemps du Web arabe* (Paris: Sinbad, 2012).

23. "The farewell to the body never occurred." Antonio A. Casilli, "Culture numérique: L'adieu au corps n'a jamais eu lieu," *Esprit* 353 (2009): 151–153.

24. Henri Bergson, *Creative Evolution* (London: Macmillan, 1960); Henri Bergson, *Matter and Memory* (New York: Zone, 1988).

25. Maurice Merleau-Ponty, *Phénoménologie de la perception* (Paris: Gallimard, 1945). Quote from Maurice Merleau-Ponty, *The Phenomenology of Perception*, trans. Colin Smith (London: Routledge, 2002), 273.

26. See Tim Lenoir's foreword to Mark B. N. Hansen, *New Philosophy for New Media* (Cambridge, MA: MIT Press, 2006), xxi.

27. Lewis Goodings and Ian Tucker, "Social Media and the Co-production of Bodies Online: Bergson, Serres and Facebook's Timeline," *Media, Culture and Society* 36, no. 1 (2013): 37–51.

28. Gonzalez-Quijano, *Arabités numériques*, 166.

29. This is the title of the concluding chapter in Bernadette Wegenstein, *Getting under the Skin: Body and Media Theory* (Cambridge, MA: MIT Press, 2006), 119.

30. Milad Doueihi, *Pour un humanisme numérique* (Paris: Editions du Seuil, 2011); English readers, see *Digital Cultures* (Cambridge, MA: Harvard University Press, 2011).

31. Jean Michel Berthelot, "Du corps comme opérateur discursif, ou les apories d'une sociologie du corps," *Sociologies et Sociétés* 24, no. 1 (1992): 13.

32. Maurice Merleau-Ponty, *L'Œil et l'Esprit* (Paris: Gallimard, 1964), 58. My translation.

33. For example, Peter Stallybrass and Allon White, *The Politics and Poetics of Transgression* (London: Methuen, 1986).

34. Kantorowicz, *King's Two Bodies*, 212.

35. Outram, *Body and the French Revolution;* Lynne Hunt, *Politics, Culture and Class in the French Revolution* (Berkeley: University of California Press, 1984).

36. Moira Gatens, "Corporeal Representation in/and the Body Politic," in *Writing on the Body: Female Embodiment and Feminist Theory,* ed. Katie Conboy, Nadia Medina, and Sarah Stanbury (New York: Columbia University Press, 1997), 80–89.

37. Thanks to Luisa Gandolfo and Marta Zarzycka for feedback on this issue during a presentation I gave in February 2015 at the Netherlands Institute for Advanced Study. The debate triggered by the martyrdom of Sally Zahran focused on whether she wore the *higab* (Muslim headscarf) or not. See Walter Armbrust, "The Ambivalence of Martyrs and the Counter-revolution," *Cultural Anthropology,* online "Hot Spots" (2012), http://www.culanth.org/fieldsights/213-the-ambivalence-of -martyrs-and-the-counter-revolution.

38. Joan Wallach Scott, *Parité! Sexual Equality and the Crisis of French Universalism* (Chicago: University of Chicago Press, 2005): "Embodiment . . . was the opposite of abstraction; hence women could not be abstract individuals" (5).

39. Examples include Stephanie Van de Peer, "The Moderation of Creative Dissidence in Syria: Reem Ali's Documentary *Zabad,*" *Journal of Cultural Research* 16, nos. 2–3 (190–201); David Feith, "Syrians Unleash the Powers of Creative Dissent," *Wall Street Journal,* February 17, 2012, http://www.wsj.com/articles/SB1000142405297020 479530457722321218553920; Donatella Della Ratta, "Creative Resistance Challenges Syrian Regime," *al-Jazeera,* December 25, 2011, http://www.aljazeera.com /indepth/opinion/2011/12/20111222162349451619.html; and Layla al-Zubaidi, "Syria's Creative Resistance," *Jadaliyya,* June 8, 2012, http://www.jadaliyya.com/pages /index/5920/syrias-creative-resistance. In March 2013, I went to see the *Syria's Art of Resistance* exhibit at the Round Tower in Copenhagen, an exhibit featuring paintings, graffiti, photographs, and videos, which showed in Amsterdam at the Prince Claus Fund Gallery from June 4 to November 23, 2012. In 2015, Bryn Mawr College in suburban Philadelphia showed *Creative Dissent: Arts of the Arab World Uprisings,* whose maiden run occurred at the Arab American National Museum in Dearborn, Michigan, a year earlier.

40. For a sustained discussion of the "postideological," see Hamid Dabashi, *The Arab Spring: The End of Postcolonialism* (London: Zed, 2012), 157–163.

41. Scholars of media and activism rarely delve into creativity, and the "culture-jamming" literature concerns low-risk subversion of consumer culture in relatively democratic and stable countries. Exceptions include James M. Jasper, *The Art of Moral Protest: Culture, Biography and Creativity in Social Movements* (Chicago: Uni-

versity of Chicago Press, 1997), Vicki Mayer, *Below the Line: Producers and Production Studies in the New Television Economy* (Durham, NC: Duke University Press, 2011), and my colleague Guobin Yang, *The Power of the Internet in China: Citizen Activism Online* (New York: Columbia University Press, 2009). Hans Joas, *The Creativity of Action,* trans. Jeremy Gaines and Paul Keast (Chicago: University of Chicago Press, 1996), offers a philosophically grounded framework.

42. See Philip Rizk, "The Necessity of Revolutionary Violence in Egypt," *Jadaliyya,* April 7, 2013, http://www.jadaliyya.com/pages/index/11073/the-necessity -of-revolutionary-violence-in-egypt; Selima Karoui, "Art et Violence, Où commence l'un, où finit l'autre . . . et vice-versa," *Nawaat,* December 3, 2013, http://nawaat.org /portail/2013/12/03/art-et-violence-ou-commence-lun-ou-finit-lautre-et-vice-versa/; Hossam al-Hamalawy, "#Jan25-The Myth of 'Non Violence,' " 3arabawy, April 27, 2011, http://arabawy.org/28151/suez-revolution.

43. Jasper, *Art of Moral Protest,* 94.

44. Elliott Colla, "In Praise of Insult: Slogan Genres, Slogan Repertoires and Innovation," *Review of Middle East Studies* 47, no. 1 (2013), 38.

45. Joas, *Creativity of Action,* 79.

46. Laura Mason, *Singing the French Revolution: Popular Culture and Politics* (Ithaca, NY: Cornell University Press, 1996), argued this about revolutionary songs.

47. See Timothy Mitchell, "Everyday Metaphors of Power," *Theory and Society* 19 (1990): 545–577.

48. Graffiti creators are often grasped as "networks" rather than individuals. See Yakein Abdelmagid, "The Emergence of the Mona Lisa Battalions: Graffiti Art Networks in Post-2011 Egypt," *Review of Middle East Studies* 47, no. 2 (winter 2013): 172–182.

49. This is a war-induced "trajectory of creative migration." Michael Curtin, *Playing to the World's Biggest Audience: The Globalization of Chinese Television and Film* (Berkeley: University of California Press, 2007)

50. Michael Warner, "Publics and Counterpublics," *Public Culture* 14, no. 1 (2002): 77–78.

51. Thanks to Aswin Punathambekar for suggesting "entangled temporalities" after I spoke at a symposium at the University of Pennsylvania in September 2014.

52. I borrow this notion from art history. See Lynda Nead, *The Female Nude: Art, Obscenity and Sexuality* (London: Routledge, 1992), and Marcia Pointon, *Naked Authority: The Body in Western Painting 1830–1908* (Cambridge: Cambridge University Press, 1990).

53. I adapt this from "heroic dignity." See Outram, *Body and the French Revolution.*

54. Mikhail Bakhtin, *Rabelais and His World,* trans. Helene Iswolsky (Bloomington: Indiana University Press, 2009). See also Stallybrass and White, *Politics and Poetics of Transgression.*

55. Badiou, *Rebirth of History.*

56. Annabelle Sreberny-Mohammadi and Ali Mohammadi, *Small Media, Big Revolution: Communication, Culture and the Iranian Revolution* (Minneapolis: University of Minnesota Press, 1994), 19.

57. Those claims are dubious. For example, the April 7 Youth Movement in Egypt has a political program: http://6april.org/ro2ya.

58. Mayer, *Below the Line,* 41–42.

59. Kantorowicz, *King's Two Bodies.*

60. Tunisia, Egypt, and Syria are historically and geopolitically important countries that cover a spectrum of insurgency types—more or less successful "transition," stalled revolution, and civil war/global proxy conflict—relevant beyond these specific countries.

PART II. BURNING MAN

1. Robert Hariman and John Louis Lucaites, "Public Identity and Collective Memory in U.S. Iconic Photography: The Image of 'Accidental Napalm,'" *Critical Studies in Media Communication* 20 (2003): 35–66.

2. Malcolm Browne, *The New Face of War* (Indianapolis: Bobbs-Merrill, 1965), 179, quoted in Michelle Murray Yang, "Still Burning: Self-Immolation as Photographic Protest," *Quarterly Journal of Speech* 97, no. 1 (2011): 10.

3. Sallie King, "They Who Burned Themselves for Peace: Quaker and Buddhist Self-immolators During the Vietnam War," *Buddhist-Christian Studies* 20 (2000): 127–150; Yang, "Still Burning," 1–25.

4. James Verini, "A Terrible Act of Reason: When Did Self-Immolation Become the Paramount Form of Protest?," *New Yorker,* May 16, 2012, http://www.newyorker.com/culture/culture-desk/a-terrible-act-of-reason-when-did-self-immolation-become-the-paramount-form-of-protest; Sharan Newman, *The Real History of the End of the World* (New York: Berkley, 2010).

5. Ashis Nandy, "Sati as Profit versus Sati as Spectacle: The Public Debate on Roop Kanwar's Death," in *Sati, the Blessing and the Curse: The Burning of Wives in India,* ed. John Stratton Hawley (New York: Oxford University Press, 1994).

6. Ashis Nandy, "Sati: A Nineteenth Tale of Women, Violence and Protest," in *Rammohun Roy and the Process of Modernization in India,* ed. V. C. Joshi, Raja Rammohun Roy, and Rajat K. Ray (Delhi: Vikas, 1975), 68; some Algerians clung to the veil after the French outlawed it.

7. Nandy, "Sati as Profit," 133.

8. Cara Santa Maria, "Burn Care, Self-Immolation: Pain and Progress," *Huffington Post,* April 9, 2012, http://www.huffingtonpost.com/2012/04/06/burn-care_n_1409232.html.

9. Ibid.

10. Addressing sati through the question "Can the Subaltern Speak?," as Gayatri Chakravorty Spivak famously did, reduces self-burning to speech and neglects physical agony. Lata Mani, *Contentious Traditions: The Debate on Sati in Colonial India* (Berkeley: University of California Press, 1998), 77. See also Aishwarya Lakshmi, "The Liminal Body: The Language of Pain and Symbolism around Sati," *Feminist Review* 74, no. 1 (2003): 18.

11. Talal Asad, "Agency and Pain: An Exploration," *Culture and Religion: An Interdisciplinary Journal* 1, no. 1 (2000): 29. For Asad, views of pain as "passion" opposite to agency as "action" introduce a tautology in which the only way for the self to get rid of control is to control itself.

12. Tahar Ben Jalloun, *L'Étincelle: Révoltes dans les Pays Arabes* (Paris: Gallimard, 2011).

13. Robert Pape, *Dying to Win: The Strategic Logic of Suicide Terrorism* (New York: Random House, 2005), 4.

14. Asad, *On Suicide Bombing,* ch. 2, "Suicide Terrorism," specifically p. 51. For more, see Wendy Pearlman, *Occupied Voices: Stories of Everyday Life from the Second Intifada* (New York: Thunder's Mouth Press/Nation Books, 2003), and Christopher Reuter, *My Life Is a Weapon* (Princeton, NJ: Princeton University Press, 2004).

15. Farhad Khosrokhavar, "The Arab Revolutions and Self-Immolations," *Revue d'Etudes Tibétaines* 25 (December 2012): 169–179.

16. Ghassan Hage, " 'Comes a Time We Are All Enthusiasm': Understanding Palestinian Suicide Bombers in Times of Exighophobia," *Public Culture* 15, no. 1 (2003): 65–89, 78.

17. Ibid., 3.

18. Ibid., 55. Asad also adds to Pape's identification of suicide bombings as strategic acts of war, suggesting that the practice is militarily and communicatively ineffective.

19. Pape, *Dying to Win,* 79.

20. Gayatri Chakravorty Spivak, "Can the Subaltern Speak?," in *Marxism and the Interpretation of Culture,* ed. Cary Nelson and Lawrence Grossberg (Urbana: University of Illinois Press, 1988), 298.

21. Karin Andriolo, "The Twice-Killed: Imagining Protest Suicide," *American Anthropologist* 108, no. 1 (March 2006): 100–113. Among other posthumous accolades, Sands had a street in Tehran named after him. See also Stephen J. Scanlan, Laurie Cooper Stoll, and Kimberly Lumm, "Starving for Change: The Hunger Strike and Nonviolent Action, 1906–2004," *Research in Social Movements, Conflicts and Change* 28 (2008): 275–323.

22. See Younes Arar, "The History of the Palestinian Captive Movement Hunger Strike and the Story of Khader Adnan," *Palestine Solidarity Project,* February 20, 2012, http://palestinesolidarityproject.org/2012/02/20/the-history-of-the-palestinian -captive-movement-hunger-strike-and-the-story-of-khader-adnan/; "The History of

the Palestinian Political Prisoners Hunger Strike," *UFree,* June 4, 2014, http://www
.ufreeonline.net/index.php/site/index/news/491/3; "Palestinian Prisoner on Hunger
Strike for 24 Days," *Ma'an News,* October 13, 2014, http://www.maannews.net/eng
/ViewDetails.aspx?ID=732907; "Strike of Arab Prisoners in Israel," *Journal of Pales-
tine Studies* 7, no. 1 (1977): 169–171; and "Al Issawi a Symbol of Non-Violent Resis-
tance," *Gulf News,* December 26, 2013, http://gulfnews.com/opinions/editorials/al
-issawi-a-symbol-of-non-violent-resistance-1.1270779.

23. "Bahrain Activist Khawaja Ends Hunger Strike," *BBC News World,* May 29,
2012, http://www.bbc.com/news/world-18239695.

24. Ibid.

25. "Jailed Bahrain Activist Ends Hunger Strike," *Agence France Presse,* September 25,
2014, http://www.afp.com/en/node/2875524.

26. "A Statement by Alaa Abdulfattah's Family," Free Alaa Facebook page, Au-
gust 19, 2014, https://www.facebook.com/freealaa2013/posts/%20797985810253065
?fref=nf.

27. Amr Hamzawy, *The Hunger Strike, Al-Shorouk* [Arabic], August 24, 2014,
translated as Amr Hamzawy, *The Hunger Strike, Atlantic Council,* September 8, 2014,
http://www.atlanticcouncil.org/blogs/egyptsource/the-hunger-strike.

28. As of late 2014. See "On Hunger Strikes: A Brief Background," *Mada Masr,*
October 14, 2014, http://www.madamasr.com/sections/politics/hunger-strikes-brief
-background.

29. Lionel Wee, "'Extreme Communicative Acts' and the Boosting of Illocu-
tionary Force," *Journal of Pragmatics* 36, no. 12 (2004): 2161–2178.

30. Michael Biggs, "Dying for a Cause—Alone?" *Contexts* 7 (2008): 27.

31. Didier Fassin, "The Trace: Violence, Truth and the Politics of the Body," *So-
cial Research* 78, no. 2 (2011): 294.

32. Robert Cameron and David Vaughan, "Jaroslava Moserova—Remembering
Jan Palach," *Czech Radio 7-Radio Prague,* January 23, 2003, http://www.radio.cz/en
/section/witness/jaroslava-moserova-remembering-jan-palach.

33. Ibid.

34. Robert Hariman and John Louis Lucaites, *No Caption Needed: Iconic Photo-
graphs, Public Culture, and Liberal Democracy* (Chicago: University of Chicago Press,
2007), 27.

35. Yang, in "Still Burning," calls this "the nested nature of rhetorical arti-
facts" (4).

36. Fassin argues that the reversal of structural violence into political violence
forces the state to take it seriously.

37. Andriolo, "Twice-Killed: Imagining Protest Suicide," 102.

38. Marc Fisher, "In Tunisia, Act of One Fruit Vendor Unleashes Wave of Revo-
lution through Arab World," *Washington Post,* March 26, 2011, http://www.washing
tonpost.com/world/in-tunisia-act-of-one-fruit-vendor-sparks-wave-of-revolution

-through-arab-world/2011/03/16/AFjfsueB_story.html. Accounts vary, suggesting that state television did not report on this for a period of between three and twelve days.

39. The "college" reference has a middle-class resonance. Though Merlyna Lim, in "Framing Bouazizi: 'White Lies,' Hybrid Network, and Collective/Connective Action in the 2011 Tunisian Uprising," *Journalism* 14, no. 7 (2013): 921–941, cites a Greek documentary claiming a video of the act exists. Mohamed Zayani, *Networked Publics and Digital Contention: The Politics of Everyday Life in Tunisia* (New York: Oxford University Press, 2015), concurs that no photo or video exists and learned of the image's Korean provenance during interviews in Tunisia.

40. Marwan M. Kraidy, *Reality Television and Arab Politics: Contention in Public Life* (New York: Cambridge University Press, 2010).

41. Mohamed Zayani, "Social Media and the Reconfiguration of Political Action in Revolutionary Tunisia," *Democracy and Society* 8, no. 2 (2011): 3. See also Joanna Kuebler, "Overcoming the Digital Divide: The Internet and Political Mobilization in Egypt and Tunisia," *Cyber-Orient* 5, no. 1 (2011), http://www.cyberorient.net/article .do?articleId=6212.

42. Thomas Poell and Kaouthar Darmoni, "Twitter as a Multilingual Space: The Articulation of the Tunisian Revolution through #sidibouzid," *NECSUS: European Journal of Media Studies,* vol. 1 (2012), http://ssrn.com/abstract=2154288.

43. For details, see Zayani, *Networked Publics and Digital Contention.*

44. Robert F. Godec, "Embassy Tunis, Diplomatic Cable 000679," *WikiLeaks,* June 23, 2008.

45. Robert F. Godec, "Embassy Tunis, Diplomatic Cable 000516," *WikiLeaks,* July 27, 2009.

46. Ibid.

47. Marwan M. Kraidy, "Governance and Hypermedia in Saudi Arabia," *First Monday* 11, no. 9 (2006), http://firstmonday.org/issues/special11_9/kraidy/index.html .2006, and *Reality Television and Arab Politics.*

48. Poell and Darmoni, "Twitter as a Multilingual Space."

49. Zayani, "Social Media," 1, cautioned against media-centrism. See also Marc Lynch, "Tunisia and the New Arab Media Space," *Foreign Policy,* January 15, 2011, http://www.foreignpolicy.com/posts/2011/01/15/tunisia_and_the_new_arab_media _space.

50. Nicolas Beau and Catherine Graciet, *La régente de Carthage: Main Basse sur la Tunisie* (Paris: La Découverte, 2009), 19. See Delphine Cavallo, "Développement et Libéralisation Économique en Tunisie: Eléments d'analyse des Discours de Légitimation," 51–74, and Béatrice Hibou, "Il n 'y a pas de Miracle Tunisien," 11–36, in *La Tunisie de Ben Ali: La Société Contre le Régime,* ed. Olfa Lamloum and Bernard Ravenel (Paris: l'Harmattan, 2002).

51. Cavallo, "Développement et Libéralisation," 53.

52. Peter J. Schraeder and Hamadi Redissi, "Ben Ali's Fall," *Journal of Democracy* 22, no. 3 (2011): 5–19.

53. Elodie Auffray, "Dans la Tunisie de Ben Ali, l' 'Étrange Culte du Numéro 7,'" *Libération*, January 20, 2011, http://www.liberation.fr/monde/2011/01/20/dans-la-tunisie-de-ben-ali-l-etrange-culte-du-chiffre-7_708806.

54. Cavallo, "Développement et Libéralisation," 51.

55. Nouri Gana, "Rapping and Remapping the Tunisian Revolution," in *Resistance in Contemporary Middle East Cultures: Literature, Cinema, and Music*, ed. Karima Laachir and Saeed Talajooy (London: Routledge, 2013), 219.

56. Cavallo, "Développement et Libéralisation," 56.

57. Ibid., 62.

58. Abdelwahhab Meddeb, *Printemps de Tunis: La Métamorphose de l'Histoire* (Paris: Albin Michel, 2011), 25–26, my translation from French original.

59. Béatrice Hibou, "Il n'y a pas de Miracle Tunisien," in *La Tunisie de Ben Ali: La Société Contre le Régime*, ed. Olfa Lamloum and Bernard Ravenel (Paris: l'Harmattan, 2002), 40.

60. Beau and Graciet, *La régente de Carthage*.

61. Beau and Graciet coined the term *voyoucratie;* see ibid., 11. "Thugocracy" is my translation.

62. Ibid., 31.

63. Schraeder and Redissi, "Ben Ali's Fall," 6.

64. Fouad Harit, "Tunisie: Ben Ali et le Culte du Chiffre 7, *Afrik.com*, January 22, 2011, http://www.afrik.com/article21804.html.

65. Auffray, "Dans la Tunisie de Ben Ali."

66. Hibou, "Il n'y a pas de Miracle Tunisien," 47.

67. Ibid.

68. Gana, "Rapping and Remapping," 219.

69. Schraeder and Redissi, "Ben Ali's Fall," 8.

70. French journalist Denis Jeambar thus characterized the French elite view. Beau and Graciet, *La régente de Carthage*.

71. See Amin Allal and Karine Bennafla, "Les Mouvements Protestataires de Gafsa (Tunisie) et Sidi Ifni (Maroc) de 2005 à 2009—Des Mobilisations en Faveur du Réengagement de l'État ou Contre l'Ordre Politique?" in *Protestations Sociales, Révolutions Civiles, Transformations du Politique dans la Méditerranée Arabe, Revue Tiers Monde, Hors Série 2011*, ed. Sarah Ben Néfissa and Blandine Destremau (Paris: Armand Collin, 2011).

72. Abdelwahhab Meddeb, *Printemps de Tunis*, 48. This parallels the self-immolation of Ryszard Siwiec in Warsaw, months before that of Palach in Prague, and that act's political "inertness." Thanks to Slawomir Lotyz and Ewa Stanwyck for this tidbit.

73. Laryssa Chomiak, "Spectacles of Power: Locating Resistance in Ben Ali's Tunisia," *Portal* 9, no. 2, (2013), http://portal9journal.org/articles.aspx?id=102.

74. Gana, "Rapping and Remapping," 211; Nouri Gana, "Rap and Revolt in the Arab World," *Social Text* 113, vol. 30, no. 4 (2012): 25–53. Unlike *mizwid,* the traditional singing "frantically quarantined from the public sphere" (209), rap was decisively political.

75. Gana, "Rapping and Remapping," 211.

76. David Peisner, "Inside Tunisia's Hip-Hop Revolution," *Spin,* August 24, 2011, http://www.spin.com/articles/inside-tunisias-hip-hop-revolution/.

77. An early online video garnered more than a quarter million views. For a full version, see "El Général, the Voice of Tunisia, English Subtitles," YouTube video, 4:18, posted by "Michelangelo Severgnini," January 10, 2011, https://youtu.be/IeGlJ7OouRo.

78. Gana, "Rapping and Remapping," 214.

79. Gana, "Rap and Revolt," 37; Gana, "Rapping and Remapping," 219.

80. Gana, "Rapping and Remapping," 215, argued that *Rayyes Lebled's* "overall goal is not revolt but reform."

81. See the official music video "Emel Mathlouthi—Kelmti Horra (Clip Officiel)," YouTube video, 5:39, posted by "travail liberté," March 10, 2012, http://youtu.be/DWmRk3j_7Yg.

82. See Jacob Uzzell, "Biopolitics of the Self-Immolation of Mohamed Bouazizi," *e-international relations,* November 7, 2012, http://www.e-ir.info/2012/11/07/biopolitics-of-the-self-immolation-of-mohamed-bouazizi/.

83. Evoking both de Gaulle's 1958 Algiers speech ("je vous ai compris") and Bourguiba's January 1978 speech "J'ai été trompé" (I was deceived) after bread riots resulted in more than a hundred deaths; see Abdelwahhab Meddeb, *Printemps de Tunis,* 49.

84. Thomas Lemke, *Bio-Politics: An Advanced Introduction* (New York: New York University Press, 2011), defines biopolitics as "essentially the political economy of life," 60.

85. Ali Al-Saqqa, "Kharabeesh: An Arab Platform for Dark Humor, *Assafir* [Arabic], December 27, 2012.

86. See "Le Journal du Zaba 001," YouTube video, 3:09, posted by Kharabeesh al-Maghreb January 19, 2011, http://youtu.be/XHya2xHA5qw.

87. Mohamed-Salah Omri, " 'Gulf Laughter Break': Cartoons in Tunisia during the Gulf Conflict," in *Political Cartoons in the Middle East,* ed. Fatma Müge Göçek (Princeton, NJ: Markus Wiener, 1998), 133–154.

88. Allen Douglas and Fedwa Malti-Douglas, *Arab Comic Strips: Politics of an Emerging Mass Culture* (Bloomington: Indiana University Press, 1994), ch. 8, "Tradition Viewed from the Maghrib: Tunisia," 130–149.

89. Omri, " 'Gulf Laughter Break,' " 133–154.

90. "Mille et Une Nuits, Episode 01-les Ben Ali," YouTube video, 3:08, posted by "tunisie2rep," September 19, 2008, http://youtu.be/yRzAKRDqXuQ.

91. "Tarak Mekki Mille et une nuits Épisode 07 Séchoir Magique" YouTube video, 2:12, posted by "Tunisie deuxième république," September 20, 2008, http://youtu.be/ouSYZoWi8H8.

92. Perrine Mouterde, "La Toile, Caisse de Résonnance de l'Exaltation Suscitée par la Révolution Tunisienne, *France 24,* January 19, 2011, http://www.france24.com/fr/20110118-tunisie-internet-mefiance-peurs-fierte-gouvernement-ben-ali-opposition.

93. Maha Ben Abdeladhim, "L'Humour au Temps de la Révolution," *France 24,* January 23, 2011, http://www.france24.com/fr/20110122-tunisie-ben-ali-humour-facebook-rh%C3%A9torique-jeunes-resistance/.

94. Ibid.

95. "404 Not Found" appeared when Tunisians tried accessing censored websites. In response, pictures circulated of the ruling couple in a Peugeot 404. Ammar is a name typically associated with an old man, but some say it was the surname of a chief regime censor.

96. Rami Zureik, *Food, Farming and Freedom: Sowing the Arab Spring* (Charlottesville, VA: Just World Books, 2012).

97. Annia Ciezadlo, "Let Them Eat Bread: How Food Subsidies Prevent (and Provoke) Revolutions in the Middle East," *The Arab Revolt* (*Foreign Affairs,* e-book, March 23, 2011); Larbi Sadiki, "Towards Arab Liberal Governance: From the Democracy of Bread to the Democracy of the Vote," *Third World Quarterly* 18, no. 1 (1997): 127–148.

98. "Let Them Eat Baklava: Food and the Arab Spring," *Economist,* March 17, 2012, http://www.economist.com/node/21550328; Ciezadlo, "Let Them Eat Bread."

99. Ibid. The list of the leading twenty importers of wheat in 2010 includes four Arab countries in the top ten (Egypt, 1; Algeria, 4; Iraq, 7; and Morocco, 8) and Tunisia was 17th. Syria saw a 20 percent spike in prices in the first half of 2008, after the government liberalized agriculture. Paula Mejia, "Bread and Freedom," *The Majalla,* June 27, 2011, http://www.majalla.com/eng/2011/06/article3992. Bread prices rose by 37 percent in Egypt, and by the onset of the January 25 Revolution, annual food price inflation stood at 18.9 percent. Rami Zurayk, "Use Your Loaf: Why Food Prices Were Crucial in the Arab Spring," *Guardian,* July 17, 2011, http://www.theguardian.com/lifeandstyle/2011/jul/17/bread-food-arab-spring/.

100. Ciezadlo, "Let Them Eat Bread"; see Zurayk, *Food, Farming and Freedom;* Edmund Burke III, "Understanding Arab Protest Movements," *Arab Studies Quarterly* 8, no. 4 (1987); Khalid Kishtainy, "Violent and Non-Violent Struggle in Arab History," in *Arab Non-Violent Political Struggle,* ed. Ralph Crow, Philip Grant, and Saad Eddin Ibrahim (Boulder, CO: Lynne Rienner, 1990), 9–24.

101. Edward P. Thompson, "The Moral Economy of the English Crowd in the Eighteenth Century," *Past and Present* 50 (1971): 76, 78.

102. Sadiki, "Towards Arab Liberal Governance," 141.

103. Timothy Mitchell, "Everyday Metaphors of Power," *Theory and Society* 19 (1990): 545–577, after Bourdieu.

104. Michelle Nougoum, " 'Captain Khobza,' Le Super-Héros de la Revolution Tunisienne," *Afrik.com,* July 8, 2011, http://www.afrik.com/article23233.html; "Baguette Gunman a Hit with Tunisian Facebook Users," *Radio Netherlands World,* July 18, 2011, http://www.rnw.nl/africa/bulletin/baguette-gunman-a-hit-tunisian-facebook-users; Mohamed Haddad, "Tunisia's Baguette-Wielding Activist Gives Bread Riots Modern Meaning," *Daily Star,* July 19, 2011, http://www.dailystar.com.lb/News/Middle-East/2011/Jul-19/144019-tunisias-baguette-wielding-activist-gives-bread-riots-modern-meaning.ashx#axzz3HkLncsBC.

105. The two photos circulated heavily online. Many links no longer work, but a few at least were still accessible as of January 13, 2015. These were YouTube videos (e.g., "revolution tunsien images أجمل صور الثورة," posted by TunTV on July 4, 2011, https://www.youtube.com/watch?v=2039TJASs8Q) and Facebook pages (e.g., JE SUIS TUNISIEN II, https://www.facebook.com/JESUISTUNISIENII).

106. Haddad, "Tunisia's Baguette-Wielding Activist."

107. Ibid.

108. See "Focus Magazine: Captain 5obza Le Film," YouTube video, 57:46, posted by "FocusMagazineTN," January 14, 2012, http://youtu.be/RGoP9CA6waY.

109. Captain 5obza Facebook page, https://www.facebook.com/captain5obza?sk=wall.

110. Haddad, "Tunisia's Baguette-Wielding Activist."

111. Hage argued that suicide bombers have "become a sign that Palestinians have not been broken. They are a sign of life. For what better sign of life is there, in such violent conditions, than the capacity to hurt despite the greater capacity of the other to hurt you." Hage, " 'Comes a Time We Are All Enthusiasm,' " 74.

112. "The power and value of the body result from a process of abstraction based on the desire for eternity." Achille Mbembe, "Necropolitics," *Public Culture* 15, no. 1 (2003): 11–40, 37.

113. See Fassin for more on the connection between political and structural violence. Didier Fassin, "The Trace: Violence, Truth and the Politics of the Body," *Social Research* 78, no. 2 (2011): 281–298.

114. In wartime Lebanon a joke had it that a poor man made a fortune by putting a sculpture of Hafez al-Assad in a square and charging a pound for a slap, ten for a kick, and twenty-five for a spit at the dictator. "Tunisian Web Users Are Poking Fun at Fallen President Ben Ali," *France 24,* January 21, 2011, http://www.france24.com/en/20110121-2011-01-21-1140-wb-en-webnews/.

115. This quotation is how Outram titled chapter 6 of her book; see Outram, *Body and the French Revolution.*

116. For a comparative discussion of the classical and grotesque body, see Stallybrass and White, *Politics and Poetics of Transgression.*

PART III. LAUGHING COW

1. John Beusterien and J. Baird Callicott, "Humor and Politics through the Animal in Cervantes and Leopold," *Comparative Literature Studies* 50, no. 1 (2013): 43–63.

2. Stallybrass and White, *Politics and Poetics of Transgression,* 2.

3. Ibid., 46.

4. See Michael Collins Dunn, "Egyptian Farmer Arrested for Labeling His Donkey 'Al-Sisi,'" *Middle East Institute Editor's Blog,* September 23, 2013, http://mideasti .blogspot.com/2013/09/egyptian-farmer-arrested-for-labeling.html.

5. Susan Hack, "Art in Egypt: Where to Find Cairo's Donkey Installations," *Condé Nast Traveler,* May 15, 2013, http://www.cntraveler.com/stories/2013–05–15/photos-2013 -caravan-festival-arts-donkeys-cairo-egypt. See also "St Paul's Cathedral in London to Host 'Peaceful Donkeys' Exhibit from Cairo," *Ahram Online,* August 20, 2013, http://english.ahram.org.eg/NewsContentPrint/5/0/79358/ Arts—Culture/0/St-Pauls-Cathedral-in-London-to-host-peaceful-donk.aspx; and "From Cairo to London: 25 Life-Sized Painted Donkeys arrive at St Paul's from Egypt," *Art Daily,* August 31, 2013, http://artdaily.com/news/64700/From-Cairo-to-London—25-life-size-painted -donkeys-arrive-at-St-Paul-s-from-Egypt.

6. Heba Hesham, "El-Eleimy Referred to PA Ethics Committee for Insulting Tantawi," *Egypt Daily News,* February 26, 2012, http://www.dailynewsegypt.com/2012/02 /26/el-eleimy-referred-to-pa-ethics-committee-for-insulting-tantawi/.

7. Beth Baron, *Egypt as Woman: Nationalism, Gender and Politics* (Berkeley: University of California Press, 2005), 59.

8. Elias Hanna Elias, *La presse arabe* (Paris: Maisonneuve et Larose, 1993).

9. Kantorowicz, *King's Two Bodies;* Chroust, "Corporate Idea and the Body Politic."

10. Unverified circulation figures may have reached 150,000.

11. Eli Lake, "Mubarak Fails to Silence Egyptian Editor," *New York Sun,* June 30, 2006, http://www.nysun.com/foreign/mubarak-fails-to-silence-egyptian -editor/35336/.

12. Naomi Sakr, *Transformations in Egyptian Journalism* (London: I. B. Tauris, 2013*),* 35–36.

13. Ibid., 16.

14. The sociologist Sa'deddin Ibrahim coined the term in an article about Iraq, Syria, and Egypt, which led to his prosecution and conviction.

15. See http://www.waelk.net and http://twitter.com/@wael.

16. Usama Saraya, "Leaders' Photo Expressive" (September 17, 2010), *al-Ahram,* http://www.ahram.org.eg/archive/Issues-Views/News/39340.aspx [Arabic]. See also "Usama Saraya, al-Ahram's Editor-in-Chief, Writes: 'Photo of Leaders Expressive and al-Ahram Had Exclusive on All Summit Photos'" (September 17, 2010), *al-Yawm*

al-Sabe‘ http://www.youm7.com/story/2010/9/17/أسامة_سرايا_رئيس_رنير_تحرير_الأهرام_

[Arabic], accessed Jan- يكتب_الزعماء_ورة_الزعماء_الزعبيرية_تعبيرية_وال/279146#.VGxmqYuRLwx
uary 6, 2014; Nadia Abou el Magd, "Anger over Photo Doctored to Put Mubarak in
Front," _The National,_ September 17, 2010, http://www.thenational.ae/news/world
/africa/anger-over-photo-doctored-to-put-mubarak-in-front.

17. Yosri Fouda, _Akher Kalam,_ "Crisis of the Image," http://youtu.be/OSb5323ifrY,
uploaded September 26, 2010.

18. Sarah Carr, "Update Your History Books," _Inanities,_ September 15, 2010,
http://allthegoodnameshadgone.blogspot.com/2010/09/update-your-history-book
.html.

19. Yasser Baker, _The Ethics of the Journalistic Photo_ (Cairo: self-published, 2011),
chapters available at the author's blog at http://hekiattafihahgedan.blogspot.com/ 2012
/02/blog-post_25.html. Baker notes that the photo of Mahmood Shaker Abdulmen‘em,
second commander of the air forces, was barred from all mass media in an effort to
portray Mubarak as the sole figure behind the historic air attack of the 1973 war.

20. Al-Shazhli's grandson revealed the story after Mubarak's departure.
See Mahmoud Sa‘deddin (March 29, 2011), "After Returning 'Star of Sinai' to
Sa'deddin al-Shazhli, Mubarak Used Expressive Photos Thirty-seven Years before
al-Ahram to Erase the History of Commander Al-Shathli from the Panorama of
the October War. . . . Here Is the Story of the President's Fabricated Photos in the
War Room," _al-Youm al-Sabe',_ http://www.youm7.com/News.asp?NewsID=379100#
.UvULpnlN3wI, accessed January 6, 2014.

21. Amro Ali, "Saeeds of Revolution: De-Mythologizing Khaled Saeed," _Jadaliyya,_
June 5, 2012, http://www.jadaliyya.com/pages/index/5845/saeeds-of-revolution_de
-mythologizing-khaled-saeed. For a standard media account of the incident, see
"Khaled Said: The Face That Launched a Revolution," _Ahram Online,_ June 6, 2012,
http://english.ahram.org.eg/NewsContent/1/64/43995/Egypt/Politics-/Khaled-Said
-The-face-that-launched-a-revolution.aspx.

22. Linda Herrera, _Revolution in the Age of Social Media: The Egyptian Popular
Insurrection and the Internet_ (London: Verso, 2014); Ali, "Saeeds of Revolution."

23. Activist Mohamed Mostafa, quoted in Sahar Khamis and Katherine Vaughn,
" 'We Are All Khaled Said': The Potentials and Limitations of Cyberactivism in Trig-
gering Public Mobilization and Promoting Political Change," _Journal of Arab and
Muslim Media Research_ 4, nos. 2–3 (2011): 145–163.

24. Colla, "The People Want."

25. Khamis and Vaughn, " 'We Are All Khaled Said.' "

26. Ibid.

27. Herrera, _Revolution in the Age of Social Media._

28. Khamis and Vaughn quote an Egyptian activist and blogger who described
Said as a "handsome, professional young man" (" 'We Are All Khaled Said,' " 149),
Halverson et al. referred to him as a "businessman" (Jeffrey R. Halverson, Scott W.

Ruston, and Angela Trethewey, "Mediated Martyrs of the Arab Spring: New Media, Civil Religion, and Narrative in Tunisia and Egypt," *Journal of Communication* 63 [2013]: 318), and *al-Ahram* called him a "young entrepreneur" ("Khaled Said: The Face That Launched a Revolution"). Mike Giglio labeled Said as a "small businessman" (Mike Giglio, " 'We Are All Khaled Said': Will the Revolution Come to Egypt?," *Daily Beast,* January 22, 2011, http://www.thedailybeast.com/articles/2011/01/22/we-are-all-khaled-said-will-the-revolution-come-to-egypt.html) and called Ghonim the "Facebook Freedom Fighter" (Mike Giglio, "The Facebook Freedom Fighter," *Newsweek,* February 21, 2011).

29. Ali, "Saeeds of Revolution."

30. Ibid.; Khatib, *Image Politics in the Middle East,* calls it a "floating image," 12.

31. Edward Ziter, "The Image of the Martyr in Syrian Performance and Web Activism," *TDR/The Drama Review* 57, no. 1 (2013): 116–136.

32. See "Bassem Youssef's 'Qatari' Homeland Song Goes Viral," *Ahram Online,* April 6, 2013, http://english.ahram.org.eg/NewsContent/1/64/68564/Egypt/Politics-/VIDEO-Bassem-Youssefs-Qatari-homeland-song-goes-vi.aspx; Marwan M. Kraidy, "No Country for Funny Men: Comedian Bassem Youssef Returns to Egypt's Fear-Gripped Media Environment," *al-Jazeera America,* February 25, 2014, http://america.aljazeera.com/opinions/2014/2/no-country-for-funnymen.html.

33. See Badreiah al-Bishr, *The "Tash Ma Tash" Battles: A Reading of the Prohibition Mentality in Saudi Society* (Beirut: Arab Cultural Centre, 2007) [Arabic], and Kraidy, *Reality Television and Arab Politics.*

34. Sakr, *Transformations in Egyptian Journalism.*

35. "Al-Hurriya wal-'Adala, Gone with the Wind," *al-Akhbar,* September 26, 2012, www.alakhbar.com [Arabic]. Not to mention the August 14, 2013, dispersal of pro-Morsi sit-ins in Raba'a al-Adaweya and al-Nahda squares in Cairo, which led to the death of at least fifty-one protesters.

36. Hisham Jaber, *Political Jokes of the Arabs: From Innocent Mockery to Psychological War* (Beirut: World Book Publishing, 2009), 125.

37. Issandr El-Amrani, "Three Decades of a Joke That Just Won't Die," *Foreign Policy,* January 2, 2011, http://www.foreignpolicy.com/articles/2011/01/02/three_decades_of_a_joke_that_just_wont_die.

38. Fahmy, *Ordinary Egyptians,* 42.

39. Jaber, *Political Jokes of the Arabs,* 99.

40. Fahmy, *Ordinary Egyptians.*

41. Ibid., 87.

42. Cited in Fahmy, *Ordinary Egyptians,* 148, emphasis added.

43. Jaber, *Political Jokes of the Arabs,* 109. See also Khalid Kishtainy, *Arab Political Humor* (London: Quartet, 1985).

44. Samer S. Shehata, "The Politics of Laughter: Nasser, Sadat and Mubarek in Egyptian Political Jokes," *Folklore* 103, no. 1 (1992): 75–91.

45. Ibid., 81.

46. Ibid., 82.

47. http://twitter.com/mubarakthegreat.

48. Ibid.

49. Margaret A. Rose, *Parody: Ancient, Modern and Postmodern* (Cambridge: Cambridge University Press, 1993).

50. Robert Hariman, "Political Parody and Public Culture," *Quarterly Journal of Speech* 94, no. 3 (2008): 247–272, particularly p. 254.

51. See Kraidy, *Reality Television,* for more on hypermedia space.

52. Muhammad Hassanayn Haykal, "Mubarak and His Time: From the Stage to the Square," *al-Shorouk,* February 19, 2012, http://www.shorouknews.com.news /print.aspx?cdate=15012012&id=a7015b61–0884–4c31–a091–3bb25f3f3d63 [Arabic].

53. Muhammad Hassanayn Haykal, *Mubarak and His Time: From the Stage to the Square* (Cairo: Dar al-Shuruq, 2012), excerpted in Muhammad Hassanayn Haykal, "Mubarak and His Time: From the Stage to the Square," *al-Shorouk,* February 19, 2012, http://www.shorouknews.com.news/print.aspx?cdate=15012012&id =a7015b61–0884–4c31–a091–3bb25f3f3d63 [Arabic].

54. Declaring victory in the historic October 1973 war, Mubarak highlighted his own contributions (Hany Zayed, "Password Returns Mubarak to October 1973 Spotlight," *al-Watan,* January 10, 2013, http://alwatan.com.sa/Politics/News_Detail.aspx ?ArticleID=162474&CategoryID=1 [Arabic]), took credit for rebuilding the air force following the 1967 "setback" (Khalid Riyadh, "Commanders of October War— al-Shathli: Sadat Instructions behind Success of Crossing. Mubarak: 1967 Setback Gave us Logic to Rebuild our Forces," *al-Balad,* December 9, 2013, http://www.el-balad .com/641425 [Arabic]), and cast himself as a central figure in Egypt's victory in the 1973 war (Basnat Zayneddin and Muhammad Taha, "Salah Mahran, 'October Broadcaster': Mubarak Abridged Triumph to Air Strike," *al-Masry al-Youm,* October 17, 2013, available http:///www.almasryalyoum.com/news/details/329501 [Arabic]).

55. Ahmad Hafiz, "Heikal: Mubarak 'Did Not Understand Things Quickly' and His Personality Is More Complex Than the Laughing Cow, for the Following Reasons," *al-Ahram,* January 19, 2012, http://gate.ahram.org.eg/UI/NewsContentPrint /13/54/162021.apx [Arabic].

56. Ibid.

57. 'Abdulrahamn Youssef, "The Laughing Cow and the Sacred Cow," *al-Yawm al-Sabe',* May 21, 2012, http://www.youm7.com/News.asp?NewsID=683768#.U5CFj hbMroA [Arabic].

58. Ibid., emphasis added.

59. Ibid.

60. Ibid.

61. To watch the original song by Ahmad Fuad Nagm, see "The Haha Cow," YouTube video, 4:51, uploaded by "Shadi Al-Mahmoudi," January 27, 2010, http://

youtu.be/ghGSW-K2_m8. For a recent Tahrir Square performance, see "'Ezza Belba': The Haha Goring Cow—The Second Friday of Anger," YouTube video, 2:18, uploaded by "Hani Hani," May 28, 2011, https://www.youtube.com/watch?v =lMWSSsSnjfQ.

62. My translation from Arabic.

63. See the blog *This Is Not Graffiti,* particularly an October 30, 2011, post titled "The Cow," available at http://thisisnotgraffiti-cairo.blogspot.nl/.

64. Baron, *Egypt as Woman,* 59.

65. See Mia Gröndahl, *Revolution Graffiti: Street Art of the New Egypt* (London: Thames and Hudson, 2013), 87. Another graffito, "Petrol Cow," appeared on Youssef Al-Guindi Street in Cairo on October 28, 2011. An update of the "Dairy (Cash) Cow" motif, it extends the metaphor of exploitation by adding three petrol pump handles coming out of the cow's body. It may be a stretch to glimpse an allusion to Gulf petro-monarchies meddling in Egypt's revolution, but the mural reflects the persistence of animal imagery as political idiom.

66. Bassem Youssef, "Ehna Thawrat Culottat," *El-Bernameg,* season 2, episode 3, produced by Tareq al-Qazaz, directed by Muhammad Khalifah, aired by CBC. See the stencil of Tantawi's underwear in Don Karl and Basma Hamdy, *Walls of Freedom: Street Art of the Egyptian Revolution* (Berlin: From Here to Fame, 2014), 64.

67. Youssef, "Ehna Thawrat Culottat."

68. Ibid.

69. For example, on May 13, 2013, the blog *Morsy and Me: Presidential Shenanigans* featured a post titled "Poking the Bear" ridicules Morsi as "a certain big bear with a big beard but a soft and squidgy head" who when he "feels all of those taunts wielded at him by no-good regular folks" reacts "in the only way he knows how. He growls and roars and mauls them with his executive, judiciary and legislative big-bear-strength. GRRAAAAAWWWWRRR!!" *Morsy and Me: Presidential Shenanigans,* http://www.morsyandme.com/?p=840, accessed on June 1, 2014.

70. Youssef, "Ehna Thawrat Culottat."

71. Ibid.

72. Ahmed Nour and Adam Robinson, "Egypt's Abdul Fattah al-Sisi 'Cult' Sees Surge in Merchandise," *BBC News,* March 31, 2014, http://www.bbc.com/news /world-middle-east-26775516.

73. Leila Zaki Chakravarti, "From Strongman to Superman: Sisi the Savior of Egypt," *Open Democracy,* April 28, 2014, https://www.opendemocracy.net/5050/leila -zaki-chakravarti/from-strongman-to-superman-sisi-saviour-of-egypt.

74. Lubna Abdel Aziz, "Catch the Al-Sisi Mania," *al-Ahram Weekly,* September 19, 2013, http://weekly.ahram.org.eg/News/4103/44/Catch-the-Al-Sisi-mania.aspx.

75. Ibid.

76. *Merriam-Webster, s.v.* "kismet," accessed June 3, 2014, http://www.merriam -webster.com/dictionary/kismet.

77. Abdel Aziz, "Catch the Al-Sisi Mania."

78. Ibid.

79. Ghada Shareef, "O' Sisi . . . All You Need to Do Is Wink!" *al-Masry al-Youm,* July 25, 2013, http://www.almasryalyoum.com/news/details/198680 [Arabic].

80. Chakravarti, "From Strongman to Superman."

81. As the leader is masculinized, the nation is feminized. The metaphor of Egypt as woman has historical purchase. See Baron, *Egypt as Woman.*

82. Chakravarti, "From Strongman to Superman."

83. Ibid.

84. Ibid.

85. Ursula Lindsey, *The Cult of Sisi* (blog), *New York Times,* September 12, 2013, http://latitude.blogs.nytimes.com/2013/09/12/the-cult-of-sisi/.

86. Chakravarti, "From Strongman to Superman."

87. Ibid. This image is satirical.

88. "Saudi King Hails Sisi's 'Historic' Election Win," *al-Arabiya,* June 3, 2014, http://english.alarabiya.net/en/News/2014/06/03/Saudi-king-hails-Sisi-s-historic -election-win.html.

89. Pushback in the form of an online petition protesting the pledge had by November 3 garnered 350 journalists' signatures.

90. Muhammad Salah, "Mubarak's Trial: Testimonies of the Great Uncover Secrets," *al-Hayat,* September 8, 2011, http://international.daralhayat.com/print /305173, accessed September 9, 2011 [Arabic].

91. El-Sayed Gamal Edeen, "Mubarak's Name to Be Removed from Egypt Squares and Public Facilities," *al-Ahram English,* May 20, 2014, http://english.ahram .org.eg/NewsContent/1/64/101834/Egypt/Politics-/Mubaraks-name-to-be-removed -from-Egypt-squares-and.aspx.

92. Hossam Bahgat, "The Mubarak Mansions," *Mada Masr,* May 20, 2014, http://www.madamasr.com/sections/politics/mubarak-mansions.

93. Amir Hazza', "Mubarak Cries after Wearing Blue Uniform for First Time," *al-Ahram,* June 1, 2014. See also an updated Amir Hazza', "Mubarak in Blue Uniform . . . a Tear and a Smile and Kisses in the Air," *al-Ahram,* June 1, 2014, http://gate.ahram.org .eg/ News/162021.aspx [Arabic].

94. Amir Hazza', "Mubarak in Blue Uniform."

95. Shima' Rasheed, "Mubarak Denies Crying: 'Surely They Photographed Someone Else,'" *al-Shuruq,* June 1, 2014, http://www.shorouknews.com/news/print .aspx? cdate=01062014&id=753ea461–2f58–4dd6–8ef6-ded6b06391e7 accessed June 2, 2014 [Arabic].

96. Muhammad Salah, "Cairo Awaits Sisi's Installation . . . and Mubarak Cries," *al-Hayat,* June 1, 2014, http://www.alhayat.com, accessed June 2, 2014 [Arabic].

PART IV. PUPPETS AND MASTERS

1. See Ibrahim al-Koni, *The Puppet*, trans. William M. Hutchins (Austin: University of Texas Press, 2010).

2. The third graffito is a modification of the second, reflecting the SCAF's tightening grip on politicians. See Karl and Hamdy, *Walls of Freedom*, 172, 177.

3. Muhammad Jom'a, "*Al-Shorouk* Publishes Proceedings of the Verdict that Sentenced Al-Shenawy-the-Eye-Sniper to Three Years in Jail," *al-Shorouk*, March 5, 2013, http://www.shorouknews.com/news/view.aspx?cdate=05032013&id=16fdab48-1c7e-4a76-9008-f6c0474d93e7 [Arabic], accessed February 1, 2015. Some activists, including the academic Atef Botros, told me they believe police aimed at the head, in order to kill, rather than the eye, but sniped eyes quickly became arch-symbols of police brutality.

4. My approximate translation of *gada' ya basha . . . gat fee 'aynah*. Muhammad Dunya, "Videographer of 'Eye Sniper' to *Al-Ahram:* I Am Terrorized . . . and Fear for My Life and My Family," *al-Ahram*, December 9, 2011, http://ahram.org.eg/archive/742/2011/12/9/38/117815/219.aspx [Arabic], accessed February 1, 2015. Farha Ghannam, in *Live and Die Like a Man: Gender Dynamics in Urban Egypt* (Stanford, CA: Stanford University Press, 2013), translates *gada'* as "the honest, brave and capable man" (291).

5. Ahram Online, "'Sniper of the Eyes' Surrenders to Authorities," November 30, 2011, http://english.ahram.org.eg/NewsContent/1/64/28165/Egypt/Politics-/Sniper-of-the-eyes-surrenders-to-authorities-.aspx; Jom'a, "*Al-Shorouk* Publishes Proceedings"; Patrick Kingsley, "Eye Sniper of Tahrir Square Is in Jail, but Has Anything Changed?" *Guardian*, March 6, 2013, http://www.theguardian.com/world/shortcuts/2013/mar/06/eye-sniper-tahrir-egypt-jailed; Fahmy Howeidy, "Justice Is the Foundation of Security," *al-Shorouk*, March 10, 2014, http://www.shorouknews.com/columns/print.aspx?cdate=10032014&id=e36bec65-c634-45d6-9385-81cb89fbc60a [Arabic], accessed February 1, 2015.

6. Agence France Presse, "Egypt Police Eye Sniper Turns Himself In," *Al Arabiya News,* November 30, 2011, http://english.alarabiya.net/articles/2011/11/30/180134.html.

7. Mikala Hyldig Dal, "Eye-Snipers: The Iconoclastic Practice of Tahrir," *Seismopolite*, July 6, 2014, http://www.seismopolite.com/eye-snipers-the-iconoclastic-practice-of-tahrir.

8. Seeing and shaming were part of the revolution very early on. Shayfeen.com "documented, often through images, incidents of transgression . . . a new politics (128) of seeing, presence and image reversal." Khatib, *Image Politics in the Middle East,* 128–129.

9. Karl and Hamdy, *Walls of Freedom*, 261.

10. Details vary, but the Eye of Horus is at the center of celestial myths of sun and moon, light and darkness. See Geraldine Pinch, *Egyptian Mythology: A Guide to the Gods, Goddesses, and Traditions of Ancient Egypt* (Oxford: Oxford University Press,

2004), and Herman te Velde, *Seth, God of Confusion,* trans. G. E. Van Baaren-Pape (Leiden: E. J. Brill, 1967).

11. Waldemar Deonna, *Le Symbolisme de l'oeil* (Paris: Éditions E. de Boccard, 1965), 25–26.

12. Amanda E. Rogers, "A Street Called Mohammed Mahmoud," *Cairo Review of Global Affairs,* June 6, 2014, http://www.aucegypt.edu/GAPP/CairoReview/Pages /articleDetails.aspx?aid=612; Sara Mousa, "Ammar Abo Bakr: Committing Murder, Then Marching in the Funeral Procession," *Jadaliyya,* January 27, 2014, http://www .jadaliyya.com/pages/index/16192/ammar-abo-bakr_committing-murder-then -marching-in-. See Abo Bakr telling how he painted the one-eyed victims in "Street Art Egypt: Ammar Abo Bakr," Vimeo video, 4:13, posted by "mariekezwilling," February 17, 2013, https://vimeo.com/59835511.

13. Abo Bakr is from the Upper Egypt town of Minya but was an assistant professor of fine arts in Luxor. Personal communication with artist, via his manager, September 13, 2015.

14. See Hany Na'eem, *Graffiti of the Uprisings: A Journey to the Backstage of Street Language* (Beirut: Arab Scientific Publishers, 2013) [Arabic]; Mona Abaza, "Walls, Segregating Downtown Cairo and the Mohammed Mahmud Street Graffiti," *Theory, Culture and Society* (2012): 1–18.

15. Khatib, *Image Politics in the Middle East,* 155.

16. Roland Barthes, *Camera Lucida: Reflections on Photography,* trans. Richard Howard (New York: Hill and Wang, 1981), 5, 9, quoted in David Morgan, *The Embodied Eye: Religious Visual Culture and the Social Life of Feeling* (Berkeley: University of California Press: 2012) , 29.

17. Hans Belting, "Image, Medium, Body: A New Approach to Iconology," *Critical Inquiry* 31, no. 2 (2005): 308.

18. Quoted in Adrienne de Ruiter, "Imaging Egypt's Political Transition in (Post-) Revolutionary Street Art: On the Interrelations between Social Media and Graffiti as Media of Communication," *Media, Culture & Society* 37, no. 4 (2015): 581–601, quote from 585.

19. Khatib, *Image Politics in the Middle East,* 146–147.

20. As Mona Abaza wrote in "The Dramaturgy of a Street Corner," *Jadaliyya,* January 25, 2013, http://www.jadaliyya.com/pages/index/9724/the-dramaturgy-of-a -street-corner, "Repertoire . . . might explain . . . the insistence of revolutionary artists to repaint the same murals time and again."

21. Khatib, *Image Politics in the Middle East,* 154.

22. I borrow "zoning" from Abaza, "Walls, Segregating Downtown Cairo," 1–18; for more details, see Bel Trew, "Street Artists Paint 'through' SCAF Walls, in Protest," *Ahram Online,* March 10, 2012, http://english.ahram.org.eg/NewsContentPrint /5/0/36405/Arts—Culture/0/-Street-artists-paint-through-SCAF-walls,-in-prote .aspx.

23. Soraya Morayef, "The Seven Wonders of the Revolution," *Jadaliyya,* March 22, 2012, http://www.jadaliyya.com/pages/index/4776/the-seven-wonders-of-the -revolution. Abaza surmised they were "inspired by the work of the British artist Banksy on the West Bank." Abaza, "Walls, Segregating Downtown Cairo," 7.

24. Trew, "Street Artists Paint 'through' SCAF Walls."

25. Ibid.

26. Gilles Deleuze and Félix Guattari, *Milles Plateaux* (Paris: Éditions de Minuit, 1980). See also Mark Halsey and Alison Young, " 'Our Desires Are Ungovernable': Writing Graffiti in Urban Space," *Theoretical Criminology* 10, no. 3 (2006): 295.

27. There were physical openings through doors in buildings on both sides of the street.

28. Morayef, "Seven Wonders of the Revolution."

29. See the exhibit *Before This It Was Just a Wall,* featuring body-themed graffiti from Beirut, which I curated at the University of Pennsylvania in 2013–2014, with the help of Marina Krikorian, under the auspices of the Project for Advanced Research in Global Communication. A link to the digital version can be found at https://www.asc.upenn.edu/news-events/news/it-was-just-wall-exhibit-plaza -lobby.

30. Morayef, "Seven Wonders of the Revolution."

31. With key suspects being Mossad-PLO double agents, the assassination triggered a diplomatic crisis between the United Kingdom and Israel.

32. Naji al-Ali, *A Child in Palestine: The Cartoons of Naji Al-Ali* (London: Verso, 2009).

33. Maurice Merleau-Ponty, *L'Œil et l'Esprit* (Paris: Gallimard, 1964).

34. Morgan, *Embodied Eye,* 5.

35. André Bazin, "The Ontology of the Photographic Image," in *Classic Essays on Photography,* ed. Alan Trachtenberg (New Haven, CT: Leete's Island, 1980), 238, quoted in Morgan, *Embodied Eye,* 30.

36. Martin Jay, "The Rise of Hermeneutics and the Crisis of Ocularcentrism," *Poetics Today* 9, no. 2 (1988): 311.

37. Criticizing Descartes's *The Dioptrics* (1637), Merleau-Ponty himself argued that vision in Descartes is based on touch.

38. Morgan, *Embodied Eye,* 40–44, discussed the convergence of seeing, touching, and believing in the paintings of the German master Albrecht Dürer.

39. Ibid., 54.

40. Human Rights Watch, *All According to Plan: The Rab'a Massacre and Mass Killings of Protesters in Egypt,* August 12, 2014, http://www.hrw.org/reports/2014 /08/12/all-according-plan-0; "Rabe'a: A Tight Plan for the Crime," *Al-Quds Al-Arabi,* August 14, 2014, http://www.alquds.co.uk/?p=206921 [Arabic]; authorities denied entry to Human Rights Watch officers traveling to Cairo to present the report.

41. Dal, "Eye-Snipers."

42. See Reuters, "Egyptians Defiant over Use of 'Rabaa' Symbol," *Voice of America,* November 29, 2013, http://www.voanews.com/content/egyptians-defiant-over-rabaa-symbol/1800249.html.

43. Al-Quds Al-Arabi, "Spread of Rabe'a Motto and Attempts to Criminalize It," November 22, 2013, http://www.alquds.co.uk/?p=106248 [Arabic].

44. Al-Quds Al-Arabi, "Elissa Stirs Controversy in the Wake of Making Rabe'a Motto," November 24, 2013, http://www.alquds.co.uk/?p=106597 [Arabic].

45. Mada Masr, "How Do You Write a Banned Number?" December 30, 2013, http://madamasr.com/content/how-do-you-write-banned-number.

46. Al-Quds Al-Arabi, "Hazem Badar, an Egyptian Referee . . . Escaping from the Rabe'a Sign," January 1, 2014, http://www.alquds.co.uk/?p=118910 [Arabic].

47. Masr, "How Do You Write a Banned Number?"

48. See, among others, Motasem A. Dalloul, "Rabaa and Nahda Give Birth to New Victory Sign," *Middle East Monitor,* August 20, 2013, https://www.middle eastmonitor.com/articles/africa/6997-rabaa-and-nahda-give-birth-to-new-victory -sign; Glen Kates, " 'Four-Finger Salute' Shows Solidarity with Egypt's Muslim Brotherhood," *Radio Free Europe,* August 24, 2013, http://www.rferl.org/article printview/25085068.html; Marwa Gamal, "For Egyptians . . . the Palm for Jealousy and Fingers for Politics," *Al-Quds Al-Arabi,* November 18, 2014, http://www.alquds .co.uk/?p=252449 [Arabic]. The term *fulul* is tricky to translate, and "regime remnants" is an approximation.

49. See Raoul Makarius and Laura Makarius, "Ethnologie et Structuralisme: Le Symbolisme de la Main Gauche," *L'Homme et la Société* 9 (1968): 195–212.

50. Gottfried Korff, "From Brotherly Handshake to Militant Clenched Fist: On Political Metaphors for the Worker's Hand," trans. Larry Peterson, *International Labor and Working-Class History* 42 (1992): 70–81.

51. Ibid., 81. According to Korff, it is the RFB's use of the clenched fist in protest marches that compelled the Nazis to come up with their infamous salute.

52. One can trace Egyptian hand symbolism as far back as Akhenaton (1336–1353 BC), when a hand spread from the god Amun to bestow sacredness on the pharaoh.

53. Hanan Sabea, " 'I Dreamed of Being a People': Egypt's Revolution, the People and Critical Imagination," in *The Political Aesthetics of Global Protest: The Arab Spring and Beyond,* ed. Pnina Werbner, Martin Webb, and Kathryn Spellman-Poots (Edinburgh: Edinburgh University Press, 2014), 67–92.

54. Samar Media, "Syrian Cartoonist Ali Ferzat: 'They Broke My Hands to Stop Me from Drawing Assad,' " *Jadaliyya,* July 7, 2012, http://www.jadaliyya.com/pages /index/6328/syrian-cartoonist-ali-ferzat_they-broke-my-hands-t.

55. See *Before This It Was Just a Wall.*

56. miriam cooke, "Tadmor's Ghosts," *Review of Middle East Studies* 47, no. 1 (2013): 33.

57. Tripti Lahiri, "A Short History of the Congress Hand," *Wall Street Journal,* March 28, 2012, http://blogs.wsj.com/indiarealtime/2012/03/28/a-short-history-of-the-congress-hand/; and *Guruprasad's Portal* (blog), "The Story behind Congress Hand Symbol," March 22, 2014, http://guruprasad.net/posts/the-story-behind-congress-hand-symbol/.

58. See Vasanthi Hariprakash, "How Indira's Congress Got Its Hand Symbol," NDTV, December 22, 2010, http://www.ndtv.com/offbeat-life/how-indiras-congress-got-its-hand-symbol-442625.

59. Rasheed Kidwai, quoted in Lahiri, "Short History of the Congress Hand" and *Guruprasad's Portal,* "Story behind Congress Hand Symbol."

60. See the party's website, http://www.mdc.co.zw/.

61. Depictions of the motto can be seen in Mykala Hyldig Dal, "Transliterations of Rabaa," in Karl and Hamdy, *Walls of Freedom,* 244–245.

62. Deonna, *Le Symbolisme de l'Oeil,* 70–78.

63. Malek Chebel, *Le Corps en Islam* (Paris: Presses Universitaires de France: 1999), 65.

64. Karl and Hamdy, *Walls of Freedom,* 208.

65. Charles Hirschkind, *The Ethical Soundscape: Cassette Sermons and Islamic Counterpublic* (New York: Columbia University Press, 2009). See Walter Armbrust, "History in Arab Media Studies: A Speculative Cultural History," in *Arab Cultural Studies: Mapping the Field,* ed. Tarik Sabry (London: I. B. Tauris, 2012), 32–54. Armbrust argues that the image was ascendant from 1919 to 1975.

66. Jay, "Rise of Hermeneutics and the Crisis of Ocularcentrism," 66: "The eye resembles feminine genitals that it joins in the symbolism of shellfish . . . erotic specificities are attributed to the eye." In Kraidy, *Reality Television and Arab Politics,* I analyze anti-ocularism in Saudi Arabia, manifested in women's dress and confinement to private space and in hostility against television.

67. Armbrust, "History in Arab Media Studies," 36: Ocular-centrism "places text in a world of representable objects distinguished from the mind of a thinking subject, thereby dispersing authority to the texts themselves."

68. At least one graffito of a hand I saw in Beirut featured an open palm with a bent index finger, combining mystical defense and worldly insult.

69. Belting, "Image, Medium, Body," 311.

70. Though pushing the angle of an anti-ocular Islamist politics too far runs the risk of flirting with reductionist Orientalism, evidence suggests that it was one factor among others.

71. Armbrust, "History in Arab Media Studies," 36.

72. Deonna, *Le symbolisme de l'oeil,* 71.

73. Ibid.

74. Marlin Dick, "Syria under the Spotlight: Television Satire That Is Revolutionary in Form, Reformist in Content," *Arab Media and Society* 3 (2007), http://www.arabmediasociety.com/?article=419.

75. On the importance of Ramadan to television, see Kraidy and Khalil, *Arab Television Industries.*

76. Dick, "Syria under the Spotlight."

77. Christa Salamandra, "Prelude to an Uprising: Syrian Fictional Television and Socio-Political Critique," *Jadaliyya,* May 17, 2012, http://www.jadaliyya.com/pages /index/5578/prelude-to-an-uprising_syrian-fictiona-tele.

78. I am grateful to Rana Jarbou' for first mentioning this to me.

79. Salamandra, "Prelude to an Uprising." Samer Barqawi, a collaborator of the original director al-Laith Hajju, directed the episode.

80. See, among others, Na'eem, *Graffiti of the Uprisings,* 73.

81. Firas al-Khoury, "Graffiti Wars and Syria's Spray Man," *al-Akhbar English,* October 6, 2011, http://english.al-akhbar.com/content/graffiti-wars-and-syria%E2%80%99s -spray-man; Salamandra, "Prelude to an Uprising."

82. Mediaoriente, "Drawing Freedom on Syria's Walls—A Tribute to "Spray Man" Nour Hatem Zahra," April 30, 2012, http://mediaoriente.com/2012/04/30 /drawing-freedom-on-syrias-walls-a-tribute-to-spray-man-nour-hatem-zahra/.

83. Al-Khoury, "Graffiti Wars and Syria's Spray Man."

84. miriam cooke, *Dissident Syria: Making Oppositional Arts Official* (Durham, NC: Duke University Press, 2007), 23.

85. Several people have argued that revolutionary graffiti can be understood as "taking back public space," for example, Na'eem, *Graffiti of the Uprisings,* Khatib, *Image Politics in the Middle East;* Abaza, "Walls, Segregating Downtown Cairo," 4; in addition to Marwan M. Kraidy, "A Heterotopology of Graffiti: A Preliminary Exploration," *Orient-Institut Papers* 3 (2013), http://www.perspectivia.net/content /publikationen/orient-institut-studies/2–2013/kraidy_graffiti.

86. Wedeen, *Ambiguities of Domination;* cooke, *Dissident Syria,* 73.

87. Michel Foucault, *Discipline and Punish: The Birth of the Prison* (New York: Vintage, 1991), p. 138, quoted in cooke, *Dissident Syria,* 74.

88. See Michel Foucault, *Surveiller et Punir: Naissance de la Prison* (Paris: Gallimard, 1976), in particular chapter 1, "Les corps dociles," 159–199. See also Saba Mahmood, "Feminist Theory and the Egyptian Islamic Revival," *Cultural Anthropology* 16, no. 2 (2001): 202–236.

89. Na'eem, *Graffiti of the Uprisings,* 70.

90. Rabih Alameddine, *An Unnecessary Woman* (New York: Grove, 2014), 88.

91. Paul D. McGlynn, "Graffiti and Slogans: Flushing the Id," *Journal of Popular Culture* 7 (1972): 353, my emphasis.

92. Tala F. Saleh, "Marking Beirut," in *Arabic Graffiti,* ed. Pascal Zoghbi and Don Karl (Beirut: From Here to Fame, 2011).

93. Maria Chakhtoura, *La Guerre des Graffiti, Liban 1975–1977* (Beirut: Editions Dar An-Nahar, 1978). See also Rasha Salti, "Urban Scrolls and Modern-Day Oracles: The Secret Life of Beirut's Walls," *Third Text* 22, no. 5 (2008): 615–627.

94. Saleh, "Marking Beirut," 74.

95. Salti, "Urban Scrolls and Modern-Day Oracles," 620: "The content is different, but also purpose, interlocution, interpellation, dissemination, scope and quantity."

96. Pascal Zoghbi, "Beirut's Graffiti Writing and Street Art," in Zoghbi and Karl, *Arabic Graffiti*, 81.

97. It is an abomination that white, European expats are allowed more easily than Lebanese citizens to access Beirut's largest green space.

98. Reconstruction efforts carved Lebanon's television landscape according to sectarian lines while sapping public television, and the 1994 Audio-Visual Media Law consecrated that structure. See Marwan M. Kraidy, "Broadcasting Regulation and Civil Society in Post-War Lebanon," *Journal of Broadcasting and Electronic Media* 42, no. 3 (1998): 387–400.

99. Though always scornful of popular culture, al-Munajjed's opinions are not always kooky. A best-circulating sermon of his on the Lebanese reality TV show *Star Academy* was learned and insightful. See Kraidy, *Reality Television and Arab Politics*.

100. Zoghbi, "Beirut's Graffiti Writing and Street Art," 81.

101. Analytically, Beirut is a proxy for Damascus that enables in situ collection of political graffiti without incurring significant safety risk.

102. Whereas in Egypt the debate about revolutionary art was associated with graffiti, the daily bloodletting in Syria spurred a bifurcation between political graffiti and the development of Syrian art proper, which grew in cyberspace and safer environments like foreign studios and galleries.

103. Hamra is a fiefdom of the Syrian Socialist Nationalist Party (SSNP), a militantly pro-Assad party whose foot soldiers have exacted pain from protesters against the Syrian regime. See Jadaliyya Reports, "One Night in Hamra," August 4, 2011, http://www.jadaliyya.com/pages/index/2305/one-night-in-hamra.

104. Na'eem, *Graffiti of the Uprisings*, 73.

105. For a detailed analysis, and for pictures of the stencil's different iterations, see Kraidy, "Heterotopology of Graffiti."

106. Na'eem, *Graffiti of the Uprisings*, 73.

107. I learned this from two participating activists I interviewed in July 2012, who requested anonymity.

108. Na'eem, *Graffiti of the Uprisings*.

109. I have repeatedly encountered this trope since conducting dissertation research in Lebanon in 1994. The notion of Lebanon as a loose woman who is penetrated by a variety of powerful political actors echoes the sense of vulnerability that one finds in, for example, the myth of La Malinche in Mexico. It is a metaphor of politico-cultural power.

110. Colla, "In Praise of Insult," 45.

111. See *Before This It Was Just a Wall*.

112. Donna Lee Bowen and Evelyn A. Early, eds., *Everyday Life in the Muslim Middle East* (Bloomington: Indiana University Press, 2002), 329.

113. Kraidy and Khalil, *Arab Television Industries*.

114. For Wedeen the cult itself was an instrument of governance, regimenting Syrian bodies into scripted spectacles where "the body functions . . . to substantiate rather than legitimate power." Wedeen, *Ambiguities of Domination*, 21–22.

115. Osama Kamal, "The Unbeatable Art of Ali Farzat," *al-Ahram Weekly*, September 22, 2011, http://weekly.ahram.org.eg/2011/1065/entertain.htm, accessed January 15, 2014.

116. Lahham also capitalized on the growing media market, returning to the scene with *Ahlam Abul-Hanna* [Abul-Hanna's Dreams] in 1996 and *'Awdat Ghawwar* [The Return of Ghawwar] in 1998.

117. See Zeina Erheem, "In Syria Events Bloom in Humor on Facebook," *al-Hayat*, November 27, 2011, http://www.international.daralhayat.com/print/333050 [Arabic], accessed March 10, 2013; Ella Wind, "Dark Humor Facebook Pages of the Syrian Occupation," *Jadaliyya*, August 20, 2012, http://www.jadaliyya.com/pages/index/6950/dark-humor-facebook-pages-of-the-syrian-opposition.

118. "Top Goon—Diaries of a Little Dictator," Kickstarter, accessed February 17, 2015, https://www.kickstarter.com/projects/masasitmati/top-goon-diaries-of-a-little-dictator?ref=live.

119. I got the Rimbaud mention from Mohammed Ali Atassi, "The Puppet Rebellion: Creative Protest against Syria's Regime," *Qantara*, January 20, 2012, http://en.qantara.de/content/creative-protest-against-syrias-regime-the-puppet-rebellion.

120. Souria Houria [Syria Freedom], "*Top Goon—Diaries of a Little Dictator*: A Revolutionary Satirical Puppet Theatre Webseries Calling for Funds to Help It Produce a Second Season," April 21, 2012, http://souriahouria.com/top-goon-diaries-of-a-little-dictator-a-revolutionary-satirical-puppet-theatre-webseries-calling-for-funds-to-help-it-produce-a-second-season/.

121. See "~~Occupied~~ Liberated Kafranbel: The Little Syrian Town That Could," accessed February 17, 2015, http://www.occupiedkafranbel.com/.

122. See David Kenner, "The Little Syrian Town That Could," *Foreign Policy*, July 5, 2012, http://foreignpolicy.com/slideshow/the-little-syrian-town-that-could/.

123. Kraidy, *Reality Television and Arab Politics*.

124. Maher is the dictator's hot-tempered younger brother and commander of the Republican Guard and the Syrian Army's elite Fourth Infantry Division. Rami Makhlouf is Maher and Bashar's maternal cousin, Syria's chief oligarch and wealthiest individual, in control of Syria's private sector. Ali Mamlouk is a longtime adviser to the Assads and the overall boss of Syria's multiple security services.

125. Speech by Bashar al-Assad, President of Syria, at Damascus University on June 20, 2011, official English translation from the Syrian Arab News Agency (SANA), available at http://www.al-bab.com/arab/docs/syria/bashar_assad_speech_110620.htm.

126. See "Masasit Mati—*Top Goon* Episode 2 Who Wants to Kill a Million?," YouTube video, 6:25, posted by Massasit Matti, November 27, 2011, http://youtu.be /7A0bG4vssz0. For the sake of faithfulness to the web-series creators, the translation is taken verbatim from the English subtitles (even if said translation is not 100 percent sensitive to the intricacies of Syrian vernacular Arabic).

127. Al-Jazeera English, "Little Dictator," filmmakers Hugh Macleod and Annasofie Flamand, *Witness,* August 21, 2012, http://www.aljazeera.com/programmes /witness/2012/08/2012820111648774405.html.

128. See http://www.kickstarter.com/projects/masasitmati/top-goon-diaries-of-a -little-dictator?ref=live; and Souria Houria [Syria Freedom], "*Top Goon—Diaries of a Little Dictator.*"

129. The Prince Claus Fund also supported 'Ali Ferzat.

130. "The Fund," Prince Claus Fund for Culture and Development, http://www .princeclausfund.org/en/the-fund.

131. Rima Marrouch, "Syrian Opposition Artists Puppet the Regime," *The Arab World in Revolution(s),* April 10, 2012, http://monde-arabe.arte.tv/en/rima-marrouch -syrian-opposition-artists-puppet-the-regime-2/.

132. Linda S. Myrsiades, "Resistance Theater and the German Occupation," *Journal of the Hellenic Diaspora* 17, no. 2 (1991): 6.

133. See Serdar Özturk, "Karagöz Co-Opted: Turkish Shadow Theatre of the Early Republic (1923–1945)," *Asian Theatre Journal* 23, no. 2 (2006): 292–313; Ziad Fahmy, *Ordinary Egyptians: Creating the Modern Nation through Popular Culture* (Stanford, CA: Stanford University Press, 2011), 40–41.

134. Malu Halasa, Zaher Omareen, and Nawara Mahfoud, eds., *Syria Speaks: Art and Culture from the Frontline* (London: Saqi, 2015), 271.

135. Fahmy, *Ordinary Egyptians,* 167.

136. Jamil, director of *Top Goon,* quoted in Hugh Macleod and Annasofie Flamand, "Top Goon: Puppet Drama Lampoons Syria's Bashar al-Assad," *Global Post,* December 12, 2011, http://www.globalpost.com/dispatch/news/regions/middle-east /111212/top-goon-syria-puppet-show-bashar-al-assad, emphasis added. One of the creators told Mohammed Ali Atassi in "The Puppet Rebellion" that "the puppet theatre that we are presenting is like the demonstrations in which we took part. In both cases we have violated what was prohibited and bypassed the red lines. . . . When I play . . . Beeshu . . . I have the same feeling . . . that . . . provokes me to shout in the street of Damascus: 'The people want the fall of power.'"

137. Atassi, "Puppet Rebellion."

138. Mark Levenson, "Memorandum re: Puppetry in Other Media," unpublished paper presented to the Futurism Conference, San Luis Obispo, CA, May 15, 1992, quoted in Stephen Kaplin, "Puppetry in the Next Millennium," *Puppetry International* 1, (1994): 37–39.

139. Kaplin, "Puppetry in the Next Millennium," 37.

140. Tom Sherman, "Vernacular Video," in *Video Vortex Reader: Responses to You-Tube*, ed. Geert Lovink and Sabine Niederer (Amsterdam: Institute of Network Cultures, 2008), 161.

141. Ibid., 163.

142. Ibid., 161.

143. Thi Minh-Ha Trinh, *When the Moon Waxes Red: Representation, Gender and Cultural Politics* (London: Routledge, 1991), 190.

144. On the aesthetic of "cuteness," see Sianne Ngai, *Our Aesthetic Categories: Zany, Cute, Interesting* (Cambridge, MA: Harvard University Press, 2012).

145. See Sheila Kohring, "Bodily Skill and the Aesthetic of Miniaturisation," *Pallas* 86 (2011): 35.

146. John Mack, *The Art of Small Things* (Cambridge, MA: Harvard University Press, 2007), specifically, chapter 6, "Small as Powerful."

147. Kenneth Gross, "The Madness of Puppets," *Hopkins Review* 2, no. 2 (2009): 198.

148. Claudia Orenstein, "Thinking inside the Box: Meditations on the Miniature," *Theater* 39, no. 3 (2009): 150.

149. Susan Stewart, *On Longing: Narratives of the Miniature, the Gigantic, the Souvenir, the Collection* (Durham, NC: Duke University Press, 1992), 46.

150. Claude Lévi-Strauss, *The Savage Mind* (Chicago: University of Chicago Press, 1966), 44, quoted in Néstor García Canclini, *Hybrid Cultures: Strategies for Entering and Leaving Modernity*, trans. Christopher L. Chiappari and Silvia L. López (Minneapolis: University of Minnesota Press, 1995), 125.

151. He wrote that "the intrinsic virtue of the reduced model is that it compensates the renunciation of the perceptible dimensions with the acquisition of intelligible dimensions." Lévi-Strauss, *The Savage Mind*, 46, quoted in García Canclini, *Hybrid Cultures*, 125.

152. García Canclini, *Hybrid Cultures*, 125.

153. Ibid., 126. For more on miniatures and enchantment, see Kohring, "Bodily Skill and the Aesthetic of Miniaturisation," 35.

154. See Robert Hariman, "Political Parody and Public Culture," *Quarterly Journal of Speech* 94, no. 3 (2008): 254.

155. See George Harrison Shull, "What Is 'Heterosis'?" *Genetics* 33, no. 5 (1948): 439–446, http://www.ncbi.nlm.nih.gov/pmc/articles/PMC1209417/.

156. I discuss the distinctiveness of hybrid media forms in Marwan M. Kraidy, *Hybridity, or the Cultural Logic of Globalization* (Philadelphia: Temple University Press, 2005).

157. Gross, "Madness of Puppets," 193.

158. Atassi, "Puppet Rebellion."

159. Puppet-making is "intimate and personal due to size and reflects the need to shift dimensions in the bodily engagement between miniature and the life-sized user." Kohring, "Bodily Skill and the Aesthetic of Miniaturisation," 38.

160. See *Russia Today*, "Assad to RT: 'I'm Not a Western Puppet—I Have to Live and Die in Syria," *RT.com*, November 8, 2012, http://rt.com/news/assad-exclusive -interview-syria-240/, emphasis added.

161. BBC, "Syria Crisis: US Decries Assad 'Western Puppets' Speech," January 7, 2013, BBC, http://www.bbc.co.uk/news/world-middle-east-20928361, emphasis added.

162. For a compendium of Syrian creative insurgency, see Halasa, Omareen, and Mahfoud, *Syria Speaks*.

163. World at School, "Puppets Help Children to Deal with Disasters, War and Poverty," January 14, 2015, http://www.aworldatschool.org/news/entry/puppets -help-children-deal-with-disasters-and-conflicts-1489; Al-Jazeera English, "Syria: No Strings," filmmaker Karim Shah, *Witness*, August 20, 2014, http://www.aljazeera.com /programmes/witness/2014/08/syria-no-strings-2014817105747216504.html; Lutfia Rabbani Foundation, "Bridging the Gap between Communities with Puppets," September 5, 2014, http://www.rabbanifoundation.org/bridging-the-gap-between -communities-with-puppets/.

164. Gross, "Madness of Puppets," 188.

165. "Assala, Oh, If Only This Chair Could Speak," YouTube video, 2:38, posted by "amoude.net," December 30, 2011, http://youtu.be/jOayt5S8mcw [Arabic].

166. In medieval times "the king appears as one acting *vice Dei,* in the place of God and on the throne of God." Kantorowicz, *King's Two Bodies*, 160.

167. Recall that the ruler's chair was a recurring feature of 'Ali Ferzat's cartoons. Media, "Syrian Cartoonist Ali Ferzat."

168. Syrian Arab News Agency Tishrin, "Artist Wadi' al-Safi Praises President Al-Assad's Support for Arab and Lebanese Artists," October 19, 2011, http://thawra .alwehda.gov.sy/_archive.asp?FileName=317170082201110190010855 [Arabic].

169. "Assala, Oh, If Only This Chair Could Speak, Song of Syria's Revolution," YouTube video, 9:18, from an interview televised by al-Arabiya, posted by "assala50," October 14, 2011, http://youtu.be/EIkcCoy5wwA [Arabic]. Ironically, the only Arab country named after one family is Saudi Arabia, the sponsor of al-Arabiya and the leading Arab supporter of Syria's armed opposition to Assad.

170. Hiyam Bannout, "Assala Supports the Rebels in Syria and Her Brother Shuns Her," *al-Sharq al-Awsat*, May 22, 2011, http//:www.aawsat.com [Arabic].

171. "Assala's Brother Attacks His Sister, Says He Would Burn Himself and His Son, Were Bashar to Fall," YouTube video, 0:49, posted by "MrSirya75," May 22, 2011, http://youtu.be/TW7UO5wQnd8 [Arabic].

172. Assafir, "Raghda Attacks Assala: 'I Am with Assad against Foreign Interven-tion,'" December 14, 2011, http://www.assafir.com [Arabic]. See also al-Masry al-Youm, "Raghda Attacks Assala for Bashar's Sake: The Assad Regime Cured You from Polio," December 13, 2011, http://www.almasryalyoum.com/print/542471 [Ar-abic]; *al-Ahram,* "Raghda Attacks Assala, Reminds Her of Her Treatment for Polio and of the Gratitude She Owes Syria," December 14, 2011, http://gate.ahram.org.eg

/NewsContentPrint /13/56/146996.aspx [Arabic]; Raghda's Facebook page, accessed February 12, 2014, http://www.facebook.com/Raghdaa.Syrian.Actress.

173. For an extensive treatment, see Marwan M. Kraidy, "The Politics of Revolutionary Celebrity in the Contemporary Arab World," *Public Culture* 27, no. 1 (2015): 168–183.

174. See Kraidy, *Reality Television and Arab Politics.* The authenticity debate in Arab music follows a *tarab* (classical song) versus pop binary. A Romantic exaltation of authenticity has been a key feature of Arab nationalist thought. On the authenticity debate around Old Damascus, see Christa Salamandra, *A New Old Damascus: Authenticity and Distinction in Urban Syria* (Bloomington: Indiana University Press, 2004), 19.

175. Georges Moussa, "Assala: I Lack Faith and I Live in a Mold Made of Ice," *al-Hayat,* September 2, 2005, http://international.daralhayat.com.

176. "Reem Nasry: Syria on Top of the Universe," YouTube video, 4:26, posted by "Reem Nasri Official," January 24, 2012, http://youtu.be/PEcn1fdtGwc.

177. YouTube video, http://www.youtube.com/watch?v=Dlb8k6E8I2g, account terminated.

178. See https://www.facebook.com/notes/big-events-in-syria/-/200638116646397. Assala was a victim of several hacking attacks, including of her Facebook page in October 2012. See "Syrian Hacker Hacks into Assala's Official Website," May 18, 2011, *Syrianews*, http://Syria-news.com [Arabic], and "Assala's Facebook Page Hacked," October 26, 2012, *al-Masry al-Youm*, http://www.almasryalyoum.com /node/1202506 [Arabic].

179. "If Only This Chair Could Speak . . . New Release by Artist Assala Nasri," YouTube video, 8:08, posted by "adnan trablse," September 1, 2011, https://youtu.be /NpmgIDWlB_k.

180. See http://www.youtube.com/watch?v=Ca2lIg-HB4A.

181. "Assala's Brother Attacks His Sister," https://youtu.be/TW7UO5wQnd8.

182. See "Assala and Her Dream to Meet Obama . . . and the English Language," YouTube video, 3:12, from an interview on "The Honey and I" talk show on the Lebanese Broadcasting Corporation, posted by "asalahtv," September 15, 2009, http:// youtu.be/4uMXIGuT4JE. See also "If Only This Chair Could Speak," https:// youtu.be/NpmgIDWlB_k. The noun *'asl* has many meanings, including *origin, root, stock, foundation, descent, lineage,* and also *principle, basic rule.* In this context a better translation would be *essence.* The adjective *'asly* means original, genuine, authentic, pure, true.

183. The Assads have bankrolled medical treatment for a number of prominent Syrian and Lebanese artists, such as the late composer 'Assi al-Rahbani and the singers Sabah and Wadi' al-Safi. Assala herself was a beneficiary as a child when she underwent treatment for poliomyelitis at the state's expense. Even as the uprising unfolded in 2012, the Syrian government was paying medical bills for George Wassouf,

a leading Syrian singer supporting the Assad regime: the sovereign as healer and provider.

184. Raphael Eitan, an Israeli general and right-wing politician, uttered this infamous phrase. Steven Erlanger, "Rafael Eitan, 75, Ex-General and Chief of Staff in Israel, Dies," *New York Times,* November 24, 2004, http://www.nytimes.com/2004/11/24/obituaries/24eitan.html?_r=0.

185. Syriannews, "Assala Backs Away from Her Song That Attacks President Al-Assad and She Says She Does Not Hate Him," October 31, 2011 [Arabic].

186. See "Assala: Get Lost, Bashar!" http://www.youtube.com/watch?v=56BRhR66VfI.

187. For cultural control, see cooke, *Dissident Syria.* For economics, see Bassam Haddad, *Business Networks in Syria: The Political Economy of Authoritarian Resilience* (Stanford, CA: Stanford University Press: 2011).

188. See the discussion of the "makeover" in Omar Alghazzi, "Nation as Neighborhood: How Bab al-Hara Dramatized Syrian Identity," *Media, Culture & Society* 35, no. 5 (2013): 586–601. See also the "good life" in Lisa Wedeen, "Ideology and Humor in Dark Times: Notes from Syria," *Critical Inquiry* 39 (2013): 841–873.

189. Haddad, *Business Networks,* 1, original emphasis.

190. Celebrities constitute "a powerful type of legitimation of the political economic model . . . the basis of capitalism." David Marshall, *Celebrity and Power: Fame in Contemporary Culture* (Minneapolis: University of Minnesota Press, 1997), x.

191. Here it may be useful to remember that Assala hails from a Sunni family, which facilitates her demonization by mostly Alawi regime supporters.

192. "Latifa and the Tunisian Revolution," Facebook video, 1:46, posted by "Supporting and Protecting the Revolution," February 15, 2011, https://www.facebook.com/video/video.php?v=168501383196988.

193. "Raghda, Syrian Actress," https://ar-ar.facebook.com/Raghdaa.Syrian.Actress.

194. For English-language sources, see Virginia Danielson, *The Voice of Egypt: Umm Kulthum, Arabic Song, and Egyptian Society in the Twentieth Century* (Chicago: University of Chicago Press, 1997), and Sharifa Zuhur, *Asmahan's Secrets: Woman, War, and Song* (Austin: University of Texas Press, 2000).

195. In a footnote to chapter 10 of the last (1939) version of *The Work of Art in the Age of Its Technical Reproducibility,* Walter Benjamin drops a phrase about "the star and the dictator" being the winners in the new-media age. See Lambert Dousson, "La Vedette et le Dictateur: Sur une note de bas de page de *L'Oeuvre d'art à l'époque de sa reproducibilité technique* de Walter Benjamin," *Astérion* (2010), http://asterion.revues.org/1580.

196. Al-Quds Al-Arabi, "Assala: Syria Is Not Bashar's Property . . . and His Defenders Are 'Criminals,'" November 29, 2011, http://www.alquds.co.uk [Arabic].

197. The associated argument, disseminated by regime media, that by betraying her family Assala could not *not* betray her nation, posits Assad as a *paterfamilias,* a father of both family and nation, thus symbolically restoring his personification of nation and state and the Syrian body politic.

198. Assala's revolutionary journey took an unexpected turn in August 2013 when she accepted an invitation to sing at a festival in the West Bank, violating a thick red line around visiting Israeli-controlled territory. Syrian authorities initiated legal action against Assala, denying political motivation. See Badee'a Zaydan, "Assala First Syrian to Sing in Palestine Since Its Occupation," *al-Hayat,* July 30, 2013, http://alhayat.com/home/Print/537217?PrintPictures=1 [Arabic], and 'Alaa Halabi, "Syrian Judiciary Prosecutes Assala: You Communicated with the Enemy," *Assafir,* August 19, 2013, http://www.assafir.com/Windows/ArticlePrintFriendly.aspx?EditionId=2541&ChannelId=61345&ArticleId=1465&reftype=menu&ref=rm [Arabic].

PART V. VIRGINS AND VIXENS

1. On the night of November 20, 2012, the most recent tweet said, "May the military regime fall . . . social and political freedom," and there were 16,551 "likes" and 4,286 "comments" at the bottom of the page.

2. See http://6april.org/r02ya [Arabic] or http://shabab6april.wordpress.com/about/shabab-6-april-youth-movement-about-us-in-english/. The group began on Facebook in April 2008 when it called for a strike in Mahallah al-Kubra, the industrial-textile city. So despite an interest in speech freedom evinced on April 6's Facebook page, it is more accurately understood as a secular youth movement with roots in labor organizing.

3. A handful of bloggers and leftist or "critical" journalists (among others, Beirut's *al-Akhbar* and London's *Al-Quds Al-Arabi*) struck small, dissenting fissures. See also Karina Eileraas, "Sex(t)ing Revolution, Femen-izing the Public Square: Aliaa Magda Elmahdy, Nude Protest, and Transnational Feminist Body Politics," *Signs: Journal of Women in Culture and Society* 40, no. 1 (2014): 40–52; Sara Mourad, "The Naked Body of Alia: Gender, Citizenship, and the Egyptian Body Politic," *Journal of Communication Inquiry* 38, no. 1 (2013): 62–78; and Marwan M. Kraidy, "The Revolutionary Body Politic: Preliminary Thoughts on a Neglected Medium in the Arab Uprisings," *Middle East Journal of Culture and Communication* 5, no. 1 (2012): 68–76.

4. Hussameddin Muhammad, "Fadwa Slayman Makes History on al-Jazeera and Blogger Aliaa Lays Bare Both Government and Society," *Al-Quds Al-Arabi,* November 16, 2011 [Arabic].

5. Another line of analysis would pursue al-Mahdy's call to Egyptian men to wear the hijab in solidarity with Egyptian women, therefore threatening socially constructed, religiously enforced gender boundaries and hierarchies.

6. 'Adel Sabry, "An Invitation to View the Body of an Egyptian Girl," *al-Ahram*, November 21, 2011, http://www.alahram.org.eg/Free-Opinions/News/114127.aspx [Arabic].

7. Julia Kristeva, *Powers of Horror: An Essay on Abjection*, trans. Leon Roudiez (New York: Columbia University Press, 1982), 4.

8. Khodr Salameh, "Why, O Aliaa?" *Jou'aan*, November 16, 2011, http://www .jou3an.wordpress.com/2011/11/16 [Arabic]. On the issue of timing, see Maya Mikdashi, "Waiting for Alia," *Jadaliyya*, November 23, 2011, http://www.jadaliyya.com .pages/index/3208/waiting-for-alia.

9. Salameh, "Why, O Aliaa?"

10. Mikdashi, "Waiting for Alia." A 2013 Egyptian video documentary titled *Libido* claims that Egypt ranks second worldwide in Google searches for "sex."

11. From the prolific literature on Marianne, I recommend Maurice Agulhon's trilogy, *Marianne au Combat: L'Imagerie et la Symbolique Républicaines de 1789 à 1880* (Paris: Flammarion, 1979); *Marianne au Pouvoir: L'Imagerie et la Symbolique Républicaines de 1880–1914* (Paris: Flammarion, 1989); and *Les Métamorphoses de Marianne: L'Imagerie et la Symbolique Républicaines de 1914 à nos Jours* (Paris: Flammarion, 2001). In English, see *Marianne into Battle: Republican Imagery and Symbolism in France, 1789–1880* (Cambridge: Cambridge University Press, 1981); and Lynn Hunt, *Politics, Culture and Class in the French Revolution* (Berkeley: University of California Press, 1984). For discussions of body imagery in the French Revolution, see Antoine De Baecque, *Le Corps de l'Histoire: Métaphores et Politique (1770–1800)* (Paris: Calmann-Lévy, 1993); and Outram, *Body and the French Revolution*.

12. Hunt, *Politics, Culture and Class,* 62.

13. For example, Marcia Pointon points out that "when Courbet adapted Delacroix's composition for the cover of Baudelaire's radical journal *Le Salut Public* (plate 24) in 1848, he subsumed Liberty into the male fighter with the silk top hat." Marcia Pointon, *Naked Authority: The Body in Western Painting 1830–1908* (Cambridge: Cambridge University Press, 1990), 67. See also Hunt, *Politics, Culture and Class,* 94–97.

14. Beth Baron, *Egypt as Woman: Nationalism, Gender and Politics* (Berkeley: University of California Press, 2005), 68.

15. Ibid., 67.

16. Ibid., 73.

17. Ibid., 81.

18. Walter Armbrust, *Mass Culture and Modernism in Egypt* (Cambridge: Cambridge University Press, 1996), 7.

19. Lila Abu-Lughod, *Dramas of Nationhood: The Politics of Television in Egypt* (Chicago: University of Chicago Press, 2005).

20. Saba Mahmood, "Feminist Theory and the Egyptian Islamic Revival," *Cultural Anthropology* 16, no. 2 (2001): 213.

21. Kenneth Clark, *The Nude: A Study in Ideal Form* (New York: Pantheon, 1956), 3.

22. John Berger, *Ways of Seeing* (Harmondsworth, UK: Penguin, 1972), 54, cited in Pointon, *Naked Authority*, 15.

23. For a systematic critique of Clark's argument, see Lynda Nead, *The Female Nude: Art, Obscenity and Sexuality* (London: Routledge, 1992).

24. Kirsten Scheid, "Necessary Nudes: *Hadatha* and *Mu'asira* in the Lives of Modern Lebanese," *International Journal of Middle East Studies* 42 (2010): 203. Arabic to my knowledge has no distinct words for "nakedness" and "nudity."

25. Pointon, *Naked Authority*, 22. Renoir once infamously answered, when asked how he was able to paint with severe hand arthritis, "with my prick," and Kandinsky, in a famous 1913 statement, conjured a colonial rape scene, comparing the canvas to "a pure, chaste virgin" that he had to "bend . . . forcibly to [his] wish" and "conquer it . . . like a European colonist" when describing the process of painting. Quoted in Nead, *Female Nude*, 56.

26. Pointon, *Naked Authority*, 26.

27. Ibid., 82.

28. There are a few women artists who do female nudes, including the Dutch-South African artist Marlene Dumas, whose career retrospective *Marlene Dumas: The Image as Burden* I saw at the Stedelijk Museum in Amsterdam as I was drafting this chapter.

29. Pointon, *Naked Authority*, 64.

30. A great deal has been published about women, nationalism, and Islam in Egypt. Classics include Leila Ahmed, *Women and Gender in Islam: Historical Roots of a Modern Debate* (New Haven, CT: Yale University Press, 1992); Margot Badran, *Feminists, Islam and Nation: Gender and the Making of Modern Egypt* (Princeton, NJ: Princeton University Press, 1995); Baron, *Egypt as Woman;* Salma Botman, *Engendering Citizenship in Egypt* (New York: Columbia University Press, 1999); and Lila Abu-Lughod, *Do Muslim Women Need Saving?* (Cambridge, MA: Harvard University Press, 2013). See also Huda Shaarawi, *Harem Years: The Memoirs of an Egyptian Feminist,* trans. Margot Badran (London: Virago, 1986).

31. William Kidd, "Les Caprices Anglais de Marianne," in *La République en Représentation: Autour de l'Oeuvre de Maurice Agulhon,* ed. Maurice Agulhon et al. (Paris: Publications de la Sorbonne, 2006).

32. Pointon, *Naked Authority*, 72.

33. See ibid., 67–68. Poem by Auguste Barbier, quoted on 68. Maurice Agulhon, the French historian known for his analysis of how Marianne became a standard-bearer of the early French Republic, argued that sexuality and allegory are not related when it comes to women's bodies, and that nudity ought to be understood in the narrow confines of the political convention where it occurs. *A Rebel's Diary* and the scandal it spurred undermine Agulhon's separation of sexuality and nakedness.

34. Here one can glimpse the "implicit alliance between the erotic and the political which transgresses in so far as it begins to transform into an imagery of sexuality that is, essentially, an imagery of power" that Pointon saw in Delacroix's *Liberté;* Pointon, *Naked Authority,* 77.

35. Though few women artists have resorted to nude, full-bodied self-portraits, wear and underwear have traditionally been central to feminist art. Lizz Fields, *An Intimate Affair: Women, Lingerie, and Sexuality* (Berkeley: University of California Press, 2007).

36. "Samira and the Army: The Story of a Young Egyptian Woman," YouTube video, 22:44, posted by "tahrirDiaries," November 15, 2011, http://youtu.be/c29CAXR141s [Arabic].

37. Sherene Seikaly, "The Meaning of Revolution: On Samira Ibrahim," *Jadaliyya,* January 28, 2013, http://www.jadaliyya.com/pages/index/9814/the-meaning-of -revolution.

38. The Daily Beast, "Indonesia Uses Banned Virginity Tests," November 18, 2014, http://www.thedailybeast.com/cheats/2014/11/18/indonesia-uses-banned-virginity -tests.html.

39. Evan Smith and Marinella Marmo, *Race, Gender and the Body in British Immigration Control: Subject to Examination* (London: Palgrave Macmillan, 2014), 5.

40. This is the title of chapter 4 in Smith and Marmo, *Race, Gender and the Body.*

41. Alan Travis, "Virginity Tests for Immigrants 'Reflected Dark Age Prejudices' of 1970s Britain," *Guardian,* May 8, 2011, http://www.theguardian.com/uk/2011/may /08/virginity-tests-immigrants-prejudices-britain.

42. Abdel-Rahman Hussein, "Egyptian Army Doctor Cleared over 'Virginity Tests' on Women Activists," *The Guardian,* March 11, 2012, http://www.theguardian .com/world/2012/mar/11/egypt-doctor-cleared-virginity-tests.

43. Shahira Amin, "Egyptian General Admits 'Virginity Checks' Conducted on Protesters," *CNN World,* May 31, 2011, http://www.cnn.com/2011/WORLD/meast /05/30/egypt.virginity.tests/.

44. Both Ibrahim, twenty-five, and Salwa Hosseini, twenty, were vocal about the abuse. For more on Hosseini's description of the brutal treatment, see Amnesty International, "Egyptian Women Protesters Forced to Take 'Virginity Tests,'" March 23, 2011, http://www.amnesty.org/en/for-media/press-releases/egyptian-women-protesters -forced-take-%E2%80%98virginity-tests%E2%80%99–2011–03–23.

45. The *Egyptian Initiative for Personal Rights* documented the case, which was covered heavily in the West. See David D. Kirkpatrick, "Egyptian Court Says 'Virginity Tests' Violated Women's Rights," *New York Times,* December 27, 2011, http://www .nytimes.com/2011/12/28/world/africa/egyptian-court-says-virginity-tests-violated -womens-rights.html, and Riazat Butt and Abdel-Rahman Hussein, "'Virginity Tests' on Egypt Protesters Are Illegal, Says Judge," *Guardian,* December 27, 2011, http://www .theguardian.com/world/2011/dec/27/virginity-tests-egypt-protesters-illegal.

46. Seikaly, "Meaning of Revolution." Ahmed Adel el-Mogy faced charges of "public indecency and disobeying military orders"; he notably did not face any sexual assault charges (Butt and Hussein, "Virginity Tests").

47. Ayse Parla, "The 'Honor' of the State: Virginity Examinations in Turkey," *Feminist Studies* 27, no. 1 (Spring 2001): 69, 81.

48. Noteworthy here is Foucault's notion of "corrective" examination as tool of disciplinary power; Michel Foucault, *Surveiller et Punir: Naissance de la Prison* (Paris: Gallimard, 1975).

49. "Samira and the Army."

50. On feminists' disillusionment with the Arab state, see Nadje al-Ali, "Gendering the Arab Spring," *Middle East Journal of Culture and Communication* 5, no. 1 (2012): 26–31; and Zakia Salime, "New Feminism as Personal Revolutions: Microrebellious Bodies," *Signs: Journal of Women in Culture and Society* 40, no. 1 (2012): 14–20.

51. "Samira and the Army." This is one rare instance when Samira Ibrahim was simply called "Samira."

52. See Hiba 'Abdulsattar, "Activists Criticize Media and Society's Interest in Aliaa al-Mahdy and Their Ignoring of Samira Ibrahim," *al-Ahram,* November 19, 2011, http://gate.ahram.org.eg/NewsContent/13/54/138941/ [Arabic]; and 'Abdullah Al-Biyary, "Why Did the Media Care about the Naked Girl but Did Not Care about the 'Virginity Test' Crime against Demonstrators?," *Al-Quds Al-'Arabi,* December 31, 2011, http:www.alquds.co.uk [Arabic].

53. According to Karl and Hamdy, *Walls of Freedom,* 99, "in his sketchbook, Abo Bakr added to the drawing: 'We have to question and reeducate ourselves." In personal correspondence, Abo Bakr intimated he was honoring both Ibrahim and al-Mahdy, so he was not intentionally celebrating the former and criticizing the latter.

54. Mostafa Sheshtawy, "Two Dead, Over 170 Injured in Bloody Crackdown on Cabinet Sit-in," *Daily News Egypt,* December 16, 2011, http://www.dailynewsegypt .com/2011/12/16/1-dead-over-100-injured-in-bloody-crackdown-on-cabinet-sit-in/.

55. See "Shocking Video: 'Blue Bra' Girl Brutally Beaten by Egypt Military," YouTube video, 1:23, from Russia state-supported television channel Russia Today, posted by "RT" on December 18, 2011 http://youtu.be/mnFVYewkWEY.

56. See Sherine Hafez, "Bodies That Protest: The Girl in the Blue Bra, Sexuality, and State Violence in Revolutionary Egypt," *Signs: Journal of Women in Culture and Society* 40, no. 1 (2014): 20–28. The woman who would become a fleeting figure of the Egyptian revolution did not get the worst abuse that day. Azza Helal Sulayman, forty-eight years old and the daughter of a general in the armed forces, a woman in a red coat who can be seen on video at the scene trying to help the Blue Bra Girl, got a fractured skull and a bruised face. She told CNN in a post-assault interview that the police removed her outerwear, exposed her underwear, and kept beating her up.

57. Wael Qandil, "For Your Sake," *al-Shorouk,* December 19, 2011, 4 [Arabic].

58. Though woman typically symbolizes Egypt, it is only when a man was dragged and denuded, in February 2013, that one commentator exclaimed *misr ta 'arrat!!* "Egypt is naked/exposed!!" See Muhammad Salmawy, "Egypt Is Naked/Exposed!!," *al-Masry al-Youm,* February 2, 2013, http://www.almasryalyoum.com [Arabic].

59. Qandil's (Wael Qandil, 2011) referring to her as "Arwa" reflected early confusion about the identity of the trampled woman. I could not locate any stories about a journalist named Arwa being abused by the police, and the timing suggests the reference was to the Blue Bra incident. However, a column published a week later identified her correctly as "Ghada." See Iqbal al-Tamimi, "An Egyptian Woman Exposes/Denudes Men," *Al-Quds Al-Arabi,* December 27, 2011, http://www.alquds.co.uk [Arabic].

60. See "The Story of an Image . . . Sitt al-Banat," YouTube video, 2:21, posted by "AlMasry AlYoum," December 18, 2012, http://youtu.be/PFFyKvSZqr [Arabic].

61. See "Ghada Kamal's Testimony Following Her Assault by the Army on December 16," YouTube video, 5:56, posted by "Muhammed Emam Elshewy," December 18, 2011, http://youtu.be/Rgq4prhzots [Arabic].

62. "Ghada's Testimony, Who Was Beaten and Denuded by Garbage from the Army," YouTube video, 14:20, posted by "Canale di Kanattanbir," December 18, 2011, http://youtu.be/QxoZoQqTRQg [Arabic].

63. Islam Gamal, "Sitt al-Banat: I Give a Mandate to the Army against Terrorism and I Will Participate in Today's Demonstrations," *al-Yawam al-Sabe',* July 26, 2013, http://www.youm7.com/news/newsprint?newid=1177700 [Arabic].

64. Nead, *Female Nude,* 6.

65. Antonio A. Casilli, "A History of Virulence: The Body and Computer Culture in the 1980s," *Body and Society* 16, no. 4 (2010): 2.

66. Ibid., 24.

67. Donna Haraway, "A Cyborg Manifesto: Science, Technology, and Socialist-Feminism in the Late Twentieth Century," in *Simians, Cyborgs and Women: The Reinvention of Nature* (New York: Routledge, 1991), 149–181.

68. Alison Fraiberg, "Of Aids, Cyborgs, and Other Indiscretions: Resurfacing the Body in the Postmodern," *Postmodern Culture* 1, no. 3 (1991): 21.

69. Casilli, "History of Virulence," 3. Long before the digital era, women were understood in terms of contagious threats. See, for example, Palmira Brummett, "Dogs, Women, Cholera, and Other Menaces in the Streets: Cartoon Satire in the Ottoman Revolutionary Press," *International Journal of Middle East Studies* 27 (1995): 433–460.

70. See also Walter Armbrust, "The Revolution against Neoliberalism," *Jadaliyya,* February 23, 2011, http://www.jadaliyya.com/pages/index/717/the-revolution-against-neoliberalism.

71. Donna Haraway, "The Biopolitics of Postmodern Bodies: Determinations of Self in Immune Systems Discourse," *Differences: A Journal of Feminist Cultural*

Studies 1, no. 1 (1999): 3–43. See also Robert Payne, "Virality 2.0: Networked Proximity and the Sharing Subject," *Cultural Studies* 27, no. 4 (2013): 540–560.

72. Tarek El-Ariss, "Hacking the Modern: Arabic Writing in the Virtual Age," *Comparative Literature Studies* 47, no. 4 (2011): 534.

73. Ibid., 536.

74. Both novel and blog incorporate street signs. Both woman and novel have been understood as allegories of the nation. As El-Ariss explains, "'Hack,' transliterated into Arabic and then translated as 'ikhtiraq al-nizam'" ("infiltrating the system") (ibid., 543).

75. John Durham Peters, *Speaking into the Air: A History of the Idea of Communication* (Chicago: University of Chicago Press, 1999), 190.

76. Mark B. N. Hansen, *Bodies in Code: Interfaces with New Media* (London: Routledge, 2006); Casilli, "History of Virulence"; Karen Knorr Cetina and Alex Preda, "The Temporalization of Financial Markets: From Networks to Flow," *Theory, Culture and Society* 24, no. 7/8 (2007): 116–138.

77. Initially identified as Amina Tyler, it turned out her real name is Amina Sboui. Why she was known as Tyler is not clear. Tunisians referred to her as "Amina Femen."

78. Eline Gordts, "Amina Tyler, Topless Tunisian FEMEN Activist, Sparks Massive Controversy," *Huffington Post,* March 25, 2013, http://www.huffingtonpost.com /2013/03/25/amina-tyler-femen_n_2949376.html.

79. Ashley Davis, "Tunisian Preacher Calls for Execution of Topless Female Activist Amina Tyler," *Opposing Views,* March 27, 2013, http://www.opposingviews .com/i/society/tunisian-preacher-calls-execution-topless-female-activist-amina-tyler.

80. Nadine Kanaan, "Amina the Tunisian: The Body a Fort to Liberty," *al-Akhbar,* March 25, 2013, http://www.al-akhbar.com/node/180015 [Arabic].

81. *Al-Quds Al-Arabi,* "Amina Femen . . . Mentally Ill . . . Victim of Society or Political Game in Tunisia?," March 19, 2014, http://www.alquds.co.uk/?p=145325 [Arabic]; Kanaan, "Amina the Tunisian: The Body a Fort to Liberty"; Nadine Kanaan, "Amina the Tunisian: Statements under Pressure," *al-Akhbar,* April 10, 2013, http://www.al -akhbar.com/node/180773 [Arabic]; HesPress, "Femen from Tunisia: We Went Naked So That Islamists Release Amina," May 29, 2013, http://www.hespress.com/international /80380 [Arabic].

82. Jadaliyya Reports, "Statement Supporting Topless Tunisian Feminist," March 28, 2013, http://www.jadaliyya.com/pages/index/10890/statement-supporting -topless-tunisian-feminist-s.

83. FEMEN, 2013, http://femen.org/en/about; according to Rubchak, Hutsol and other students founded Femen after visiting the United States and attended "an exchange program for women as leaders" in 2007. Marian Rubchak, "Seeing Pink: Searching for Gender Justice through Opposition in Ukraine," *European Journal of Women's Studies, 19,* no. 1 (2012): 55–72. See also Camilla M. Reestorff, "Mediatised

Affective Activism: The Activist Imaginary and the Topless Body in the Femen Movement," *Convergence: The International Journal of Research into New Media Technologies* (2014): 1–18.

84. Yuliya Popova, "Feminine Femen Targets 'Sexpats,'" *Kyiv Post*, September 25, 2008, http://www.kyivpost.com/content/ukraine/feminine-femen-targets-sexpats -29898.html.

85. From their own website: see FEMEN, 2013, http://femen.org/en/about.

86. Inna Shevchenko, "Sextremism: The New Way for Feminism to Be!" *Huffington Post*, February 7, 2013, http://www.huffingtonpost.co.uk/inna-shevchenko/sex tremism-the-new-way-for-feminism_b_2634064.html.

87. Kira Cochrane, "Rise of the Naked Female Warriors," *Guardian*, March 20, 2013, http://www.theguardian.com/world/2013/mar/20/naked-female-warrior-femen -topless-protesters.

88. Kanaan, "Amina the Tunisian: Statements under Pressure."

89. *Al-Quds Al-Arabi*, "The Family of a Tunisian Femen Activist Protests against the Judiciary," July 17, 2013, http://www.alquds.co.uk/?p=63950 [Arabic]; HesPress, "Femen from Tunisia," May 29, 2013.

90. *Al-Quds Al-Arabi*, "Amina Femen . . . Mentally Ill?"

91. Jeune Afrique, "Tunisie: la Femen Amina Dénonce la Torture et des Violences en Prison," July 22, 2013, http://www.jeuneafrique.com/Article/ARTJAWEB201307221 50010/; Lilia Blaise, "Reportage au Tribunal de M'saken: Amina, Encore Libre de Dénoncer," *Nawaat*, July 23, 2013, http://nawaat.org/portail/2013/07/23/amina-encore-libre -de-denoncer/; Damien Glez, "Amina de tous les Pays, Unissez-vous!" *Jeune Afrique*, July 23, 2013, http://www.jeuneafrique.com/Article/ARTJAWEB20130723100253/tunisie -hrw-feminisme-justice-tunisienneamina-de-tous-les-pays-unissez-vous.html.

92. Ahmed, *Women and Gender in Islam*; Spivak, "Can the Subaltern Speak?"; Abu-Lughod, *Do Muslim Women Need Saving?*

93. Jeune Afrique, "Tunisie: Entre Amina et les Femen, le Divorce est Consommé," August 20, 2013, http://www.jeuneafrique.com/Article/ARTJAWEB 20130820135516/.

94. *Al-Quds Al-Arabi*, "Topless Women in Front of Cairo's Embassy in Paris Condemning Death Sentences in Egypt," April 30, 2014, http://www.alquds.co .uk/?p=162660 [Arabic].

95. Femen, "Topless Jihad. Brussels," April 4, 2013, http://femen.org/gallery/id/168 ?attempt=1.

96. Bim Adewunmi, "If Femen Was Set Up by a Man, Where Does That Leave Its Topless Protests?" *Guardian*, September 4, 2013, http://www.theguardian.com /commentisfree/2013/sep/04/femen-man-topless-protests-victor-vyatski.

97. Anna Lekas Miller, "FEMEN's 'Topless Jihad,'" *Nation*, July 1, 2013, http://www .thenation.com/article/175056/femens-topless-jihad. See also Sara M. Salem, "Femen's Neocolonial Feminism: When Nudity Becomes a Uniform," *al-Akhbar English*, De-

cember 26, 2012, http://english.al-akhbar.com/content/femens-neocolonial-feminism
-when-nudity-becomes-uniform.

98. Jeune Afrique, "Tunisie: Entre Amina et les Femen."

99. Kanaan, "Amina the Tunisian: Statements under Pressure."

100. Dina Demrdash, "Egypt's New Hijab-Clad Superheroine," *BBC News*, December 8, 2013, http://www.bbc.com/news/world-middle-east-25254555.

101. Deena Mohamed, *Qahera: A Superhero* (blog), July 20, 2013, accessed December 1, 2014, http://qaherathesuperhero.com/post/61173083361.

102. Ibid.

103. See Michelle Browers, *Political Ideology in the Arab World: Accommodation and Transformation* (New York: Cambridge University Press, 2009), and more recently Sune Haugbolle, "Reflections on Ideology after the Arab Uprisings," *Jadaliyya*, March 21, 2012, http://www.jadaliyya.com/pages/index/4764/reflections-on-ideology-after-the-arab-uprisings.

104. Amr Hamzawy, "The Crisis and Re-Establishment of Egyptian Liberals," *al-Shorouk*, July 31, 2013, http://www.shorouknews.eg.

105. Ahram Online, "Egypt's Liberals Are as Intolerant as Islamists: Bassem Youssef," October 29, 2013, http://english.ahram.org.eg/NewsContent/1/64/85039/Egypt/Politics-/Egypts-liberals-are-as-intolerant-as-Islamists-Bas.aspx.

106. This from the section "Who Are We?" on the group's website, http://6april .org/us [Arabic].

107. See "Our Vision," http://6april.org/ro2ya [Arabic].

108. Ibid.

109. Here is a classic example of such voices by an *al-Ahram* columnist: "I would like to assure sister Aliaa that she is not the first rebellious young woman . . . and this is intellectual freedom with which we may agree or disagree, but we disagree with the style of presenting this thought. A leader of rebellious thought against society's view of women is Nawal al-Saʿdawy but she said that she was ʿagainst veiling women and also against laying women bare; I am in favor of respecting woman as a rational being that can neither be veiled nor laid bare." Sabry, "Invitation to View the Body of an Egyptian Girl."

110. Ruwayda Mroueh, "Has the Struggle of Arab Women Come to Public Sex and Disrobing?" *Al-Quds Al-Arabi*, December 9, 2011, http://www.alquds.co.uk [Arabic].

111. Ibid.

112. See, among others, Nancy Fraser, "Recognition without Ethics," *Theory, Culture and Society* 18, no. 2/3 (2011): 21–42; and Judith Butler, "Merely Cultural," *New Left Review* 227 (1998): 33–44.

113. Kristeva, *Powers of Horror*.

114. Muhammad Khayr, "The Egyptian Revolution Enunciates Its Children," *al-Akhbar*, November 19, 2011, http://www.al-akhbar.com/node/26031.

115. Ibid.

116. Ibid.

117. Disgust "bears the impress of desire": Stallybrass and White, *Politics and Poetics of Transgression,* 77. See also Nead, *Female Nude,* 32.

118. Khayr, "Egyptian Revolution."

119. Iconoclasm is endemic to Western public sphere theories, from John Dewey to Jürgen Habermas.

120. See Armbrust, *Mass Culture and Modernism.*

121. Meenakshi Durham, "Body Matters: Resuscitating the Corporeal in a New Media Environment," *Feminist Media Studies* 11, no. 1 (2011): 53.

122. Joan Wallach Scott, *Parité: Sexual Equality and the Crisis of French Universalism* (Chicago: University of Chicago Press, 2005), 5. See also Joan Wallach Scott, *The Politics of the Veil* (Princeton, NJ: Princeton University Press, 2007). I find Scott's elaboration of the notion of abstract individuality in France useful to analyze the Arab uprisings because it enables a focus on embodiment as political liability.

123. Scott, *Politics of the Veil,* 169.

124. I am grateful to Marina Krikorian for pointing this out to me.

125. Sally Zahran is another martyr who was usually called by her full name, though she was an ambivalent figure who was depicted both *higab*-clad and unveiled, Armbrust, "Ambivalence of Martyrs and the Counter-Revolution."

126. See Nead, *Female Nude.*

127. If we believe that "women's corporal visibility and citizenship rights constitute the political stakes around which the public sphere is defined," then the Egyptian public sphere appears to be no place for women. Nilufer Göle, "The Gendered Nature of the Public Sphere," *Public Culture* 10, no. 1 (1997): 61–81.

128. Al-Mahdy did not respond to my numerous attempts to schedule an interview with her, and she informed me, through mutual acquaintances, that she decided not to give any interviews.

129. Aliaa al-Mahdy, "Talk about Feminist Nude in Art/Protest in Växjö Konsthall," posted to Twitter, November 22, 2014, https://twitter.com/aliaaelmahdy/status /536334952187437056.

PART VI. REQUIEM FOR A REVOLUTION?

1. Crane Brinton, *The Anatomy of Revolution* (New York: Vintage, 1965), 24.

2. David Batty, "Arab Artists Flourishing as Uprisings Embolden a Generation," *Guardian,* January 17, 2012, http://www.theguardian.com/artanddesign/2012/jan/18 /arab-artists-spring-global-exhibitions.

3. Shehab Fakhry Ismail, "Revolutionizing Art," *Mada Masr,* October 15, 2013, http://www.madamasr.com/opinion/culture/revolutionizing-art.

4. Ganzeer, "Concept Pop," *Cairo Review of Global Affairs,* July 6, 2014.

5. Adham Selim, "Towards an Art That Hides Nothing Behind," *Mada Masr,* August 3, 2014, http://www.madamasr.com/sections/culture/toward-art-hides-nothing-behind.

6. Jessica Winegar, *Creative Reckonings: The Politics of Art and Culture in Contemporary Egypt* (Stanford, CA: Stanford University Press, 2006), 10. This is a global phenomenon; see Ngai, *Our Aesthetic Categories,* 17.

7. Winegar, *Creative Reckonings,* 12; Sultan Al Qassemi, "Egypt's Long History of Activist Artists," *Tahrir Institute for Middle East Policy,* October 31, 2014, http://timep.org/egypts-political-art-history/; Sonali Pahwa and Jessica Winegar, "Culture, State and Revolution," *Middle East Report* 263, no. 42 (2012): 2–8, 5.

8. Chahinaz Gheith, "Graffiti on Cairo Walls: Art or Insult?" *Ahram Online,* November 2, 2013, http://english.ahram.org.eg/NewsContentPrint/5/0/88776/Arts—Culture/0/Graffiti-on-Cairo-walls-Art-or-insult.aspx. See also Michael Baxandall, "Patterns of Intention," in *The Art of Art History: A Critical Anthology, New Edition,* ed. Donald Preziosi (Oxford: Oxford University Press, 2009), 45.

9. Anthony Alessandrini, "Aesthetic Uprisings," *Jadaliyya,* May 1, 2011, http://www.jadaliyya.com/pages/index/1388/aesthetic-uprisings.

10. Ngai, *Our Aesthetic Categories,* 34–35.

11. See, respectively, http://www.madamasr.com/, http://www.aucegypt.edu/GAPP/CairoReview/Pages/default.aspx, and http://timep.org/.

12. See http://www.jadaliyya.com/; http://muftah.org.

13. Michael Warner, "Publics and Counterpublics," *Public Culture* 14, no. 1 (2002): 77–78, and 62, called this "the differential deployment of style."

14. See Rowan El Shimi, "Public Space Negotiations: Art Continues despite Struggles," *Ahram Online,* December 28, 2014, http://english.ahram.org.eg/NewsContent/5/35/118891/Arts—Culture/Stage—Street/Public-space-negotiations-Art-continues-despite-st.aspx. El-Shimi, however, translated *al-fan midan* as "art is a square."

15. Nestor García Canclini, "Monuments, Billboards and Graffiti," in *Mexican Monuments: Strange Encounters,* ed. Helen Escobedo (New York: Abbeville, 1998), 215–251; Nadia Radwan, "Revolution to Revolution," *Cairo Review of Global Affairs,* July 6, 2014, http://www.aucegypt.edu/GAPP/CairoReview/Pages/articleDetails.aspx?aid=617.

16. Naje, "Between a Rock and a Hard Place."

17. Asa Fitch, "Culture vs. Cultural Investment Stirs Debate in Oil-Rich Gulf," *Wall Street Journal Blog,* October 29, 2013, http://blogs.wsj.com/middleeast/2013/10/29/culture-vs-cultural-investment-stirs-debate-in-oil-rich-gulf/.

18. Sultan Al Qassemi, "Thriving Gulf Cities Emerge as New Centers of Arab World," *al-Monitor,* October 8, 2013, http://www.al-monitor.com/pulse/originals/2013/10/abu-dhabi-dubai-doha-arab-centers.html#. As usual, the debate sidelined the Maghreb (Algeria, Libya, Morocco, and Tunisia).

19. Abbas al-Lawati, "Gulf Cities have Long Way to Go before Leading Arab World," *al-Monitor,* October 14, 2013, http://www.al-monitor.com/pulse/originals /2013/10/gulf-dubai-abu-dhabi-doha-arab.html.

20. Maysaloon, "Syria's Role among 'Arab Culture Centers,'" *Syria Deeply,* October 14, 2013, http://www.syriadeeply.org/op-eds/2013/10/1533/syrias-role-arab-culture-centers/.

21. Winegar, *Creative Reckonings,* 305.

22. Abdelmagid, "Emergence of the Mona Lisa Battalions."

23. Naje, "Between a Rock and a Hard Place."

24. Lisa Pollman, "French-Tunisian Artist eL Seed on His Arabic Roots, 'Lost Walls' and Reclaiming Purple," *Art Radar,* June 6, 2014, http://artradarjournal.com /2014/06/06/french-tunisian-graffiti-artist-el-seed-on-his-arabic-roots-lost-walls-and -reclaiming-purple-interview/.

25. Catriona Davis, "Tunisian Artist Graffitis Minaret, Fights Intolerance," *CNN,* September 20, 2012, http://edition.cnn.com/2012/09/19/world/meast/el-seed-grafitti -minaret.

26. Tafline Laylin, "Tunisia's Tallest Minaret Sprayed with el Seed Calligraffiti," *Green Prophet,* September 20, 2012, http://www.greenprophet.com/2012/09/tunisias -tallest-minaret-sprayed-with-el-seed-calligraffiti/; Reuters, "Tunisian Artists Use Graffiti to Fight Religious Extremism," *al-Arabiya,* September 7, 2012, http://english .alarabiya.net/articles/2012/09/07/236596.html.

27. Pollman, "French-Tunisian Artist eL Seed."

28. Ibid.

29. Ibid.; Daria Daniel, "Tunisian Artist Popularizes 'Calligraffiti,'" *al-Monitor,* December 4, 2014, http://www.al-monitor.com/pulse/originals/2014/12/faouzi-khleefi -el-seed.html.

30. Pollman, "French-Tunisian Artist eL Seed."

31. Mostafa Hedaya, "So Close, Yet So Far: Tunisia, Art, and Revolution," *Hyper- allergic: Sensitive to Art and Its Discontents,* May 17, 2013, http://hyperallergic.com /71317/so-close-yet-so-far-tunisia-art-and-revolution.

32. Naje, "Between a Rock and a Hard Place."

33. For a blow-by-blow analysis of these sketches, listen to my November 9, 2014, interview with Audie Cornish on "All Things Considered," *National Public Radio,* "Anti-ISIS Satire Lampoons Militant Group's Hypocrisy," http://www.npr.org/2014 /11/10/363101475/anti-isis-satire-lampoons-militant-groups-hypocrisy.

34. "Egyptian Activist Publishes Naked Photo of Herself on ISIS Flag," *Al-Quds Al-Arabi,* August 24, 2014, http://www.alquds.co.uk/?p=211104 [Arabic].

35. See "Egyptian Female Activist Defecates on ISIS Flag," *Al Arabiya,* August 26, 2014, http://english.alarabiya.net/en/variety/2014/08/26/Egyptian-female-activist -defecates-on-ISIS-flag-.html; Nick Gillespie, "Powerful: Egyptian Feminists Liter- ally Shit, Bleed on ISIL Flag (NSFW)," *Reason,* August 25, 2014, http://reason.com /blog/2014/08/25/powerful-egyptian-feminists-literally-sh.

36. Peggy McCracken, *The Curse of Eve, the Wound of the Hero: Blood, Gender, and Medieval Literature* (Philadelphia: University of Pennsylvania Press, 2003); Melissa L. Meyer, *Thicker Than Water: The Origins of Blood as Symbol and Ritual* (New York: Routledge, 2005); Malek Chebel, *Le Corps en Islam* (Paris: Presses Universitaires de France, 1999), 121–123; Thomas Buckley and Alma Gottlieb, eds., *Blood Magic: The Anthropology of Menstruation* (Berkeley: University of California Press, 1988).

37. Aliaa Magda Elmahdy, "Embracing Menstruating Vaginas," *A Rebel's Diary* (blog), November 23, 2014, http://arebelsdiary.blogspot.nl/2014/11/embracing-mesntruating-vaginas.html?zx=1e916f345f84d07d.

38. McCracken, *Curse of Eve*, 64.

39. As Joan Wallach Scott explained, a key tenet of French universalism was abstraction. Because "the difference of sex is considered an obstacle to abstraction, and . . . women were taken as an embodiment of the difference of sex. Embodiment . . . was the opposite of abstraction. Hence women could not be abstract individuals." Though aware of the different context, I find this useful because it enables a focus on embodiment as political liability. Scott, *Parité*, 5.

40. Nour Rashwan, "'Tahrir Young Woman's Friend Shares Details of the Harassment Incident,'" *al-Shorouk*, June 10, 2014, http://www.shorouknews.com/news/print.aspx?cdate=10062014&id=bce2986f-d34c-47ee-8a39-c4b461d3f141 [Arabic].

41. Ahram Online, "El-Sisi Visits Tahrir Sexual Assault Victim, Apologises to Egypt's Women," *al-Ahram*, June 11, 2014, http://english.ahram.org.eg/News/103444.aspx.

42. Salim 'Azour, "Harassment Headlines Military Coup Era," *Al-Quds Al-Arabi*, June 13, 2014, http://www.alquds.co.uk/?p=179982 [Arabic]; An-Nahar, "Ghada Abdelrazzaq Envies Harassment Victim for her Nearness to Sissi," June 13, 2014, http://www.annahar.com/article/141552 [Arabic]; Usama Ghareeb, "Girls and Tramadol," *al-Masry al-Youm*, June 11, 2014, http://www.almasryalyoum.com/news/details/462465 [Arabic].

43. Fathy Mahmoud, "The System of Harassment," *al-Ahram*, June 17, 2014, http://www.ahram.org.eg/NewsPrint/296937.aspx [Arabic].

44. Galal Amin, "Meditations into Harassment," *al-Shorouk*, June 17, 2014, http://www.shorouknews.com/columns/print.aspx?cdate=17062014&id=9dc62689-363c-499c-85fb-3dd6946ceb6b [Arabic].

45. Fahmy Howeidy, "Harassment," *al-Shorouk*, June 12, 2014, http://www.shorouknews.com/columns/print.aspx?cdate=12062014&id=c293adb3-d9ce-4fcb-b094-72bf6c36cd0d [Arabic].

46. Gamal Diab, "The Harasser and the Scandalous," *al-Masry al-Youm*, June 15, 2014, http://www.almasryalyoum.com/news/details/464733 [Arabic].

47. Ahmad al-Sayyed Naggar, "El-Sisi: Decisive Measures and Full Enforcement of the Law—The President Visits Harassment Victim and Apologizes to Her and to

Every Egyptian Lady," *al-Ahram,* June 12, 2012, http://www.ahram.org.eg/NewsPrint
/295016.aspx [Arabic].

48. See Ibrahim Ahmad, "Eighteen Hours after the Shaima al-Sabbagh Inci-
dent . . . Interior Ministry: Her Killing Is a Devastating Loss and Our Forces Used
Only Gas to Disperse the March," *al-Yawm al-Sabeʿ,* January 25, 2014, http://www
.youm7.com/news/newsprint?newid=2040434 [Arabic]; David D. Kirkpatrick,
"Coming to Mourn Tahrir Square's Dead, and Joining Them Instead," *New York
Times,* February 3, 2015, http://www.nytimes.com/2015/02/04/world/middleeast
/shaimaa-el-sabbagh-tahrir-square-killing-angers-egyptians.html?_r=0; BBC Trends,
"Shamia al-Sabbagh's Killing Inflames Social Media," January 25, 2015, http://www
.bbc.co.uk/arabic/blogs/2015/01/150125-trend-shaima.

49. Ahmad, "Eighteen Hours after the Shaima al-Sabbagh Incident."

50. Associated Press, "Egypt Prosecutor Imposes Media Gag Order on Killed Pro-
tester," *Daily Star,* February 12, 2015, http://www.dailystar.com.lb/News/Middle
-East/2015/Feb-12/287209-egypt-prosecutor-imposes-media-gag-order-on-killed
-protester.ashx.

51. Fahmy Howeidy, "Consecrating Killing," *al-Shorouk,* January 28, 2015,
http://www.shorouknews.com/columns/print.aspx?cdate=28012015$id=c08548ea
-a0b3-4956-935a-7e7ade9748b5 [Arabic].

52. ʿAmro Hamzawy, "Crime Accomplices," *al-Shorouk,* January 27, 2015,
http://www.shorouknews.com/columns/print.aspx?cdate=27012015&id=0710822e
-a2ea-452d-834e-cb3427dcba96 [Arabic].

53. Nour Rashwan, "Ibrahim Eissa: Sisi and Interior Ministry Responsible
for Shaima al-Sabbagh Martyrdom," *al-Shorouk,* January 26, 2015, http://www
.shorouknews.com/news/view.aspx?cdate=26012015&id=b4486152-d320-4c81-84b0
-bdea4e7933b6 [Arabic].

54. Wael Eskandar, "The Significance of Shaimaa's Death," *Daily News Egypt,*
January 28, 2015, http://www.dailynewsegypt.com/2015/01/28/significance-shaimas
-death/.

55. Lamiat Sabin, "Protester Shaimaa Sabbagh's Death by Police Shots Blamed
on Her Thin 'Skin over Bone' Body," *Independent,* March 23, 2015, http://www
.independent.co.uk/news/world/africa/protester-shaimaa-sebbaghs-death-by-police
-shots-blamed-on-her-thin-skin-over-bone-body-10128033.html.

56. Christoph Reuter, "Waiting to Die in Aleppo," *Spiegel Online,* September 24,
2014, http://www.spiegel.de/international/world/death-and-dying-in-aleppo-as
-syria-civil-war-rages-on-a-993123.html; Karim El-Gawhary, "Graveyard Silence Re-
places Revolutionary Euphoria," *Qantara.de,* February 5, 2015, http://en.qantara.de
/content/fourth-anniversary-of-egypts-january-revolution-graveyard-silence-replaces
-revolutionary.

57. Press TV, "Bahraini Protestor Dies from Poisonous Gas Inhalation," Feb-
ruary 20, 2015, http://www.presstv.ir/Detail/2015/02/20/398379/Bahrain-protester-dies

-from-gas-inhalation-.; Béchir Lakani, "Tunisie—CTP: 18 Cas d'Agressions contre des Journalists rien qu'en Février 2015," *L'Économiste Maghrébin,* March 3, 2015, http://www .leconomistemaghrebin.com/2015/03/10/tunisie-ctp-agressions-journalistes/#.

58. Reuter, "Waiting to Die in Aleppo."

59. Ibid.

60. Outram, *Body and the French Revolution,* 160.

ACKNOWLEDGMENTS

The idea for this book crystallized in Beirut in 2011 and developed in Philadelphia between 2012 and 2014. I wrote it in Wassenaar in the academic year 2014–2015. It bears the imprint of many colleagues, friends, and perfect strangers all over the world whose generosity and thoughtfulness nurtured this project in ways small and large. Hence the expansive acknowledgments that follow.

The John Simon Guggenheim Foundation, the American Council of Learned Societies, the National Endowment for the Humanities, and the Netherlands Institute for Advanced Studies in the Humanities and Social Sciences offered crucial fellowships. The American University of Beirut offered a base in the Arab world. The Danish-Egyptian Dialogue Institute eased a Cairo visit. The Prince Claus Fund of the Netherlands expedited access to key persons. Melani McAlister, Toby Miller, Michael Curtin, Liesbeth van Zoonen, Amy Kaplan, Jakob Skovgaard-Petersen, and Judith Naeff wrote letters or facilitated access.

At the Annenberg School for Communication (ASC), Dean Michael X. Delli Carpini provides an extraordinary working environment, and my colleagues— faculty, staff, and students—have queried, conversed, and sent nuggets about activism, revolution, and politics: Guobin Yang, Sandra Gonzalez-Bailon, Carolyn Marvin, John Jackson, Joe Capella, Amy Kaplan, Anne Norton, Joe Turow, Robert Vitalis, and Ian Lustick. At the ASC library, Sharon Black and Min Zhong helped identify, procure, and digitize sources. Richard Cardona, Tej Patel, Eric Bowden, Lizz Cooper, Waldo Aguirre, Kyle Cassidy, Mario Giorno, and Phil McLelland solved many a problem with technology. Yogi Sukwa and Hermon Mebrahtu shepherded fellowship finance and administration. Deborah Porter and her staff kept the building and my office running smoothly. Several talented Ph.D. students— Alexandra Sastre, Omar al-Ghazzi, Katerina Girginova, Nour Halabi, Sara Mourad, Kate Zambon, and Revati Prasad—helped with various tasks, and Colleen Brace, a

student assistant, helped digitize files. Marina Krikorian's help at every stage of the project was vital. Thanks also to students in my course "Communication, Culture and Revolution" and my Ph.D. seminar on the body in the digital era. Sean V. Burke, Associate General Counsel at Penn, provided legal advice.

My gratitude goes to the Center for American Studies and Research at the American University of Beirut (AUB), for awarding me the Edward W. Said Chair in American Studies (2011–2012), at a critical time for being in the Arab world. Thanks to Alex Lubin, Nancy Batakji-Sanioura, Patrick McGreevey, Ahmad Dallal, Michael Oghia, Waleed Hazbun, Sari Hanafi, Nabil Dajani, Karim Makdisi, Jad Melki, and the students who took my courses, particularly "The Arab Uprisings as Battles of Representation." In Beirut, I am also grateful to Rana Jarbou', Amal Dib, Dima Dabbous, Omar Alghazzi, Nadine Bekdache, Abir Saqsouq, Habib Battah, Omar Kabbani, Semaan Khawwam, and many others.

After the turmoil of Beirut, my year at the Netherlands Institute for Advanced Study (NIAS), in Wassenaar, in 2014–2015, was an idyllic setting for thinking and writing. Rector Paul Emelkamp and his staff—Nick den Hollander, Rita Buis, Elsbeth Offerhaus, Dindy Van Maanen, Erwin Nolet, Kahliya Ronde, Rink van den Bos, Pietry Kievit-Tyson, Mareille van der Broeke, and Daniella van Huygevoort—all made it a fabulous year. Every day at 12:28 sharp, a voice would emanate from my office phone: "Dear Fellows, it is now time for lunch." Over daily lunch at the Eagle's Nest, I had the most delightful conversations with Arthur Verhoogt, Diederik Oostdijk, Stephen Amico, Suzanna de Beers, Jamal Mahjoub, Jannah Loontjens, Luisa Gandolfo, Koen Haegens, Mark Moritz, Karl Kügle, Judith Keilbach, Antje Wiener, Jan Abbink, Ihab Saloul, Slawomir Lotysz, Martha Zarzycka, Ewa Stanczyk, Anu Realo, Eveline Crone, Dieudonné Zognong, Lex Bosman, Cars Hommes, Naomi Ellemers, Jeroen Duindam, Melissa Green, Paul Schure, Amy Verdun, Lenore Manderson, and others. Stephen, Suzanna, and Karl gave generous feedback on portions of the manuscript, and they, along with Slawomir, Ewa, Luisa, and Antje, recommended readings. I relished chatting about the craft of writing with Diederik, Koen, Jannah, and Jamal. Dindy went out of her way to help with many things above and beyond her work as a librarian, and so did Elsbeth with logistics. Thanks to my Wassenaar neighbors René and Heidi Salemink for motivating me with the gambit that no NIAS fellow who lived at 154 Van Polanenpark had completed their book while in residence during the last twenty years. That spell is now broken.

Years ago, over Iranian food in London, Annabelle Sreberny exhorted me to remember, "It is the people, not the technology!" At a formative stage, in Beirut, Yves Gonzalez-Quijano convinced me to commit to the body as the master concept for this book when I was still dithering. Yves would later read the entire manuscript and catch infelicities, and so did Mohamed Zayani, Arthur Verghoot, Elisabetta Ferrari, and Marina Krikorian. Traces of their generous and meaningful recommendations

are all over the book. At another critical time, Michael Curtin and Kevin Sanson invited me to present a paper at the University of California, Santa Barbara, and gave important feedback. In New Orleans, Vicki Mayer recommended crucial literature. An invitation from Guobin Yang to contribute to an Annenberg workshop was another opportunity for my argument to coalesce.

Heartfelt thanks to the Syrian artists-activists—in particular Ashaʻb Assoury ʻAref Tareqoh—for sharing their struggles and their hopes, in Beirut, Amsterdam, and elsewhere.

In Cairo, I am deeply grateful to Deena Mohamed and Ammar Abo Bakr for providing art and permission to use it in the book, and to Angela Boskovitch for her help.

For inviting me to speak and speaking back to me, thanks to Ernesto Braam, Netherlands Ministry of Foreign Affairs; Alex Lubin, American University of Beirut; Christine Pense, Northwest Community College, Bethlehem, Pennsylvania; José van Dijk, Robbert Woltering, Christoph Lindner, Thomas Poell, Michiel Leezenberg, Jeroen de Kloet, Esther Peeren, and others, the University of Amsterdam; Abir Najjar, Jordan Media Institute; Rita Figueiras, Catholic University of Portugal; Graeme Turner, University of Queensland, Australia; Patrick D. Murphy, Temple University; Nathalie Khazaal, Texas A&M University; Nadja von Maltzahn, Orient-Institut Beirut; David Morris, University of South Florida; Mehran Kamrava and Mohamed Zayani, Georgetown University Qatar; Yesim Kaptan, Sevda Alankus, Gokcen Karanfil, and Altug Akin, Izmir University of Economics; Lu Wei, Zhejiang University, Hangzhou; Orhan Tekelioglu, Bahçeşehir University, Istanbul; Osama Abi-Mershed and Elliott Colla, Georgetown University; Daniella Stockmann, Leiden University; Regina Lawrence, Penn Law; Nadja-Christina Schneider, Humboldt University, and Carola Richter, Free University, both in Berlin; Monroe Price and Briar Smith, Center for Global Communication Studies at Annenberg; Véronique Richard and colleagues, CELSA (Sorbonne), Paris; Katja Valaskivi, but also Heikki Hellman, Kaarle Nordenstreng, and Susanna Nikkunen, University of Tampere; Pauwke Berkers, Erasmus-University Rotterdam; Marion Muëller and Arvind Pappas, Jacobs University, Bremen; Friederike Pannewick, as well as Atef Botros, Malte Hagener, Ines Braune, and Charlotte Pardey, Philipps University, Marburg; Houda Ayoub, École Normale Supérieure, and Milad Doueihi and Yves Gonzalez-Quijano in Paris; Kari Anden-Papadopoulos, Kristina Riegert, Elie Wardini, Martin Säfström, and Marc Westmoreland, Stockholm University; for hospitality in Stockholm, Svante Fregert, Danielle and Niklas Kebbon, Joel Abdelmoez, and Miyase Christiensen; David Hesmondalgh, Bethany Klein, and colleagues, University of Leeds; and Katherine Autzilsky, the Austrian American Foundation, Vienna.

Patrick Murphy, Guobin Yang, Aswin Punathambekar, Mohamed Zayani, Will Youmans, Helga Tawil-Souri, Farha Ghannam, John Downing, Payal Arora, Miguel Aldaco, Kelly Fernàndez, Benjamin Smith, Ali Atassi, Karin Gwinn-Wilkins, Tariq

Elariss, Ziad Fahmy, Walter Armbrust, Rayya El Zein, Leila Tayeb, Lina Khatib, Dina Matar, Hamid Naficy, Naomi Sakr, Joe Khalil, Adel Iskandar, Jostein Grip-srud, Donatella della Rata, Lea Nocera, Lisa Wedeen, and Zhondang Pan contributed insights and encouragements, in person or in writing.

It has been a pleasure to work with Harvard University Press. My editor, Sharmila Sen, has been engaged and judicious from the beginning, and Heather Hughes has been very helpful.

Heartfelt thanks to the Philadelphia gang and book cover focus group, John Darling-Wolf, Fabienne Darling Wolf, Patrick Murphy, Nancy Morris, Jan Fernback, Karla Murphy, David Hollar, and Jim Thomas; and to the team who kept my reluctant back functional: Craig and Andrea Tickle, Brenda Goldschmidt in Narberth, and Mariella Brouwer in Wassenaar.

The Kraidy clan, Michel, Aida, Ziad, Ghassan, Terri, Astrid, Sarah, Omar, Léa, and Ana, embraced us when in Beirut or Paris, sent me readings and materials, and were on Skype standby at all times.

Because they were at the center every step of the way, I dedicate this book to Ute Kraidy, and to our children, Bruno and Maya.

INDEX

Abdallah of Saudi Arabia, King, 44, 70

'Abdeen Square, 207

Abdelfattah, Alaa, 28–29

Abdel Nasser, Gamal. *See* Nasser, Gamal Abdel

Abdelwahhab, Nadine, 67

Abdulhamid, Sultan, 59

Abdullah of Jordan, King, 62

Abdulrahman, Reda, 57

Abjection, 160, 174, 195, 215; and embodiment, 215; fear of, 195, 215; and women's naked bodies, 160

Abo Bakr, Ammar, 95–96, 99, 121, 174–176, 211, 218. *See also* Graffiti artists

Abstract individual, 13, 25, 197–200, 215, 228n38, 269n39; and embodiment and citizenship, 25, 182; as full citizen, 162, 167, 171, 197–199

Abstraction, 198

Abu Dhabi, 208–210

Abulmaged, Omar, 4, 56–58. *See also* Animal symbolism; Donkey

Abu-Lughod, Lila, 188

Abu Naddara, 58, 78–79

Activism, 5, 6, 21, 195, 206; accidental, 19; against Daesh, 203, 213–215; and Aliaa al-Mahdy, 162–169; and altruism, 174; and Amina Sboui, 188–189; antisectarian, 127–130; and art, 5, 211; and Assala, 154;

and body symbolism, 65–87, 131, 214; and bread, 51; click, 131; combination of gradual and radical, 53; and commerce, 211; and creativity, 228n41; and family support, 172; global, 21; gradual, 18, 52; and identity formation, 20, 143, 206; keyboard, 131; and media, 198; and naked body, 17, 195; and purity, 169; radical, 18, 52; revolutionary, 197; and Samira Ibrahim, 19, 172–174; and stencil graffiti, 131; street, 66; studies of, 198; topless, 187–188, 191, 194; and torture, 66; and virginity testing, 19, 172–174; and women, 162–163. *See also* Creative insurgency

Activist collectives: April 6 Youth Movement, 104, 106, 159, 194; Asha'b Assoury 'Aref Tareqoh, 16, 124–126; Atelier Populaire Paris poster collective, 106; Femen, 184, 186–191, 198, 214; Kharabeesh, 16, 43; Kullina Khaled Said, 16, 65–68; Masasit Mati, 134, 136–137, 139–142, 145–146; Mona Lisa Brigades, 16, 209; Noss Tuffaha, 140

Addustour, 59–60

Aesop, 55–56

Agamben, Giorgio, 43

Ahmed, Leila, 188

Akali Dal, 107

Al-Shazhly, Mona, 67

Al-Shorouk, 76, 94, 178, 179

Al-Shorouk bookstore, 218

Al-Sisi, Abdulfattah, 4, 10, 56, 57, 69–71, 83, 104, 171, 181, 193, 216–220; and Bassem Youssef, 70–71; as eagle, 84–87; as lion, 84–87; and masculinity, 85–87; and media clampdown, 69–71; merchandise, 84; as new pharaoh, 216–220; and personality cult, 84–87; and Saudi Arabia, 70–71, 87; and Shaimaa al-Sabbagh, 216–219. *See also* Animal symbolism; Body politic; Strongman

Al-Tahrir, 60

Al-Tantawi, Mohamed, 58, 80, 83, 97

Al-Toshy, Ghawwar, 132

Al-Ujayli, Abdelsalam, 114

Al-Yawm al-Sabe', 77, 218

Amanou, Slim, 32, 34

American University of Beirut, 118, 123, 273, 274, 275

American University in Cairo, 5, 93

American University in Cairo Press, 209

Amnesty International, 60, 171

Animal Farm, 55, 56

Animal imagery, 19, 56, 58, 72, 80, 82–83. *See also* Animal symbolism

Animal symbolism, 4, 13, 55–87, 123, 126–128, 203, 213; and *Abu Naddara,* 77; as allegory, 55; and American politics, 56; in *Animal Farm,* 55; in Apuleius, 56; and ass, 56; and Assad, 125–128, 149; and *assahl al-mumtana',* 55; and Bassem Youssef, 82; and bears, 80–83; and birds, 99; and bugs, 151–152; and Buridan's Ass, 56; in Cervantes, 56; and children, 55; and cockroaches, 152; and cow, 75–79; and Daesh, 203; and dictator's body, 75–79, 84–87, 89, 125–128, 149; and digital video, 138; and dog, 4; and donkey, 5, 56–58; and eagle, 84–87; and Egyptian art, 57–58; and Egyptian flag, 157; and Egyptian history, 58; and Egyptian Parliament, 58; and *el-Bernameg,* 82; and germs, 15, 92, 138, 152; and giraffe, 149; and Ibn al-Muqaffa', 55; as imagery, 19, 56, 58, 72, 80, 82–83; and insects, 152; and Israeli

general, 152; in *Kalila wa Dimna,* 55; in La Fontaine, 55; and Laughing Cow, 4, 6, 8, 18, 55–90, 92, 154, 215, 223; and *La vache qui rit,* 75–76; and lion, 84–87, 125–128; and Morsi, 80–83; and Mubarak, 75–79, 89; in Orwell, 55; and Palestinians, 152; in *Panchatantra,* 55; and pigs, 4, 56–58; and poodle, 80–83; and Qur'an, 57; and rats, 15; and religion, 57; and Sisi, 4, 84–87; and snakes, 15, 138; and *sprezzatura,* 55; and Tantawi, 58, 80–83; and time in office, 83; and Twitter, 76; and United States Department of State, 203; and Ya'qub Sannu', 77. *See also* Gradual creative insurgency; Humor; Parody; Satire

Anonymous, 34

Ansar al-Sharia, 187

Anti-ocularism, 108–109

Antisectarian activism, 127–130

April 6 Youth Movement, 104, 106, 159, 194. *See also* Activist collectives

Apuleius, 56

Arab American National Museum, 14, 209

Arab art, 17, 202, 208–211; aboutness of, 205–207; and authenticity, 202, 205–207; and creative-curatorial-corporate complex, 17, 208–211; and discourse, 205–207; and global exposure, 202; and Gulf influence, 208–209; and market, 208; and museums, 208–2011; and nude art, 165–169; and nude art and protest, 199–200; at Venice Biennale, 202. *See also* Art

Arab cultural production, 202. *See also* Arab art; Creative insurgency

Arab Network for Human Rights Information, 60

Arab uprisings, 6–9, 11, 13, 14–17, 20, 28, 34, 47, 66, 91, 101, 102, 105–107, 120, 143, 156, 159, 171, 185, 197–198, 201–203, 207, 209–214, 221, 223

Arbeiter-Illustrierte Zeitung, 105

Archive, 17, 203, 206

Armbrust, Walter, 109, 163

Art, 5, 7, 9, 11, 21, 53, 57, 71, 73, 105, 107, 109–110, 115–116, 117, 127, 139, 143, 152, 153, 157, 158, 163, 174, 183, 185, 202, 205–211;

221–224; of the dictator sovereign, 6, 10, 20, 37–38, 41, 43, 53, 59–61, 69, 73, 78, 80, 86, 92, 115–116, 123, 125, 145, 147, 148; imagery of, 10, 18, 72, 125, 131, 150, 220; as medium, 5; as metaphor, 5, 10, 82; and movement, 100–102; and pain, 30–32; and self-immolation, 23–25, 28–32, 52–53; symbolism of, 5, 10, 11, 18, 41, 43, 47, 72, 131, 138, 149–150, 220; and touching, 100–110; and vision, 100–102. *See also* Body politic; Body typology; Eye symbolism; Hand symbolism

Body politic, 83–84, 89, 176; Arab, 201–203; and arboreal metaphor, 154; author's firsthand experience with, 127; and cartoons, 107; and celebrity, 148–156; children in, 147; and creative insurgency, 20; Daesh as nostalgic version of, 212; decapitation of, 89, 155; dictator as head of, 60, 70, 83, 84, 86, 127, 132, 147; dictator as usurper of, 97; digital, 62–68; and digital culture, 182–185; as diseased, 155; dissent in, 61; in Egypt, 60–61, 70, 173–174, 182–185, 219–220; and eyes of the martyrs, 97, 109; and fear, 101; as foundational to the fall and rise of dictators, 10; as gendered, 13; king as head of, 10; medieval European notion of, 9–10; members severed from, 100–101, 116, 150, 152; and miniaturization, 145; and national sovereignty, 182–185; as opposite of body natural, 9; place of women in, 13; and public space, 115–116; and puppetry, 92; and rap, 41–42; refashioning of, 101; in revolutionary graffiti, 123–127, 131; revolutionary positioning in, 101; ridiculing the, 127; as sacred in medieval Europe, 10; as secular in contemporary Egypt, Syria and Tunisia, 9; in Syria, 123–127, 132–156; and sovereign power, 155–156; as threatened by insurgents, 15; in Tunisia, 35, 38, 42; of the United States during the Vietnam War, 23; and virality, 183

Body typology: classical body, 53, 64, 69, 73, 83, 90, 92, 101, 134, 145, 147, 213; grotesque body, 6, 18–19, 53, 64, 69, 73, 90, 134–135, 145, 213, 215; heroic body, 6, 9, 18–19, 53,

68, 92, 114, 131, 134, 197, 223. *See also* Creative insurgency

Bolshevik Revolution, 105

Boq'at Daw', 111–114, 133

Bouazizi. *See* Al-Bouazizi, Tarek al-Tayeb Mohamed

Bourguiba, Habib, 35–36, 44, 50

Bourguibisme, 35–36

Bovine, 4, 75–78

Bread symbolism, 7, 10–11, 47, 50; in activism, 7, 10, 47, 50–51; in bread riots, 7, 10, 51; and Captain Khobza, 7, 11, 16, 50–51; and Old Left, 195; in political contracts, 10–11, 47; in political slogans, 11; in political systems, 47

Brinston, Crane, 201

Brooklyn Artists Alliance, 209

Browne, Malcolm, 23

Bryn Mawr College, 209

Buddhist militants, 191

Buridan's Ass, 56. *See also* Animal symbolism

Burning Man, 4, 5, 8, 18, 23–53, 92, 223

Burqa, 189–190

Byblos, 130

Cairo, 92–110; demonstrations/graffiti in, 78–79, 93–102; violence in, 93–110, 216–220; and walls, 92–110. *See also* Al-Mahdy, Aliaa; Egypt; Graffiti; Harassment; Murals

Cairo Review of Global Affairs, 206

Caliphate, 203, 212. *See also* Daesh

Calligraffiti, 17, 210–211. *See also* Graffiti genres

Cameron, David, 146

Capitalism, 75, 154, 163–164, 184, 188

Captain Khobza, 7, 11, 16, 50–51. *See also* Bread symbolism

Caravan Festival of the Arts, 57

Cartoonists, 45, 56, 73, 100, 106–107, 116, 133, 163

Casilli, Antonio, 12

Celebrity, 149–150, 153–155, 210

Central Security Forces, 93

Tunisian slogans, 43; two modes of, 18–19; typology of bodies in, 19–20; as violent and peaceful, 14; and wall of fear, 101; and walls, 98–101, 117–131; webcomics as, 190–192

Creativity, 14, 15, 18, 20, 143, 155, 166, 223; and activism, 228n41; and aesthetics, 14; as embodied, 15, 20; of male artists painting female nudes, 166; and rebellion, 14, 143, 155, 223; and revolutionary action, 15. *See also* Creative insurgency

Culotte, 80–82

Cult of death/death cult, 212, 215. *See also* Daesh

Cyberwar, 149–151, 155. *See also* Digital communication

Dabiq, 212

Daesh (Islamic State), 11, 21, 108, 125, 146, 153, 201, 203, 211, 212–215, 222–223; activism against, 203, 212–215; as nostalgic body politic, 212; parody of, 203, 212–215

Damascus Spring, 111, 133

Damascus University, 137

Danish Center for Culture and Development, 209

Dawkins, Richard, 187, 192

Dawlat al-Khilafa, 203. *See also* Daesh

Dawlat al-Khurafa, 203. *See also* Daesh

Defecation, 83, 214

Delacroix, Eugène, 7, 162, 166–168

Deleuze, Gilles, 99

Demonstrations, 50, 81–82, 103, 120, 125, 128, 142, 170, 173, 181, 203, 223

Der'a, 113, 116, 123, 127, 146, 221

Derry, 98

Dictator's body, 20, 97, 115, 147, 155. *See also* Animal symbolism; Body politic

Diderot, 110

Digital communication, 5, 7, 12, 30, 68, 142, 149, 161, 182–183; and *al-Ahram* scandal, 62–64; and anonymization, 217; as artifact, 66; and biology, 183–185; and blogs, 161, 183; and body politic, 62–64, 160; and celebrity, 148–156; and circula-

tion, 142; as cyberwar, 149–151, 155; and dictator's body, 38, 62–64, 148–156; and Egypt, 159–164; and hacking, 34, 149, 151, 184, 185, 186; and hybridity, 142; and hypermedia space, 32, 76, 206; and images, 17; and Khaled Said, 65–68; and manipulation, 38, 62–64; and martyrdom, 68, 218; and media wars, 148–156; and memory, 206; and metrics of popularity, 143; and national identity, 5, 182–185; and national sovereignty, 182–185; and networks, 11, 183; and revolutionary politics, 5, 17; role in Arab uprisings, 11, 34, 65–68, 134; and satire, 72; and self-dissemination, 167; and trolls, 151; and virality, 142; and women's bodies, 5, 182–185. *See also* Internet; Social media

Digital culture: and comic strips, 189–192; and comical avatars, 64; and Khaled Said, 65–68; and martyrdom, 65–68, 218; and national sovereignty, 182–185; and nudity, 18; and permanence, 183; and puppetry, 7, 17; and rhetoric of virulence, 183; and understanding of body, 12, 183–185; and video, 12, 43, 132–147. *See also* Video; YouTube

Digital video, 12, 32, 43, 141, 143; of aftermath of Bouazizi's death, 32; of Blue Bra Girl, 177–181; *Elf Leila w Leila,* 45; and instant replay, 143; by Kharabeesh, 16, 43; *Le Journal du Zaba,* 215; Mosireen Video Collective, 95; and repetition, 143; *Top Goon,* 132–140

Dignity, 3, 10, 11, 19, 25, 29, 50, 53, 89, 172, 180, 209, 219, 223

Docility: as conceptual issue, 115; of regime-sanctioned political groups in Syria, 154

Doha, 208–210

Donkey, 4, 56–58, 83, 149. *See also* Animal symbolism

Don Quixote, 56

Doueihi, Milad, 12

Dream TV, 67

Dubai, 208–210

Dubček, Alexander, 31

Duc, Thich Quang, 23